TRENDS IN ART EDUCATION FROM DIVERSE CULTURES

Edited by Heta Kauppinen and Read Diket

1995

The National Art Education Association
1916 Association Drive
Reston, Virginia 22091

About NAEA

Founded in 1947, the National Art Education Association is the largest professional art education association in the world. Membership includes elementary and secondary teachers, art administrators, museum educators, arts council staff, and university professors from throughout the United STates and 66 foreign countries. NAEA s mission is to advance art education through professional development, service, advancement of knowledge and leadership.

ISBN 0-937652-79-2

CONTENTS

PART I—HISTORICAL PERSPECTIVES

—continued—

CONTENTS (continued)

PART II—PROJECTS AND PROSPECTS

PART III—MULTICULTURAL AND CROSS-CULTURAL ISSUES

ABOUT THE AUTHORS

■ **HETA KAUPPINEN**, PhD, The Pennsylvania State University; MA and BA, University of Helsinki; M.Ed., University of Applied Arts, Finland. She is currently a member of the Faculty of Art Education at the University of Georgia, Athens, Georgia, and was formerly Chief Inspector of Art Education for the government of Finland. She has authored and co-authored 18 books and curriculum materials published in Finland and the United States. She is the writer and co-writer of over 70 articles in scholarly journals and chapters in books that have appeared in several European countries and the United States. She has lectured on art education in most European countries, Canada, and the United States. She served as World Counselor, 1978—1981, for INSEA, the International Society for Education Through Art, Secretary of the INSEA 1971 regional conference, Secretary of the Finnish Art Teacher Association, 1970—1973, and Director of the Lifelong Learning Affiliate of NAEA, the National Art Educators Association, 1991—1993. She has exhibited her paintings and drawings in Finland and in United States.

■ **READ M. DIKET**, PhD, is Director of the Honors Program, and the Center for Creative Scholars, and Assistant Professor of Art and Education at William Carey College in Hattiesburg, Mississippi. She received her undergraduate degree in art and education from the University of Mississippi, and a masters degree from the University of Southern Mississippi, in art education with an emphasis in the education of the gifted. She received the PhD degree from the University of Georgia, combining art education, psychology, and art criticism/history. Manuscripts by Dr. Diket have appeared in scholarly books and publications. She has received numerous awards and recognition for art programming.

■ **BRIAN ALLISON**, ATC, AdvDipEd, PhD, FRSA, FNSEAD, is Emeritus Professor of Education and formerly Head of the School of Education and Dean of the Faculty of Education, Humanities, and Social Sciences at Leicester Polytechnic. He served as World President of INSEA 1982—1985 and President of the National Society for Education in Art and Design 1986. He served as Chairman of the NSEAD Editorial Board of the *Journal of Art and Design Education*. He has served on many national committees in the United Kingdom. He has taught at the California State University, Los Angeles, the Nedlands College of Education, Perth, and the University of Melbourne, Australia. He has published and lectured widely throughout the world. He is the recipient of the Australian Commonwealth Fellowship, the 12th USA Towards Humanizing Education Award, the USSEA Edwin Ziegfeld Award, the Fellowship of the National Society for Education in Art and Design, an Honorary Fellowship of Bretton Hall College, and Associate Fellowship of Leicester Polytechnic.

■ **VERA ASSELBERGS** is an art sociologist who has taught as Professor in Art Education and Art Sociology at the Amsterdam College of Higher Education since 1974. She worked as a scientist at the national Dutch Institute of Arts Education 1970—1974. Her articles on art education and sociology have appeared in several professional journals. Her latest book is *Van Sniesschoule tot centrum voor kunstzinnige vorming* (School of Crafts, 1892—1992), 1992.

■ **ANA MAE T. B. BARBOSA**, PhD, is Professor of Art Education at the University of Sao Paulo, Brazil. She received her doctorate from Boston University and was World President of INSEA. She has published in professional journals and books in various countries and has lectured widely both nationally and internationally.

■ **ULLA BONNIER** is President of The Swedish Board of Art Teachers, consulting art teacher in the city of Lund, and consulting expert in art education for the government of Sweden. She has given presentations at international conferences and published articles on art education. She is a co-author of a text on the study of mass media.

■ **DOUG BOUGHTON**, PhD, is Professor of Art Education, South Australian College of Advanced Education. He received his doctorate from the University of Canberra and has published several articles on art education.

■ **HANAN BRUEN** is Director of the Curriculum Center at the University of Haifa, Israel, and publishes frequently on educational and arts educational topics in European and American journals.

■ **BARBARA CARLISLE**, PhD, is Associate Dean in the School of Fine Arts at Miami University, Ohio. She has served as a consultant to the Kellogg Foundation for arts education programming and is the author of several publications in the field of arts education and art history. She received her doctorate in art history from the University of Michigan.

■ **MARIE-FRANCOISE CHAVANNE** has served on the INSEA World Council since 1978. She was elected Vice President in 1981 and INSEA World President in 1984. Since 1991, she has worked as Pedagogical Regional Inspector in art education, in charge of the west region of Paris. She taught art for 20 years at the college and lycée lev-

els. She has served as Consultant Professor in CIEP (International Center of Pedagogical Studies) of Sevres, France, as Pedagogical Counselor, and as a member of various research groups. She is the author of several articles on art education appearing in national and international publications. She has contributed to organizing the INSEA conference in Sevres as well as many UNESCO projects.

■ **MAHMOUD EL-BASSIOUNY**, PhD, is Professor Emeritus, College of Art Education, and former Dean of the College, Helwan University, Egypt. In 1939, he gained a diploma from the School of Applied Art in Cairo, and in 1942 a further diploma from the Art Department of Cairo Higher Institute of Education, where he was the first graduate. He received his MA degree in 1947 and his doctorate in 1949 from the Ohio State University while serving there as a member of the Egyptian Government Mission. On his return, he joined Cairo College of Art Education as an instructor and later became Dean, Professor, and Chairman of the Department of Education. After 25 years' service in Egypt, he served as in the same capacities at King Abdulaziz University in Mecca. setting up a new Department of Art Education, and later at Quatar University, Doha, Quatar. In 1986, he assumed his position at Helwan University. Professor El-Bassiouny is the author of 36 books dealing with education and art education, as well as articles in professional journals and newspapers. He is an active painter. He served as INSEA World Counselor for several mandates and as Vice President 1963—1966.

■ **LUIS ERRÁZURIZ**, PhD, works as a researcher and lecturer in the Aesthetic Institute of the Catholic University of Chile. He received his Mph and PhD degrees from the Institute of Education, University of London. He is a founding member of the Chilean Society for Art Education and represents Chile on the Latin American Council for Education Through Art. Dr. Errázuriz has published several scholarly articles in Chile and other countries and presently is working on a book about the history of art education in Chile since 1797.

■ **BOGOMIL KARLAVARIS**, PhD, received his doctorate in the field of art pedagogy. He works as Professor at the Pedagogic University in Rijeka and has taught also in the Higher Pedagogic Institute in Novi Sad, the Academy of Fine Arts in Belgrade, and the Academy of Fine Arts in Novi Sad in Yugoslavia. He is the author of several books and numerous articles and has lectured and consulted nationally and internationally in art education. He served several mandates as President of INSEA's European Region and as World Counselor for INSEA. Dr. Karlavaris is an active painter and has exhibited his work in about 60 personal and over 400 group shows in many European countries and in Yugoslavia. He has received numerous art awards and medals as well as recognition for his work in art education.

■ **ANDREA KARPATI**, PhD, is an art historian and educator who works as Associate Professor of Education at Eötvös Loránd University and at the Hungarian Academy of Crafts and Design, Institute for Cultural Theory and Art Teacher Education, where she is also Coordinator of Postgraduate Studies. She is responsible for national art education research projects on curriculum development and assessment. Her publications include 6 books and about 50 studies published in 7 languages. She serves on the editorial consulting boards of Studies in Aesthetic Education (USA), and the Journal of Art and Design Education (Great Britain) and the editorial board of the Hungarian Journal of Education.

■ **AALTJE KNOOP** is Professor of Art Education at a teacher education college in Amsterdam. She has studied textiles, drawing, and social pedagogy. She has authored books about children's work in textile crafts, and her articles have appeared in several professional journals. She is President of the Society for Teachers of Textile Arts (AVDTex).

■ **AKIO OKAZAKI**, MEd, is Associate Professor of Art Education at Utsunomiya University, Japan. He received his bachelor's degree from Kochi University, in 1975 and his master's degree from Osaka University of Education in 1979. He teaches art education at Utsunomiya University. His research includes the history of American and European art education and its influence on Japanese art education. His articles has been published in several scholarly journals and books in the United States and Japan. He has presented papers at many international conferences.

■ **LOIS PETROVICH-MWANIKI**, PhD, taught art in the former West German schools for 5 years in the 1970s. Since then, she has researched contemporary and historical trends in West German and Kenyan art education, as well as multicultural art education, and has published articles on these topics. In 1987, she received her doctorate from Purdue University. She received a grant from The Ohio State University to conduct further research on the Kunstunterricht movement in Germany. Currently, she is responsible for the undergraduate and graduate art education programs at Western Carolina University.

■ **JOHN STEERS** qualified in painting and ceramics at Stourbridge College of Art and Goldsmith's College, University of London. He taught art and design in comprehensive schools in London and the West of England. He was appointed as General Secretary of the NSAE (now the National Society for Education in Art and Design, NSEAD) in 1991. In this capacity, he represents NSEAD's interests before many national committees and organizations. He served as International Secretary of INSEA, International Society for Education Through Art, 1983—1990. He is currently Vice President of INSEA.

■ **MARY STOKROCKI**, Ed.D., is Associate Professor of Art Education at Arizona State University, Tempe. She received her doctorate from The Pennsylvania State University (1981), her master's degree from the Massachusetts College of Art in Boston (1976), and her bachelor's from SUNY College at New Paltz, New York (1969). She has conducted ethnographic research for the past 12 years, focusing on portraits of art teachers, their problems, and solutions, most notably on multicultural art teachers in inner-city Cleveland, in Rotterdam, Holland, and on a Navajo reservation. In 1992, she was awarded the Mary Rouse Award for outstanding performance in research,

teaching, and leadership. She is state representative for USSEA, the United States Society for Education Through Arts.

■ **JAROMIR UZDIL**, PhD, studied art history, psychology, and pedagogy at the Charles University of Prague, Czechoslovakia, and painting and art theory at the Polytechnical University. After World War II, he studied painting and art history in Paris on a scholarship from the French government. Since 1947, he has worked as a member of the Pedagogical Faculty as senior lecturer, and later as Professor at the Academy of Applied Arts in Prague. He has published more than 200 literary works, including 12 books. He served several mandates as World Counselor for INSEA and as President of the INSEA World Congress in Prague, 1966. He has received many honorary awards, including the 1990 Ziegfeld Award. He lives and works in Prague and lectures abroad. Most recently he published in English a study of the work of J. A. Comenius as it relates to problems in art education.

■ **SOLOMON IREIN WANGBOJE**, PhD, University of Benin, Nigeria, was World Counselor for INSEA 1985—1988. He is a recipient of the USSEA Ziegfeld Award. He has published and lectured both nationally and internationally.

■ **IRENA WOJNAR**, PhD, University of Warsaw, is Chairperson of the National Committee on Aesthetic Education (Poland). She is the author of 6 books on aesthetic education and several articles published in Great Britain and the United States. She is editor of Paedeia, the Journal of Art Education.

■ **KAZUMI YAMADA** is Associate Professor in Art Education at Hokkaido University of Education, Hakodate, Japan. He graduated in 1981 from Tokyo Gakugei University and worked as an art teacher at the university's Takehaya Junior High School, 1981—1988. His research interests include the history of postwar art education. He has developed databases for art and craft education. His publications appear in the field of history of art education.

■ **RICHARD YEOMANS**, PhD, majored in painting at the University of Newcastle on Tyne, where he studied under the British Pop artist Richard Hamilton. He is an active painter and has held 12 solo exhibitions and participated in numerous group shows in London, the Midlands, and the North of England. As an art historian he has a special interest in the art of the 19th and 20th centuries and a particular interest in Islamic art and architecture. He received his masters degree in art education from Birmingham Polytechnic and his doctorate from the University of London, where he researched the pedagogy of Victor Pasmore and Richard Hamilton. Since 1978, he has worked as a lecturer in painting and art history in the Department of Arts Education at the University of Warwick and is involved with teaching art at all levels from junior school to adult education.

FOREWORD

■ ROBERT J. SAUNDERS

I am both honored by and indebted to Heta Kauppinen and Read Diket for asking me to write an introduction for this multicultural anthology of *Trends in Art Education from Diverse Cultures* and think about the issues involved. As I read the names of the prominent authors, the countries they represent, and their writings, it becomes clear that we are no longer just dealing with diverse cultures and a trend toward multiculturalism, but with a movement that is world wide.

But where does the trend stop and the movement begin? The history of art education is a record of trends and movements, some lasting longer than others, some forgotten except by the historians who resurrect knowledge about them, others still with us. Is there a difference between them? My copy of the *American Heritage Dictionary* defines trends and movements in somewhat similar terms: "trend . . . 1. a direction of movement; a course; flow. . . 2. a general inclination or tendency . . ." and "movement . . . 1. an act of moving; a change in position . . . 2. the activities of a group of people to achieve a specific goal . . . 3. a tendency or trend." The difference between them may be a matter of degree; a specific group of people must be actively trying to create a movement. This is not unlike the Cubists and Futurists, who created movements by writing manifestos.

To see how this shift from trend to movement happened in art education, we might look at the *discipline-based art education* (DBAE) phenomenon. It began in the mid-1960s, when classroom linguistics and performance objectives were being applied to art programs and curriculum guides. The usual art curriculum phrase *art history and appreciation* was found to include three different areas of inquiry: art history,

aesthetic education, and art criticism. A trend in this direction began among some art educators, and the term *discipline-based art education* was sometimes applied to it, but its influence on the broader field of art education was minimal. Then, around 1984, the Getty Center for Education in the Arts began exploring the potential of DBAE to improve the quality of and give validity to art education in the schools. At that point, what had been a slowly flowing trend became a major movement, with the publications, conferences, and strategies necessary to provide the means by which change could take place.

Multiculturalism in art education, as a movement, has more of a grass roots origin. It has grown, not through the strategies of an organization, but through diverse dedicated people who are themselves actively involved in moving art education into multicultural channels through such organizations as the United States Society for Education Through Art (USSEA), the International Society for Education Through Art (INSEA), and national art education organizations in various countries. The members of these organizations are activists who have influenced art education to expand its multicultural orientations in curricula, conferences, and publications.

Trends in Art Education from Diverse Cultures feeds this grass roots multicultural movement by bringing together works from authors in Africa, Asia, Australia, Europe, and South America, as well as diverse cultures within North America. The trends represented here give energy to the movement. The New Age, in which all races live together in peace, will be brought about with the help of works such as this. So read this rich new addition to the literature with your eyes open and your peripheral vision ever widening.

Opposite page: Photo courtesy of Vivienne della Grotta. © 1982.

Courtesy of Kaiju Haanpaa, Children's School of Art, Vihti, Finland.

INTRODUCTION

■ HETA KAUPPINEN

Recent political changes, especially in Eastern Europe, have opened channels for the cross-cultural exchange of ideas and burgeoning international cooperation in art education. In many countries, art education is undergoing a process of reorganization in response to this openness. The process of reorganization requires adopting a Janus attitude, looking both backward into the rich heritage of art education ideas and forward to a vision of future prospects in a cooperative world.

The current mass migrations of people across borders in all parts of the world and the breakup of countries into ethnic units may not be an aberration; it may be the tendency of the future. These occurrences represent contradicting cultural forces. The migration makes various parts of the world more multicultural, while new homelands are formed on the basis of ethnic purity. Violence arising from cultural differences is increasing and is often uncontrolled both within societies and among large cultural areas. These processes challenge the field of education to develop curricula reflecting and responding to multicultural concerns.

Trends in Art Education from Diverse Cultures brings together 30 art educators from 21 countries to provide information about the past record of art education along with recent developments and future prospects. The authors report on art education within 27 national or local cultures from Europe, the Middle East, Africa, Asia, the Pacific, and the Americas. Many of the authors are seasoned and distinguished scholars. They are handing down to younger generations visions for the future and their wisdom, based on their experience with and understanding of art education since the era preceding World War II.

The book provides a cross-cultural forum in which the authors express major themes and often reach consensus. Their concern is our sociocultural and physical environment—the universal responsibility to care for the natural and cultural environment and to preserve and foster cultural expressions. They call for the clarification of art education's position on the economic play of power that gave birth to a systematic art educa-

tion and still holds art education in its grip in many places in the world. Does art education prefer economic injustice and senseless efforts for economic growth that deplete natural resources, or does it advocate sharing the benefits and finding meaning for life in spiritual, nonmaterial values? Authors, who have experienced political oppression emphasize the political nature of art. People can be educated through art to surrender to oppression or to resist. Art education can serve a purpose in eradicating inequality, discrimination, and violations of human rights by exploring and expressing these major themes. These themes have frequently been explored in great works of art. Are they, then, also central to art education?

PART I: HISTORICAL PERSPECTIVES

Developments in art education reported from 16 countries express the vital role of cross-cultural influences. The cross-cultural exchange of philosophies, ideas, curriculum models, and teaching practices has taken place throughout the 150 years of public art education. The authors identify channels and means of cross-cultural exchange and discuss how various influences have been adopted and assimilated in diverse cultures. Although the sequence of developments has been similar in various countries, the philosophical and pedagogical content has been diversified according to the differences in the cultural, political, and social background of each country.

In the countries featured here, art education in public schools began in the mid-19th century as an outgrowth of the progressing Industrial Revolution. A goal was to educate skilled workers and craftsmen to improve the quality of products in the competitive market. Art education came to schools first as line drawing and geometry. Many national and international exhibitions revealed a need to revive the aesthetic standards of products and enhance the aesthetic discrimination of consumers. The authors note such exhibitions as the World Exhibitions of 1851 and 1900 in Paris; the Art Applied to Industry exhibition of 1877 in

Amsterdam; the World Expositions of 1851 and 1862 in London, and the Centennial Exhibition of 1876 in Philadelphia.

Industrial competition made it necessary to revise drawing programs and broaden goals. For example, the Dutch syllabus included self-motivation, diligence, and perseverance—qualities well appreciated in industry. The Swedish syllabus incorporated the development of aesthetic sensibilities and intellectual abilities. The Egyptian syllabus for line drawing was based on rendering ornamentation in the Egyptian, Greco-Roman, Coptic, and Islamic traditions. The British and Australian syllabuses cited goals of improved memory, observation skills, enhanced intelligence, good taste, and moral values. New methods included drawing from memory or dictation, models, prints, and nature as well as free-arm drawing and inventive drawing. Japanese art education emphasized handicrafts. The Japanese government wanted to reform practical education to increase production, promote trade, and keep up with and overtake the industrialized world.

The art education philosophies of Walter Smith and the Scandinavian slöjd (crafts) nurtured curriculum revisions. Smith's ideas reached such countries as Brazil, Australia, and Japan. His belief in art as popular education, as opposed to art as cultural accomplishment, and his emphasis on the idea of the existence of a general capacity for drawing represented new, progressive thinking. His aim for precise, clean craftsmanship developed through progressive exercises reflected his background at the South Kensington School of Industrial Drawing and Crafts. The Scandinavian philosophy of slöjd was adapted readily to the art education needs of many European countries, Japan, and Australia. This philosophy emphasized the generally civilizing influence of drawing, and the development of intellect and aesthetic sensibility, as well as simultaneous and harmonious growth of body and soul.

The period from the beginning of the 20th century to the start of World War II witnessed universal growth in the scope and content of art education. Art history, aesthetic appreciation, national and local art traditions, folk art, architecture, and environmental planning appeared in syllabuses along with the recognition of the child's individual expression. The research on spontaneous expression in child art that originated and thrived at the turn of the century was adapted to art education, but in a controlled manner. Serious study of theoretical material and purposeful application of formal and expressive aspects to studio work moderated children's spontaneity. Increasingly, women came to art education and contributed to the progress of instruction, curriculum planning, and publication in professional journals and books. The utilitarian and pragmatic orientation gave way to an era of cultural concern, aesthetic awareness, and an understanding of the uniqueness of individuals.

There is not much reporting on art education during World War II. The written history of art education usually divides its development into the eras of before and after the war. However, what happened during the war is as important to later developments as what happened before the war. In Japan, for example, during the increase in militarism and authoritarianism, children were not allowed to express their creativity freely. With the onset of World War II, craft fields increased and craft texts were written from the practical viewpoint of defense. The needs of national defense and nationalism changed education to indoctrinate a philosophy of national defense and creation of devices. After the war, craft maintained its prominence, but new goals replaced the dubious wartime aims. Finnish art teachers initiated new approaches to exploring social and political issues and realities through art and increased their interest in their national art heritage, women artists, and design. They created a system for using works by local artists in teaching art criticism and examining selected reproductions and works of art in art therapy. After the war, many of these approaches continued to develop. Art education universally took a drastic turn in its philosophy, goals, and methods. In a world largely divided into the Eastern and Western Blocs, different political pressures influenced the development of art education.

Creative expression appears in the art education syllabuses after World War II, from about 1945 to 1965. Literature about child art and creative expression became largely available after the war. The UNESCO seminar "The Role of the Visual Arts in Education," held in 1954 in Victoria, Australia, expressed strong support for creative expression as a major aim of art education. The proceedings from the seminar demonstrated almost total commitment to the creativity ideology, as exemplified by a paper titled "The Importance of Not Teaching How to Paint." Creative expression in art education developed in diverse ways. For example, in Egypt, local materials were introduced to the system of studying art at all grade levels. Arts and crafts were unified and measured by common aesthetic criteria. The technique was no longer considered as separate from the form of creation or from the personality of the student. In Chile,

the syllabus cited as goals the development of children's capacity for creativity and appreciation of art. But creativity remained subordinate to the purposeful study of art, which continued to have a strong utilitarian tendency. In Swedish art education, creative expression was to counterbalance modes of thinking and behavior that occurred during the war in Nazism and fascism. Creative expression was used to educate individuals who would be able to make their own judgments. Free, creative activities would develop free thinking and the ability to question authority. In Japan, a child-centered approach to art education was established for the first time. The new emphasis was that people should express their thoughts and demands frankly. In Eastern Europe, creative expression became a spontaneous opposition to the dogmatic restrictions of the totalitarian ideology.

The prominent ideologies of the era came from the thinking of Viktor Lowenfeld, Herbert Read, and the Bauhaus school. Read and the Bauhaus influenced art education in Europe. The Bauhaus theory emphasized process rather than product, problem solving, experimentation, and formal aspects of art. In Great Britain, the Bauhaus theory was central in the Basic Design movement that infiltrated art education. In East Germany, the Bauhaus theory was a basis for the study of form which offered an outlet from ideological pressures. In West Germany, the Bauhaus theory's support for the cathartic qualities of art steered instruction toward the use of traditional German art. In many European countries, the application of the Bauhaus theory to art education led to a rather disciplined study of a variety of materials and techniques. In Chile, Egypt, Japan, and Australia, ideas for creative expression came from Victor Lowenfeld.

In the late 1960s and during the 1970s, a new orientation demanded the development of concepts rather than skills, specialized knowledge of art, and greater intellectual input. In West German and Nordic art education, social concerns, experimentation with the interrelationship of political and social issues, visual communication, and contemporary media dominated art education. Because these trends challenged society and political authorities, they were absent from East European art education, which was under the totalitarian system. In Great Britain, multicultural awareness and the development of critical skills represented a modified version of trends toward increased social and political regard. In Japan, education was required to emphasize science and be modernized to educate human resources to support the high growth of the nation's economy. The tendency was to question the

system of learning content and to set economic efficiency as the goal of revision. Concurring with these ideas, the Japanese Federation for Education Through Art selected the theme "Science and Art Education" for the INSEA 1965 Conference in Tokyo. Joining the environmental movements of the 1970s, art educators revived environmental concerns in many art education curricula. The INSEA 1971 conference "Environment and Its Preservation, Protection, and Development in Art Education" in Finland initiated the development of methods and content for environmental education through art.

PART II: PROJECTS AND PROSPECTS

This section represents trends in art education, that are developing in the contemporary world. The authors in this section, like the authors of the chapters in Part I, express a need for developing curricula based on the uniqueness of each country or nation. They point out the necessity to define the characteristics and find the identity of art education in diverse cultures. They caution against direct adoption of art education philosophies, ideas, and practices but do not exclude cross-cultural cooperation and exchange. Developing cultural pluralism and diverse identities in art education demands exhaustive research on the present and past. Large-scale surveys, observations, and evaluations of the state of art education, as in Hungary, are indispensable. The Hungarian research agenda incorporates documentation of outcomes following different educational approaches, identification of interactions with socioeconomic and psychological factors relative to model programs, assessment of localized teaching packages, and pilot programs for teacher education and inservice support for alternative curricula. This type of extensive research requires governmental support and a democratic basis apart from private interests. Almost all the countries, featured in this book, have a national curriculum or general guidelines or nationally approved texts. All these forms of national guidance allow freedom to individualize art education programs locally and for the purposes of individual schools and teachers. Continuing evaluation and modification of curricula, as well as regular revisions, have benefited art education. Old practices and undeserved ideas are discarded and new ones are introduced along with systematic inservice education of teachers and dissemination of relevant curriculum materials. In Great Britain, for the first time in British history, the government has introduced a national curriculum. Its implementation in art education will be worthy of attention. In the United States, a National Committee for Standards in the Arts is working to define national

quality standards for grades K through 12 in the arts disciplines.

All the authors in this section mention economic means and ends relative to the arts. Few others choose to elaborate the issue of practice in art education that is economically driven.

PART III: CROSS-CULTURAL AND MULTICULTURAL ISSUES

The visual arts express cultures most effectively because, as Wangboje notes, they use symbols, myths, and other forms of inherited and accumulated understanding to create visions of life embodying the fears, hopes, aspirations, and beliefs of specific cultures. The visual arts also use techniques and materials found in each culture to express and interpret that culture's particular experience. Cultural diversity is visible in habitats, environmental settings, and immediate surroundings. People's ways of dressing, their outfits and costumes, their manufactured and handcrafted products, and the arrangements they make of everyday and decorative objects tangibly reflect their cultures. Works of art express the human significance and meaning of life, sometimes as specific to a culture but frequently as universal, across cultures. Often in the most compelling and powerful works, art expresses universal experiences in human life. These universal experiences constitute the forces of unity in cultural diversity.

Cultural diversity appears in cultural differences among nations, among ethnic and other cultural groups within society, and among individuals. Cross-cultural influence crosses the boundaries of countries, while multicultural influence occurs within countries and societies. There are other concepts related to cultural diversity. The transcultural concept bridges the cross-cultural and multicultural concepts in a unified territory. Cultural pluralism is an orientation that allows all groups live and work together while maintaining their cultural identities. The concept of cultural pluralism appears frequently in goals for cross-cultural and multicultural education.

Education for cultural pluralism faces many challenges. As Broudy (1981) has pointed out, a society requires varying degrees of interdependence. The question is how much autonomy can be allotted to cultural groups while still avoiding cultural separatism or atomism. How can minorities maintain enough separation from the dominant culture to develop their own cultural tradition? Another problem is attitudes toward

cultural pluralism. Multicultural education argues that we should respect all cultures. But is it possible to respect all cultures? Respect has such synonyms as admire, adore, cherish, idolize, or worship. Is it necessary to respect cultures that violate human rights or are a threat to law and order? Is a racist practice an antithesis of cultural harmony or a way of cultural expression? Is it valid to respect only selected aspects of a culture and disregard the unpleasant ones? Wangboje notes that cultures are valuable because of what each can contribute to the overall well-being of humankind. A further challenge is political systems. Democracy is basis for cultural pluralism, but how intrinsic is cultural pluralism to other political systems? Can demands for cultural pluralism cause political upheaval and calamity in otherwise stable and serene cultures?

The enriching effects of cultural pluralism can be controversial. Green (1966) argued that no one person's or group's way of life is so rich that it may not be further enriched by contacts with other points of view. We can learn from varied ways of thinking, feeling, expressing, and viewing the world. But how much enrichment from diverse sources does it take to dilute an original culture, or when will enrichment saturate a culture so that it disappears and becomes new and different? How do we regulate the conforming effects of mass media and avoid the onset of a monoculture? The teacher is a key factor. In many multiethnic countries, it is likely that a teacher from the dominant culture teaches a multiethnic class. Does such a situation bring forth unity in diversity or uniformity and monoculture? In multiethnic countries, is it necessary to intensify the recruitment of student teachers from various ethnic groups? A basis for such recruitment can begin in the early childhood education that encourages various cultural expressions.

Finally, because a culture is the sum of its expressions, what area of culture should be studied in art education? Is it the study of the cultural environment—its physical and social aspects? How much knowledge and understanding of these can be acquired through investigating singular objects and works of art? Are research methods of art history and criticism sufficient, or are methods for a comprehensive study of cultures needed? Are techniques adapted from anthropology and sociology adequate, or is it necessary to develop new ways of study? A range of methods used in the cooperative peace project "Nordic Paradise" by Nordic art teachers provides many useful ideas for multicultural study.

Multicultural concerns have a long record in art education. In some countries, such as Egypt, even the early line drawing program had multicultural underpinnings. Multicultural concerns appeared as a recognition of folk art, local art forms, and materials in the curricula at the beginning of the 20th century. Multicultural awareness and attempts at systematic multicultural instruction increased in the 1970s. The INSEA 1985 conference in Bath "Many Arts, Many Cultures," called for decisively recognizing the importance of multicultural issues in art education. However, multicultural art education is still in its infancy.

Implications

How do the authors in this book contribute to our understanding of art education in the past, present, and future? They bring us to an awareness of major elements and a discernment of fresh ideas and new categorizations. An emerging idea—central to goals, curriculum content, and methods of art education—is the perception of education as an ongoing, lifelong process. For example, in Japan, the new education reform was carried out for the sake of establishing a society devoted to lifelong learning. Voices from the Eastern European countries express similar concerns. Similar to the regard for lifelong learning is the issue of personality traits. The authors point out that art education has a history of being a part of the character building of individuals in forming personality traits that various societies have regarded as virtuous. However, the authors question what the personality traits are that art education can and is willing to develop in the contemporary world.

A common concern in these chapters is the political nature of art, which infiltrates art education. For many, art education has shown its capability to become a channel for political involvement, sometimes for the darkest aims of oppression, sometimes for the brightest hopes of humanity. The written history of art education exposes its engagement in political ideologies, economic interests, and social movements both good and bad. However, much of the adverse and troublesome in art education is still absent from its record; an honest examination and disclosing of events and outcomes are called for. The matter in question is the very identity of art education. Is art education an aesthete, critic, and maker of art, isolated in an ivory tower, or a political activist in the tumults of the world? Is it a spineless handyman used for many purposes, or a successful coach in creating a beautiful and healthy environment and teaching dedication to art? Is it all of these things, or still something else?

Many of the authors lament the declining status of art education. It has changed from a required course to an optional one. But there always is space in the curriculum for an irreplaceable subject, which art education periodically has been. Art education's very survival and prosperity may depend on discovering its qualities, that are universally worthy and found in diverse cultural systems of the contemporary world. The authors see as vital and evolutionary such major themes in art education as concern for the physical and sociocultural environment; care for cultural values; and solidification of the cultural identity of individuals, groups, and nations. It is the ardent hope of the authors and editors of this book that their contributions will inspire increasing cooperation across nationalities for the benefit of art and the humankind.

References

Broudy, H. S. (1981). Cultural pluralism: New wine in old bottles. In J. M. Rich (Ed.), Innovations in education. Boston: Allyn and Bacon, (pp. 145-152).

Green, T. (1966). Education and pluralism: Ideal and reality [Twenty-Sixth Annual J. Richard Street Lecture]. Syracuse, NY: Syracuse University School of Education.

HISTORICAL PERSPECTIVES

EDITORIAL

■ HETA KAUPPINEN

This section features developments in art education from Australia, Brazil, Chile, Egypt, and Japan, as well as from the Western European countries of Sweden, the Netherlands, and Great Britain and the Eastern European countries of Czechoslovakia, Yugoslavia, East Germany, Poland, Bulgaria, Rumania, Hungary, and the Soviet Union. The authors see cross-cultural influences as significant in the development of art education. Art education philosophies, ideas, curriculum models, and teaching practices have been exported from one country to another throughout the world. Sometimes the influence has been through a direct adoption, and sometimes through a careful transformation and assimilation to each country's own cultural tradition. Cross-cultural influences have enriched art education; often a new and unique form of art education has emerged from the interweaving of different influences. The authors offer important insights into the processes of reconciliation of two or more influences on art education. The authors from Eastern Europe provide unprecedented firsthand information about art education in the totalitarian system. This may be unparalleled in the history of art education because the authors revised their manuscripts as the Eastern European countries were liberated.

Vera Asselbergs and **Altje Knoop** analyze shifts during one century of art education in Dutch primary schools. A century ago, art became compulsory in the Dutch schools to revive aesthetic standards in industrial production and enhance the artistic sense of consumers. The proper teaching of art included geometry and perspective, precise copying, and the skills of neatness and precision. The Scandinavian slöjd movement was influential for the basic principles of instruction. Crafts were seen as a medium for disciplining the potential working population and keeping it from idleness, rowdiness, and other improper behavior.

Outcomes of the emerging research on child are at the turn of the century were readily applied to teaching. A synthesis between drawing geometrical shapes and encouraging children's natural interests emerged as a method of instruction. The ideas of Cizek and Rothe challenged the teaching profession to move toward creative self-activation of children and the years 1945 through 1968 marked the breakthrough of free expression in art. However, its free expression orientation sidetracked art education to being a pleasant frill, and thus it began to return to the concept of being more than expression. Many ideologies of art education emerged from the various organizations of art teachers. Revising art programs meant including a personal interpretation of reality in student work, teaching art appreciation and formal aspects of art, and systematic assessment and evaluation.

Ana Mae Barbosa writes about Walter Smith's influence on Brazilian art education and the efforts by Brazilian liberals to overcome the concept of art as an elitist activity. During the first half of the 19th century, art had become an activity of the elite and was under the steady influence of David and the French neoclassic style. The French Mission provoked a process of discontinuity traditional colonial art and a separation between people and art. *O Novo Mundo*, a newspaper published in New York between 1872 and 1889, was a vehicle for the liberal concept of education, and it also transmitted Walter Smith's ideas to Brazil. The principal issue was to intensify Brazil's interest in industrial arts and industrial progress. Drawing, with an emphasis on precise, clean craftsmanship, provided the means to successful education in industrial design. Rui Barbosa, a liberal politician and education reform leader, adapted Smith's ideas to Brazilian education. One aim of the interpretations of Smith's thought in Brazil was to fight against elitism in art. Smith's man-

ual was applied to art education in that country until 1958.

Mahmoud El-Bassiouny explores the developments of art education in Egypt. The centralized educational system facilitated the dissemination of philosophy and methods of art education. At the turn of the century, a line drawing method was abstracted for art education from the local traditions of Egyptian, Greco-Roman, Coptic, and Islamic art. Memory drawing, perspective, pastel drawing, and crafts developed from the line drawing system. The International Conference for Education in Arts, in Paris, 1937, marked a reform in Egyptian art education. Research on child art and Franz Cizek's ideas influenced the reform in public schools. The reform included the discovery of child art, a change of focus from skills to expression, an exploration of the link between art education and current social problems, the respect of local traditions in art and folk art, and adoption of an interdisciplinary orientation. The reform also meant elevating standards in art teacher education. Male and female art teachers received different training until 1966, when a unification of separate institutes took place. The 1960s and 1970s were devoted to developing research and graduate studies in art education as well as organizing art education locally. The aims of art and crafts were integrated, and local artists and craftsmen contributed to art instruction in the schools.

The current rapid expansion of the population, more than 1 million a year, has crowded schools. Special art classrooms are now needed to house regular classes, sometimes of more than 100 students. There is a shortage of more than 4,000 art teachers. To deal with the situation, the government has established new departments for art teacher education. However, many graduates choose to work in fields other than art education. The syllabus in the public schools includes exploration of local materials, folk art, and works by eminent artists. Students are educated to understand works of art, improve the aesthetic qualities of the environment, and employ aesthetic discrimination in all aspects of life. The most challenging aim is the development of an integrated human being through art.

Ulla Bonnier discusses developments in Swedish art education in the context of the country's political and social background. In a centralized educational system, art education began as a compulsory subject in 1842. Focused on line drawing, its goals were to prepare students for working life and to develop their aesthetic sensibilities, intellectual capabilities, dexterity, and competent draftsmanship. The orientation was aesthetics for daily, life including the design of furniture, household goods, and buildings. Demands for spiritual values challenged this pragmatic orientation, the argument being that humankind's need for products and goods is limited while the need for beauty is unlimited. The democratization and reform of the Swedish school system began after the World War II. Goals of art education included cultivating knowledge of Sweden's artistic heritage, aesthetic discrimination, critical thinking, and cooperation. The frightening consequences of Nazism and Fascism in Europe challenged education. Free creativity was introduced to art education to counterbalance blind trust in authority and develop independent thinking. The 1969 syllabus included the study of art and the environment, art appreciation, and the contemporary media. Art history was taught as a separate subject. The skills of expressing oneself through the contemporary media, media criticism, and understanding visual communication became increasingly dominant. This orientation was intended to prevent indoctrination and manipulation of the masses by those who control the information flow.

Doug Boughton analyzes changes in Australian art education during the past 100 years. He identifies three major periods: the hand-eye training period, from the late 19th century to World War I; the creativity period, from the 1940s to the 1960s, and the studio discipline period from the 1960s to the present. The first influence came from the South Kensington drawing program, which in turn derived ideas from 18th century European academies of art. Drawing developed to include object, memory, design, geometric, and scale drawing, as well as expressive drawing to some extent. The creativity period derived from Franz Cizek's ideas, which came to Australia from Austria through Britain. The change toward creativity was slow, and approaches of the earlier period were retained alongside the new approach. Writings of Herbert Read and the popularization of Cizek's philosophy by Victor Lowenfeld continued to maintain the ideology of creative expression. The studio discipline period brought substantive components of art theory, history, and appreciation to curricula while earlier methods also persisted. This persistence in retaining earlier practices and the time lag—sometimes close to 40 years—in adapting new influences make the development and characteristics of Australian art education distinctive. In the 1960s, art educators experimented with such orientations as aesthetic education, design education, integrated arts education, and art from a social relevance point of view. In the 1970s, a national policy for art education was established. Study in visual arts consists of two equally important components: (1) reflect-

ing on and responding to visual art forms, and (2) making visual art. Syllabuses were broadened to include popular arts; folk and primitive arts; fine arts; and environmental, product, and graphic design. State examinations in art for the purpose of achieving university entrance status are in place.

Luis Errazuriz explores the main developments in Chilean art education, which began as a compulsory subject more than a century ago. Boys studied line drawing while girls were taught home economics, embroidery, and needlework. A major aim was to educate boys to become skilled and able to contribute to industrial development. Another aim of drawing was to support the study of other subjects. Influences came from Belgium, France, and Germany. In the beginning of the 20th century, teaching became more creative and included drawing from nature. The intellectual development of students was important. Art history was introduced to the syllabus, and soon thereafter study of the Chilean cultural background and heritage. In 1933, the syllabus included painting, sculpture, architecture, and the chronological study of art history. From 1949 on, creativity became an aim as an outcome of the increasing North American influence and such literature as Viktor Lowenfeld's *Creative and Mental Growth (1947)*. Herbert Read's ideas represented another major foreign influence. From 1967 to 1970, aims of the subject were to serve the economic needs of the country by developing the creative potential of students and providing them basic knowledge of environmental planning and architecture. In the 1980 syllabus, art history and drawing from nature were prominent. The latest developments included environmental planning, Chilean painting, Native ceramics, visual communication, and commercial art.

Bogomil Karlavaris examines art education in Eastern Europe from 1945 to 1991. The oscillations in ideological repression and changes in relations between two military blocs, the Warsaw Pact and NATO, affected art education. Periods of dogmatic exclusivism in times of confrontation alternated with periods of liberalization in times of easing of international tensions. The political circumstances made it difficult to develop art education unless it conformed to the educational philosophy of the totalitarian system. Keeping up with the developments in art education elsewhere and contributing to the advancement of art education in the civilized world required heroic and sometimes canny and daring efforts on the part of art education leaders and teachers in schools. the Soviet Union was a leading ideological authority. Art was given the role of influencing the conscience of people

and their motivation for building and defending socialism. Reality had to be shown in an optimistic way, which in practice meant glorification of achieved results in society.

However, in each Eastern European country, art education developed in a unique fashion based on a different cultural background and ways of dealing with the totalitarian educational philosophy. Three major orientations in art education developed. First, the compromise between children's spontaneous expression and educational themes from everyday life in the spirit of socialist realism emerged as an instantaneous opposition toward dogmatic and ideological restrictions. Furthermore, from the influence of the Bauhaus, especially in East Germany, developed a theory of shape and form as a neutral and objective field of aesthetic study. Moreover, the escape into national and folk tradition in art developed. In this orientation the form of expression is considered national although its content may be socialistic. Finally, an orientation focusing on the integration of aesthetic fields developed, most significantly in Hungary.

Jaromir Uzdil analyzes the history of Czechoslovakian art education before and after World War II. The timeless educational philosophy of Comenius (1592—1670) provided the foundations for the development of art education. It involves insight into the natural world as well as the world created by man, and is dominated by ars, a creative endeavor originating from human ingenuity. The philosophy has been germane to ideas from various sources such as research on child art, Cizek, the Bauhaus, folk art as an enhancement of national self-realization, and developments in art history. Under the totalitarian system, Czech art education had to defend itself against many instructionally primitive deformations. Art educators succeeded in maintaining relationships with the outside world through INSEA and other international organizations. Books and journals, in which a number of persecuted authors were able to publish articles under pseudonyms, maintained a progressive and scholarly orientation in art education. Thus, there was not much to catch up with after the "Velvet Revolution" in 1989. Czechoslovakian art educators could note with satisfaction that their field had not been left as far behind as other subjects in the humanities.

Kazumi Yamada analyzes the development and problems of art education in Japan. The history of art education includes the development of an official system, a manual or textbook system, and unauthorized

movements against them. Yamada distinguishes several patterns of development. They begin with the introduction of Western art education in the mid-19th century, followed by the rediscovery of Japan's traditional art, art in general education, and free-drawing education. After World War II, a new style emerged within a high-growth economy, and learning was more relaxed with content reduced. Texts provided through the Ministry of Education have guided Japanese art education since its beginning, while independent movements have enriched it. Japanese art education also maintains its vitality and renewal through international contact and regular revisions. Recently, the proportion of elderly citizens in Japanese society has increased, and with it has come a change in people's consciousness. The ways of learning of adults, women, and the elderly have become an issue. Education reform was carried out for the sake of establishing a lifelong learning society. Following this trend of thought, art education emphasizes aesthetic sensitivity, ability in the design process, creative craft expression, and appreciation. Another challenge, still to be answered, is how to adapt such aims as character-building experiences through art education to Japan's high-technology, computerized society.

Richard Yeomans examines the Basic Design movement, which represented a radical change in British art education during the 1950s and 1960s. It meant a loose dissemination of educational ideas and values inspired by the Bauhaus and European constructivism. The movement aimed for modernism and a reform of the National Diploma in Design. The Diploma had engendered good craft techniques but provided a poor basis for design and failed to nurture analytical and critical modes of thinking. During the 19th century, British design education implemented the South Kensington method, concentrating on applied art and grammar of ornament. William Morris and the Arts and Crafts movement changed the method with an emphasis on the understanding of material and the making process. The Arts and Crafts movement failed to meet the requirements of industrial-based design, but its principles prevailed in the requirements for the Diploma. Although the Bauhaus artists settled for a while in Britain, knowledge of their ideas and methods was not profound and their writings were not readily available. Therefore, Victor Pasmore and his circle of abstract artists developed the Basic Design methods. Like the Bauhaus school of thought, Basic Design was concerned with teaching the formal elements. It emphasized the empirical, open-ended, and experimental nature of design. In the context of its major principles, Basic Design courses were as diverse

as the individual artists who taught them. In some cases, Dada, Surrealism, and Pop art influenced Basic Design. Performance art also began to emerge. Basic Design methods influenced design education into the 1970s and some aspects penetrated British secondary and primary school art education. Statements in the new National Curriculum indicate the presence of Basic Design principles by the inclusion of formal elements. A goal is to develop knowledge and skills to select, control, and use the formal elements of the visual language of line, tone, color, composition, form, and space.

References

Lowenfeld, V. (1947); Lowenfeld and Brittain, (1964). *Creative and Mental Growth;* a textbook on art education. New York: The Macmillan Company.

QUALITY CRITERIA SHIFTS IN ONE CENTURY OF ART EDUCATION IN DUTCH PRIMARY SCHOOLS

■ VERA ASSELBERGS
■ AALTJE KNOOP

A century ago, art became a compulsory subject in Dutch primary schools. Its content has given rise to many discussions. Shifts in the views on the aims of teaching art, crafts, and textile arts reflect shifts in the views of general education. This chapter explains what content-related developments were started by the shifting quality criteria of arts education and who took the lead in this process.

The 1877 exhibition "Art Applied to Industry" at the Amsterdam Museum voor Volksvlijt revealed a great need for reviving aesthetic standards in producers and consumers. This exhibition also convinced a large number of people of the inferior quality of Dutch industrial products. Some years before, Victor de Stuers had also criticized the lack of artistic sense of the Dutch population in the famous Dutch literary magazine *De Gids*. In 1878, the Leeuwarden art teacher Molkenboer wrote a leaflet as part of a contest of the Society for Public Welfare, titled "What Is Elementary, Useful and Feasible in Primary and Secondary Education to Educate Artistic Sense and Enhance Artistry?" Molkenboer's answer to this question was proper teaching of drawing. To him, proper meant geometrical. In the manner of the Frenchman Dupuis, whose method had been popular in secondary education, primary school children mainly focused on eye and hand exercises. They learned to draw straight lines, angles, quadrangles, curves, and circles and finally progressed to the more intricate three-dimensional shapes and ornaments. Drawing from nature (i.e., copying objects—the reward of this persistent, conscientious geometry—was a skill only a handful of students mastered.

1889—1901: Usefulness and Neatness

In 1889, geometrical drawing became compulsory in primary schools. In the meantime, the Nederlandse Vereeniging voor Teekenonderwijs (NVTO), the Dutch society of drawing teachers, established in 1880, had introduced a primary teaching certificate that had official status. Geometry and perspective were

the main elements. Most teachers were not skilled enough to teach this kind of drawing and soon resorted to the many teaching aids that were introduced such as stigmatographs (printed dots to be connected by lines) and wall charts. The 1898 Zwier and Jansma charts, especially, dominated drawing instruction for decades.

Drawing was dominated by precise copying activities. Neatness and precision also characterized the subject of plain needlework, and not just for aesthetic motives, as is evident from the reasons why this subject became compulsory in primary schools in 1878. Plain needlework instruction was considered essential for girls. Because the same tasks are essential in housekeeping, instruction in plain needlework was seen as one of the best means to promote school attendance, especially in the countryside. Plain needlework instruction aimed to prepare girls for their future tasks as mothers and housewives. Crafts teaching, which had been advocated since 1876 by the Society for Public Welfare and the Society for Education of the People, was influenced by the Scandinavian slöjd (crafts). Courses were set up for teachers to give students after-school instruction in the basic craft principles.

Soon the educational values of this subject were recognized. Craft skills were very useful, but educators also hoped to promote love of working, conscientiousness, neatness, self-motivation, diligence, and perseverance by teaching these skills. These qualities were highly valued in industrial circles too. It is hardly surprising, then, that the Groningen section of the Dutch Society of Industry published a report in 1888, *About Craft Instruction and Industry,* as a means of promoting prosperity among the people. Its conclusions were that crafts, being a stimulus to the simultaneous and harmonious growth of body and soul, should be integrated into public education. Craft instruction was thought to be a sovereign remedy against idleness, hooliganism, and heavy drinking. In short, it was a perfect medium for disciplining the potential working

Note: The article is based on several articles and books in Dutch by the authors as well as government documents and research publications in Dutch.

population. In 1881, examinations were given to qualify primary school teachers for a craft certificate.

The Craft Teacher Society wanted to turn crafts into a compulsory subject and its plans were supported by education inspector J. Fabius. In about 1892, the first complete crafts curricula were implemented in primary schools in The Hague, Haarlem, and Enschede. The same year, the subject was first taught at the Amsterdam City Primary Teacher Training College. In 1895, it was introduced at the Haarlem Primary Teacher Training College and the associated student teacher school. In 1899, craft became compulsory at the state colleges for primary school teachers.

1901—1918: Craftsmanship Versus Natural Development

In about 1900, the criticism of the aesthetic consequences of the Industrial Revolution extended to include the formal, hypocritical, bourgeois lifestyle of the average citizen. In the wake of this criticism, Ellen Key characterized the school as an impenetrable undergrowth of follies, prejudices, and miscalculations that undermined the child's natural craving for knowledge and independence. The criticism resulted in the movement of Reform-Educational vom Kinde aus, which emphasized the education of head, hand, and heart along the lines of natural child development that had been discovered through the new science of child psychology.

In about 1900, studies of the spontaneous development of child art revealed a discrepancy between these developments and regular teaching of drawing. In their spontaneous art children did not draw from observation and they certainly did not draw in a geometrical fashion. They just followed their interests. In their earliest work, they started by drawing animals, mainly tadpoles, and human figures. They didn't start by using geometrical shapes or by copying.

The so-called Reform movement in art education, which made its way into the Netherlands from Germany, was in fact a synthesis between drawing geometrical shapes and following the child's natural interests. Drawing objects from the child's environment that had latent geometrical shapes, such as buckets, footstoves, and tops, along with decorative art, were the main elements. The world of the child was important, and neatness and precision were pushed into the background. This new movement in art teaching was very controversial in the Netherlands. In 1906, a government committee left for Germany to study the

German Reform movement in art education. The report of the committee stated that children really enjoyed drawing in this way, but that they wrongly assumed that drawing was easy. Teachers no longer corrected mistakes in the drawings as they used to do in the old system. That is why the results were too superficial, not precise enough, and had incorrect perspective. Children who were taught along these lines had to break a lot of habits before they were able to produce anything professionally worthwhile.

Reform thinking also changed the face of Dutch crafts teaching. Self-activation and active observation were the new features, which coincided with the child's natural inquisitiveness and liveliness.

At the turn of the century, the general educational value of the subject of fancywork was questioned. According to Miss Kooistra, principal of the National Training Institute for Primary School Mistresses in Apeldoorn, the subject was quite legitimate if only such simple activities were taught as sewing on buttons or strings and mending and marking clothes, because these were important skills for working-class girls.

1918—1940: The Fight for Creative Self-Activation

In 1920, the equal treatment of private and state schools was legalized, which made the number of private schools grow rapidly. This caused some serious financial problems, which made the government decide to raise the number of students per class and provide no money for educational reforms. But what the new Education Act did offer was room for experiments. The principles of new education promulgated by educators such as Montessori, Parkhurst, and Steiner were translated into Dutch. More and more people started to criticize the one-track, knowledge-oriented school with its lack of individuality and underestimation of social, ethic, aesthetical, and physical values. In 1929, Kees Boeke founded the Kindergemeenschap (Children's Community), a progressive school in Bilthoven. In 1936, he founded the Study Group for Educational Innovation (WVO), the Dutch branch of the New Education Fellowship, the international organization of educational reformers.

In 1921, a special Ministry of Education and Science was created. This ministry had its own education inspectors. The period in between the wars was characterized by a distributive education policy. The government distributed the means, but it did not inter-

fere with educational content. In art education, all sorts of different methods were published: the traditional Zwier & Jansma method, the Back to Nature method (an adaptation of the 1909 Not a Day Without a Line), and also a number of innovative methods such as the 1933 *Developing Natural Art Skills* by Leeflang and Hardenberg. Following the ideas of the Austrian art and crafts teaching reformers Cizek and Rothe, spontaneity in child art was emphasized. Many data had been collected by Louise Belinfante-Ahn, who had been asked by Jan Ligthart to study the spontaneous art of her own children. For the first time, Dutch art education was influenced by developments in research on child art.

The self-satisfied NVTO did not like these innovations at all. Dissatisfied with the conservative course of their society, nine art teachers from The Hague founded their own society, which they called H9. The changes in art teaching this group wanted to bring about were based on the most recent psychological, educational, and visual theories. Personal expression of feeling was the central issue. To achieve this personal expression, students had to represent fairy tales or the subconscious, or they had to use color as an element of form and not purely as a decorative means. The group propagated its views in its own magazine, *Nieuw Inzicht* (New Insight).

In its annual report of 1935, the education inspectorate pointed to the dubious quality of art education in primary schools. Art education had deteriorated because there were so many different or vague aims, views, and methods. There was no adequate counseling in either the much-practiced copying method or the free expression system.

The Dutch Society for Art Education decided to draw up a curriculum for primary school art teaching, which was eventually published in two parts in 1938 and 1940. According to this curriculum, children should not start with true-to-life representations of visual images. They should be encouraged to represent their inner images. Aesthetic assessment criteria hardly got beyond the traditional emphasis on neatness and precision.

In the 1920 education bill, crafts had originally been a compulsory primary school subject. The continuous fight among craftsmen about the issue of teaching content and teaching form annoyed the educational world and was one of the reasons that craft was turned into an optional subject. In 1929, the Society's certificate changed into the official primary school R-certificate.

After some time, the differences of opinion between advocates and opponents of the Reform education principles slowly dissolved into a general desire for stimulating creative self-activation in the child. Important stimuli were the courses given in the Netherlands in 1937 and 1938 by Rothe, on the initiative of the Study Group for Educational Innovation and the H9 group. In the late 1930s, *Craft* magazine showed the very first examples of less rigid craft forms. It also contained elements of contemporary design.

1945—1968: Breakthrough of Free Expression

At first, war experiences seemed to have a catalyzing effect on innovation, but it soon breakthrough ideals gave way to the reestablishment of the old community structures. In education, the torch of the pre-war pioneers was passed on to young innovators. With the help of government grants, the three national Education Advisory Centers—a Roman Catholic, Protestant, and nondenominational—started promoting innovation by giving inservice education courses. The authoritarian, knowledge-oriented schools were slowly replaced by schools that focused on individuality, self-activation, and comprehensive cultural education.

In 1948, the international child art exhibition called "Art and Child" was on show in the Stedelijk Museum in Amsterdam. This exhibition opened the eyes of many people to the spontaneous visual power of the child. Selecting the art for the Dutch section of this exhibition, the Dutch educator Pancratius Post was struck by its depressing quality. There was one exception, the work sent in by Ina van Blaaderen, who had become acquainted with expressive art teaching in England during the war.

In the Dutch East Indies, Post had discovered the authenticity of child expression. His 1933 essay for the teacher training course in educational science had been a psychological study of child art. In *Child Expression in Our Day and Age* (Post 1951), a publication of the pedagogical institute Nutsseminarium where Post later worked as an art education specialist, he proposed an experimental school for child expression. This "Nutsvolksschool voor Beeldende Kunsten" was accommodated in the attic of the Stedelijk Museum. Ina van Blaaderen was one of the teachers, as was Ad Pieters, an artist of "De Ploeg" origin.

After the 1949 Cobra exhibition at the Stedelijk Museum, more Dutch artists became interested in the expressive power of spontaneous child art. In the same year, a Study Group for Aesthetic Education was formed as part of the Study Group for Educational Innovation. As one of its members, Ina van Blaaderen proposed a study center for child expression. The new center was accommodated in a houseboat in Amsterdam and named Werkschuit (Workboat) in 1950.

Freedom of expression was mainly synonymous with being freed from the traditional arts and crafts movement, which was still dominated by the copying of wall charts and models. This sense of freedom was felt most intensely when working with unusual materials and techniques such as different kinds of paint, potato- and linoprints, tear and paste work, and the so-called "worthless materials." In the 1950s, children often had to work in groups to stimulate their social skills.

The free-expression movement did not get beyond the stage of unconditional admiration for student work that had been made without adequate counseling. Working on the basis of visual elements such as line, color, plane, scheme, rhythm, and contrast proved to be too difficult for many teachers. In the assessment of the work, it was the creative process, the intensity, and the pleasure, rather than the visual qualities of the creation itself, that were important.

This free-expression movement was mainly criticized by the NVTO. In the early 1960s, this society had made a halfhearted switch to the free-expression movement, but it made another shift some years later to dialectics, a theory that reintroduced the interpretation of visual reality. In the 1970s, this movement influenced primary education.

In the 1960s, free expression also made its way to the crafts. Technical, aesthetic, and expressive qualities were integrated in craft teaching for the very first time. In many schools, crafts still an optional subject—started appearing in the regular schedule. In these years, free-expression theories also reached the field of plain needlework but in practice the technical orientation prevailed. This dual track characterized most manuals and other works published in this era.

Things started to change in 1967 with *Creation and Expression* by G. van Leeuwen. Usefulness had disappeared from the needlework terminology. In the first 2 years of primary school, boys and girls should take part in expressive needlework together, while in the third year and up, only girls should be taught it. Plain and fancy needlework were now called textile arts.

1968—1989: More Than Expression

In the 1970s, the government clearly started to interfere with primary school innovations. In 1973, the Innovation Committee for Primary Education was set up. Schools were nicer places to be, even for the approximately 100,000 children of different ethnic origins. Compensatory programs were just one of the many means to achieve equal opportunities for all in schools that focused on the individual. A 1968 report of the education inspectorate stated that the arts were seldom taught with any continuity. Usually they were just pleasant frills juicing up the factual subjects. The introduction of the so-called "creative period" at the end of the school week or on Wednesday mornings reinforced this image. The many short and long inservice courses of the 1970s had not helped to change this image, either. Free expression had sidetracked art education; it became just a welcome interval in the "real" work. The dialecticians believed that art education should be more than expression. It should stimulate the dialectics between visual reality and personal interpretation of this reality, but seeing seemed to be more important than feeling. Teachers wanted more methodical procedures, and new publications reintroduced visual elements and art appreciation in the curriculum and emphasized assessment and evaluation.

At the teacher training institutes, students had to specialize in one of the visual arts. More and more R-registrations (the crafts registration) appeared on teaching certificates. But in spite of this, a relatively large number of schools appointed content area teachers for teaching crafts. Parents also often helped out in art classes. Because of the large number of different people involved in teaching crafts (e.g., general teachers, subject teachers, and parents), it is difficult to get an overall view of content and assessment criteria for this subject. Even if one manages to get some impression of aims and goals by analyzing the school work plan, it is not clear whether and how these aims are realized.

To bring about changes in the conventional patterns, the teacher training institutes allowed boys into the creative textile art classes. In many primary schools, the recommendation of the Nutsseminarium had been taken to heart, and boys and girls were both doing textilework in their first few years at school. The new views were promulgated in methods such as

Textile Arts for Children by Hetty and Marijke Mooi, and *Working with Textile* by Aaltje Knoop. The Textielvaardig method has also reached the schools. But, as in crafts, we do not have a clear view of the actual practice of teaching. Here too, a fairly large number of content area teachers and parents help out. Content and assessment criteria are far from clear.

In the past century, art, crafts, and textile arts have all moved in the same direction as far as aims, content, and assessment criteria are concerned. But we do not know where they differ and agree in the practice of teaching. We need to know this if we want to plan the future of primary school visual arts education properly.

Anyone taking a closer look at history examines events and motives to find clues for the future. Vita brevis est, longa ars. We sincerely hope that the organizations of art teachers fight for their common cause: taking care of the quality of primary school art education. Anyone who feels deeply about the quality of education, should take this advice to heart.

References

Post, P. (1951). Over de woordenschat van zesijange kinderen in tweetalig Friesland. Groningen, Wolters.

Walter Smith's Influence in Brazil and the Efforts by Brazilian Liberals to Overcome the Concept of Art as an Elitist Activity

■ ANA MAE BARBOSA

The year 1870 is generally acknowledged as having marked the start of modern economic development in Brazil, the beginning of a more open social organization, and the emergence of more liberal thought and attitudes. The creation of the Republican Party in Brazil in that year opened an age of severe and systematic criticism against many aspects of the previous social organization, including the situation of education under the (1822) Empire. At the same time, frequent statements about the necessity to extend education to the people and slaves were made by the abolitionists, who were preoccupied with the future of the slaves after emancipation. Their chief concerns were about literacy and preparation for work.

The necessity for appropriate art teaching was referred to as an important aspect of preparation for industrial work, looking for principles which would emphasize the union between art and design in industry. Brazilian intellectuals and politicians looked enthusiastically to the ideas of Walter Smith, the former headmaster of the Leeds School of Art in England, a champion of art training for artisans and of art expression in industry who had been appointed Director of Art Education to the Commonwealth of Massachusetts in the United States. Smith's influence had reached Brazilian education chiefly through the propaganda of *O Novo Mundo* (a newspaper published in New York) concerning the teaching of industrial art, . . . politician Rui Barbosa's project of reform in primary and secondary teaching, and . . . educator Abilio Cesar Pereira Borges's book *Geometria Popular*. These various interpretations of Smith in Brazil fought to greater or lesser degrees against elitism in art.

During the first half of the nineteenth century, art had become an activity of the elite. The organizers of the Academy of Fine Arts, who had initiated the institutional teaching of art in Brazil, were a group of artists, all members of the Academy of Fine Arts of the Institute of France and fully alleged French Bonapartists. Lebreton, the leader of the group that was known as the French Mission, was permanent secretary of the Institute of France, which opened in 1795 to replace the old academies of art. Under the steady supervision and influence of David, the master of the French Neoclassic style and a revolutionary painter, the Institute of France had been transformed into an academy of higher reputation than the *Ecole des Beaux Arts,* influential all over Europe, and, according to Nikolaus Pevsner, the most modern at that time.[1]

After the downfall of Napoleon and the Bourbons' return to power, the Bonapartists of the Institute of France fell into a state of disgrace. At this time, Alexandre Von Humboldt, the well-known German naturalist who lived in Brazil, met with the ambassador of Portugal to contact French artists and craftsmen to organize the teaching of the arts in Brazil. Lebreton took charge of reuniting the group. In March of 1816, they arrived in Rio de Janeiro with the objective of establishing an institution named the Royal School of Sciences, Arts and Crafts on August 12, 1816. Later, on October 12, 1820, they changed the name to the Royal Academy of Drawing, Painting, Sculpture and City Architecture. A new official act changed it to the Academy of Arts a month later, on November 23, 1820, and to the Imperial Academy of Fine Arts in 1826, the name under which the school began to function.

The difference in designation was not only nominal but reflected the change in the content and objectives of the program. The plans presented by Lebreton for the Royal Academy of Sciences, Arts and Crafts in Brazil stressed mainly technical objectives and followed the Parisian experience of Bachelier, applied to the teaching of artistic activities and mechanical crafts.

Reprinted from *Journal of Art & Design Education, (3)* 2, 1984, 233-235.

The school that had intended to collaborate in establishing the basis of a more pragmatic cultural-economic policy was transformed into an Imperial Academy of Fine Arts, a vehicle of a vested interest of another nature, to provide for a landed nobility. A predominantly artistic orientation substituted for the former plans, which, given the poverty of Brazilian culture, surprised foreign visitors. Von Martius, a German naturalist who visited Brazil, called attention to the irrationality of our civilization and economy.

The Neoclassic manifestations implanted by law had large repercussions amongst the petit-bourgeois, who saw the advantages of aligning themselves with a group of distinguished artists from France and operating as official tools for the systematic transmission of culture, thus rising from one class to another.[2] The Neoclassic art in France was bourgeois, but in Brazil it was bourgeois art, useful for both the aristocratic regime and the whole system of monarchy. The French Mission provoked a process of discontinuity with the traditional colonial art and stressed the separation between people and art.

When the French Mission arrived, it found a popular art already established in Brazil, an art based on the Portuguese, but distinctly Brazilian. The artists who practiced it all originated from the popular class and were regarded by the upper class as mere artisans, but they had broken the mold of Jesuitic Baroque design, the import from Portugal, transforming and rejuvenating the style and arriving at Brazilian Baroque. This was the contribution of the popular class. The newcomers, the members of the Mission, were strongly Neoclassic in conviction, and this determined their activities at the Court, in public decoration, and in their art teaching at the Academy. The emotion-ally heated outburst of Brazilian Baroque was replaced by the academic and intellectual coldness of Neoclassicism.[3] The transition was abrupt, and for the Brazilians, who had up to that time imported artistic models, however delayed, from Europe, the modernity represented by Neoclassicism provoked suspicion; moreover it removed the popular participation in the creation of art.

Architecture, painting, sculpture, and decoration, which had been popular activities after the creation of the Imperial Academy of Fine Arts, became upper-class activities, an embellishment produced and enjoyed only by the elite. In order to understand the complicity of the Academy of Fine Arts with the elite, it is important to remember that, at the time of its creation, there were only two types of institutions of high-er education, a military school and courses in medicine. These fulfilled the necessity to form an elite to defend the colony against invaders and to care for the health of the Court. The function of forming an elite that would culturally enhance the Court rested on the Imperial Academy of Fine Arts, which separated art from contact with the people, reserving it for the fortunate few, a talented few.

Contrary to this elitist misuse of art in education, some liberals affirmed that popular education for work was the main goal of art in school, and their recommendations were directed to the need to develop technical knowledge of drawing, accessible to all individuals, so that, freed from their ignorance, they would be able to be genuinely inventive. To educate the instinct of execution, removing impediments to invention was the basic principle.

O Novo Mundo (The New World) was the vehicle for the liberal concept of art teaching related to industrial art and to geometrical drawing as an instrument of development. *O Novo Mundo* was a journal published monthly in New York 1872—1889 by Jose Carlos Rodrigues, a Brazilian, and written in Portuguese. This newspaper had great repercussions among Brazilian intellectuals. While deficient media of communications kept underdeveloped nations in cultural isolation, this newspaper was one of the principal sources to provide Brazilians with the most current news and happenings of the times. In addition, its publisher, Rodrigues was considered not only a journalist but an intellectual of great prestige among the Brazilian "intelligentsia." The principal aim of the journal was to sell American products and the American way of life in Brazil, presenting American social institutions as models for Brazilian society. The most eulogized American social institution was education. In the field of education, they paid special attention to the spread of women's education and art education as education in industrial art.

One of the first statements that echoed in Brazil in favor of teaching drawing was made by Andre Reboucasi in *O Novo Mundo*.[4]

> There exists linear drawing, in which a ruler and compass are utilized, and there is representative drawing without the use of any instrument. The first is within the reach of all who do not have physical defects, requiring only a little patience and good will.

The second is more difficult. Only the privileged maintain this faculty innate, but it is rare, that after two or three years of practicing linear drawing, the individual is not able to represent almost any object without the aid of a ruler or a compass.

We will give you an example.

The English are perhaps the most unartistic people in the world.

Moreover, in their first world exposition in London in 1851, the objects of art that were presented, were so grotesque that they were ridiculed by visitors. Prince Albert was a witness to this misfortune and made an effort to save his adopted fatherland from this ridicule. He launched an admirable campaign and founded day and night schools for the teaching of drawing throughout the United Kingdom.

In the Exposition of 1862, great progress was already noted. From there on, English art, if it cannot compete with the Parisian elegance, gives us a good notion of things to come, in carrying the soul to eternal regions of beauty.[4]

The fact that Merimee took advantage of the unexpected success of English art in 1862 to unmask the numerous defects of the *Ecole des Beaux Arts* of Paris is mentioned by Reboucasi and Anibal Mattos. Rui Barbosa quoted Merimee's advice and warning. He indicated that English art, especially backward in 1852, had made ten years of prodigious progress and if it continued to march at this speed, it would soon be left behind.[5] The English lesson in the World Expositions of 1851 and 1862, referred to by Reboucasi, was frequently used as an argument to demonstrate the need for the teaching of drawing, that kind of linear and geometrical drawing which was considered the basis of industrial art. It was stressed that the principal reason for the success of England in the 1862 World Exposition was given to the intensification of art teaching through the creation of many specialized schools, led chiefly by the South Kensington School.

In 1908, Anibal Mattos, professor and artist, wrote in an article for the *Diario de Minas* that the importance of drawing was poorly recognized because of a lack of competent individuals to point out the insufficiencies in its teaching. Meanwhile, Laboulay, in his essay on industrial art, affirmed that England, with its

heightened good sense after the Exposition of London, seeing what it needed to do in the field of art, not only founded museums, but also a great number of special schools. England's leaders recognized that the future of its immense export commerce depended on the artistic progress of its producers. On the occasion of the Universal Exposition of London in 1851, Baron Carlos Dupin, in a report directed to the Emperor of France, declared that the proportion of first prizes conferred on foreigners was eight in 1,000 participants; however, this proportion rose to thirty for the French. The most enlightened minds of the commission of the French institutions tried to find the reason for such great disequality and French superiority and discovered it in our *artistic and geometric schools of drawing* (original emphasis) in Lyon, Nime, and Paris; in the schools of arts and crafts, which offer the richest collection and the complete teaching of sciences and of useful arts.[6]

There was, meanwhile, another International Exposition, the Centennial Exhibition of 1876 in Philadelphia, which intensified Brazil's interest in industrial arts. In this exposition, the United States demonstrated the possibility of competing with the best designed European products, as well as a superiority in machine design. A report about the Philadelphia Exhibition, written by M. Bouisson, an observer from France, had great repercussion among Brazilians, who were at that time swayed by francophilia. Abilio Cesar Perira Borges argued the necessity in France to defend its prominence, which had not been contested in the arts. He noted that France enjoyed immense resources that should become foundations for well-conceived teaching in the primary schools. It is not enough to have excellent professors specialized in art; it is not enough to have good courses and good schools; it is necessary that all instructors are capable of giving the school population the first instructions in drawing.

After suffering its disgrace, France plunged into work with notable energy and dedicated itself with equal ardor to the teaching of drawing, giving new strength and vitality to the productive forces where art originates. The general teaching of art, on the one hand, favors the development of artistic taste and ability, and on the other hand, makes the public capable of appreciating beauty in its diverse forms.

In this manner, there develops supply and demand. The field is cultivated and the seeds are sown, yielding the future harvest. From this, we have the auditorium

and the creators, the public that passes judgment and the artist that produces and creates.[7]

The amazing industrial progress of the United States was attributed to the early initiation of American youth into the study of drawing. The well-organized American teaching of applied and industrial art was reported in Brazil through *O Novo Mundo,* which published a special issue about the Centennial Exhibition.[8] In addition, it had been giving notices about the Centennial Exhibition since October 1875 and discussed its results in art industry until 1877.

Walter Smith exhibited at the State Centennial work from the Normal School and from twenty-four towns in Massachusetts.[9] His exhibit was so successful that shortly after many towns in all parts of the United States began to foster art instruction.[10] It is important to note that *O Novo Mundo's* propaganda about the progress of industrial art teaching in the United States and in European countries had begun before the Centennial Exhibition. In October 1874, an article about Walter Smith had been published evidencing his successful effort to bring progress to the state of Massachusetts through the teaching of art. This article mentioned that Walter Smith's background was the South Kensington School of Industrial Drawing and Crafts and that he had become State Director of Scholastic and Industrial Art Education for the state of Massachusetts and principal of the first Massachusetts Normal Art School. It also stated that he was chiefly known for the value he placed on geometric exercises in drawing, his emphasis on the ideal of the existence of a general capacity for drawing, and his emphasis upon precise, clean craftsmanship developed through progressive exercises. It is instructive that similar [evaluations of] Smith's work are found [in] Frederick M. Logan. Considering the importance of Walter Smith for art education in the United States, he suggests some correspondence between his exercises and the problems concerning skills raised by the Bauhaus: "Granted that there is only a slight correspondence between the actual exercises in Smith's manual and the infinitely inventive problems of the Bauhaus, there is some comparison to be made in the kind of experience each outlines: in the step-by-step progression with each problem based on the one preceding in the craftsmanship required, in the use of forms abstracted from individualized picture-making symbols."[11]

Stuart Macdonald also agrees with the slight relationship between Smith's methods and the Bauhaus, suggesting that the United States assimilated the ideas of the Bauhaus over a decade ,before the British did

because the industrial path upon which Walter Smith set American art education supplied a fertile background.[12] Logan affirms that Smith's emphasis on the exact performance of an exactly defined and limited problem is in itself not necessarily a poor practice. He argued for the acquisition of a broader set of skills and an understanding of the quality of line, texture, color, and the visual manipulation of forms.[13]

O Novo Mundo applauded Smith as the one principally responsible for the development of industrial art education in the United States through his work at the Normal School in Boston. Some years later, Richard Boone, in *Education in the United States* (1889), affirmed almost the same thing, stating that the establishment of this Normal School "marked the beginning of an intelligent interest in drawing in the United States."[14] *O Novo Mundo* guaranteed a proper valuation of English and American art education among the Brazilian educators, but it was Walter Smith's ideas that chiefly influenced the liberal politicians, such as Reboucasi; Rui Barbosa and the educators Abilio Cesar Pereira Borges, and Anibal Mattos, who wrote specifically about Smith's teaching of art:

> This manual education is not properly the teaching of a craft, but the work of the hands applied to educational ends. It is the instilling in the student of affection and interest, and what is most important, the respect for work, habits of orderliness, exactitude and neatness, independence, and confidence in himself, the self-reliance of the English people; attention, interest, and perseverance. For peoples who are wavering and inconstant, like the Latins, in general, and in specific, for our people, it would be a great advantage to apply Smith's method of teaching drawing which would form the spirit ready for the fight and for resistance, giving them confidence of victory in the future. It is through this system that North America has amazed the world with its greatness.[15]

Walter Smith's strong belief in art as popular education opposed to art as cultural accomplishment was closer than any other to the nature of the liberals' idea of decreasing the elitism of art. Smith cared so deeply for principles of popular education that he resigned from the Leeds School of Art (1868) when that institution began to base its teaching on ostentatious premises.[16]

"The teaching of drawing, its popularity, its adaptation to industrial ends, has been the principal impulse

for prosperity of work in all of the countries already initiated in the immense contest, such as England, the United States, France, Germany, Austria, Switzerland, Belgium, Holland, and Italy."[17] The statement by Rui Barbosa represents the general thinking of the liberals at that time and was expressed in his *Pareceres* (Legal Opinion) about the Reform of Secondary and Higher Education (1882) and about the Reform in Primary Schools (1883) of Leoncio de Carvalho. As a member of Parliament, he was directed to judge these projects of educational reform. He presented his ideas in six large volumes which were new projects for Brazilian education, instead of mere *Pareceres*, and theoretically the most well-founded ideas ever presented to our legislature. These ideas were in perfect accord with the most modern concepts and pedagogical techniques of the epoch. Rui Barbosa's pedagogical ideas had great influence all over Brazil for many years. While politically active, he was frequently moved to reaffirm his guiding principles. For example, in his inaugural speech in his campaign for the presidency of the Country on 3 October 1909, he affirmed: "My pedagogical ideas, fully developed and presented twice before Parliament in 1882, have not depreciated with time and remain intact to the present."[18]

In his conception of pedagogy, drawing had an immensely important place in the secondary school curriculum and more especially in that of the primary school. No other Brazilian educator . . . dedicated to the study of the educational process in general has concentrated in such minute detail on the teaching of drawing or art as Rui Barbosa. His liberal political theory was directed at a practical function, to enrich the country economically. This would only be possible through industrial development. He considered the technical and industrial art education of the people to be one of the basic conditions for this development. To him, artistic education would be one of the most solid foundations for popular education.

The introduction of art education in the American public school system, mainly through geometric drawing, had already demonstrated enormous success in the well-designed American products presented in the Centennial Exhibition. For this reason, Rui Barbosa intended to introduce the American model of art teaching, and Walter Smith's practices, into Brazil's secondary schools. He established in his project that drawing should be a compulsory subject in the curriculum of the secondary schools in all grade levels, and supported his decision with a long excerpt (10 pages) from Walter Smith's book, Art Education: Scholastic and industrial, which he translated into Portuguese.

He determined in Article 79 of the Project that

the department of drawing, gymnastics, and music will be provided by means of a contract of four years at the most, renewable at the end if convenient.For the two first ones the government will hire, through our agents abroad, men of high merit in these specialties and capable of organizing teaching in the country; for drawing preference is given to the United States, England and Austria, for gymnastics to Sweden, Saxony and Switzerland.[19]

In the justification, it refers to the quality of the English schools of drawing and to the founding in Vienna of an institution analogous to that of Kensington which proved in 1873 for Austria what 1862's had proved for England.[20] He referred to success of the industrial products of these countries in the world fairs held in the years mentioned. He explicitly mentioned Walter Smith when explaining the source of Article 79. Remembering that at the time of the Industrial Drawing Act, there were only five drawing teachers in Massachusetts, he argues: "What did the Americans do? What we propose to do for Brazil. They appealed abroad, turned to England and called for such an eminent man as Walter Smith of the School of Art of the Kensington Museum."[21] Perhaps the shortness of time in which Rui Barbosa was obliged to draw up his Project limited his sources of consultation, which can be summarized as follows.

1. Joaquim Vasconcelos—*Reforma do Desenho* Porto, 1879.
2. Science and Art Department of the Committee of Council on Education, 28th Report—Presented to both Houses of Parliament by Command of her Majesty, Queen Victoria.
3. Science and Art Department of the Committee of Council of Education, *South Kensington Art Directory*, containing regulations for promoting instruction in art, London, 1881.
4. Felix Regamey—*L'Enseignement du Dessin aux Etats Unis*—Paris, 1881.
5. Walter Smith—*Art Education: Scholastic and Industrial* Boston, 1873.

As we can see, Walter Smith was central to Rui Barbosa's readings. The first book praises the teaching of drawing in England; the two reports outline the English system of art teaching, including that of the school where Smith was trained and to which he was officially connected. Finally, he read Smith himself, and a book about the American system of teaching in which the Englishman was praised. Therefore, Walter

Smith was the axis around which Rui's ideas on the teaching of drawing started to take form. His views were literally accepted in the report about secondary teaching, presented as a model to be followed by Brazil. Rui Barbosa's ideas, or rather Walter Smith's views on art education were defended as a condition of progress for almost thirty years. Immediately after the publication of this report on Secondary Teaching, Abilio Cesar Pereira Borges, a leading educator in Brazil, published *Geometria Popular,* a book to be used in primary and secondary schools. It was almost a translation of Walter Smith's method with a few adaptations to the Brazilian cultural context.[22] It had enormous success and was used in schools during the first half of the twentieth century. Its last edition was published in 1959. However, Rui Barbosa's project on . . . primary education reinforced the idea of teaching drawing with industrial aims and was less dependent on Walter Smith's books. After analyzing the position of drawing in education in countries like England, Austria, Prussia, Belgium, and Germany, Rui Barbosa quoted the English Art Directory of August 1881 (p. 12): "An art class is a class for instruction in elementary drawing."[23]

This affirmation is interesting as we have already seen that in the Project for Secondary Teaching, Walter Smith was the only guide of his theoretical, practical recommendation. Besides, the summing up of Barbosa's methodological principles in his Primary Project shows that he actually continued to follow Smith's track. His principles were:

1. All teaching of drawing should be based on geometric forms through free hand tracing.
2. The teaching of drawing should be oriented towards conventionalizing forms:
 A. Geometrical forms, due to their regularity, will precede the natural ones, which are irregular.
 B. The natural forms which are to be drawn will have to be first reduced to geometrical forms.
3. It is important to use "rede estimografica" for the drawing of models from memory or dictation, considering the value of aided drawing to be less than that of drawing without use of ruler or compass.
4. The drawing from models or prints should be preceded by study of the object as a whole and in its parts, comparing them.
5. Drawing with a fixed time limit was essential to banish inertia.
6. Inventive drawing has the composition of elements already known.

7. The drawing should be used to help other subjects, especially geography.

These principles are clearly based on the "scientific" approach to art teaching of Walter Smith. I do not know why Rui Barbosa chiefly recommended the methods of South Kensington for primary education in Brazil instead of those of Walter Smith that actually inspired him. At that time, the methodology used in England had changed completely and no longer corresponded to principles stated by Rui Barbosa himself. By 1875, the English system of art education had shifted its orientation from decorative arts towards the study of antique statues, attending to "the capricious wishes of the middle class."[24]

The newly appointed Director of Art, together with Frederic Leighton and Lawrence Alma Tadema, belonged to a group of esteemed High Artists who sought noble and ideal beauty through Classical Art and the nude model using the methods of the continental ateliers.[25] Such methods were the source used in Brazil by the Imperial Academy of Fine Arts, the methods so strongly refused by the liberals and Barbosa himself. On the other hand, all the principles determined by Rui Barbosa are the basic points in Walter Smith's methodology. They constituted an outline of Smith's methods. Smith's central point was free hand geometrical drawing. He accepted ruling and measuring only as a way to correct the drawing. Smith's Cards were an effort to conventionalize forms of objects. Besides he strongly recommended reduction and enlargement and permitted the use of auxiliary lines (rede estimografica) in dictation exercises, to be erased after the drawing was completed. The necessity of analysis of form before drawing was clearly explained by Smith in his *Teacher's Manual* (pages 11, 12). The function of drawing in helping other subjects is stressed by Smith in *Art Education: Scholastic and Industrial,* translated by Rui Barbosa.

"Especially will drawing be found a ready handmaid to scientific study, illustrating its axioms, recording its phenomena, and explaining its laws. It should be regarded as a servant, or vehicle to assist expression in the study of others' subjects as it is in geography, by means of map drawing."[26] In the Report on Primary Teaching, Rui Barbosa included some samples of maps drawn by children in order to demonstrate the excellence of such procedure, without referring this time to Smith's ideas so precious to him in the *Reforma do Ensino Secondario e Superior.* He demonstrates the need for creating a Normal School for Art and a Museum Annexe. To organize them, "a profes-

sional knowing the system and the work of the South Kensington and Austrian museums should be hired at least for fifteen years."[27] However, he demonstrates superficial knowledge of the methods of these institutions. The bibliography on Art Education and Teaching of Drawing quoted in the *Parecer sobre a Reforma do Ensino Primario* (Primary Reform) includes:

1. Elementary Drawing copy-book for the use of children from four years old and upwards in schools and families, compiled by a student certified by the Science and Art Department, London. Chapman & Hall.
2. Felkin, H. M. *Technical Education in a Saxon Town*, 1881.
3. Felkin, H. M. *Technical Education in a German Town.*
4. Harding, H. D. *Lessons on Art Education* by William Walker, 10th ed., London.
5. Mesnil, A du. Lettre, a M. Jules Ferry, Ministre de L'Introduction Publique et des Beaux Arts, Paris, 1880.
6. Nichols, George Ward. *Art Education Applied to Industry*, New York, 1877.
7. Peabody, Elisabeth. *Plea for Froebel's Kindergarten as First Grade of Primary Art Education.*
8. Regamey, F. *L'Enseignment du dessin aux Etats-Unis*, Paris, 1881.
9. Smith, Walter. *Art Education: Scholastic and Industrial*, Boston, 1873.
10. Stetson, Charles. *Modern Art Education.*
11. Vanderhaegen, E. Quelle est L'Importance de la Geometrie et du Dessin dans l'Enseignment Primaire? Rapport in Congress Intern de L'Enseignement, Bruxelles, 1880.

In 1901 the Educational Law *Codigo Epitacio Pessoa* officialized Rui Barbosa's proposals on the teaching of drawing, perpetuating Walter Smith's influence chiefly in the secondary school, at least for half a century. An examination of portfolios of the 1940s[28] and 1950s[29] and my own experience as a secondary school student show that the same contents and sequence of contents of Smith's manual were still being taught until 1958. However, Smith's methodological principles had been loosely followed and his objective, the preparation for work, completely lost during the long progress through time.

Notes

[1]Nikolas Pevsner studies the Institute de France's methods in *Academies of Art, Past and Present* (Cambridge, England: University Press, 1940), pp. 190-242.

[2]Nelson Werreck Sodre, *Sintese da Historia da Cultura Brasileira* (Rio de Janeiro: Civilizacao Brazileira, 1972), p. 24. "They found in the intellectual activities of political character and of aesthetical character, the possibility of higher social classification."

[3]Carlos Cavalcanti, 'O predominio do Academismo Neoclassico in Roberto Pontual, *Dicionario das Artes Plasticas no Brasil* (Rio de Janeiro; Civilizacao Brasileira n.d) n.p.

[4]Andre Reboucasi republished in Abilio Cesar Pereira Borges, *Geometria Popular* (Rio de Janeiro: Livraria Francisco Alves, 41st ed., 1959). p. 246.

[5] Rui Barbosa, *Obras Gmpletas Reforma do Ensino Secondorio e Superior* (Rio de Janeiro: MEC, 1941), Vol. 9, Tomo I, p. 168 (Ist ed. 1882).

[6]Anibal De Mattos, *Bellas Artes* (Minas Gerais; Imprensa Official 1923), p. 120-131.

[7]Apud, A.C.P. Borges, *op. cit*, p. xc.

[8]*O Novo Mundo* , May 1876.

[9]Stuart Macdonald, *The History and Philosophy of Art Education* (London: University of London Press, 1970), p. 258.

[10]Ibid., p. 258.

[11]Fredrick M. Logan, *Growth of Art in American Schools* (New York: Harper & Brothers, 1955), p. 69.

[12]Macdonald, *op. cit*, p. 261.

[13]Logan, *op cit*., p. 69.

[14]Richard Boone, *Education in the United States* (New York: Appleton, 1889), p. 229.

[15]Mattos, *op cit*, p. 122.

[16]Macdonald, *op. cit*.: 'Smith's resignation in 1869 was motivated by his belief in art as popular education, as opposed to art as cultural accomplishment,' p. 256.

[17]Rui Barbosa, *Obras Gmpletas Reforma do Ensino Secondario e Superior vol. 9* Tomo 1, p. 166.

[18]Apud Rivadevia Marques Junior, *Politica Education Republicana* (doctoral dissertation, Universidado do Estado de Sao Paulo), p. 43 (mimeographed).

[19]Rui Barbosa, *Obras Gmpletas Reforma do Ensino Secondario e Superior* 10, Tomo 1, p. 259.

[20]Ibid., p. 169.

[21]Ibid., pp. 169-170. According to Stuart Macdonald, Walter Smith had taught before going to the United States in the Leeds School of Art, not in the Kensington School *History and Philosophy of Art Education*, p. 256. However, the Leeds School of Art was under the supervision of the Kensington School, and he was trained by Redgrave at the Kensington.

[22]A comparative analysis of A.C.P. Borges' *Geometria Popular* and Walter Smith's *Cards* and *Teacher 's Manual of Freehand Drawing* is made in Ana Mae Barbosa *American influence on Brazilian Art*

Education — Doctoral Thesis, University of Boston, 1978 (mimeographed).

[23]Rui Barbosa, *Obrus Completas Reforma do lnsino Primario*, 10, Tomo 2, p. 180. (Ist ed. 1883).

[24]Walter Shaw Sparrow quoted by Stuart Macdonald, *op. cit.*, p. 263.

[25]Stuart Macdonald, *op. cit.*, p. 263.

[26]Walter Smith, quoted by Rui Barbosa, *Reforma do Ensino Secundario e Superior*, p. 165.

[27]Rui Barbosa, *Reforma do Ensino Primario*, 2 Tomo 4, p. 121.

[28]Artist and teacher Fernanda Milani's portfolio, San Paulo.

[29]Artist and teacher Paulo Portela's portfolio, Sao Paulo.

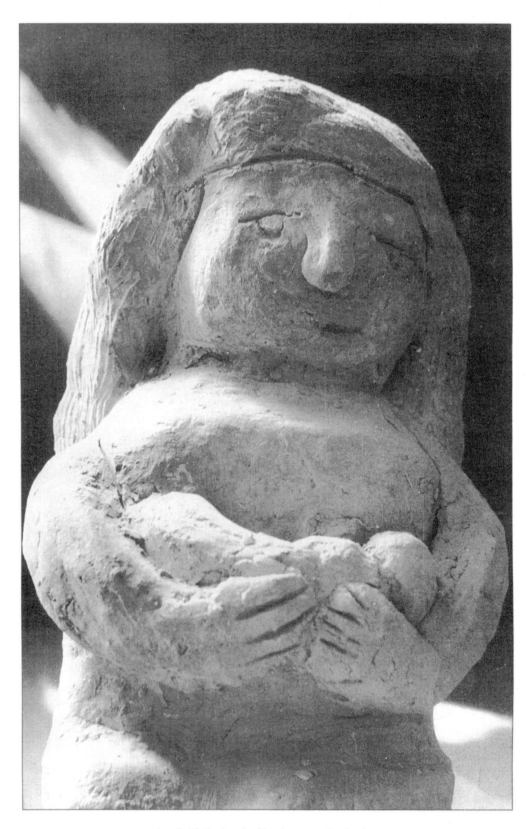

Age 7: Motherhood—Simple expression in clay.

THE HISTORY OF ART EDUCATION IN EGYPT

■ MAHMOUD EL-BASSIOUNY

To speak of art education in Egypt, one has to cover a scope of nearly half a century, bearing in mind that it is not isolated from the general system of education, politics, and the traditional history of art that has flourished in the country for thousands of years (Magazine of International Federation, 1938).

The Samplers

From the 1890s to the 1920s, samplers were the method used for teaching drawing in public schools. A sampler is a simplified model in linear drawing abstracted from the old local traditions: Egyptian, Greco-Roman, Coptic, and Islamic. It was given to students to imitate using a net of squares. A good copy usually achieved the best marks. It had to be precise, neat, exact, and clean. Any hesitation in using the pencil meant that the student was not clever enough. Students usually obtained low marks. This period is reflected in a few Arabic books organized to meet the scope of the curriculum. This writer has seen similar books that were used at the time in England and in France, the two influential countries in the Middle East at the time.

Centralized System

When I was a student at the primary school in Damietta (1927—1931), the second stage of evolution of art education took place in Egypt. The system was centralized; therefore one school can serve as an example of all the schools during that period. There were four major approaches to art education at that time: (1) learning perspective, (2) memory drawing, (3) pastel drawing, and (4) crafts.

Laws of Perspective

The art room was adjusted to meet the demands of the curriculum. To study perspective, there was a round glass shape attached to a wheel in the ceiling, with a little handle used to get the shape up or down.

Therefore, it was easy to view the shape at different levels: above, frontally, and below the level of vision. Glass objects were considered ideal for those starting to master the laws of perspective, and books were written to explain the theory. It was not easy for the young students to grasp the idea. The art teacher would carry his students' art books home for correction. At the next lesson, every student in the class was happy to see that the teacher had corrected his or her drawing and made it look like adult drawing.

Memory Drawing

Memory drawing is another story. There was a square drawing book devoted to memory drawings. The teacher showed students a geometrical form, say the triangle, and after pointing with his finger around the form, asked students to close their eyes and make the drawings in the air. The third step was to put the memory on the paper. It was very hard for students to do that. These drawings were never exact. They usually were very small and far from identical to the original.

Pastel Drawing

Pastel drawings were made in a special pastel book. The studies were centered around the imitation of natural objects in color: a tomato, a carrot, an onion, an orange, bees. One object was repeated to fill the whole page. With this study, there was a trend toward decoration, since the objects were sometimes drawn as a frieze using the different means of repetition.

Crafts

As for the crafts approach, it was a sort of drill, whether in clay, plasticine, wood, wire, paper, or colored paper cutting. There was a standard for each drill, a way to do it, outlined in a book named *Thinking Hands,* which was translated into Arabic by the leaders in crafts at the time. This was a fundamental source of knowledge.

A Vanished Era

This era has vanished; it was a stage in which the aim was centered on the acquisition of skill, memorization of laws of perspective, and imitation. Individual differences were not recognized. The personality of the student was neglected. There was no clear differentiation between the achievement of a child at age 7 and another at age 14. All were treated under an adult standard.

The leaders of art education at the time were associated with the study of drawing and crafts. The subject was not yet called art education. Four men dominated the field: Mohamed Abd El-Hadi, Habib Georgy, and Shafik Zahir, who were responsible for drawing, and Abdullah Hagag, who was devoted to crafts.

These approaches in art education continued until 1937. There were formal examinations to earn the final certificates for teaching drawing and crafts, with primary and secondary levels emphasizing the same aims.

Federation Internationale Pour L'Education Artistique Conference 1937

In 1937, the FEA Conference in Paris opened a new era in Egyptian art education. Participants brought back new knowledge of child art and spread the influence of Franz Cizek. Some of Egypt's leaders, mentioned earlier, contributed to that conference. Mohamed Abd El-Hadi informed this writer that he was spending his vacation in Paris, learned that there was a conference, and attended.

The recommendations of the FEA Conference were to (a) establish a recognized system for preparing teachers of drawing and (b) define the need for qualified teachers of art. The training of such teachers should meet these requirements (El-Bassiouny, 1984):

1. The secondary school certificate (baccaloria) would ensure a minimum level of general culture.
2. Study of arts and crafts would take place in an institution of higher education for the arts or applied arts.
3. Study would include art history (university syllabus).
4. Study of principles of education and psychology, with special reference to the psychology of children and their drawings from the 3rd year up to adolescence would be undertaken.

5. One year would be spent in training before the teaching license could be received.

A New Department Established

Mohamed Abd El-Hadi was so enthusiastic about the trends discussed in the conference that upon his return he introduced a project to the Ministry of Education to open an art department in the Higher Institute of Education for the training of art teachers. The students at the time were graduates from the Fine and Applied Art Colleges with certain specializations. The department was opened in 1937. The first graduates were from the class of 1939. I was graduated from the new department in 1942.

A similar department was established for women in a separate institution. However, entrance to this program was gained with the secondary school certificate or its equivalent. Female students in art education represented a special system from 1937 up to 1966, when the two institutes of art education for men and women were united.

A Unique Contribution

The art department in the Men's Institute of Education remained in place until 1950. It made the following contributions to art education in general public schools:

1. The discovery of child art was broadly accepted.
2. There was a change from mere skills to the trends of creation.
3. Teachers discovered the individual differences in art expression.
4. Art education was applied to current social problems.
5. The respect of local art tradition in various epochs was stressed along with an appreciation of folk art.
6. A new scope for art education related it to other disciplines.
7. There was an emphasis on developing the attitude of the art teacher toward planning the lessons, linking each with the other, and knowing how to evaluate the results. Teachers learned how to exhibit the art works of young students for appreciation, criticism, and the exchange of experiences.

In 1946, I was sent as a cultural emissary to the United States. I obtained my MA in 1947 and my PhD in 1949, the first Egyptian to get this graduate qualifi-

cation. During my studies, I contacted Herbert Read and had the chance to study with him at Kenyon College, where Read made valuable comments on my dissertation. I was also able to contact many other eminent scholars in art education at the time: Edwin Ziegfeld, Victor D'Amico, C. D. Gaitskell, Shaefer Simmern, Viktor Lowenfeld, Harold Alberty, V. T. Thayer, Laura Zierbes, C. D. Kircher, and Games W. Grimes. I read the literature that was influential at the time—John Dewey, Albert C. Barnes, and Thomas Munro. Through INSEA, in particular, I contacted such art educators as Elliot Eisner, Brent Wilson, Kenneth Marantz, Albert Hurwitz, Gilbert Glark, Marie-Francoise Chavanne, and Manuel Barkan, to mention just a few.

Institute for Art Education

Upon returning to my country in 1950, I was appointed as a staff member in the art department at the Institute of Education. This was its closing year; the Institute of Art Education was established in 1950 as a special institute for educating art teachers. I was appointed head of the Education Department and dean of the Institute in 1965.

When the number of graduates from the Colleges of Fine and Applied Arts was not sufficient to meet the number of teachers needed, administrators decided to establish another Institute in 1962. It paralleled what had been taking place in the Women's Institute. By 1966, the Ministry of Education allowed me to unite the men's and women's institutes into one, which is now the College of Art Education Hilwan University, in Zamalik.

Achievements

I served as dean up to the beginning of 1975. During this time, which represents 10 very important years (1965—1975) in the history of art education in Egypt, some new values were achieved:

1. The establishment of graduate study in art education leading to MA and PhD degrees.
2. Segregation between men and women was abolished in the art teacher preparation curriculum. Both studied the same curriculum.
3. Development of research, which started when we were a separate institute, was continued in theses and dissertations leading to academic degrees.
4. The system attracted students for graduate studies from the neighboring countries of Jordan, Libya, Saudi Arabia, Qatar, and Kuwait.

5. The new faculty of the College of Art Education was trained locally instead of pursuing their training abroad.
6. New books in Arabic on art education appeared to enrich the field and replaced the old books that considered skills as their main aim.

In Public Schools

In reviewing the changes that took place in public schools after this evolution, it is worthwhile to divide the time into two large periods: 1956 to 1970 and 1970 to 1991.

The Years 1956—1970

The thinking of authorities in art education in the Ministry of Education was reflected in the following activities:

1. A regular conference meeting was held each year in one capital of the 25 zones of the Arab Republic of Egypt. Each zone represents a unique environment. It differs from West to East, from North to South, from the seashore to the greenland to the desert.
2. Local materials were adjusted and entered into the system of studying art education at all levels. Unconventional examples seen in exhibitions ran parallel to the conferences to support the idea of adjusting art education to the local environment. I was invited to several of these conferences and contributed talks on the theme of each conference and saw examples of such local materials as bamboo, reeds, shells, empty containers, plastic bubble pack, boxes, jars, aluminum cans, wires, strings, yarns, and construction paper.
3. A book was published about the findings of each conference with the names of those attending and illustrations of the exhibitions.
4. In schools, there was no longer an isolation between art and crafts. Both were seen as different media used to achieve the same aim; the integration of the learner as a creative individual whether the media belonged to art or crafts. The previous trends that affected the production of crafts were changing. Crafts techniques were no longer looked upon as separate from the form of creation or from the personality of the student. Craft work is, after all, a work of art that has to be produced and measured by the principles of art and also by the values inherent in art tradition throughout the ages.

5. Local craftsmen were invited to give demonstrations to students so that the link between the school and environment reached a climax.
6. Experimental art education was encouraged, and each art supervisor arranged the exchange of visits between staff or schools benefiting from those experiments.
7. Those who used to attend such conferences were art supervisors in the central ministry and in each zone, the senior art teacher from each school, leaders of teacher training in art, and the undersecretary of state for education.

The Years 1970—1991

This period encompasses the last 20 years, from the 1970s up to the 1990s, and it is different in spirit from the first period. Many external factors have influenced this change in atmosphere. For one thing, professional art educators who graduated from the college of art education after 5 years of training are no longer enthusiastic about working in the profession of teaching. Financial considerations force them to seek other jobs that provide more salary and do not obligate them to work in schools outside Cairo.

Another factor is that the population expansion in Egypt has crowded the schools. Each class contains 60 or 70 students. In some elementary schools, more than 100 students occupy a single class. School administrations have transformed art rooms into regular classrooms. Art teachers have no place to work in, no place for materials or student work. The prestige and respect of the subject is diminishing. I asked students, who receive their training under my supervision, whether or not they would work in teaching. None indicated that they would do so. The shortage of art teachers in public schools currently totals 4,000.

Thus, we have contradictions. On the one hand, we have a higher level of training that reaches the PhD level, many books that have appeared in the field, and many international conferences attended by faculty of the college. On the other hand, fewer teachers are coming into the profession and the subject is neglected in schools because of the problems of bureaucracy.

Other Arab countries also make use of these art education graduates. Saudi Arabia presently offers them higher salaries than Egypt because in that country, art educators are rare. Authorities differentiate between one who is qualified in art education and one who has merely studied art.

A Way Out

Some believe there is a way out. The Ministry of Education has established about 17 departments of art education in colleges of education throughout the different zones of Egypt. Each department's enrollment is over 50 students. The study leads to a BA in art education. There are also books being written to help teachers and students do their jobs creatively. Graduate studies are open to those who have the initiative to continue their studies.

Competition

The problem, however, lies in the other more attractive jobs graduates of art education usually find. The labor market has its own laws and its own logic. Many art education graduates work in different jobs: as decorators in television; selling goods of Khan El-Khalili in the airport; helping organize exhibits in the Ministry of Culture; training families to produce local crafts in the Ministry of Social Affairs; and working with the gifted in houses of culture scattered in zones that belong to the Ministry of Culture. It is not a question of whether these kinds of jobs are proper for art educators; they obtain better salaries. When we tell authorities in the Ministry of Education to raise the art educators' salaries, they refuse, giving the excuse that they would then have to raise the salaries of all teachers, which is not possible. Thus, the professional art educator is becoming rare in schools. There are intrusions of less qualified educators who take these jobs, regardless of the quality of their understanding or achievement. The Ministry of Education drills them yearly to improve their performance.

The Syllabus

The art education syllabus is aimed toward providing wide experiences in art and crafts to students in public schools. The philosophy is that each child has his or her own way of expression, and his or her own unique style, which the art teacher should not interfere with. On the other hand, art teachers are not passive. They have much to do to provide challenging art experiences for their students. They teach composition and color relationships and help students differentiate between good paintings and bad ones. Art teachers can read children's expressions in art and know well which drawings are automatic and mechanical and which are genuine. So they help students to acquire the right attitudes during drawing lessons. In other words, they encourage students to think independently, discover their own problems, and orchestrate their efforts for

Age 5: Children at recess. Teacher: Amani Abd El Rahman. Sample of an Egyptian Children's drawings—a repetition of schema of the human being.

solutions. Art teachers do not encourage imitation. For some, imitation is a method of learning and acquiring skill, but if it leads to mere copying, it makes students lose their personality. It is contrary to the creative process. How will young students widen their experience, learn more, or be aware of other people's solutions if they do not indulge directly or indirectly in a process of acquiring such knowledge? Children have to observe all phenomena around them by using their eyes, or the camera lens, or a microscope. They have to investigate nature and discover its visual laws. Children do not take things ready made by others. They must do their own research. They are responsible for their own thinking and gradually acquire the tools for it through reading, observing, and analyzing works of art in museums, galleries, or books.

The syllabus provides a variety of opportunities to students of art education in public schools. They may have experiences in drawing, painting, collective work, ceramics, sculpture, woodwork, metalwork, weaving, tapestry, and design. They may have chances to handle local crafts derived from rural materials existing in the environment. They may link their artistic expression with knowledge they have gained in other disciplines.

Nourishment

Students learn to be critical, not to accept without questioning. They are taught to sense the aesthetic values existing in nature, works of art, or in their own work or the work of other students. We do not encourage students to imitate comic strips or cartoons. These types of illustrations are alien to children, and they do not foster the development of children's art expression. On the other hand, much benefit can be gained from scrutinizing works of folk art and the art of eminent artists who have shown some link with child art in the 20th century, such as Paul Klee, Henri Matisse, Marc Chagal, Joan Miro, Jean Dubuffet, Rufino Tamayo, Ben Shan, Karl Appel, and Henri Rouseau. The Islamic illustrations of manuscripts are also of great value (El-Bassiouny, 1983).

The development of artistic expression requires nourishment. Children should be introduced to good examples of works of art that are appropriate for their age development. If not guided, children will usually be influenced by book illustrations, posters, window shows, and caricatures, as happened with the students of Franz Cizek years ago (Munro, 1929). Visual sources must be selected and competently introduced

to students at different age levels in order to preserve the genuine quality of their artistic development.

Art Books for Kindergarten

I had the chance with one of my colleagues to write two books on art for kindergarten children, ages 4 to 6 years. We included examples from nature such as plants, animals, birds, fishes—examples of works of art made by children of the same age level or those of artists whose work is linked with the type of expression characteristic of children at this stage. It was the first time in Egypt that such books were available for children at this early stage. We had to compete with other books on the market that tell the child how to copy drawings which can spoil the child's unique expression. In our two books, we arranged sources that enrich the artistic vision of these young children. The first book contains roses, butterflies, birds, fishes, animals, children's drawings of figures, and suns, along with works of local and international artists. The second book contains plants of Egypt, the cat, the owl, the butterfly, the shell, the bear, the lion, the kangaroo, ducks, tree leaves, the rooster, the giraffe, children playing and drawing, children's expression of figures at age 4 and 5, and a collection of paintings of local and international artists (El-Bassiouny & Nawarig, 1989).

There are obstacles to putting theory into practice with these two books. The first problem is how to use them. Who will use them? Are teachers trained to follow the philosophy that underlies them? To answer these questions, I met with more than 200 teachers who work in kindergartens. I explained the philosophy behind the two books, asked them to make drawings of certain subjects, and gave grades. During the encounter I discovered that there were no art teachers at this level, the teaching is left to general educators whose knowledge of art is nil. Thus, the books are not used enough. They await new generations of teachers who may better understand art education.

Industrialization

Another movement in public education has sought to industrialize the arts, especially in the schools known as fundamental education schools, or basic education schools. But this trend has not met with favor from art educators, who search for the personality of students, their aesthetic culture, and unique expression. The trend follows practices, particularly drills such as those existing in technical schools, that do not match the aims of art education.

Schools are not isolated from the state. Since the revolution of 1952, there have been many trends, but they have not lasted long. During the political movement after socialization, emphasis was placed on group work and socialistic subject matter. When the trend was toward industrialization, the movement affected art education, making functional work the aim. After the 1956 war with England, France, and Israel, art education had something to say about the fights and battles of war.

Summary of Major Trends

The major trends in art education in Egypt in the last half century can be summarized as follows:

1. The period of samplers (from 1900—1920) was aimed at the acquisition of skill through imitation.
2. The period of the laws of perspective (from 1920—1936) promoted academic art.
3. The discovery of child art, along with the aim of searching for the freedom of the individual and developing the imagination, was paramount during the laissez-faire period (from 1936—1946).
4. A scientific approach in art education was aimed at developing an integrated human being. It used lesson planning and the influence of modern art and local tradition (1946—present).

Important Names in Art Education

Art education in Egypt has also been affected by INSEA local and international conferences. It reflects the thought and creative attitudes of the mission members who returned home during the 1950s: from the United States; Mahmoud El-Bassiouny, Hamdy Khamis, Abou Khalil Loutfy, Youssef Sida, and later Loutfy Zaki; from England; Moustafa El-Arnaouty, Abd El Gani El Shal, and previously Saad El-Khadim. But the man whose influence cannot be forgotten is Youssef El-Affifi, the teacher of all those mentioned. Zeinab Abou was responsible for educating women art teachers in Egypt for more than 20 years. The current generation, our students, includes Fargali Abd El-Hafeez, Kamal El-Masry, Nawal Hafez, Laila Soliman, Abd El-Rahman El-Nashar, and Nabil El-Housseiny. In the Ministry of Education, two names should be mentioned: Abou Saleh El-Alfy and Ahmoud El-Shal, who played a great role in local conferences, exhibitions, and syllabuses.

Future Hopes

As time passes, more and more is expected from art education. The development of each citizen's taste, aesthetic values, and critical outlook; the capacity to change the environment and give it a better appearance; the understanding of works of art in local museums and various references; the capacity for aesthetic discrimination in all aspects of life—these are just a few aims we expect art education to fulfill today and in the future. The most challenging aim is the development of an integrated human being through art. It is an aim that is approached but never fully reached.

References

El-Bassiouny, M. (1962). *Experiments in art education.* Cairo: Dar El-Maerif.

El-Bassiouny, M. (1983). *Characteristics of Qatari children's drawings.* Doha: Qatar University.

El-Bassiouny, M. and Nawarig, F. A. (1989). Art for the kindergarten: first and second book. Cairo: Ministry of Education.

Magazine of International Federation for Art Education, Drawing and Art Applied to Industries, Cairo Branch, April 1938, p. 26.

Munro, T. (1929). Franz Cizek and the free expression method, in *Art and Education* (p.311). Merion, PA: The Barnes Foundation.

Bibliography

El-Bassiouny, M. (1989). History of art education in the Arab Republic of Egypt. *INSEA News, 4,* 234.

_____. (1985). *Foundation of art education* (3rd ed.). [In Arabic]. Cairo: The World of Books.

_____. (1984). *Art education, West to Middle East.* Cairo: Dar El-Maarif.

_____. (1984). Egypt, modern methods and an ancient tradition. In *Art in education: An international perspective* (pp.135-145). University Park and London: The Pennsylvania State University Press.

_____. (1980). Modeling and collective painting in an Egyptian primary school. *School Arts,* pp. 10—24.

_____. My views and philosophy of art education for my country, the Arab Republic of Egypt. *Athene, The Journal of the British Society for Education Through Art, 15,* (5), 8-10 [Incorporates the *Third Journal of INSEA,* 1969—1972].

_____. (1964). Art education in the United Arab Republic. *Studies in Art Education, 5,* (2).

_____. (1953). Traditional culture and artistic form. In Education and art, (pp. 166-167). Paris: UNESCO.

_____. (1951, July-August). Stories in clay by children under ten, *UNESCO,* (pp. 10).

_____. (1948). Child art in Egypt. In *Arts in childhood.* [Series III-Bulletin 4, (pp. 6-8)]. Tennessee: Fisk University.

A traditional drawing of Islamic manuscript of the elephant and the moon-Klaila and Dimnah. The rabbit and the king of elephants in the moon's well. Probably Syrian–Library of Podlian, Oxford (172 x 244 mm). A picture used in art appreciation with Children. (courtesy of Mahmoud El-Bassiouny)

It Is What One Does that Counts: Developments in Swedish Art Education

■ ULLA BONNIER

The world around us has changed dramatically during the last century. In the 1920s and 1930s, the urban landscape was calm and relatively free of visual graphics compared to what we see today. The modern city makes other demands on the people who live and work there. The skills and knowledge now required are considerably different from those required a few decades ago. It is not only the external surroundings that have changed. Our home environments have undergone similar changes. Leisure time was previously spent reading and perhaps listening to the radio. Now it is not unusual to listen to the radio, read—a comic perhaps—and gaze listlessly at the television, all at the same time. We have increased our abilities to extract meaning from the welter of information around us. We have trained ourselves to pick the essentials out from the information deluge.

It is first and foremost in the field of visual communication that information science has expanded, and these increases in visual communication have occurred at the cost of verbal communication. This has increased our need to know more about visual messages. The need for skilled professionals in the field of visual communication has also increased. New professions have been created, and others have undergone changes. Graphic artists are needed in many fields. Film and video production are thought to be the professions of the future. Even within established professions, visual communication is important. In industry and administration, for example, the need for sketches, charts, symbols, and billboards is increasing.

The status and content of art teaching have been influenced by the dominant ideology of the ruling class throughout time. Cultural appreciation and creative development have traditionally been emphasized in the teaching of art. In recent years, insights into the image as a form of communication have radically changed art as a school subject. It has expanded to embrace all types of modern society's visual communication.

Preparing for Work Life and Developing a Sense of Taste

Drawing has been taught in Swedish schools since 1842. In the beginning, elementary school teachers taught line drawing. Art teaching was characterized by the desire to prepare pupils for work life and to develop their aesthetic sensibilities. Pupils were to be given opportunities to improve their drawing skills and thereby raise the standard of their work. The subject was considered primarily as being supportive to the teaching of handicrafts.

For the advancing industrial society of the mid-19th century, the goals of education comprised competent draftsmanship, intellectual development, and manual dexterity. For a long time, art education was considered to be of purely practical help. Many years would pass before the subject was considered as having a part to play in a liberal arts education.

Drawing was a compulsory subject in schools from 1850 despite the absence of qualified teachers. It was only in the 1870s, arising out of a reorganization of the Swedish Handicrafts' Guild School in Stockholm, that the training of drawing teachers began in the new technical school. Actually, "technical school" was something of a misnomer, but the buzzword of the day was technology. The teachers trained there taught only in senior schools. Classroom teachers were responsible for art education in elementary schools.

Aesthetics for Daily Life

In 1909, in a lecture entitled "Concerning the Teaching of Drawing," C. Lindholm expressed his belief in the importance of everyday art and our need to develop an aesthetic sense:

> We know that visual images awaken specific emotions and that word derive their intrinsic value through their ability to recall and recreate visual form. Angry words are not as frightening to a child as the sight of an angry face.

27

A newspaper article which some time ago pointed out that Japanese teachers punish their pupils, not by scolding, but by showing them sights which provoke an emotional reaction considerably worse than physical pain, is a case in point.

Lindholm's term everyday art includes all objects used in our daily lives such as furniture, household goods, and buildings. Artists preferred to distinguish design as the making of useful objects, which, in their opinion, lacked artistic merit. Lindholm bemoaned the fact that many craftsmen were content to copy and did not aspire to original design. Lindholm's thoughts mirrored social conditions. Technical advances meant that goods were competing not only on their technical merit, but also on the grounds of visual impact and packaging. This tendency was influenced by exhibitions and reviews.

In Germany in 1907, Deutscher Werkbund was established. It was the first of many organizations founded to elevate artistic and technical standards in industrial production. In Sweden, The Swedish Hand Crafts Association (Svenska Slöjdföreningen) became the center for new ideas from the continent. Form and visual impact received increasing attention. Nowadays, our decision to buy a product is often based on its visual appeal, rather than its intrinsic value. Advertisers control our responses to their products and create needs from them, a veritable "technology of the senses" (Haug, *Kritik av Varuestetiken*). This aesthetic paradigm is made possible by the transition from production to consumerism.

In 1919, drawing instruction in elementary schools continued to consist of accurate copying, but it now included drawing from memory and imagination. In the upper-level classes, line drawing continued. With the new reform in teaching, art was seen as a communication tool. Art was encouraged in workbooks and as illustrations in other subjects.

Preparing for working life was underplayed in the first half of the 20th century. The development of aesthetic sensibility was seen as more important. Pupils' sensitivity to aesthetics and ethics were developed, and advanced line drawing was relegated to certain streams in senior school.

The school reform of 1927 opened secondary schools to girls. Drawing appeared on the schedule, with 8 teaching hours per week for boys and 7 for girls. The goal of art education was

to sharpen powers of observation, to develop a feeling for form and color, to impart theoretical and practical knowledge, including the ability to do independent freehand profiles and perspective sketches and to produce, with appropriate color washes, simple working drawings.

Practical and Spiritual Matters

The adaptation of schools to the demands of working life was questioned in an article in *The Journal of Swedish Art Teachers* (Tidning för Sveriges Teckninglärare). The same publication is now called *Art in School* (Bild i skolan). The chairperson of the National Association of Art Teachers, G. Nordlander, claimed that spiritual development had been neglected. People did not only need training for a profession in order to compete successfully in the already oversubscribed job market. Nordlander opposed the demand for increased training in specific skills that would not solve the unemployment problem. An increased general education program would not solve the problem either, but "indirectly and with time would direct the way to good taste and noble pleasures and create a more sure base on which young people could build their lives and future happiness." Production, distribution, and trade could not occupy the entire population. However, Nordlander continued, each one of us is a consumer and each one must earn a living. If we do not wish to return to a subsistence economy, we must seek outlets in spiritual activities. Our needs for food, clothes, or cars are limited, while the need for beauty is unlimited. By increasing young people's desire for beauty we would be contributing to the solution of the crisis in spirituality. In his article, Nordlander referred to the following quotation from José Ortega y Gasset's *The Rebellion of the Masses* (1929, 1930, 1932): "The world economic crisis had, at its base, the large increases in production capacity which, together with artificially protected capital, caused this situation. These facts in turn brought about market speculation."

Even people without capital could speculate on the stock market, since credit facilities were readily available. As long as the market continued to rise everything was fine, but as the market leveled, it became apparent that many shares lacked capital support. The collapse of the U.S. stock market in 1929 precipitated a world economic crisis. Production capacity had long overtaken buying power, and this worsened the crisis. Growing unemployment was one of its worst results.

The prevalent philosophy assumed that it was the "rebellion of the masses" that was responsible for the

spiritual impoverishment of culture. Ortega y Gasset's *Rebellion of the Masses* was the inspiration for both right-and left-wing extremists in their fight against the spiritual bankruptcy of mechanism.

The German philosopher and literary historian Arnold Hauser pointed out in *Die Sozialgeschichte der Kunst and Literatur* (1951, 1958) that this group of more or less conscious reactionaries prepared the way for fascism. The mobilization of antiscientific, antideterministic forces was nothing less than the beginning of the world reaction against the light of democracy and socialism.

Nordlander argued that there was scant opportunity in the teaching of art to exert any influence on culture. There was not much time devoted to a second-class subject. Teachers were faced with an almost impossible task. According to Norlander, "Demands and expectations associated with education are hard on the teachers, who must first and foremost make a choice between crass egotism, career and professional advancement, or the furthering of cultural aims." Nordlander hoped that art education would impart the insights of a good general education as well as aesthetics to senior pupils. As adult citizens, they would remember their art lessons and judge them according to their spiritual and material worth.

At this time, young artists were exploring new forms of art expression. These experiments were frustrated by Nazism and fascism. In Germany, a committee was founded with the express purpose of singling out those artworks which best represented the social realities of the Nazi regime. These artworks were exhibited in a newly built gallery, *Haus der Deutschen Kunst*, popularly known as "Hauptbahnhof Athens." In his opening address, Hitler forbade German artists "to use colors other than those perceived in nature by the normal eye. He who insists on doing otherwise is sick and medical authorities will put an end to his hereditary taints—or he will be classed as a traitor and punished by law."

The exhibition consisted of two parts, and, in contrast to the chosen, "correct" artworks, one could also see those which were considered to be "degenerate"— "Entartete Kunst." The exhibition was in fact a polarization, causing the viewer to contrast and evaluate similar motives. Modern art was regarded as a product of mental illness, and naturalism was exalted in its place.

Learning to see and to make accurate representations of the world around us was dominant in the philosophy of art from the end of the 1930s to the beginning of the 1940s. This concept also found expression in Swedish art education. "Observation and the Teaching of Drawing" was the title of an article written in 1942 by Seth Jonson,* in the journal *Drawing* (Techning). He emphasized the importance of learning to see the world around us, although only in the sense of reproducing it accurately. It was significant that pupils were taught the rules of perspective and shading, which would enable the completed picture to achieve a certain balance and presence. The untrained eye would be taught to see color in shadow. Natural resistance would be conquered by wholesome education.

Toward a New School

A reconsideration of the Swedish school system began with the investigation of 1940 chaired by Minister of Education, Gösta Bagge, leader of the right-wing party. The etymology of Sweden's Department of Education is a matter of some interest. Up until 1967, it was known as *Ecklesiastikdepartementet*, its stem being derived from the Greek word for "church." The Department of Education, established in 1840, was concerned with both ecclesiastic and educational matters. It is worth remembering that Swedish education had for a long time been influenced by the Church.

In 1946, after the dissolution of the coalition government and before the school investigation of 1940 had finished its work, a new Minister of Education, Tage Erlander, was appointed. His mission was to oversee the proposals of the school commission. The commission presented its main ideas in 1948. The goal before had been the adaptation of schools to the needs of modern society. It was believed that the old school system was the product of undemocratic social forces and therefore, in many ways, opposed to the society that it should serve. Previously, the task of schools had been to produce workers. This development had led to demands for specific skills and much emphasis had been placed on the control and uniformity of these skills. Opportunities for experimentation and alternative teaching methods had been limited. The commission felt schools should foster democratically inclined individuals. Teaching should not be authoritarian; instead, it should recognize the pupil's individuality and unique abilities. Independence, critical thinking, and cooperation would be emphasized.

The value of independence was given particular attention

in the debate about the psychological assumptions of the totalitarian regimes. Society ruled by the people demands that its citizens should have a critical disposition in order to resist false ideologies.

Democracy has no use for people who cannot think for themselves. But independence and a critical disposition are not enough. Self-sufficiency can lead to egotism, self-promulgation, anti-socialism. A critical disposition can be transformed to negativism.

Schools should therefore present tasks to pupils in a way that will inspire them to co-operate. (School Committee, 1948, p. 4)

The old question-and-answer teaching methods would, as far as was possible, be replaced with methods of a more free and active nature.

Criticism of the old elementary schools was primarily directed against deficiencies in the teaching of the social sciences and the Swedish language. English would be introduced as a compulsory subject. The commission also spoke out in favor of increased aesthetic studies:

It is, in addition, of national concern that schools, by imparting deeper insights, can serve as a counterfoil to sensationalist novels, inferior art, worthless musical entertainments, unsuitable films, etc.—things which despoil the tastes of the majority.

Schools should kindle in their pupils a love of [sic] beauty which would enable them to utilize the treasures of their cultural heritage and thereby enrich their lives. (School Committee, 1948, p. 7)

Free Creativity

School politics found its way into art education, as Lilian Anshelm pointed out in her *Drawing* (Techning) article of 1949. She referred to two tendencies in modern art instruction in Great Britain. On the one hand, there were so-called "free art teachers" to encourage children to express themselves spontaneously. The teacher would provide material and a stimulating environment, but not interfere with the children's own creativity. On the other hand, there

were art teachers who believed that discussion and cooperation would also stimulate children's interest. Anshelm was in favor of the latter, although she saw both practices as compatible. Independent activity in combination with the appropriate guidance would ensure creativity in both imaginative and practical exercises. Many types of material would be made available, such as watercolors, powder paints, paintbrushes, various sizes of paper, ink, charcoal, crayons, tools for lino cuts, clay, kilns, and projectors. No drawers or cupboards would be locked, for these materials should be freely available. Freedom with responsibility was emphasized and explained to pupils. However, class sizes were too large for the project to succeed. Anshelm regarded art as a sort of laboratory subject, which in Sweden comprised a maximum of 20 pupils. Anshelm also felt that ample space was needed, with separate alcoves for clay modeling, wood sculpting, and other three-dimensional work. The art classroom became an entire industrial arts school on a small scale.

The school reforms introduced by the school commission of 1946, had behind them the 1930 world economic crisis and the frightening influences of Nazism and fascism in Europe. It was natural to want to close the education gap and to produce young adults who would be able to make their own judgments based on their own experiences. Free, creative activities would, among other things, help to counterbalance blind faith in authority.

Herbert Read, the art philosopher, belonged to the school of "free art teachers," as noted by Anshelm in her article. For Anshelm, Read was an anarchist. He believed that feeling, instruction, and fantasy would conjure forth untold possibilities within the individual.

At that time, the growth of the visual media was increasing dramatically. In his book *The Communications Revolution*, Frederick Williams drew an analogy between the development of communication science and the passage of a single day. It is only during the very last second that our information and communication explosion has occurred. It was as late as 1952 that regular broadcasts began on Swedish television. From the beginning of the 1940s, the camera had documented familiar scenes and events. One could say that the photo album had replaced the diary. This new way of remembering events spread to the general public and became considerably more common than the diary ever had been.

The New School After 20 Years of Investigation

The school commission of 1946 proceeded with its inquiry and in 1950 a decision was reached. After a period of experimentation, the old school system, comprising elementary school, various forms of middle school, and grammar school, would be replaced by a uniform school system. This entailed a total revision of the Swedish school system.

The new school system was instituted by most municipalities and in 1955 the new syllabus was introduced. The main issue was how to combat inequality. At the experimental stage, the municipalities had grouped together those pupils who would continue on to higher education. Depending on the pupils' choice of subject, they were placed in the same class. There was thus little difference between the new schools and the old grammar schools they were meant to replace. The reform continued up until 1962, when comprehensive schools were introduced.

Despite advances in the field of visual communication, the goals set for art education reflected none of this, a fact that can probably be explained by institutional inertia. Teachers at the Art Teachers' College (Techningslärarinstitutet) derived their teaching methods from experience. As they had been taught, so they taught.

I attended teacher education college from 1963 to 1966, and the instruction was distinguished by exercises in draftsmanship and observation. The syllabus comprised methods and teaching of free-hand drawing, line drawing, and calligraphy. Other related subjects included composition, art history, psychology, pedagogics, speech, homemaking, art psychology, and art pedagogics, as well as practical training. Additional subjects consisted of working in different media, with the exception of photography, which was a new subject both to us and our teachers. Free expression had no place here.

The 1962 syllabus for comprehensive schools provided relatively many art teaching hours. The subject was compulsory: 2 hours per week in grade 7. Pupils in grades 8 and 9 could choose 2 out of 3 hours in music, art, or crafts. Art teachers could also provide extracurricular art instruction. Although these classes fell outside of normal school hours, teachers were paid the same rate. Many pupils in grades 4 through 6 came to these lessons, receiving skilled instruction in art just as their friends who enrolled in music classes received qualified music instruction.

Legislation in 1969 saw the application of a new syllabus. The Board of Education (SÖ) had in 1967 suggested revisions to the goals and directions of 1962. The background of the changes in the new syllabus was the revolutionary social changes that occurred at the end of the 1960s. Signs of these changes are evident in the amendment, which replaced the expressed hope of cherishing and maintaining cultural traditions with the desire that "schools shall provide pupils with perspectives concerning the changeable nature of society in order that they might better understand present conditions and maintain those from the past which they deem to be valuable." Schools would also strive for equality and for understanding of groups that have special problems in modern society. Pupils would be encouraged to debate prevalent conditions and norms.

Pupil discrimination continued to be an issue. It was decided to give emphasis to the role of art education in order to "stimulate the pupil to make constructive use of his free time and to develop his interests and skills."

The 1962 syllabus had required pupils to choose between various creative activities. The majority (90%) had chosen crafts in grade 7, where the choice between music and crafts art was compulsory. In grade 8, most pupils (80%) chose a combination of crafts and art. Music was a forgotten subject.

Increasing Aims and Decreasing Obstacles

Many art teachers had expressed the hope of expanding the scope of art teaching into the sphere of communication. Greater knowledge of new techniques was needed to adapt the subject to the growing needs of a society ever more influenced by information and communication technology. Through the sympathetic influence of the Art Teachers' Association, the goal descriptions of the 1969 syllabus came to include art appreciation and art and the environment. Visual communication and understanding the media became important factors in art education.

Although the aims of the subject increased, however, there were insufficient resources. Despite the aims in the syllabus, art education lost teaching hours. The revised subject content demanded more information and more teachers, but the opportunities for teaching art were reduced. Extracurricular art lessons were

replaced by 2 hours per week of voluntary activities for grades 7 through 9. Pupils tended to choose activities in the practical or creative fields. Subject choices were also changed; pupils had to choose between German and French as a third language, art, technics, and domestic science. All subjects chosen were weighted equally as entrance qualifications to upper secondary school.

Art was the area in which art teachers were busiest. The aims of this subject were to introduce the pupil to various forms of artistic expression. A supplement to the syllabus was a simple model for mass communication. Words, images, and movement would be integrated in art education. Communication skills, both in the sending and the receiving of information, would be explored during art lessons.

The effects of the international student revolts of 1968 were also felt at the Teachers' College of Art (Techningslärarinstitutet), where both teachers and students, supported by teachers in the schools, revolted against the lack of social and educational relevance in art and education. Art education took a new direction and content to reflect with prevalent social conditions.

The 1964 reforms for upper secondary schools meant that art was no longer compulsory. Pupils could choose between music and art. As a replacement, art and music history were introduced in certain theoretical streams. Today 85% of pupils in upper secondary schools never come into contact with art as a school subject.

The syllabus for comprehensive schools has been completely revised, beginning with the recommendations of 1969. Upper secondary curricula have been changed to accommodate the new comprehensive school pupils. The content of art education has been expanded to cope with the increasing importance of the visual media. In 1976-1978, a bulletin from the Board of Education (SO 42/1975-76) stated, "Supervisors of the school syllabus must, on the one hand, ensure that art education fosters skills in the creation, enjoyment and analysis of art; on the other hand, they must use the creation and study of art as a general learning experience." The curriculum also took into account the growing social significance of the mass media. To counterbalance the consumerism prevalent in the media, the viewing of which took up a large percentage of pupils' time, schools would provide opportunities for creative writing, painting, and music.

The Board of Education suggested that the subject's name be changed from drawing to art, due to the developments that had taken place in this subject. With that directive as a point of departure, the Board of Education then suggested that the time devoted to art education should be reduced by 20 minutes per week. Such a step was averted by the intervention of the Teacher's Union. Art is included in comprehensive school education so that pupils can

• develop an interest in means of expression other than speech and writing
• develop an understanding of composition, form, and color
• find stimulation in their own creative activities
• develop skills in the analysis of various kinds of visual imagery
• be instructed in the techniques of representation: shading, perspective, as well as photography, film and television.

The main points here are technique, analysis, visual communication, creativity, and understanding the media.

In upper secondary schools it was hoped that pupils would

• develop their communication abilities, creative abilities, and their experience of the media
• increase their knowledge of and skills in representation, analysis, evaluation, and the use of various types of visual communication
• increase their awareness of art and of visual communication for the individual and for society
• increase their appreciation of design and their abilities to examine and evaluate form as well as
• develop an understanding of contemporary art and culture and thereby develop a historical perspective, compare overviews, and personal values. (Lgy. 70)

The main points for upper secondary school art education were visual communication, representation, analysis, and the use of visual media. Knowledge of the environment included analyses of its configurations, understanding that art entails a study of the environment.

Invest in Art

In 1985-1986 a comprehensive campaign was begun by the Board of Education and government cultural advisors, together with the Art Teacher's Union. The following is a quotation from a communication sent to

all schools and other interested parties at the start of the campaign:

Children and young adults today live in a world dominated by visual images. Insistent messages come to us via the visual media which, both in form and content, offer us enticing, but also frightening, values and lifestyles.

The lack of resources and opportunities for individual self- expression is highlighted against the background of the bewildering array of visual stimuli [my emphasis].

So too is the need for a humanistically based perspective.

We can thus conclude that the importance of the visual media is on the increase in today's society. Schools have an important task in supplying pupils in both comprehensive and upper secondary schools with the necessary knowledge concerning the making, understanding, and use of the visual image.

Understanding the visual message must be seen as a democratic right comparable to reading and writing. Providing opportunities for artwork during school hours should be viewed as a self-evident necessity, just as offering computer instruction is. The following extract is taken from the 1968 budget proposals:

At a time when economic and technical issues carry more weight than social debate and development, it is particularly important that we give prominence to humanistic and cultural concerns. By concerning ourselves with humanistic and cultural matters we can hope to find enlightened solutions to our economic and technological problems and to foster the bonds of common humanistic, equality and harmony in our progress.

The deliberations of the Committee for Mass Media in *Via Satellite and Cabel* (SOU 1984:65) stated:

A basic skill which schools provide to children is the ability to read and write. They receive guidance in the evaluation of literature. Good reasons can be advanced as to why they should receive the equivalent in connection with the visual media, at the same time being assisted to develop a critical attitude to them.

Despite documented evidence of the content and importance of art education, the subject has been continually affected by cutbacks. The number of teaching

hours per week has been reduced in both comprehensive and upper secondary schools, and this undermining of the subject continues.

The new proposal for training comprehensive school classroom teachers recommends a substantial reduction of art in the training of classroom teachers for grades 1 through 7. A week-long study period is considered sufficient, as compared to the 5 to 8 weeks required previously. This short training period is contrary to the importance otherwise accorded to the subject in the text of these proposals. This is particularly difficult to understand in the light of the survey conducted by the Board of Education concerning the continuing education program for the new teachers' education system. Teachers in grades 1 through 6 considered that their needs for continuing education were greatest in the area of art education.

Prospects for Art Education

Lasse Svanberg, in *The Electronic Horse* (Liber, 1979), sketched a scenario of information and communication technology in the community of the future. He represented this community by an inverted triangle. At the triangle's base, in this case the top, there is an overabundance of electronic gadgets controlled by multinational media corporations and politicians. At the triangle's apex, in this case the bottom, the individual sits at a typewriter, pondering a blank piece of paper. This is where it all begins: with some marks on paper, with thoughts, vision, and creative ability. There is clearly an imbalance between the investments made in technology and those intended for artistic regeneration.

Preparations made for the teaching of critical approaches to the media are undermined by the lack of resources and emphasis on theoretical subjects. Only by personal experience, by doing things oneself, can one develop an appreciation of quality and thereby question the value of productions. Learning by doing is as relevant today as it has always been.

The risk posed by the information explosion is that large groups of people, particularly among the working class, can be manipulated by those who control the information flow. The education gap is growing larger, not smaller. We risk creating a society that consists of a small, powerful elite of politicians and intellectual snobs.

The field of visual information is increasing more rapidly than any other. People do not learn to handle

the mass media by talking about them. Separating the practical aspects of such a study from talking and thinking is not only impossible but oppressive, and it favors those sociocultural groups whose relationships reflect the abstract and theoretical attainment of knowledge.

School authorities have, through their own studies, proved that pupils, particularly from a working class background, do not achieve satisfactory results in school. Rather than increasing their self-confidence during their school years, working class children tend to lose it. This naturally has a constraining effect on their future development. For this group of pupils, this is a result of incorrect teaching methodology. Their need for practical, concrete learning experiences is not being met. In the march of technology and shortsighted profit making, political leaders have forgotten that the low point of the population triangle requires input. Goals and guidelines are not enough. It is not what one says, but what one does that counts!

References

Hauser, A. (1951). *The social history of art.* Translated in collaboration with the author by Stanley Godman. New York: Knopf.

Hauser, A. (1958). *Die Sozialgeschichte der Kunst and literatur.* Muchen: H. Beck.

Ortega y Gasset, J. (1929. 1930). *La rebelion de las masas.* Madrid: Revista de occidente.

Ortega y Gasset, J. (1932). *The revolt of the masses.* Authorized translation from the Spanish. New York: W. W. Norton & Co.

Read, H. (1943). *Education through art.* London: Faber & Faber.

Notes

The article is based on several articles and books in Swedish by the authors and government documents and research publications in Swedish.

THE CHANGING FACE OF AUSTRALIAN ART EDUCATION: NEW HORIZONS OR SUBCOLONIAL POLITICS?

■ DOUG BOUGHTON

Until recently, Australian art education has reflected overseas ideologies and practice shaped only slightly by local interests, educational theory, and politics. Not surprisingly, the most significant influences have come via Great Britain and, more recently, North America. Large distances within the country and its isolation from the rest of the world, together with the lack of a research tradition in the field, have in the past inhibited development of art education theory and practice that are uniquely Australian in their character.

Origins of Australian Art Education

During the past 100 years, Australian art education has gone through three clearly identifiable phases similar to the development evident in Great Britain, the United States, and Canada. These were the *hand-eye training period*, from the late 19th century to World War I, the *creativity period*, from the 1940s to the 1960s, and the *studio discipline period*, from the 1960s to the present (Hammond, 1981). Each of these phases mirrored overseas developments, although the time lag between implementation of new initiatives in England or North America and subsequent adoption in Australia has been, on occasion, close to 40 years.

The Hand-Eye Training Phase

In 1852, the Department of Practical Art was established within the Board of Trade at South Kensington in England to improve, among other things, the design skills of British workers. By 1856, a Department of Science had been added to the Department of Practical Art, and both were administered within a newly created Department of Education (Mandelson, 1985). The overriding concern of the British government was to maintain industrial supremacy in the international marketplace, particularly in textiles manufacture. The methodology chosen to do this was to develop design skills in students through rigorous drawing exercises. Through such exercises it was believed that students would not only acquire important coordination skills, but also develop improved memory, observation skills,

enhanced intelligence, good taste, and moral values. The mode of teaching was teacher centered and highly prescriptive (Mandelson, 1985). The major influence on the South Kensington drawing programs was derived from 18th century European academies of art (Hammond, 1981).

Similar concerns about industrial competitiveness in the United States resulted in the appointment of Walter Smith, an Englishman, who was imported to implement the South Kensington principles in Massachusetts in the early 1870s. Smith developed drawing as the first required art course in the United States and was employed to train teachers in its implementation (Chapman, 1978). As was the case in England and the United States, early colonists in Australia were concerned with nurturing newly developing manufacturing industries. Prior to the early 1890s, however, there was little evidence of systematic attempts to promote industrially appropriate skills through schools. Until the establishment of school system bureaucracies, opportunities in art and design for children were supported by various influential colonists who held differing views about the value of the educational outcomes of such experiences. Some had vested interests in promoting skills useful to their own manufacturing industries, while others were concerned about offering opportunities for social accomplishment and the growth of moral values. The major thrust of art education after the 1880s had more to do with industrial design sparked by the minerals and pastoral boom than it did with fine art (Emery, 1988). The promotion of drawing in schools is illustrated by the fact that all primary school teachers were required to hold a certificate of proficiency in drawing before they could gain their diploma (Emery, 1986).

Although there was some evidence that the South Kensington materials were used in South Australia in the early 1870s (cf. Young, 1986), the first indication of a systematic attempt to implement them occurred in New South Wales with the publication of the South Kensington ideology in the *NSW Educational Gazette*.

Note: An earlier version of this paper was published in *Studies in Art Education, 30* (4), (1989), 197–211.

35

Frederick Woodhouse was appointed in 1889 as the first superintendent of drawing in New South Wales schools responsible for the improvement of instruction in that subject. It appears that he was given the same mandate in Australia as that addressed by Walter Smith in the United States almost 20 years earlier (Hilson, 1987). The courses he developed included five main forms of drawing: object, memory, design, geometric, and scale. Expressive drawing was also included, but less frequently.[1] In all, the time lag between the establishment of the South Kensington Department of Education and the publication of Woodhouse's drawing courses in New South Wales was over 35 years.

A second element of the hand-eye training phase in Australia was *manual training*, which consisted of wood sloyd, paperwork, and needlework. The origins of these interests can be traced to Russia, Scandinavia, and Germany. Although derived from different sources, both manual crafts and drawing were linked by common beliefs in the virtues of hand-eye training (Hammond, 1981).

The Creativity Phase

After World War I, art education in Australia entered a transition phase, largely due to the ideas of the Austrian Franz Cizek. Prior to World War I, art in Australia was called "drawing;" by World War II it was called "art." The development of art within Australia between the wars was curiously disjointed (Mandelson, 1985). Cizek's influence came to Australia from Europe via Great Britain.

Cizek's ideas first came to the attention of British educators in 1921 through an exhibition of his students' work. His notions of the creative potential of young children and the belief that the mind of the child was qualitatively different from that of the adult resulted in an art education pedagogy that was distinctly different from the prevailing hand-eye discipline. Cizek's ideas were popularized in Britain by educators such as Tomlinson and Richardson, and by 1931 they are widely accepted (cf. Dimmack, 1958).

In the United States, the work of John Dewey provided fertile ground for the acceptance of Cizek's philosophy and the redefinition of child art. Acceptance of the creativity doctrine in Australia was very slow. Despite early exposure to Cizek's philosophy in South Australia, the only state to recognize overseas developments before 1940 was Western Australia. M. P. Harris, a Scottish-trained educator, lectured in South

Australia on Cizek methodology in 1922 (cf. Mandelson, 1985). She also published an article in the South Australian Education Gazette outlining the essence of these teaching procedures (Harris, 1923). It was not until the 1936 syllabus rewrite that Western Australia expressed an interest in creativity, albeit in the form of compromise. Noticeable in that document was the replacement of geometric drawing with pattern or design making.

In his documentation of the slowness of the Australian response to overseas developments Mandelson (1985) commented:

> Until 1937 and in particular until Australian complacency was disturbed by overseas experts in art education who came to this country in 1937 for the New Education Conference, states other than Western Australia and Tasmania operated as if the new concepts of child art did not exist. . . . Developments in Western Australia and Tasmanian experiments received no mention outside of their own state. Even those who traveled abroad failed to notice the new approach (p.40).

Roy Knudson, Inspector of art in New South Wales, observed that the creativity movement had no influence in New South Wales until after 1947, and that influence was short lived, giving way to a more *disciplined* approach by the mid-1950s (Knudson, 1988). One influence, which may be regarded as a turning point for Australian art education, was the 1937 New Education Conference organized by K. S. Cunningham for the Australian council for Educational Research. This was a traveling conference that moved from Brisbane to Sydney, Canberra, Melbourne, Hobart, Adelaide, and Perth over a period of 7 weeks. Various prominent overseas speakers, such as Paul Dengler of the Austro-American Institute of Education in Vienna, and Arthur Lismer, Educational Supervisor of the Toronto Art Gallery, were featured on the conference program. In some states, response to the conference presentations was reflected in curriculum change. New South Wales effected an uneasy compromise between a teacher-centered approach and a child-centered curriculum. In a similar attempt to retain elements of both approaches, South Australia recommended, that children should have unrestricted opportunities to draw, while at the same time claiming that drawing required disciplined lessons and formal training to acquire the necessary conventions. Victoria placed more emphasis on formal work and the development of good taste, while Queensland made no change until 1952 (Mandelson, 1985).

It was not until the early 1950s that evidence of a commitment to the creative *free expression* ideology was apparent in every state and territory of Australia. The catalyst appears to have been the UNESCO seminar "The Role of the Visual Arts in Education" held in Victoria in 1954. The proceedings from this conference reflect strong support for creative expression as the major aim of art education in Australian schools. This support was expressed by artists, teachers, inspectors, and administrators who met at the conference for the first time to discuss the intended outcomes of art education in Australia.[2]

The proceedings of the Victoria seminar demonstrated almost total commitment to the creativity ideology. A paper by Oeser (1958), *The Importance of Not Teaching How to Paint,* typified the sentiments of the conference. Bernard Smith's (1958) editorial support of Oeser demonstrated something of the mood of the seminar: "The natural creativeness of children and its usually fatal contact with stereotyped attitudes imposed by society is one of Professor Oeser's special interests and his essay should be brought to the notice of everyone in the country charged with the care of children (p. viii)."

John Dabron, Supervisor of Art in the New South Wales Department of Education, in another paper, outlined the principles he believed should guide art education, the most important of which was creative activity (Smith, 1958). Dabron's influence from the time of his appointment in 1947 was powerful and convincing. His influence and belief in the primacy of creative expression was felt in the schools until his retirement in the early 1970s.

One of the more unusual developments to arise from the Victoria UNESCO seminar was the resolution that the Australian Broadcasting Commission be urged to "conduct regular sessions on art appreciation in a popular way over the national network as it does in connection with other arts" (Smith, 1958, p. 87).

As an extension of this idea, and in an attempt to overcome the enormous problems of distance in the state of New South Wales, Dabron produced a series of radio broadcasts that were widespread in their impact and effective in promoting the creativity doctrine. Activities and topics such as "rhythm patterns (brushes loaded with paint)," "emotive topics (to draw out a child's expressionist tendencies)," and "topics that tapped the imagination (drawn from the child's more direct experience)" were promoted over public radio in the 1950s (Knudson, 1988).

Again the time lag between change in British practice and Australian recognition of that ideological shift was 20 years. Factors responsible for softening the educational inertia during the 1940s in Australia were the writings of Herbert Read and the popularization of Cizek's philosophy by Victor Lowenfeld.

The impetus of the creative expression ideology is still manifest in some Australian schools today. The 1972 Queensland Department of Education *Program in Art for Primary Schools* , which continued as the guideline in that state into the late 1980s, submitted as its first aim "to develop creativity." In the second section, the stages of child development in art (derived from Lowenfeld and Lansing) were outlined, with recommendations for the teacher to assist the child's progress through them. This is despite the decline in interest in creativity and *natural* artistic development as a central concern of art education overseas. It was not until 1990 that a few selected schools in Queensland moved to trial curriculum materials in design that reflected a move away from the earlier traditions.

The Studio Discipline Phase

Beginning in the mid-1960s, Australian art education entered a transition period from *free* to *disciplined* expression in specific studio areas. Although studio disciplines were dominant, earlier themes also persisted. Drawing was still a powerful element of art programs in some states. The South Australian art curriculum was still called drawing, and it reflected interest in technical drawing and design applications until the next revision. In New South Wales, the 1911 *Drawing Syllabus for High Schools* clearly associated design with applied art, a concept that continued until 1965. Art history, or appreciation, was another element in all state curricula requiring a significant amount of teaching time, particularly at the senior high school level. References to substantive components of art theory, history, or appreciation are frequent in state school curricula from the turn of the century to the present.

In North America the art education debate shifted in focus from *creativity* to *aesthetic education* with Barkan's (1966) now widely popularized notion of a problem- and discipline-centered art education using as role models the triumvirate of artist, critic, and historian. That Barkan's notion of aesthetic education could be so hotly debated in the North American literature and so widely ignored in terms of its effect on the development of Australian art curricula for 20 years is, in some ways, difficult to understand. One of

the most powerful reasons is probably a deep-seated cultural orientation deriving from the traditional links existing between Australia and Great Britain. The Australian art educator Max Dimmack, in his 1958 book *Modern Art Education in the Primary School,* commented on this phenomenon:

> It is considered natural that the pattern of art education here should follow the English because of cultural ties. Developments in education in England sooner or later appear in education in Australia, and art proves no exception. Art education in Australia is English in character. A stronger influence from America could be absorbed; the benefits of two strong streams of overseas thought would prove of inestimable value (p. 10).

The development of a conception of discipline-based art education (DBAE) in Australia in the 1960s should not be confused with the American term as outlined by Greer (1984). In Australia, several possible directions were explored following the rejection of instrumentalist values characterized by the *creativity* claims. These included some isolated experiments with *aesthetic education, design education, integrated arts education,* and art from a social relevance perspective. However, the dominant model has become a disciplined form of studio, skill-based, product-oriented expression widely accepted throughout the country. Students in both schools and colleges engage in disciplined study, through studio practice, of traditional fine arts and crafts disciplines such as painting, drawing, printmaking, metalcrafts, ceramics, and so on.

A model of Victoria teacher education described by Hammond (1981) characterized the practice in Australian institutions for the past 20 years. In the initial years of an art teacher education course, students study a variety of fine arts disciplines in studios set up along traditional art school lines. Emphasis is on skilled production of *art* objects and the production of original and personal forms of expression. In the latter years of the program, students select a specific studio for *depth* study. Art history is usually a minor strand of study that supports the major studio endeavor. At the end of the program, the graduate teachers regard themselves as "printmaker," "painter," or "ceramist" and so forth, depending on their area of specialization. The effect these teachers have had on secondary schools is to establish specialist studios in school art rooms and to construct curricula based on fine arts or crafts studio disciplines.

Current state curriculum guides in South Australia, The Northern Territory, and Queensland clearly illustrate this studio focus. The 1984 South Australian *Art Craft and Design in Schools* requires the provision of learning opportunities for students in design, drawing, painting, film and photography, printmaking, sculpture, and appreciation. The 1987 Northern Territory core curriculum *The Arts for Primary Schools Years T—7* recommends that arts and crafts be offered through drawing, painting, printmaking, sculpture, and fibers and fabrics, as five major areas of expressive activity. In the Northern Territory junior secondary document *The Arts for Junior Secondary Years 8—10* (1987), the five major studio areas are maintained, with the additional requirement that these areas are to be studied through the elements of line, shape, color, texture, and tone. In Queensland, the 1972 *Program in Art for Primary Schools* directs student experience through painting and drawing, textiles, construction, modeling and carving, printmaking, and enjoyment of art.

It is not difficult to understand the reasons for this commitment to disciplined studio expression if one reflects upon the origins of Australian art education. Given the slowness of the state education systems to respond to overseas development, together with the lack of a tradition of systematic research and theory generation within the country, it is not surprising that the elements of discipline characteristic of the hand-eye phase should marry with the expressive qualities of the creativity era. An indication that elements of both ideologies would persist is seen in the reluctance of art teachers to abandon disciplined drawing in favor of creative expression in the curricula of the 1940s in Victoria and South Australia.

The struggle to resolve the tension between these two philosophies is typified by the development of art education spearheaded by two influential personalities with antithetical philosophies in New South Wales from the late 1950s to the early 1970s. John Dabron, Inspector of Art in New South Wales as mentioned before, was tireless and convincing in his promotion of the creativity approach in that state. Equally effective in the promotion of a more formal, structured approach to art teaching during the same period was Nita Playford. Playford's approach was based essentially on formalism, directed observation for the development of representational drawing skill, and formal analysis of artists' work in order to develop an understanding of the language of vision. Because of their fundamental philosophical disagreement, these two influential personalities agreed to focus on different levels within

the school system. Playford developed the primary (elementary) art program, while Dabron concentrated on secondary schools.

These contrasting philosophies co-existed uneasily in New South Wales until the threads of the two approaches were woven together in 1974 in the state's *Visual Art Curriculum for Primary Schools.* This curriculum "maintained allegiance with the philosophy of expressionism, yet was supported by a focus on formalism" (Sullivan, 1987, p. 2). In many ways it exemplified the paradigm of art education evident throughout the country in the 1970s.

At present there are signs of change in Australian art education that reflect a break away from the dominance of fine arts studio disciplines. Following a recommendation to the Australian Institute of Art Education (Boughton, 1983), a national policy was developed by that organization (AIAE, 1986) and was subsequently ratified by the art education associations of every state and territory in the country. That national policy is significant in two respects. First, it recommends that the visual arts be studied as two interrelated, and equally important components: (1) reflecting upon and responding to visual art forms and (2) making visual arts. Second, it recommends the broadening of visual arts study to include design arts (environmental, graphic, and product design), popular arts, folk and primitive arts, and fine arts. The overall impact of the policy is to require an increased emphasis on the study of art theory and a deemphasis on making art and traditional fine art study, with a concomitant increase of the understanding of visual arts in various social contexts. In a sense, this policy is an expression of the mood of change that found expression in the curriculum revisions conducted in most states in the late 1980s.

The most recent revision in Tasmania has clearly and directly recognized the AIAE policy in that the four main areas of study in grades 9 through 12 have been identified as design arts, fine arts, folk arts, and popular arts (Broomhall, 1988). This constitutes a clear and deliberate broadening of the art curriculum beyond traditional fine arts study.

Similarly, in Victoria, the newly developed *Arts Framework P—10* has removed the studio discipline approach. Popular arts and design have been included, and stress has been placed on the relationship between making and appreciating art as equally significant and interrelated learning activities. Again these changes are responsive to the AIAE national policy recommen-

dations. The Victoria curriculum has retained elements of the creativity era in that art and craft making is still promoted as a vehicle for the expression of feeling, to emphasize the importance of the individual, and as a means to enhance self-image.

The 1987 Western Australia curriculum *Arts and Crafts* represents a significant break with the established tradition in Australia. This curriculum proposes a course comprising five elements. At the center is studio arts which is the most conventional aspect. The more unusual elements are visual literacy, visual inquiry, art criticism, and art history. The structure of this curriculum reflects the spirit of the AIAE policy in that greater emphasis is placed on reflection and response to visual arts, while the differentiation between art history and art criticism echoes some of the same concerns that characterize the American DBAE debate.

In South Australia, the current curriculum stresses the significance of the *consumer-critic* in a tripartite program comprising learning experiences students are to have as artist/designers, craftspersons, and consumer critics (Education Department of South Australia, 1984). In 1988—1989, New South Wales implemented three new visual arts syllabi. These are documents designed to provide guidance for grades K through 6, 7 through 10, and 11 through 12. A feature of the planning of these guides is a consistent theoretical framework throughout to achieve systematic development in the learner from kindergarten through grade 12. The interest reflected here is similar to the structural concerns central to the DBAE debate. A studio specialist focus does not appear in this set of documents. The platform upon which the programs are constructed is that "students learn in the visual arts by creating and interpreting images." Emphasis is still heavily on students' personal responses and expression through materials, although greater weight has been placed on reflection and response to visual images by students than has been the case in the past, particularly in the K through 6 program.

A characteristic of almost all senior school visual arts programs in Australia, which sets them apart from the North American tradition, is the practice of state public examinations in art for the purpose of achieving university entrance status. Systems of state accreditation have produced senior school art curricula heavily weighted with theory (art history) components in order to satisfy university entrance expectations of academically rigorous study. As a consequence, intensive study of art history, chronologically or thematically,

has been a normal expectation of senior-level visual arts study for over 20 years in most states.

Present Influences

Despite the almost apathetic response of Australian art educators to contemporary thought in the past, current indications are that Australia is poised on the brink of a new intellectual tradition. Since the influential International Society for Education Through Art conference in Adelaide in 1978, a new period of transition has become evident. Through the INSEA conference, Australian art educators were confronted with a powerful new set of ideas equivalent in impact to the Victoria UNESCO seminar of 1954. In the past 10 years, at least 40 Australians have obtained overseas research degrees and subsequently taken up influential positions in the field. A spin-off effect of this overseas connection has been a greatly accelerated series of visits and lecture tours by influential overseas art educators.

Many of the visits of these scholars have occurred in conjunction with the national conferences of the Australian Institute of Art Education. This professional association has grown significantly over the past 12 years since the publication of the first edition of its journal in 1976. The annual national conferences and the journal, published three times each year, have provided an enormous stimulus to professional debate in Australia that has not previously been evident on a national scale.

Despite these encouraging signs, however, the future of Australian art education is beset by a variety of conflicting forces, some of the more powerful being social, technological, economic, and political influences. The DBAE debate has won some space in the literature, although it is uncertain whether the curriculum effects mentioned before are the consequence of that debate or have occurred through independent decision making by regional curriculum developers. The most insidious of current influences are political forces, both federal and state, which are likely to overwhelm the positive impetus provided by other factors. We will examine these now.

Social Change

Four social changes are likely to affect the future of arts education in Australia. The first is a rising level of education within the community. This will occur as a direct result of government policy to improve Australia's international competitiveness in overseas markets. Preoccupation with the global marketplace is the hallmark of governments in all western countries, and Australia is no exception. In comparison with other industrial nations, Australia fares badly in terms of participation rates in tertiary education, a statistic that is popularly viewed with some concern because of the implications for the development of an advanced technological and marketing base for the nation. To improve levels of education within the Australian community, the government has developed strategies to increase the grade 12 retention rate from 53% in 1987 to 65% by the early 1990s (Dawkins, 1988). This represents a substantial gain in fewer than 10 years, given the 1982 grade 12 retention rate of only 35%. In a 1988 government paper outlining the future of tertiary education in Australia, John Dawkins, the Federal Minister for Education, committed government resources to a 10% increase in tertiary education places (Minister for Education Employment, 1988). This meant that an additional 40,000 students were enrolled in Australian universities in 1991. The future impact on the arts of increased levels of education within the population is likely to be an increase in the size of arts audiences. Hillman-Chartrand (1986), in his analysis of the arts in Canada, reported an increase in arts audiences in that country attributable to rising levels of education. Studies conducted around the world and across Canada indicate that fine arts audiences are characterized by high levels of education (cf. McCaughy, 1984). In Canada, "the fine arts audience no longer constitutes a small statistical elite. Rather it represents a significant plurality of the adult population at present, and by the year 2000 it will represent almost half of all taxpayers, taxpayers who are the most socially active, politically aware, and economically powerful members of society" (Hillman-Chartrand, 1986, p. 32).

As has been the case in Canada and the United States, with rapidly rising levels of education in Australia considerable increase in arts participation is likely. A concomitant outcome of such participation is pressure for increased arts education in schools, colleges, and universities, although this effect is not likely to be felt until after the year 2000, when the numbers of more highly educated individuals have made their way through the education system.

A second demographic, effect which is more likely to increase arts participation in the Australian community, is the aging of the population. The older one becomes the more likely it is that one will participate in arts-related activities (McCaughy, 1984). Australia is currently experiencing the same demographic

changes as other western countries as a consequence of the aging of the Baby Boom generation.

A third social change that indicates potential increases in art education is an increasing participation in arts-related occupations by Australian workers. Comparison of the census figures 1976 to 1981 shows that the number of people employed in arts-related occupations increased by 37% while the increase in the total Australian workforce was only 9% (Sumner, 1985). This demand for workers with arts skills and interests is likely to increase pressure for senior school arts curriculum choices with vocational potential. Already, design courses are evident in secondary school curriculum guides in South Australia, New South Wales, and Victoria, while a review of the crafts curriculum in New South Wales primary schools recommends a shift in focus to more contemporary design-related practice (Sullivan & Gibson, 1988).

A fourth social change that has fundamentally altered the fabric of Australian society since World War II is the exceptionally high level of immigrants accepted into the country. Except for Israel, Australia has accepted more immigrants during this century than any other country. Approximately 40% of all Australians are the product of postwar immigration, while 12% of all school-age children were born overseas (Grassby, 1978). The impact of such large groups of culturally different people attempting to reestablish themselves in a new community has been to place enormous pressure on schools to develop programs that will assist in this process. Despite an expressed policy of multiculturalism and government support for such programs, attempts to develop and implement multicultural curricula have not been particularly successful to date (Boughton, 1986). At present, enormous political potential exists for art educators to explore cultural traditions through the arts curricula of schools. Realization of this potential will depend on the strength of professional organizations and the ability of art administrators to interest teachers in reducing emphasis on fine arts studio approaches to teaching. In the visual arts, there is some indication of multicultural interest expressed in the AIAE policy statement, as discussed previously (AIEA, 1986), which could foreshadow a new consciousness in Australian art education.

Technological Changes

Technological development is ubiquitous in the western world, and the factors at work in Australia are little different from elsewhere. Again, four kinds of change are likely to influence the future of art education. The first is change in educational delivery systems of the kind that has been much documented in popular educational literature (Berman, 1987). These include access through computer technology to increased databanks of information and images, rapid retrieval of data, access and delivery of information over large distances, and increased ease of generation and manipulation of images, both still and moving. As schools acquire relatively inexpensive and powerful desktop computing equipment, delivery of the theoretical components of visual arts programs are likely to be altered significantly. Similarly, the addition of computer-generated imagery as a studio focus is likely to broaden the range of images explored by students, particularly in design applications.

A second impact of technological development on Australian society is change in the popular image world of the kind documented by Nadaner (1985) in the North American context. The content of contemporary images found in movies, toys, and particularly video games has become bizarre, aggressive, and intellectually reactionary. Nadaner's concern about the cultural content of these kinds of images, because of their violence, militarism, xenophobia, nihilism, escapism, and antihumanism, is equally appropriate in Australia. Of particular concern is the proliferation of computer video games, which are not subject to appropriate censorship laws in Australia and are easily copied and swapped by school-age children for widespread consumption. Attention by art educators to the burgeoning popular image world is inevitable. Again, response to popular arts by Australian art educators is endorsed by the AIAE policy statement.

A third effect of technological development on art education is change in the nature of studio teaching. Phelan (1984) described the aesthetic turmoil in New York created by new technologies. He predicted that the advent of postmodernism, availability of relatively inexpensive and easily used video cameras and equipment, availability of user-friendly microcomputers with considerable power, and development of alternatives to current gallery structures will fundamentally alter the nature of studio art teaching in the future. As has been the case in the past, it is certain that overseas influences will affect Australian practice in this area.

The fourth effect of technology likely to change the nature of Australian art education is the impact of systems theory derived from the workplace. In the past, application of management strategies has increased the efficiency of mass production in an increasingly tech-

nological workplace. Since the early 1970s, the spin-off effect in education has been evident in various efforts to implement curriculum models derived from behavioral psychology and systems theory.

At present, pressure from the business community on the Australian government to ensure that students graduating from school are adequately equipped to take their place in a skilled and adaptable workforce has resulted in government initiatives to develop a common curriculum framework and assessment procedures for all Australian schools.[3] Such action demonstrates a serious effort to apply a systematic model of education to the country as a whole. In 1991, bids were called by the National Steering Committee to prepare a brief to guide the writers of a national curriculum statement in the arts. The brief will be completed by mid-1992, and the national curriculum guidelines will be written by the end of 1993.

Economic Factors

Perhaps the most powerful force to shape the nature of all education in the immediate future is the economic condition of the country. If one reflects upon the origins of Australian art education, it is possible to experience a sense of deja vu in that the nation's economic struggle is again showing indications of influence on educational practice.

Two of the effects described by Hillman-Chartrand (1986) in the context of the Canadian economy are particularly relevant in Australia. These are the increasing importance of design in the marketplace and the role of advertising. As a consequence of the emergence of "the narrowcast marketplace," (Hillman-Chartrand, 1986, p. 35) the design of goods has assumed critical significance. The narrowcast marketplace as described by Hillman-Chartrand is comprised of small but economically viable markets catering to the tastes of increasing numbers of young, upwardly mobile professionals with high credit ratings and discriminating tastes. Manufacturers are increasingly attempting to develop more styles, models, and sizes in everything from cars to clothes to golf clubs. The pressure on designers to generate distinctively different and better designs is enormous. The demand for good designers continues to grow. More and more marketing companies are employing design consultants due to the realization that if the potential consumer does not like the look of a product he or she may never get close enough to find out how well it works. The highly discriminating nature of the contemporary consumer is highlighted by the willingness of customers to pay high prices for the reputation of goods imported from Europe. This is particularly evident in terms of the car market, where enormous import duties in Australia do not seem to inhibit the import and sales of German-, Swedish-, and Italian-made vehicles. Scitovsky (1976) suggested that this kind of consumer behavior derives benefit (for the North American consumer) from the finicky demands of European shoppers. The North American shopper is, in Scitovsky's view "a free rider, enjoying the benefits of other people's careful shopping without paying his share of the cost, in terms of time and effort, that careful and aggressive shopping involves" (1976, p. 178). The case is the same for the Australian shopper, who is likely to be paying even more for imported goods than the North American consumer.

Coupled with the demand for skilled designers brought about by the fierce competition for consumer dollars is the need to develop highly effective advertising strategies. Advertising lubricates the market economy, so much so that even well-designed products will not sell unless properly marketed.

Both design and advertising are derived from the arts, and particularly from the visual arts. Television advertising employs actors, singers, musicians, dancers, choreographers, copy writers, graphic artists, cartoonists, and editors to sell every kind of consumer item from lawn mowers to champagne to mouthwash.

Recent government educational policy has clearly indicated a concern to respond to the demands of business for school graduates who are adequately prepared with flexible and broad-ranging skills appropriate to the changing nature of Australian industry. While it is clear that a central issue for industry is the production of a discriminating public in terms of design awareness and the development of gifted designers, government policy in Australia has focused largely on science, technology, and business and has not recognized the central role of the arts.

Unless art educators in Australia are able to demonstrate the integral relationship that exists among the visual arts, design, craftsmanship, and engineering, it is certain that misconceived government policy in education will force the arts to the periphery of educational priorities in the future. Ironically, this may occur as a consequence of an unrecognized and unprecedented demand by industry for arts skills in high school graduates.

The DBAE Debate

To date, the DBAE debate has had some impact in Australia. In 1985 Jean Rush outlined the principles of the DBAE proposals at a national conference in Perth. She later published her remarks in the AIAE journal (Rush, 1986). A response to the Rush paper by Emery (1986) was less than enthusiastic, commenting that the priorities and curriculum principles for Australian art education appear to be different from those contained in the DBAE proposals.

It is not likely, in the absence of the stimulus of the alleged Getty millions, that the passions and commitment of Australian art educators will become as excited by the DBAE doctrine as a few of their U.S. counterparts. The DBAE ideas are unlikely to quickly convince Australian secondary art teachers that they are not already teaching in this way. The tradition of art history study, discussed previously, has long been established in Australian schools in all states and is a significant component of senior school publicly examined art curricula in all states. Increasingly, art criticism has been identified as a strategy for art study separate from history, as may be seen in the current South Australia and Western Australia state curriculum guides and support materials. Studio art has been studied in a *disciplined* manner for over 20 years. Few secondary art teachers would debate that the origins of art study derive from history, criticism, aesthetics, and studio, while many would confess difficulty interpreting *aesthetics* in terms of teaching practice. Australian primary (elementary) school art education practice, however, is still largely studio oriented. In the current climate of educational and fiscal constraint, it is not likely that human or material resources will be available to initiate significant or rapid inservice work in the teaching of art criticism, history, or aesthetics in the near future.

The demands on Australian art education at present are likely to force the development of a conception of the discipline of art that is driven by the need for broadly based vocational applications. An indication of this possibility is the model of tertiary education proposed by Brown and McKeon (1986). At the secondary school level, government proposals to initiate national curriculum structures and assessment practices are likely to increase emphasis on the theory components of visual art examinations, given the more conventional strategies for assessment in these areas. In this way, the issues that characterize the DBAE debate may also receive increased attention in Australia.

Political Factors

In March 1987, the Commonwealth Tertiary Education Commission requested a review of design in tertiary education (Davis & Broadbent, 1987). This review was initiated because of the reasons outlined previously, to help Australian industry win market success and to achieve economic growth through overseas acceptance of Australian-designed goods. Two significant recommendations for art education were made in that report: (1) "Education about design in teacher education, and thus in the primary and secondary school system , be substantially improved to create a broader societal awareness of the nature of technological change and design activity" (p.4) and (2) "The Commission encourage and provide necessary resources for the incorporation of design components into courses in teacher education, management, marketing, engineering and technology" (p.6).

Despite the recommendations, two government papers released by the Federal Minister for Education (Dawkins, 1987, 1988) have not recognized the potential contribution of art and design to the education of school children. Instead, emphasis has been placed on mathematics, science, and technology. In the policy discussion paper which is directed toward restructuring the content and focus of schooling (Dawkins, 1988), a common national curriculum framework is proposed to achieve higher levels of literacy, numeracy, and analytical skills across the nation. Priority, however, is given to mathematics and science courses, which are relevant to a technologically oriented society. Significantly, the role of the arts and design is not mentioned in the paper. Similarly, in the higher education discussion paper (Dawkins, 1987), the high-priority areas are identified as engineering, sciences and technology, economics and business studies, and Asian studies. Again the arts are overlooked.

The power of government policy in education in Australia is as formidable as it is myopic. The future of art education is not secure. To demonstrate the benefit of an art education to industry—particularly through design programs in schools—teachers and professional organizations face an enormous task in the years ahead.

The vision demonstrated by Australian governments in the past is not encouraging. In the late 1940s, pioneering work in computing by Australian scientists was discontinued because the government believed that computing had no future. Other pioneering work on transistors, wet-color photocopying, and black-box

flight recording were all discontinued for similar reasons (Horne, 1989). Future growth in the arts in the 1990s in a political climate typified by a tradition of subcolonial conservatism is without doubt the most frustrating uncertainty to confront art educators at present. Present indicators are that ill-conceived, business-driven, short-sighted, unimaginative government educational priorities will serve to stunt the growth of visual arts education in Australia at the moment of its greatest potential.

Summary

At present, Australia is demonstrating the beginning of another transitional phase stimulated by a variety of somewhat contradictory forces. These are social change, technological development, economic factors, political forces, and possible influence from the DBAE debate in the United States. Social changes such as the aging of the population, increased levels of education, and increased participation of workers in arts-related industries indicate an increased pressure for art subjects in school and continuing education courses in the future, although this demand may not be experienced immediately. The increased multicultural composition of Australian society, coupled with an expressed government policy of multiculturalism, is likely to provide unique opportunities for art courses to include significant units of study that examine the relationship of arts and culture.

Technological developments are changing the nature of educational delivery systems, and they will shortly provide enormous potential for students in isolated areas who previously lacked access to visual and written data resources. Technology has also changed the nature of studio instruction in that video and computer technology is increasingly employed in the visual arts. A concern in Australia is the change in the popular image world of young children, with some acknowledgment of the need to broaden the focus of art study from fine arts to popular, design, and primitive and folk arts indicated in the national policy statements of the Australian Institute of Art Education.

Economic changes in the country indicate an escalating demand for arts skills in the workforce, while government policy fails to recognize the significance of visual arts, stressing instead mathematics, science, business, and technology both at the school and college/university level. There is also some evidence of recognition of the substance of the discipline-based art education movement; however, this concern does not mean a slavish acceptance of a new ideology.

Government policy in Australia is opposed to many of the positive indicators of growth evident in visual arts education. A strong tradition unimaginative and ill-informed government policies appears likely to cripple development in the immediate future. Significantly, current policy has failed to recognize the potential contribution of art and design to prevailing economic imperatives in the marketplace and to important social and cultural understanding within the community.

Notes

[1]For a more detailed discussion of the influence of Woodhouse, see Mandelson, L. (1985). From drawing to art in Australian state primary schools. Journal of the Institute of Art Education, 9(1); and Hilson, M. (1987). Walter Smith: An indirect connection with Australia. Journal of the Institute of Art Education, 11(3). See also Woodhouse, F. W. (1891, July 2). Drawing: Its teaching in the public schools. NSW Educational Gazette, 1.

[2]A useful overview of the issues discussed by art educators during this period of Australian history may be gained by reading the articles contained in Smith, B. (Ed.). (1958). Education through art in Australia. Melbourne: Melbourne University Press.

[3]Two of the most significant papers illustrating the push to national curriculum and assessment procedures in Australia are Dawkins (1988) and Young Peoples Participation in Post-compulsory Education and Training (Report of the Australian Education Council Review Committee, Brian Finn, Chairperson, July 1991).

References

AIAE. (1986). *National policy: Visual arts education.* Melbourne: Australian Institute of Art Education.

Barkan, M. (1966). Curriculum problems in art education, In E. Mattil (Editor), *A seminar in art education for research and curriculum development* (pp. 240-258). (USOE Cooperative Research Project No. v-002). University Park: The Pennsylvania State University.

Berman, P. (1987, October). Futures in education: Information sharing and information technology. *Curriculum Development in Australian Schools, 5,* (pp. 7-12).

Boughton, D. (1983). Australian art education for the eighties: From philosophy to practice. *Journal of the Institute of Art Education, 7*(2), (pp. 1-18).

Boughton, D. (1986). How do we prepare art teachers for a multicultural society? *Journal of Multi-cultur-*

al and Cross-cultural Research in Art Education, 4(1), (pp. 94-99).

Broomhall, E. (1988). Tasmanian state report. *Australian Institute of Art Education Newsletter, 2,(7)*.

Brown, N., & McEwon (sic) P. (1986). An example of a discipline based model of tertiary education. *Journal of the Institute of Art Education, 10,(3)*, (pp. 35-47).

Chapman, L. H. (1978). *Approaches to art in education.* New York: Harcourt, Brace, Jovanovich.

Dabron, J. (1958). Art education and the child. In B. Smith (Ed.), *Education through art in Australia.* Melbourne: Melbourne University Press.

Davis, B., & Broadbent, J. (1987). *The responsiveness of tertiary education to the design needs of Australian industry.* Canberra: Australian Government Publishing Service.

Dawkins, J. (1988). *Strengthening Australia's schools: A consideration of the focus and content of schooling.* (Government green paper). Canberra: Australian Government Publishing Service.

Dimmack, M. (1958). *Modern art education in the primary school.* Melbourne: Macmillan.

Education Department of South Australia. (1984). *Art craft and design in schools K—12.* Adelaide: Australian Government Printer.

Emery, L. (1986). A response to Jean Rush on DBAE. *Journal of the Institute of Art Education, 10(2)*.

Emery, J. (1988). Art education in the 1980s. *Broadsheet: A Journal of Contemporary Art, 17(3)*.

Grassby, A. (1978). Australia's cultural revolution: The effect of a multicultural society on the arts. In J. Condous, J. Howlett, & J. Skull, (Eds.), *Arts in cultural diversity.* Sydney: Holt Rinehart and Winston.

Greer, W. D. (1984). A discipline based view of art education. *Studies in Art Education, 25(4)*.

Hammond, G. (1981). Art education ideologies: Current emphases in Australia. *Journal of the Institute of Art Education, 5(3)*.

Harris, M. (1923, July 14). Art and the child. *South Australian Education Gazette.*

Hillman-Chartrand, H. (1986).The arts: Consumption skills in the postmodern economy. *Journal of Multicultural and Cross-cultural Research in Art Education, 4(1)*.

Horne, D. (1989, March 11—12). Address to the Australian Labor Party caucus. *The Australian.*

Knudson, R. (1988). Sketching a background to the new visual arts syllabuses. *Art in Education, 13*.

Mandelson, L. (1985). From drawing to art in Australian state primary schools. *Journal of the Institute of Art Education, 9(1)*.

McCaughy, C. (1984). *Survey of arts audience studies: A Canadian perspective 1967 to 1984.* Research and Evaluation, Canada Council.

Minister for Education Employment and Training. (1988, August 23). *Dawkins plan for historic expansion of Australian higher education.* 161/88 Media release. Canberra: Office of the Minister for Education.

Oeser, O. (1958). The importance of not teaching how to paint. In B. Smith (Ed.), *Education through art in Australia.* Melbourne: Melbourne University Press.

Nadaner, D. (1985). Responding to the image world: A proposal for art curricula. *Art Education, 37(1)*.

Phelan, A. (1984). The impact of technology and postmodern art on studio education. *Art Education, 37(2)*.

Rush, J. (1986). Discipline based art education: Pragmatic priorities for realistic research. *Journal of the Institute of Art Education, 10(1)*.

Scitovsky, T. (1976). *The joyless economy.* London: Oxford.

Smith, B. (1958). *Education through art in Australia.* Melbourne: Melbourne University Press.

Sullivan, G. (1987). Theory analysis: Towards curriculum consistency. *Journal of the Institute of Art Education, 11(1)*, 2.

Sullivan, G., & Gibson, E. (1988). Primarily design. *Art in Education, 13*.

Sumner, C. (1985, April 2). Minister for the Arts. Response to a question by Hon. Anne Levy, reported in the *Hansard Minutes, South Australia Legislative Council.*

Young, M. (1986). *A history of art and design education in South Australia 1836—1887.* Unpublished master's thesis, Flinders University, Adelaide, South Australia.

THE HISTORY OF ART EDUCATION IN CHILE

■ LUIS ERRAZURIZ

This chapter summarizes some of the main findings of a research study of the history of art education in Chile that I carried out from 1983 through 1988, both as a researcher for the Aesthetic Institute of the Catholic University of Chile, and as a post graduate student in the Art Department, University of London, Institute of Education.

Art has been taught in one form or another in the Chilean schools for more than a century. Drawing, painting, modeling, sometimes art history, and other artistic activities have been a part of compulsory or optional subjects in the curriculum of both primary and secondary schools. Thus, generations of children have had access to art education, usually 1 or 2 hours a week.

Although art teaching in Chile has a long history—almost as long as the history of the school system itself—there has been little research specifically concerned with this area of the curriculum. Therefore, some of the fundamental questions considered in the study discussed here are as follows: Why was art introduced in the school curriculum? What have been the aims of the subject during different periods? What kinds of changes has the art curriculum undergone throughout its history?

To find answers to these questions, tt was necessary to survey official documents, syllabuses, legislation, and literature closely related to art education. The art syllabuses published by the Ministry of Education to govern art teaching, dating from 1860 until 1984, were compiled (Errazuriz, 1986a). Parallel with this, a search was conducted to find literature regarding a broad range of subjects related to art education since 1860, when art was officially introduced as a compulsory subject in primary education. The more than 300 articles found covered drawing, painting, modeling, architecture, crafts, film, and art history (Errazuriz, 1986b). Finally, the government's documentation of curriculum plans and papers that have influenced the teaching of art in Chilean schools were examined. This

study was based principally on the official syllabuses published by the Ministry of Education.

The Chilean educational system has always been centralized and controlled by the Ministry of Education. According to Cristian Cox (1984), referring to the historical centralist tendency of the Chilean Educational System, "By the turn of the century 20th century, Chile had a centralist and bureaucratically organized educational system with an increasingly professionalized teaching corps in both its primary and secondary levels. Formally the two levels transmitted a common curriculum throughout the country, a dimension of unity rooted in the centralist nature of the system" (p. 52). Thus, the influence of official programs is strong.

The Beginning of Art Education in Chile

Art as a subject in the schools was officially established in 1860 through the Law of Primary Instruction ("Schneider," 1860). For the first time in the history of Chilean education, art achieved compulsory status in the school curriculum. Boys were taught line drawing, while girls were taught home economics, embroidery, and needlework.

Before 1860, boys had been taught drawing in some senior school classes. As early as 1797, this subject was taught in the Academy of San Luis, one of the first Chilean schools. In 1813, the teaching of drawing was part of the curriculum of the National Institute, one of the main educational centers in Chile. However, the introduction of art into the school curriculum did not become systematic until 1860. A principal aim, one that determined the inclusion of art in the secondary schools, was to provide skill training for boys to aid in the expansion of crafts and industrial development in Chile.

Drawing as a Useful Skill

The first art syllabus for secondary education was published in 1893. In this program, the aim of art educa-

tion was mainly to cultivate knowledge of such subjects as mathematics, geography, and natural science. This viewpoint is clearly described in the syllabus of 1893:

We understand that Drawing cannot be considered as a subject in itself, because it is exclusively a procedure which should be put into practice in those areas where it is needed. For example, in writing, geometry, geography, and natural history, the rules that are given to the students for drawing classes, should be in harmony with those of geography and mathematics, so that students can make geometrical construction in mathematics, and draw maps in geography (Schneider, 1893).

In 1901, the first syllabus for primary education was published. It was translated from a Belgian program and adapted for schools in Chile. The main aim of this syllabus was to teach children line drawing, and it focused on basic notions of geometry and its decorative application. The European influence in Chilean art education did not come only from Belgium. Educational ideas from Germany and France also were influential, particularly during the 19th century and the beginning of the 20th century. The concepts of art education were chiefly introduced through the literature and visual material collected by teachers who visited Europe.

Drawing Seen in Broad Perspective

A new orientation for art education began with the primary education syllabus of 1910. Although the main emphasis was still on teaching geometric and line drawing, a more creative and free style of teaching was introduced that admitted the drawing of natural objects such as animals, flowers, or fruits and intuitive drawings based on the illustration of poetry and short stories. A significant change in relation to the function of art in the curriculum occurred in the secondary school syllabus for 1912. According to the guidelines of this document, "Nowadays the teaching of drawing is considered to be an essential part of children's education. That is why the Public Council for Instruction believe that drawing has to be part of the general program. For this reason, boys should learn to draw, not just because drawing should he regarded as a useful activity, but because it influences the student's intellectual development" (Errazuriz, 1986a, p. 64). The syllabus gave a broader view of the aims of drawing. At this time, the subject of art began to expand considerably from copy drawing toward more sophisticated goals of refining

the senses, the abilities of the hands, and the capacity for visual perception.

An important contribution the syllabus made was to introduce art history and promote a different approach with regard to the role of the teacher. Art history was introduced as a component in drawing classes to illustrate the masterworks of great artists and give basic notions about the features of the Middle Ages and the Renaissance in Europe. The main change in the role of the teacher was to encourage a more supportive stance toward the children. This can be understood clearly in the following instructions taken from the syllabus: ". . . the teacher should not give advice of any kind, or criticize children's work, unless serious mistakes have to be corrected. The teacher should take into account the student's feelings, for example, the impression that children have when copying from a model, also the way in which pupils use color to emphasize the features of the model" (Errazuriz, 1986a, p. 65).

Eighteen years after the primary school syllabus of 1910 was printed, a new program for primary education was published in 1928. It included a basis for teaching several art activities (e.g., modeling, paper cutting, drawing with colored chalk, and playing with sand) through which children could cultivate their visual abilities and at the same time enjoy the experience of art. The most significant change introduced by this syllabus was to integrate modeling as part of the artistic activities of children. This included not only works with clay, but also construction of geometrical forms using paper and cardboard. On the other hand, it seems that the teaching of modeling started as drawing did (i.e., mainly as just copying), and to a certain extent its purpose was useful in geometry lessons. Gradually, the absolute domination of drawing as the essential factor in the syllabuses began to decline. Through the inclusion of other activities, more opportunities were offered to explore new materials and other ways of artistic expression, and a wider concept of art in the curriculum began to take shape.

Drawing as a Means of Expression

Drawing as a way for pupils to express themselves was reinforced by the primary education syllabus of 1931. The first paragraph of this program states that "Drawing and Craft, through their different forms provide spontaneous ways of expression, and they should be considered as separate subjects" (Errazuriz, 1986a, p. 25). The syllabus emphasized the study of Chilean background and heritage, the content of which was to be developed in drawing classes. This tendency to rec-

ognize the cultural tradition was introduced for the first time to secondary education in the syllabus of 1929. The teaching of composition was to promote a creative spirit in the nation and the development of art appreciation with a nationalist emphasis. Children should gain basic knowledge about color, line, shape, harmony, contrast, and balance. The cultural heritage, along with the military tradition and primitive symbols, became a part of instruction.

Another significant change came with the 1933 syllabus for secondary schools. This change was clearly reflected in the title, "Program of Drawing and History of Art," which included painting, sculpture, and architecture. Although drawing was still considered the principal area of the program, the teaching of art history became more important. Consequently, a careful plan for its development was designed, including a chronological approach to the evolution of art from the prehistoric age until the beginning of the 20th century. This new emphasis on teaching the history of art was introduced in order to develop children's capacity for aesthetic appreciation in such a way that they "could understand beauty, feel for the works of art created by men and express their feelings and emotions about the world around them" (Errazuriz, 1986a, p. 81). In this syllabus, for the first time in the history of Chilean art education, concrete suggestions were included to make architectural projects in the last course of secondary school a part of technical drawing. These projects included the design of houses, squares, and gardens.

From Drawing to Fine Arts

One of the most significant changes in the history of Chilean art education became apparent with the primary education syllabus of 1949. For the first time, this subject, known previously as drawing, emerged as fine arts, a name that is still in use. The relevance of this change was more than merely formal. The intention was to promote the teaching of the arts in their diverse ways of expression, including painting, sculpture, drawing, drama, music, dance, and art appreciation. It was through the introduction of this syllabus that the understanding of drawing as one aspect of the teaching of art was achieved. Perhaps the most notable innovation in this syllabus was an explicit statement regarding the stimulation of the "creation of beauty, with or without a useful purpose" (Errazuriz, 1986a, p. 29).

Introduction of Creativity in the Art Curriculum

The 1949 syllabus not only referred to the development of children's capacity for expression and appreciation of art, but also laid the foundation for the development of creativity as a key aim in Chilean art education. This aim was brought about through North American influence. Ideas about creativity were made known in Chile mainly through the U. S. literature and particularly by Viktor Lowenfeld's (1947) book *Creative and Mental Growth*. On the other hand, Herbert Read's (1943) ideas about art education began to be known in Chile by the 1950s with the publication of his book *Education Through Art*. Although it would be difficult to illustrate Read's impact on Chilean art education clearly, he and Lowenfeld are considered to be the major foreign influences affecting the theory and practice of art education in Chile during recent decades.

The new secondary education syllabus of 1963, called Fine Arts, reiterated the need to develop adolescents' creative and perceptive faculties through diverse means of artistic expression such as painting, sculpture, architecture, and drawing. The most important change in this syllabus was the introduction of design, which was suggested for practice in prints, murals, and illustrations to be used in other subjects.

The Role of Design in Secondary Schools

Between 1967 and 1970, new study plans were elaborated in which art became optional for the last two courses of secondary education. Since 1893, the subject had been considered as compulsory. Under this new syllabus, the consolidation of design as a key component of the art curriculum was carried out in order to aid the industrial development of the country. According to the 1969 syllabus, "Nowadays the introduction of design in the subject of Fine Art is more necessary than ever, since all the activities of national development, like industrial crafts as well as other dimensions of more significant cultural transcendence, are orientated towards the search for national and original individuality, able to reflect our own idiosyncracy..." (Errazuriz, 1986a, p. 116).

From 1967 through 1970, the aims of art education were to serve the economic needs of the country, to develop the creative potential of adolescents, and to provide them with basic knowledge of planning and architecture.

Fine Arts as an Optional Subject

The 1980 syllabus for primary education, in force at the moment, refers mainly to the teaching of drawing and painting, emphasizing the development of the capacity to observe, draw, and copy from natural models. Less importance is given to the teaching of art history. The major emphasis is on nature drawing, so much so that its approach echoes the syllabuses of 1910 and 1912. Drawing from nature is very important in the syllabus for primary education now, as it was at the beginning of this century. With the new educational legislation of 1980, the subject of fine arts remained optional for the last two courses of primary education. This resolution ended the compulsory status of art as a subject in the curriculum that had been in effect since 1860. The 1980 legislation further worsened the position of art in secondary schools when it made the study of art optional along with music and crafts. Art education virtually disappeared, due to the fact that nowadays fine arts is considered to be part of an elective plan that combines many different areas from which each school must develop a strategy "to choose those activities which are more in accordance, on the one hand, with students and parents' interests and, on the other, with the needs of each region of the country" ("Plans and syllabuses," 1982, p. 6).

The 1982 syllabus for secondary education, in force at the moment, is very similar to the 1967—1970 programs. According to this syllabus, the subject of fine arts is designed to create conditions enabling students to "express themselves creatively through artistic experiences. Appreciate aesthetic values, both in the national and universal heritage. Develop artistic abilities which can be applied during school as well as in leisure time" (Errazuriz, 1986a, p. 143). This syllabus focuses on the development of children's vocational interest in such a way that students who choose fine arts in the curriculum may facilitate their entry to a future job or to higher education. Because of this, the program has been conceived through the development of several workshops, among which are Town Planning, Chilean Painting, Native Ceramics, Visual Communication, and Advertising.

Summary

Art was systematically introduced into the school curriculum of Chile in 1860 under the name of line drawing. Its teaching focused mainly on the practice of copying as a rigorous process of imitation of geometrical forms. The predominant purpose was practical and utilitarian, to prepare human resources capable of sup-

porting the economic development of the nation through industrial expansion. Another aim was to contribute to other subjects such as mathematics, geography, and calligraphy. These early aims have been present throughout the history of Chilean art education.

At the beginning of the 20th century, a broader view of art education was adopted. Natural and intuitive drawing were formally introduced. The teaching of art history became part of the syllabus for secondary schools for the first time in 1912. This was the first attempt to integrate art appreciation into a subject in which drawing had been the main focus. On the other hand, the teaching of modeling was introduced in the program for primary education in 1928, which offered opportunities to explore new materials and new ways of artistic expression. Beginning in 1931, drawing was understood as a way to develop children' s capacity to give expression to their feelings, emotions, and ideas, rather than to develop of their technical abilities. In the 1950s, the purpose of developing the creative capacity of children was spelled out in the syllabuses for primary and secondary education. This aim has achieved importance progressively until the present day, when it is considered to be the main function of art. On the other hand, during the 1960s, the teaching of design arose as one of the main objectives of art education. This trend still prevails, with the intent of supporting the industrial development of the country.

In 1967, fine arts became optional for the last two courses of secondary education, with the result that its long history as a compulsory subject was ended. In addition, new legislation in 1980 made fine arts optional for the last two courses of primary education, ending its compulsory position for the first time since 1860. The consequences of this legislation became worse in secondary schools, where at present fine arts is an elective subject and students must choose two subjects among music, crafts and fine arts.

While the aims of the subject were enhanced throughout this century by progressively introducing such purposes as increasing the capacity for visual perception (1912), refining the senses and providing spontaneous ways of expression (1931), and stimulating the creation of beauty with or without a useful purpose (1949), the art curriculum was also enriched by incorporating other areas such as modeling, painting, architecture, art history, and design.

Historically, the aims of Chilean art education have been mainly utilitarian. In other words, there has been a limited recognition of the intrinsic value of art in the

curriculum. Often, the statement of aims has been presented in a rather superficial way, without sufficient explanation of their scope and meaning in the school curriculum.

References

Cox, C. (1984). Continuity, conflict and change in state education in Chile. Doctoral dissertation, Institute of Education, University of London.

Errazuriz, L. (1986a). Syllabuses of art education in Chile 1893—1984. [Research DIUC 100/83]. Catholic University of Chile, Santiago, Chile.

Errazuriz, L. (1986b). One hundred years of art education in Chile. Catholic University of Chile, Santiago, Chile.

Lowenfeld, V. (1947). *Creative and Mental Growth.* New York: The Macmillan Company.

Read, H. (1943). *Education through Art.* London: Faber and Faber.

Plans and syllabuses of study for secondary education. (1982, March). Journal of Education, 94, p. 6.

Schneider, J. E. (Laws, Published in Chile. 1860). Primary instruction. General law of the subject. 1860, Nov.)

Schneider, J. E. (1893). Syllabus of drawing. Syllabuses of secondary instruction. Santiago, Chile: Cervantez.

ART EDUCATION IN EASTERN EUROPE FROM 1945 TO 1991

■ BOGOMIL KARLAVARIS

In order to understand the genesis of development and change in the theory and practice of art education in Eastern Europe, it is important to understand two phenomena. The first is the ideological basis of culture and education, including art education. The second phenomenon is the political development.

Ideological Basis

In the so-called socialist countries of Eastern Europe, the function of culture was considered to be the means of an ideological struggle. Art was given the role of influencing the conscience of people and their motivation for building and defending socialism as a system for a better life. Art could fulfill this function if it used realistic expression and showed reality in an optimistic manner which, in practice, meant glorification of achieved results in society.[1] By showing society as successful, art glorified the ruling structure and its politics. The political logic assumed that successful rule enables the blossoming of qualitative art. This same logic was applied to other aspects of life, especially sports. In short, art had to be realistic, optimistic, educational, and representative of the new revolutionary society. This ideological basis of art demanded a corresponding concept of art education that would reflect the concepts of culture and education. The model of success was the Soviet Union, the first socialist country.

Political Basis

The second important factor in understanding the development of culture and art education in Eastern European countries is the oscillations in repression by the ruling structure in relation to culture. These took place because of changes in the political and military relations of the Eastern and Western blocs. Periods of dogmatic exclusivism in times of confrontation alternated with periods of liberalization in times of easing of international tensions. After World War II (1945), a period of coexistence began between the two social systems, which was periodically accompanied by increased insecurities due to the possibilities of conflict. In the period of liberalization in 1948, Yugoslavia refused the role of being a subordinate to the Soviet Union and followed its own way of democracy, decentralization, and self-management. However, in general, the ideological dogmatism and repression in Eastern European countries increased and was reflected in culture, including art education. The repression lasted until Stalin's death in 1953. Thereafter followed a process of liberalization that enabled a flow of ideas in the time of Khrushchev, partial political independence in some countries, and an attempt to achieve total independence as manifested in conflicts in Hungary and the north of Poland in 1955. After that year, a new period of repression and ideological dogmatism began, followed by a period of liberalization beginning in 1959. Establishment of the Nonaligned Movement along with the antagonism between China and the Soviet Union represented a new concept of the theory of co-existence of two different systems. However, the conflict between the two military blocs increased with the blockade of Cuba in 1961 and the Vietnam War. Authoritarian forms of power in both blocs resulted in resistance by several social groups in Western countries, especially by the young. In the countries in Eastern Europe this turned into national resistance toward the Soviet Union. Its best example is the aspiration of Czechoslovakia toward independence. With the intervention of the Warsaw Pact in Czechoslovakia, a new period of repression and ideological one-sidedness in culture and education began.

However, a gradual liberalization was inevitable, and with the European meeting in Helsinki in 1979, a new period of appeasement began, only to be disturbed by the Afghanistan crisis that same year. After Soviet President Breznyev's term, President Andropov continued with the politics of appeasement. President Gorbachev met U. S. President Reagan in 1985, and the process of liberalization went on until the new

Note: In addition to the notes, this chapter is based on several books in Croatian by Bogomil Karlavaris as well as writings by art educators and scholars from the East European countries written in their native languages.

democratic and economic reforms brought more liberty in artistic creativity. The Berlin Wall, the symbol of divided Europe, fell in 1990.

Unfortunately, retrograde manifestations of nationalism in the countries of the Eastern Europe have built new psychological "Berlin Walls," representing negative echoes of the old rule. These are new forms of tension and confrontation that lead to repression in culture. The case of Yugoslavia is illustrative. What happened there can be partly explained by the ideological influence of extreme nationalist groups, which, by coming to power, controlled entire social and informative structure in their states, thereby negating the democratic advances of the former Yugoslavia as well as Western European tendencies for integration. In this way, the critical differences caused by conflicts of interest of the big blocs were transferred to conflicts of minor groups without any rational motives.

On the basis of this analysis, we can conclude that the development of art education in the Eastern European countries was influenced partly by dogmatic ideology in the Soviet Union. This influence was not always firm and consistent so dogmatic periods were followed by liberal periods, and confined and authoritarian periods of education were followed by periods of openness to new ideas. With this lack of stability, the development of theory suffered, but there was progress in the practice of art education, especially in those periods when creative energy could be released. This means that the Eastern European countries made their valuable contributions to the development of art education.

The Postwar Development

The postwar development of art education in Eastern Europe was heavily influenced by the former cultural and pedagogical experiences of the Soviet Union, founded first of all on the ideological concept of fine arts known as socialist realism: the realistic expression and optimistic presentation of themes from everyday life and glorification of the ruling structures. This concept however, was not equally accepted in those countries which already had established traditions in art education and research.[2] The so-called realistic concept was in opposition to the scientifically founded results of research on the development of childrens' artistic expression. Thus, art education in some countries still fostered spontaneous expression, especially in the primary school grades.

From this compromise of educational themes taken from everyday life and spontaneous artistic expression grew a new pedagogical concept—the first spontaneous opposition to dogmatic ideological restrictions. This fostering of a free and spontaneous childrens' artistic expression acted as the starting point for later development of art education by recognizing the progression of artistic talent, individuality, forming of character, and acceptance of the theory of creativity. Over time, a concept was formed that an aesthetic work is specific and has internal laws.[3] This shift from the narrow ideological concept was particularly encouraged in periods of liberalization. Another orientation, a tendency to rely on the theory of shape as a neutral but objective science, also emerged. This orientation introduced pupils to a discovery of artistic structure, which was especially tolerated in East Germany, a country that was still under the influence of the Bauhaus—[4] and in some areas in Hungary as well.[5] In this way, the autonomy of art expression built on the realistic approach.

The third orientation in art education was based partly on the tradition of art education in most countries and partly on the ideological belief that the form of expression is national but the content socialistic.[6] In art education, national tradition was fostered through working on ornaments, textiles, sketches, and handicrafts in the spirit of national heritage. In the early 1960s, special attention was paid to aesthetic evaluation of works of art, but in the spirit of socialistic realism.

The fourth orientation, a concept of integration of aesthetic field, was developed in music, particularly in Hungary.[7] The most significant aspect of this orientation is, perhaps, the theoretical and practical education of personality which means developing the child's capabilities and accepting individuality. In the mid-1960s, there were organized conferences and research on this theme, sometimes in combination with the theory of form in art education.[8] The ideological side of this concept comes from the need to form conscientious citizens who are resistant to the negative influences of bourgeois society.

However, in spite of enormous efforts and numerous conferences, research programs, and written works, the practice of art education remained on the level of spontaneous artistic expressions.[9] This was the case, especially in East Germany toward the end of the totalitarian period, when there was a pedagogical demand for the development of character and strong will as a safe barrier against the negative influences of

bourgeois ideology. This theory was also applied to art education. Many tendencies in art education in Western European countries and the rest of the world remained outside the realm of interest of the Eastern European countries. This applied to psychological components of art education, individualization in teaching, development of creativity, interaction of the cognitive and creative processes, visual perception, and tendencies in modern art. It also applied to tendencies that were initiated by left-wing-orientated specialists in the art pedagogy of Western Europe, such as visual communication, emancipation of the personality, development of criticism and tolerance, aesthetics of everyday life, and protection of the natural and cultural environment as well as in such specific fields as multicultural processes, art therapy, museum appreciation,[10] architecture and building, design, and interior design. As a matter of fact, only in the thinking and good teaching practices of Yugoslavia has there been activity in the above mentioned fields of art education.

On the whole, art pedagogy in Eastern Europe has remained within the confines of selected educational motives with spontaneous treatment of art problems, that is, a choice of themes that allow practitioners to solve art problems oriented toward the theory of form and attempts toward the forming of personality.[11] Talented pupils were channeled into artistic vocations. Differences occurred in some countries depending on their traditions and their opportunities for insight into different conceptions in the West.

Characteristics in Eastern European Art Education: Yugoslavia, Poland, Czechoslovakia, East Germany, Hungary, Bulgaria and Soviet Union

Examining the historical development of art education in the countries of Eastern Europe discloses a vast difference in concept and results. Yugoslavia, somewhat liberated from dogmatic theory,[12] initially sought more modern ways in art education, partly relying on the experience of Western Europe,[13] and thus paved the way for new areas of research in art education. This can be seen quite clearly from the change of aims in general education,[14] and particularly in art education. The first basic reforms of the educational system in Yugoslavia began in 1955 and ended in 1958. Reform in art education was based on the conclusions of the 18th UNESCO Conference on Education, which was held in 1955 in Geneva and dedicated to art education.[15] High-quality national and international childrens' art exhibitions were held in Zagreb beginning in 1953, in Novi Sad beginning in 1954, and later in

Sarajevo, Skopje, Bitola, and other towns. Other conferences, as well as congresses of INSEA (Zagreb in 1972; Novi Sad in 1969 and 1974), participation in international exhibitions and conferences, more intensive work on scientific research in art education, illustrations in textbooks and picture books, development of childrens' art expression, development of creativity, emancipation of the personality,[16] and occasional reforms of the curriculum advanced art education. In the mid-1980s, some retrograde tendencies appeared in the curriculum. The theory of form emerged from the Bauhaus experience, again dominating the art curriculum, which can be interpreted as a part of the de-ideologization of the teaching of art but meant conceptual stagnation in development.[17] While the practice of teaching progressed, the system of educating art teachers as well as educating top art education experts and researchers, stagnated.[18]

By the mid-1950s, Poland and Czechoslovakia were partly successful in freeing themselves from the influence of socialistic realism as a doctrine in the fine arts.[19] In Czechoslovakia, fine arts teaching opened the way to the recognition of free artistic expression. A large part of the credit for this must go to the special system in operation at more than 600 National Colleges of Arts, where top artists worked. The system covered enrollment of students from the ages of 5 to 25 years and fostered all aspects of creation[20] as well as possibilities for experimentation. The colleges produced perfect examples of creative works of art, which had a positive influence on art education in the schools. There were important meetings of art education experts, children's exhibitions,[21] and a wealth of official literature. In Poland, the Detska Gallery and the studio in Torunu were international meeting places and exhibition centers where research on a modern approach to art was carried out. Czechoslovakia published a yearly bibliographic text of art and musical education.[22] The number of research personnel grew in both Czechoslovakia and Poland.[23]

In East Germany, the Academy of Pedagogical Science influenced the science and theory of art education and the government began ensuring that art education was represented in international exhibitions. In the country itself, there were two traditional international art exhibitions, the Baltic countries—Osteewoche in Rostock and the countries connected by Soviet Union pipeline in Frankfurt on Odra. Teacher education was very good and pedagogically oriented. In an era of greater liberalization, a number of official international seminars were held, for example in Greifswald, Leipzig, and Berlin.[24] Official literature, including

books and journals, was available. The greatest results were achieved in the theory of form and development of the science of art.[25] Other research concentrated on didactic problems rather than on the fundamental problems of art education on which, to a large extent, an alteration of concept and orientation of the subject depends.[26] This is understandable, since the party and government agencies were responsible for fulfilling a global orientation and were not able to criticize or bring into question those policies. Experts assembled at the universities and institutions as well as at the Academy of Pedagogical Science in Berlin.[27]

Hungary and Bulgaria began with international exhibitions and manifestations,[28] with such organized official meetings as the INSEA Congresses in 1973 in Budapest and in 1984 in Sofia, and with cooperation from experts from Western Europe.[29] Both countries sent children's artwork to international exhibitions and their own representatives to international meetings. Hungary has a useful specialty of supplying its schools with standard teaching devices made in accordance with unique criteria for all schools.[30] Official journals and professional literature are available.[31] Rumania enjoyed a period of relative openness when Rumanian art education experts started cooperating with Yugoslavian art education experts. However, toward the end of the 1970s, the country became totally isolated from other countries and became stagnant in the field of art education.

The Soviet Union systematically kept track of developments in art teaching. Art education was best advanced within a small circle of experts in the central and some republican academies for pedagogical science, and partly within the society of artists. Contact with the rest of the world was extremely limited, and it was mainly established at the international exhibitions of children's art, especially through the exhibition "I see the world" (Ja Vizu Mir), held in Moscow from time to time. Efforts to reform the school system, including art education, at the end of the 1970s brought to the fore a divergence of opinion. This was made possible by greater liberalization. Official polemics began between supporters of freer expression in child art such as Boris Nemenski of the Artists Association and cautious reformers of a more realistic concept such as Boris Yusov and others at the Academy of Pedagogical Sciences. In the official literature, there were interesting magazines available for young artists, for example *Juny Hudoznik (Young Artist)*. A cooperative project was set up with Yugoslavia, especially in publishing.[32] The process of modernization, despite all resistance, gained speed.

Some distinct centers achieved significant results in art, for example the national schools of art, art centers in Leningrad and Gruzia and the Baltic countries, and a children's art gallery established by Kuhianidze Avkgandil Vahtangovic in Tbilisi. There was not, however, much outstanding research in the field of art education.[33]

Initiatives for Innovation and Reform

The general characteristics of educational policy in the centralized social systems of Eastern Europe included rigidly defined regulations, detailed and compulsory programs, obligatory directives that created mistrust between teachers, and concern for ideological consistency. The system led to authoritarian schools because the teachers were forced to employ the given tasks and subject matter in an orthodox manner. The restrictions hampered not only research but also the creative work of teachers. However, some individual teachers were supporters of innovation and established a silent resistance to the rigid concepts. The initiative for innovation was mostly taken by individual teachers or institutions who worked outside the immediate influence of the state. For the present, we cannot speak of clear changes of concept in art, but we can note genuine new tendencies.

The ideas of modernization of art education gathered momentum after 1985, under Gorbachev's initiative of democratization of society and the move toward a market economy. However, the first steps in democratization were initiated by the leaders of the Communist Party and that process was led by members of the Party. As a result, it was not possible to change the mentality behind cultural and educational policy, the more so because the newly elected government came to a large extent from the same governing social structure.

In East Germany, the Academy of Pedagogical Science itself set in motion the question of including innovation in the curriculum and expanding the subject matter, while a start-up group, whose aim was to establish a society of art teachers following the collapse of the Berlin Wall, started proceedings to de-ideologize the curriculum and establish a concept of art education similar to that of West Germany.[34]

The existing hierarchy of professionals has hindered the introduction of significant innovation in art education. However, the desire to become acquainted with the Western European and other experiences is manifest. Many international meetings have been held

to discuss the current situation in art education.[35] State agencies mainly carry out de-ideologization of the curriculum and express the wish to draw nearer to the Western European school system, but the new concepts are still quite open to discussion. They are still unclear to the new government, which can be seen, for example, in Croatia. With the aim of changing the program and even the educational system itself, some minimal changes were made in that country. A competition was drawn up for experts and the general public alike regarding these important social questions, with an expressed desire that alongside the proposals put forward models would be furnished similar to those in the neighboring countries of Italy, Austria, and West Germany.

The Creation of A New Concept of Art Education

The creation of a new concept of art education will require more work and research, which, in a short period of time, is neither possible nor useful. It would not be useful either to borrow a concept or model from another Western European country. The basic orientation will be (a) aspiring to the de-ideologization of the curriculum in art, (b) expansion of the curriculum, (c) maximum respect for individuality, (d) respect for the position of art in the school system, which has until now been underestimated (only 1 hour weekly is now set aside for art), and (e) rejection of all that hinders the initiative of the teacher and the progress of each pupil. Such aims cannot be achieved by adhering to the old methods of the totalitarian system or by emphasizing a new national ideology. The time has not yet come when a modern and flexible model for art education can be built based on the uniqueness of each country and a new approach to art. This is the task of the art education experts in the Eastern European countries, who must start with the positive results already achieved and develop the quality of the subject, which in turn would develop the qualities of each pupil.

Notes

[1] In the postwar period, the leading theories were Pavlov's theory of reflection (Sofia, 1937) and G. Lukacs's theory. Some new eclectic aesthetic theories were formed, among which Mojsej Kagan's had relevant influence (The Morphology of Art, 1972; lecture on Marxist-Leninist aesthetics, Berlin, 1974).

[2] The prewar scientific experiences in art education were partially preserved in Czechoslovakia, East Germany, Poland, and Yugoslavia.

[3] G. Lukacs. *Die Eigenart des Aesthetischen*, 1 and 2, Budapest, 1965 (Berlin, 1981).

[4] The theory of design was especially tended on the Institute for Art Education in Greifswald and in Berlin, owing to the followers of the Bauhaus school (H. Wegehaupt, W. Frankenstein, and G. Regel).

[5] At the Academy of Fine Arts in Budapest, Balogh Jenoe; at the University of Pecs, Denes Horvath.

[6] This was one of Stalin's favorite theses, which pointed out the connection between nationalistic and socialist tendencies (*The principles of Marxism-Leninism*, Moscow, several editions).

[7] The initiative was started by Bela Bartok, and it was soon adopted by kindergartens. Even today it is a theme of the Hungarian art education program, although it was never entirely materialized in primary schools.

[8] Proceedings from the congress in Greiswald, April 21—24, 1965, East Germany, at the time of liberalization and followed by a great number of foreign experts. The book had an interesting destiny. It represented high professional quality, with many color reproductions, and was printed in 1968. Then the changes in Czechoslovakia occurred, and the ideology became more rigid. The editor of the book, who was the organizer of the congress, Günther Regel, was removed from office and punished. The book was kept in the printing plant and destroyed. Only 10 copies were saved, of which this author owns one. A similar case occurred in Czechoslovakia. Professors of art at the high school level and teachers of art, as well as all other experts in the field who were not loyal to socialism and the Soviet Union, were removed from the schools. Among them was Jaroslaw Brozek, who was preparing a book *Kak Namalovat Krajinu* (How to Paint a Landscape). The book was published in 1978, but under the name of a friend, Jozef Hron. This fact was well known among art experts.

[9] Art education in Eastern Europe was formed on creative processes or on design theory, but the system was mostly regulated according to the themes and contents that educated young people. Special care was given to textbooks and teachers' handbooks. A book was printed even for aesthetic education in nursery school. (E. Schmidt-Kolmer, Ed., 1983, *Bewegungs Erziehung—Bildnerische Erziehung, Muzik Erziehung*. Berlin: Krippen-Pädagogik Lehrbuch).

[10] All major museums had experts to work with children to carry on practical art lessons or to work as museum guides. Big cities were leaders in this field: Moscow (the Pushkin Museum), Leningrad (the

Hermitage), Prague, Budapest (the Hungarian National Gallery), and others.

[11]Yugoslavia, as well as other countries of Eastern Europe, financed scientific work and research in the field of art education. Research themes published in Yugoslavia included the following: Art Education and Typology (Karlavaris et al.); Preferences of Students Toward the Work of Art (Kraguljac); The Role of Aesthetic Valuation in the Complete Process of Art Education (Kraguljac, Karlavaris, & Belamaric, illustrations by Karlavaris); Processes in Art Education: Aesthetic Capabilities (Karlavaris); The Reason for Unsuccessful Art Education for Students of Lower Classes (Berce); The State of General Culture of Students in Secondary Schools (Damjanov & Janda); Design and Visual Communications: The Relation Between Art Culture and Technical Culture (Karlavaris); The Meaning of Drawings by Kindergarten Children (Belamaric); Aspects of Historical Development of Art Education (Berce, Gerlovic, & Krajnc); The Integration of Aesthetic Fields (Karlavaris & Rosandic); The Aesthetic Arrangement of Schools (Roca); The Artist's Opinion (Butina); Stimulus and Creative Development (Grguric); The Development of Artistic Creativity (Karlavaris & Kraguljac); The Development of Creativity in the Function of the Emancipation of the Personality (Karlavaris, Barath & Kamenov); and The Valuation of Works of Art (Spajik).

[12]In the period of liberalization, a statement by Anton Mack on the congress in Czechoslovakia in the presence of R. Pfenning, West Germany, was accepted as a further orientation: "It is not important where the experience comes from, it is important whether it is useful and usable." This attitude was rejected by the education board in 1968 after the entrance of Warsaw pact troops into Czechoslovakia.

[13]The National Committee of INSEA of Yugoslavia was formed on April 14, 1958. It was active for the mandates of Josip Roca and Bogomil Karlavaris.

[14]After 1945, the aim of education was "the development . . . of conscious and active builders and defenders of socialist society . . . " In 1949, after the detachment from the Soviet Union, the formula was to educate the new, free, and brave citizens whose ideas were broad and different and who avoided unnecessary bureaucracy and narrowmindedness. In 1953, after self-government was established, the tendency was to educate such individuals who would be able not only to produce in but also to become managers of the system of social democracy. Later, it was aimed at the personality itself—development of its capabilities, as well as universality and liberation from economic dependency. Similarly, the aim of art

education was changed; it mostly had aesthetic tasks, and from them derived educational and societal tasks (*Enciklopedijski Rjecnik Pedagogije*, Zagreb, 1963).

[15]The 18th Conference of UNESCO, held in Geneva July 4—10, 1955, was dedicated to art education in schools and was attended by a delegation from Yugoslavia. It proclaimed a series of resolutions to improve art education in schools based on *Texte de Recommendation No. 41, Geneve, 1955*. Parts of these resolutions were published in *The State and Problems in Art Education in Our Society* by Karlavaris, Kulehovic, Ruzic, and Rijeka (1964, p. 23).

[16]Relevant research is mentioned in note 11.

[17]A conceptually less valuable program of art culture was proposed by engaging less experienced professionals. This is being corrected in all republics.

[18]The scientific staff developed by its own initiative; names are given in note 11.

[19]A special formation of political strength in Poland, with a remarkable influence of Polish emigration in the Western countries, had a positive effect on the cultural policy in Poland that was liberated from orthodox socialist realism by the end of the 1950s. In Czechoslovakia, this process was somehow slower, but it was still much more positive than in other countries in Eastern Europe.

[20]Special financing, management, and organization of popular schools of art have made this school (LSU) the framework for experiments. It became the theoretical source for art education methods in Czechoslovakia.

[21]The first big international exhibition of children's artwork was held in Prague in 1964, under the title "The Children and Their World." During that occasion, an international conference was held. The proceedings from the conference were published together with the reproductions of children's artworks under the name *The Aesthetic Education and Creativity* (Prague, 1965).

[22]*The Didactics of Art Education*. A selected bibliography for 1981 and 1982, Central Library, Departmental Informational Center, Pedagogical Faculty, Charles University, Prague. Edited by R. Trojan and, from 1987 on, P. Semsula.

[23]The journal *Vitvarna Vyhova* is published in Czechoslovakia, and many specialized books were published, such as handbooks for teachers and textbooks for students (Anton Macko, Otka Navratilova) and research by Jaromil Uzdil, as well as some methods books for kindergarten and primary schools (Banas, Harat, Muska, & Sefrankova). Very important was the international exhibition of children's artwork under the title The Biennial of Fantasy, which covered imaginative painting and the illustration of

literary texts from 1978. In Poland, a scholarly journal, *Paedeia*, is published, with Irena Woinar as the editor, and several important books by Irena Woinar have been published covering the field of accentuated pedagogy as well as books by Stefan Koscielecki covering the field of practical artistry. For a long time after the war, the predominant literature was about textile design (I. Levicka) or graphic design. The training of art teachers had two focuses: mostly theoretical at the universities and mostly practical in the fine arts schools. Det's Gallery in Torun, beginning in 1976, started to organize international children's biennial and yearly exhibitions.

[24]By the mid-1960s, several congresses of international experts were held in East Germany. The first one was in Greisfald in April 1965, followed by congresses in Leipzig and Berlin. This practice was stopped after 1968. After that, only few experts from East Germany attended the international congresses in Europe.

[25]Bildgestaltung (The Forming of A Picture) 1, 2, and 3, Berlin, 1977, 1979, and 1980. The team of authors included Wolfgang Frankenstein and Günther Regel (*Medium Bildende Kunst*, Berlin, 1986).

[26]The research themes represented mostly a narrow didactic sphere. Topics included Specific Review of Children's Art Work in kindergartens; The Development of Artistic and Forming Abilities; Methods and Processes in the Forming of Pictures; The Sorts, Functions, and Forms of Analysis of Printed Artworks Meant as a Didactic Means; The Study of Observations in Paintings; and The Forming of Valuations in the Process of Aesthetic Estimation. These themes were considered to be a professional secret. The rooms in the ministry were sealed so that the enemy would not find them out.

[27]Among the leading experts in the beginning were Annamaria Müller (the development of capabilities); Karl Mantay (processes in art education); Günther Regel (the development of colors), and Günther Berger (work according to the model). Later on, other experts appeared. In 1978, *The Methods of Art Education* appeared as the work of a group of authors (edited by A. Müller, A. Böhlin, M. Beerbaum, G. Berger, L. Hammer, F. Kühne, A. Neumann, W. Posse, H. Roitzsch, I. Rudolph, E. Schralpe, & H. Witzke).

[28]Two international exhibitions of children's artwork appeared in Hungary—in Debrecin and in Zanka on Balaton Lake. In Bulgaria, two reviews were organized under the name of "Flags of Peace" in Sofia and "The holiday of Art" in Michurin. Credit for the exhibition "The Children's Art Forum in Sofia" goes to Angelica Atanasova and the school Ljuben Karavelov, from Burgas.

[29]At the INSEA congress in Hamburg, 1985, material for parallel research in several countries was presented, including Hungarian research under the guidance of Günther Otto.

[30]In Veszprem, Hungary, there is an institute for didactic devices.

[31]In Hungary, two centers for research were developed: in the Academy of Fine Arts under the influence of Balogh Jenoe and at the University of Budapest by Andrea Karpati. Many authors wrote books and textbooks (e.g., Imre Domonkos and Xantus Gyula).

[32]Two publishing houses, Prosvestenije in Moscow and the Institute for Textbooks in Belgrade, have published, among other books, a handbook for art education in kindergartens.

[33]The experts on art education are gathered primarily around three institutes: pedagogical academies (Boris Yusov; W.T. Lichaczow), the Society of Fine Arts (Boris Namenski), and the Society of Organizations for Aesthetic Education and International Coordination.

[34]Günther Regel initiated the founding of the Society of Art Educators in East Germany at the beginning of 1990. On March 1, 1990, this initiative was chronicled (*Bund Deutscher Kunsterziehung in der DDR, BDK—DDR; Tagebuch, 1990, Werdegang des Grundung des Bundes Deutscher Kunsterzieher in der DDR*). At the congress of teachers of art education, Günther Regel gave a paper titled "Argumente fur eine entschiedene Auswertung der Faches Kunsterziehung." His criticism included the following: "Deshalb . . . wurde die Kunsterziehung nicht nur radikal eingeschraenkt, sondern darher hinaus auch zu einem Fach staatlich umzufunktionieren verzucht." (Because of this art education is not only basically narrowed but it has also been rearranged into the state's ideological education).

[35]During 1991, some international congresses held in Budapest were attended by a number of foreign experts; the latest one, in 1991, was about talent. A conference was also held in Czechoslovakia, in 1991. The theme was the American experience in art pedagogics.

Age 11: *Playing with Space*, paper and wooden stick.

DEVELOPMENT OF ART EDUCATION IN CZECHOSLOVAKIA

■ JAROMIR UZDIL

I: Historical Background

In a country in which education and instruction have almost always been associated with the tasks of national emancipation and committed resistance to foreign domination, pedagogics and school practice have an especially exhortative character: They purposefully address humankind's truly human qualities, its capacity for development. Therefore, in education everything is conducive to the growth of personality; it is not just of a rational character and does not just concern the pragmatic aspects of life.

This may have been the reason why the world renowned Czech educator, John Amos Comenius (1592—1670) focused his attention on what is one of the points of departure of present-day art education: that children scribble and make drawings without being prompted by anyone and often against the will of their instructors. He also knew that children notice unusual forms and shapes and that they like creative representations such as pictures in books and on walls. In his *Informatorium Skoly Materske (Nursery School Information)*, (Comenius, 1958), written about 1640, he warned parents against premature interventions in their children's developing, delicate sensual-esthetic and kinetic structures. In his *Velka Didaktika (Didactica Magna)*, (Comenius, 1912), dealing with adolescents, Comenius devised a thoroughly conceived field of instruction, psychologically and philosophically well grounded, which he called OPTICA, and which might rightly be called "visual education" today. It involves insight into the natural world as well as the world created by man, is dominated by ars, and is perceived more broadly than professional activity aimed at producing objects with exclusively esthetic-communicative content and function. Works of art are only a small and quite specific form of this ars—creative endeavour stemming from man's ingenuity.

However, in Bohemia, subjugated by the Austro-Hungarian monarchy, the practice of art education developed in another way. At best, teachers tended to provide rigorous instruction aimed at an accumulation of mutually incoherent items of knowledge. Children's activity and spontaneity were underestimated until the second half of the 19th century, when education began to return to the ideals of John Amos Comenius and when, above all, it was receptive to notions of pedagogics from the outside world. James Sully's book *Studies of Childhood (1919)* was translated into Czech and published only a few years after its publication in the West. At this time, a Czech school of psychological and pedagogical interpretation of children's drawings came into being. Later, this primary scientific interest grew into a veritable cult of children's genius.

In the 1920s, the children's art trend, supported by the developments of Expressionism, encountered the influence of the Bauhaus endeavor. Regrettably, the Bauhaus was often understood only one-sidedly, almost as a precept for abstract construction in the spirit of geometry and technical drawing and totally devoid of the ideas of such Bauhaus protagonists as Paul Klee, I. Itten, and Vasily Kandinsky. In the course of a heated controversy between the two wings, further tendencies to revive folklore in the schools petered out. At that time, folk art was seen as something that enhanced national self-realization, and its iconography and semantic significance were not fully respected or were even distorted. Finally, a compromise was achieved between the constructivists and proponents of children's spontaneity when tendencies toward psychological interpretation prevailed in preschool and grade-school education, along with rationalizing and emotionally indifferent constructivism in the education of adolescents.

After World War II, in the period of forcible Stalinization, art education had to defend itself against numerous pedagogically primitive deformations, especially in the form of polytechnical education, which was intended to subordinate children's activity to the objectives of a naively conceived industrialization expressed in so-called "improvement" proposals. Also, a cult of methodology became widespread, its aim being to unify all didactic endeavor. This negated children's individuality just as it did the teachers' indepen-

59

dent, individual, personal approach to encouraging the natural creative assets of young people. This tendency to suppress the teacher's individuality was intensified by methodological handbooks, centrally approved for nationwide use. Art education was to be a regular subject, with characteristics similar to those of physics or languages.

Fortunately, contact was continuously maintained with world developments in this sphere. In 1966, INSEA, the largest world congress of art teachers up until that time, brought together experts from both the West and the East. It was attended by some 2,000 participants, including more than 100 Americans headed by E. Ziegfeld. This important event was preceded in Prague in 1966 by a world exhibition of children's drawings, "The Child and the World." At that time, Herbert Read's *Education Through Art* was translated into Czech, and the specialized periodical *Esteticka Ychova (Esthetic Education)*, which succeeded in avoiding official pressure to a considerable degree, published a number of progressive, scientifically well founded studies. Using pseudonyms, a number of persecuted authors were able to publish their articles in this periodical; several books also ignored the official pedagogical line. Thus, there was not much to catch up with after the "Velvet Revolution" in 1989, and Czechoslovak art education could note with satisfaction that it had not been left as far behind as other subjects in the humanities.

The content of art education can be said to be constantly expanding. It not only involves drawing, painting, and modeling but also a number of other techniques of creating three-dimensional representations, as well as activities that require improvisation and the use of ephemeral material, and even some that do not result in a tangible product. It is also possible to speak of connections with entirely modern, or rather postmodern, art; however the activities are received in a nonreflective way.

The kindergarten provides a broad base for education toward an active appropriation of the world. The curriculum includes drawing and painting. Large formats, broad brushes, and nontraditional materials predominate, and large objects are built. Imaginative activity and pleasure from material realization are interlinked. Close ties exist to other aesthetic and educational activities such as music, dance, and theater. The public is acquainted with the results of kindergarten children's work at regular exhibitions. The art education program at this level is innovative and provides numerous incentives of an ecological or urban-

planning character. Kindergarten teachers are educated at special gymnasiums (secondary schools).

In elementary schools, where attendance is compulsory, there are usually 2 hours of art education weekly, up to the eighth grade. The curriculum has been conceived very thoroughly; methodological handbooks exist for all grades (we have already indicated that this may also be a retarding factor). Probably more important are frequent conferences of specialists, convened by teacher training institutions, pedagogical research institutes, and last but not least, by the Czechoslovak INSEA committee.

Art education as a compulsory subject involves a steadily increasing number of influences of a nontraditional nature concerning environmental ecology, creation of the lifestyle, and so forth. The subject matter of the curriculum is arranged cyclically and permits alterations, innovations, and individual approaches. Teachers for this level receive training in special departments of universities.

At gymnasiums (general education secondary schools), the subject of aesthetics and art education has been allotted 2 hours a week since the 1989 revolution. It is an optional subject, and two alternative curricula are being tested. The aim of the more progressive and more demanding curriculum is a closer link between information and experience, between art activities themselves and an orientation toward domestic and world art. The authors of the curriculum tried to bring the principles of artistic communication and the inner dialogue between the work of art and its viewer into the curriculum in an original way. They based it on an authentic quest for the human meaning of art and for the way in which information is interpreted. Thus, the activities of adolescents do not have the character of an introduction to artistic practice, but comprise a school of visual arts thinking, predominantly inspired by contemporary works. Art teachers at gymnasiums receive their education at universities or at the Academy of Visual Arts.

Books aimed at the practice of art education appear regularly in Czechoslovakia, as do publications for the purpose of university and scientific studies, primarily theoretical. Works by H. Read and R. Arnheim and other authors of world renown, have been translated. Major original scientific publications include books by the author of this chapter, for example *Vytvarny Projev a Vychova (Art Expression and Education)*, published in 1974, 1975, and 1978, and *Mezi Vychovou a Umenim (Between Education and Art)*, published in

1988. The monthly *Estetlcka Vychova (Esthetic Education)* carries articles and studies by many authors, including Igor Zhor, Jiri David, Jaroslav Brozek, and Jan Slavik, as well as findings from methodological experiments and generalized experiences by V. Roeselova, E. Garajova, K. Cikanova, J. Holomickova, and others.

A specific feature of art education in Czechoslovakia is the attention devoted to extramural art education provided in children's leisure-time establishments, the People's Art Schools, which exist not only in cities but also in smaller communities and offer children of all age groups a wide range of opportunities for art activities.

Art education in Czechoslovakia, which succeeded in maintaining its world orientation even during the totalitarian regime and which is imbued with educational humanism, is now facing the tasks of modernization of teachers' education, especially for those who will teach at gymnasiums, and achievement of a higher level of knowledge about world developments in the field.

II: The New Conditions

The political developments in Central and Eastern Europe are well known. The states that were previously satellites of the Soviet empire have liberated themselves and are free to seek anew their political, cultural, and national identities. The idea by which they are guided is democracy, a concept that is sometimes too idealized as being readily capable of solving the existing economic, social, ethnic, and cultural problems. Thus far, the only real—and evidently positive—change has come where freedom of opinion and expression is concerned: The principle of dialogue and free criticism is now fully observed.

In the arts and closely related activities, it is reasonable to expect the most striking shift. When this is not entirely the case, it is because of one major feature of artistic work and art education: the need to take, regardless of the political climate, the road of conscious orientation toward world developments, endeavor to gain permanent access to the latest information, and maintain live contacts with artists and art educators in all parts of the world. With regard to art education, it should be pointed out that two world congresses were held in Prague (in 1928 and 1966), and that Czechoslovak representatives have always taken an active part in international meetings. There has never been a shortage of information or of translations of major foreign books. There has always been a fast response to works of foreign and domestic underground artists in educators' work with children, and the official concept of aesthetic and art education was being violated long before the political liberation of the "Velvet Revolution" in 1989. There was consistent inquiry into the possible pedagogical contribution of some artistic activities, though artists themselves often had feelings of skepticism and attitudes of irony, protest, and distaste for established art traditions that children could not share. Perhaps it was often done by teachers only superficially, out of a desire for change and originality, and perhaps deeper philosophical reflection was sometimes absent.

Before and after the 1989 revolution in Czechoslovakia, some people expressed the view that with the influx of such new activities as "happenings," conceptual art, and performance art, the grounds for the classical and psychologically justified need to depict the world on the basis of sensory and intellectual understanding were disappearing. Art education was changing into an inconclusive game in which even the values of an emotional attitude toward natural reality might be lost when, for example, trees in woods were wrapped in bright-colored paper or hanging willow twigs were braided into plaits.

The situation changed in some respects after the consolidation of the political transformations, when the position of art education also changed in school curricula. In the gymnasiums, it was given considerably greater scope and is now capable of competing with other fields of study as an equal. Even primary schools are being founded with a larger number of hours in art education classes, and the People's Schools of Art, which used to be establishments for useful leisure-time pursuits, are being transformed into a kind of preparatory school for specialized art studies. Children's art activities have become a field of achievement, losing something of their free, noncommitted, and generally educational character. Views of the content of the curricula differ, and in the gymnasiums two widely different orientations are being tested. One is clearly based on the need to acquire certain skills in drawing, painting, modeling, and spatial creative work. The other prefers the supermodern playful and creative activities. Art history is given preference in the former and all but abandoned in the latter.

Of course, the situation is also influenced by developments at institutions of higher education, where the revolution has changed much. All academicism, even moderate forms based on the principles of classical

modernism, such as Expressionism and Cubism, was driven out of the Academy of Fine Arts, and its representatives left the facilities. A prominent place has been given to conceptual art/nonmaterial activities, action expressions, "pop" art, and other tendencies of postmodernism. Nothing at all remains of the former official creative work, let alone of what might even distantly resemble socialist realism. The situation is similar at another art school, the Academy of Decorative Arts for arts and crafts. Here, too, perhaps with the exception of craftsmanship in connection with manufacturing, not much of the former concept has remained. Ultramodern design, postmodernism both in architecture and in plastic arts, and new concepts of glassmaking and applied graphics shape the profile of the school.

In years past, the public was accustomed to a certain degree of "officiality" and traditionalism. Thus, the two schools now face prejudices and misunderstanding; precisely for this reason, they are more aware of the importance of general education and of broad, nonspecialized art education in schools.

Working purposefully and fully conscious of their objectives are the newly founded Association of Art Educators and the Czechoslovak INSEA committee. In October 1991, INSEA's latest international symposium dealt with the relationships between Czechoslovak and English-written literature and educational practice. It was attended by experts from England, Germany, Portugal, Lithuania, Estonia, and other countries.

The hopes for the further development of art education in Czechoslovakia rest on several prerequisites. Above all, the **principle of dialogue** should be based on an ever deeper and multifaceted study of the theoretical foundations of educational work with children and young people. This is not a small requirement in a society in which there were decades of attempts at not only a unified school but also a unity (if not uniformity) of pedagogical thinking. The principle of **philosophical reflection,** which is closely connected with the former should also involve what is not usually regarded as a part of the range of pedagogical problems. It is more concerned with the changing conditions of life; the general perception of values and feelings that are difficult to define, and the transformations that individual consciousness must undergo in the period of transition to a free-market economy. This does not just mean support for the anticipated political and economic changes; a certain meeting halfway that appears to be useful and therefore right from the prag-

matic point of view. On the contrary, it is an opportunity for art education to become more aware of its links to the stable conscious and unconscious components of the human personality, to better assess its capability of using unconventional means in order to humanize life. It must also find the necessary courage to act as a counterweight wherever there are instances of generalization and oversaturation, and wherever art and artistic expressions become mere commodities. Education cannot forgo its intentional character. In the limited time at its disposal, it should be able to choose, not to lose sight of the natural development of the child and to anticipate, as far as possible, social and cultural development.

It ensues from this that the teacher's responsibility does not concern merely the fulfillment of teaching norms. It requires a broad orientation toward the insufficiently mapped field of culture and lifestyle that influences nonprofessional everyday practice. Routine elements and formal knowledge should play a smaller part in teacher education. The study of original literary sources, not handbooks and instructions, is required, as well as a certain degree of artistic proficiency. The requirement for a reputable education and self-education must be expressed clearly. It is necessary both within and outside the already functioning Association of Art Educators and the Czechoslovak INSEA committee to create a broad and sociable **community of art educators,** and in this way to enhance professional self-confidence. This community should be oriented toward domestic developments and the organization of common work, as well as international relations, exchanges of experiences, and a better knowledge of living sources of information.

The prospects are there: A state that is free of the sterile functioning of the authorities is responsive to everything new and valuable.

References

Comenius, J.A. (1858). The School of infancy. An essay on the education of youth, during their first six years. London: W. Mallalieu.

Comenius, J. A. (1912). Didactica magna. Ubers and hrsg. von Walter Vorbrodt. Berlin: Union Deutsche Verlagsgesellschaft.

Sully, S. (1919). *Studies of Childhood.* London: Jonathon Cape.

Uzdil J. (1974, 1975, 1978). Cáry, Klikyháky, panáci a auto: Vytvarny projev a psychicky zivot dítete. Praha: SPN.

Uzdil, J. (1988). Mezi Vychovou a Umenim. Praha: SPN.

Age 5: *A Cat*, paper collage, drawing

DEVELOPMENT AND PROBLEMS OF ART EDUCATION IN MODERN JAPAN

■ KAZUMI YAMADA

Education Reform and the Unauthorized Education Movement

Characteristics of 100 Years of Art Education

The history of art education in modern Japan includes the development of an official system, a manual (text-book) system, and unauthorized movements against them. For the first 30 years (1872—1901), the system was largely an official-professional one. From 1902 to 1917, there was an official-education approach. During the period from 1918 to 1928, nonofficial free drawing was the key method used. The period 1929 to 1945 saw the use of nonofficial and differentiated approaches at first and later nationalistic and militaristic approaches. The period 1945 to 1991 witnessed the growth of a new educational approach for a postwar society.

When we look at the overall history of art education in modern Japan, the following pattern emerges:

1. The introduction of Western art education.
2. The rediscovery of Japan's traditional art.
3. The change from education of art into art in education.
4. The movement toward free drawing.
5. A period of intense reorganization.
6. Postwar confusion and the 6-3-3 school system.
7. The new style of art education within a high-growth economy.
8. Relaxed learning and the reduction of learning content.

Following this scheme, we shall now review the outline of a century's development of art education. From this we can gain some insight into contemporary problems and possibilities in Japan.

The Introduction of Western Art Education

The government crisis that revolutionized and established a system in art education began during the mid-19th century. It was a period when Japan's feudal gov-ernment and national isolation policy collapsed. Politically and economically, the country was opened to the world and subjected to an industrial revolution. The new Meiji government modernized education rapidly in order to catch up with the industrialized nations. The government encouraged leaders to study Western learning so that Japan could attain this goal. Authorities embraced Western educational content and methods without examining whether they were appropriate or not, and they invited foreign teachers such as Fontanesi,[1] Fenollosa,[2] Wagener,[3] and others to teach at Japanese institutions. While studying the Dutch school regulations in the *Bansho Shirâbesho*[4] for the Institute of Western Books, K. Kawakami read about the subject *drawing*. After he studied the contents, he started to teach the Netherlands approach to drawing. This method formed the basis for this subject in modern Japanese schools.

Modern schools for general education started with the school system in 1872. The Ministry of Education in Japan (Monbusho), produced textbooks to introduce drawing education into elementary schools. However, since drawing was recognized as a part of Western education, textbooks in elementary schools had to rely on several drawing books written by foreigners. For instance, Monbusho published the *Seiga Shinan (Western Drawing Methods),* translated by Kawakami. These books explained how to draw points, lines, shapes, and shading in steps. They did not emphasize thinking, expression, or creativity within children's art, but precision pencil drawing for practical science. Because the method was limited and insufficient for the schools, its introduction led to confusion within educational circles. Still, the *Seiga Shinan* were used as the first Western-style textbooks in Japan, and the method of editing used in creating them strongly influenced textbook production afterwards.

The Rediscovery of Japan's Traditional Art

During the middle of the Meiji era, there was a nationalistic reaction against the earlier uncritical importation of Western learning. This led to an inevitable con-

flict between Japan's traditional system of art education and the Western methodology. A key symbol of the conflict was the dispute between the use of pencil and hair-pencil drawing at an Education Board Inquiry on Drawing[5] in 1884 and its consequences. The board of inquiry was set up to discuss which drawing method was appropriate for education in elementary schools. As a result of the controversy, S. Koyama, who insisted on the adoption of pencil drawing, backed down and hair-pencil drawing was adopted as a policy for art education in elementary schools. Following this, Monbusho set up the Drawing Investigation Committee in 1885 and appointed as chief, G. Okakura, a man who strongly emphasized the revival of Japanese traditional art. Afterwards, the authorities ordered Okakura and E. F. Fenollosa to go to Europe to do research for textbooks in general schools. Their report had a strong influence and led to the reform of the Western method of art education in Japan. The Drawing Investigation Committee was renamed the Tokyo Fine Arts School and started to function as an educational agency to maintain Japan's traditional fine arts and handicrafts. Using this as an opportunity, drawing in general education shook itself free from Western thought, and a Japanese approach to drawing began to gain strength. In a ministerial ordinance in 1891, Monbusho stated clearly that the fundamental policy of drawing education should be based on hair-pencil drawing. Because of this policy, hair-pencil drawing textbooks[6] were published in far greater numbers than other drawing textbooks. The methodology of drawing education gradually became based on the use of the hair-pencil, and associated textbooks turned from explanatory drawing to artistic drawing, a transformation that Okayama had anticipated.

The Change from Education of Art to Art in Education

Art education using hair-pencil drawing was one of the methods that concentrated on Japanese traditional arts. However, between 1897 and 1906 there was a growing opinion that art education depended on hair-pencil drawing too much and concern that the extreme direction that nationalism was taking required a reassessment. It should be pointed out that, in general, the study of aesthetics changed at this time. That is, aesthetics and art history appeared as serious subjects at several schools, and later aesthetics was recognized as a proper academic discipline. As a result, greater public respect was afforded to the fine arts in general.

At the same time, a new movement arose in the Tokyo Fine Arts School. For example, by the time S.

Kuroda returned to Japan (after studying European painting under R. Collin) to participate in the teaching of Western painting at the Tokyo Fine Arts School, the perception of fine arts had already changed. Because the content of fine arts was then limited to Japanese traditional art, difficulties arose. In addition, trends within international art education had significant meaning at this time in Japan. It was especially important that N. Masaki took part in the first Congress of the Federation for Education Through Art (FEA) called in Paris (1900), also taking advantage of the Paris International Exhibition. His experience in Paris played an important role in establishing a modern system of art education in Japan. He learned about the art education movement in Germany via the Congress and came to understand the common belief that drawing was important for both the child's mental development and manipulating skills. He attempted to make the best use of this knowledge for the development of Japanese art education.

Parallel with this international movement, the world of art education in Japan was embroiled in an argument about the merits and demerits of hair-pencil and pencil drawing from a general education point of view. In 1902, Monbusho set up the Inquiry Committee of Drawing Education for the purpose of investigating how drawing should be established in general education. The committee included N. Masaki, S. Kuroda, R. Uehara, A. Shirahama, S. Koyama, and others. The membership was largely different from the previous Board of Inquiry into Drawing Education. After the committee investigated drawing education in the West and examined the relative merits of hair-pencil drawing and pencil drawing, it presented its report to the public in 1904. The report played an important role in the establishment of a modern system of art education. It not only had a new *child-centered* approach, suggesting that drawing education should be carried out from a general-education point of view, but also included descriptions of the purpose of drawing in general education and revision plans for a syllabus of lectures in elementary schools, secondary schools, and girls' high schools. The report became a guideline for subsequent reform of the art education system and was put to practical use in the revised ministerial ordinance of 1907. According to this, the textbooks for drawing education were organized by *systematic teaching materials*,[7] of which the textbook Shintei Gacho was one, that were carefully thought out according to a child's psychological development. Furthermore, when Masaki became headmaster of the Tokyo Fine Arts School, he was not satisfied with the technique-centered curriculum in the school. Masaki appointed

Shirahama, who had a profound knowledge of art education theory, as the head of the course and arranged a teacher training course.

As for the development of handicrafts, after the London Exhibition of 1851 Western people became interested the crafts-production of East Asian nations. Japan began to export crafts. In those days, such artisans as potters, swordsmiths, and sword decorators became separated from Samurai society and were forced to change their occupations.

Against this background, Japanese handicrafts in general education started from the model of *Frobel's Gabe* at the kindergarten attached to the Ochanomizu girls' school in 1876. The government wanted to carry out an industrial revolution in as short a time as possible because of the country's backwardness compared to Western nations. The aim was similar to the Russian policy by which Russia, aware of the delay in a domestic industrial revolution, dealt with the situation by means of a new crafts-education method, the *Russian method*. Thus, Japanese handicrafts education was established under the influence of world exhibition—especially the Philadelphia World's Fair in 1876—vocational education, Russian methodology, some investigative reports by the British Royal Committee, the Slöjd method, and so forth.

The years between 1897 and 1906 were also a period of development for handicrafts education. The government wanted to consolidate national power, increase production, promote trade, and reform practical education in order to keep up with and even overtake the industrialized world. Therefore, there was a movement away from the humanistic and toward the practical, and priority was given to handicrafts education. Under these circumstances, the ministerial ordinance was revised in 1900 and handicrafts in elementary school subjects was emphasized. It was difficult to achieve this new goal. In solving the problems encountered, the Tokyo Higher Normal School helped to establish and disseminate handicrafts education. The school was the first to set handicrafts education up as a school subject in Japan, and it determined the content of the course by publishing a detailed plan for teacher education. The plan was drawn up by H. Okayama based on handicrafts lessons in the elementary school attached to the Higher Normal School. Later, Okayama refined it under the guidance of R. Uehara and published it as the *Handicraft Textbook for Teachers in Elementary Schools*. Okayama's efforts also influenced educational administration. Consequently a summer training course was opened at

the school for 3 years beginning in 1903. Leaders, such as directors, school inspectors, handicrafts teachers, and others took part in the training course and studied Okayama's syllabi. Thus, handicrafts was practiced in elementary schools throughout the country.

The work on the education system done by Masaki and Shirahama and the inspired leadership of Uehara and Okayama played an important role in the establishment of a modern system in general art education. Their achievements were as follows:

1. They noticed the significance of teaching art within general education.
2. They realized that drawing and handicrafts should be included in the regular curriculum in elementary schools.
3. They recognized that teaching materials and textbooks should be produced according to children's interests.
4. They tried to include these elements within the education system in order to realize art education.

These achievements contributed significantly to the establishment of the modern system in art education, yet there was a problem. Used to making children imitate by using textbooks, teachers could not put the new methodology into practice.

The Free Drawing Education Movement

From another perspective, the process to systematize art education after 1872 depended on Monbusho's taking the initiative to establish it. That is, the Ministry needed to provide schoolbooks along with educational materials, arrange teachers' courses, give short-term training courses, and systematize them from an international point of view. This approach by the authorities bore full fruit in the short term. However, the framework did not have the flexibility to absorb an important factor in the dynamics of child and teacher—that is, a strong desire to learn or teach. Moreover, it did not have the flexibility to address the special characteristics of each community. Even though the educational contents were understood, they were not practiced much in class. Although *Shintei Gacho* was judged to be the best drawing textbook, drawing education depended on it too much to develop further later on. Subsequently, enthusiasm gradually disappeared and *Shintei Gacho* was relegated to the methods of the early period.

An alternative art education movement, started by a nonofficial group, began in 1919: the Free Drawing Movement of K. Yamamoto.[*] He rejected the traditional concepts and claimed that people should think of a *free drawing* method based on the child's personality and creativity. The movement shocked the world of art education and spread across the country rapidly. The aim was to realize an education based on creativity and to encourage children to free their imaginations and express themselves naturally. Yamamoto's claim was very important because it marked a revolution in art education doctrine. In those days, in general, the education world tended to react against the systematic and stereotyped method of the Herbart group and to focus on the trend of thought in *art* education. Unfortunately, Yamamoto's revolutionary approach to free drawing did not offer a clean methodology for teachers. Because of this weakness, there was a tendency for many educators to adopt a let-alone policy in teaching the child in class. The resulting confusion led to vociferous criticisms of free drawing. Yamamoto declared an end to free drawing in school art in 1928.

However, Monbusho became aware of the high quality of free drawing and compiled a textbook, *Shogaku Zuko*, establishing a new direction in drawing education from 1932 to 1937. This development was just an interpretation of the official system following the intrinsic motivation of private groups; its approach was opposite to that of Masaki and Shirahama.

Many Approaches to Reorganization

If we see the attempts at systematization by Masaki and Shirahama as a prototype, Yamamoto's movement seemed to be an approach without a prototype. Approaches came from many directions other than Yamamoto in the 1920s. For instance, rating free drawing highly, S. Shimota criticized the simple teaching method of drawing from nature; instead, he advocated the need for creation and the appreciation of the plastic world from a wide perspective. On this basis, he and his fellows established a New Drawing Education Group in 1920. T. Ishino and other young teachers criticized imitative productionism and emphasized that people should regard instructional objectives as free-based crafts production following a child's creative instinct. They established a Creative Handicrafts Group in 1923. R. Kishida wrote *an essay on drawing education*, criticizing drawing methods that imitated form without any aesthetic sense. He insisted that the students' approaches should be playful, that they should foster experience and be unconsciously creative. T. Mizutani, who returned to Japan after studying in Germany, introduced Itten's *Vorleher,* the basic course of design from the Bauhaus school, in journals and lectures. The contents strongly influenced K. Takei and M.Yabuki, leading educators, and advanced the reform of crafts, design, and crafts production. Takei published *an outline of construction and design education*, supported by R. Kawakita, in 1934. At this time there were many outstanding teachers who had gained valuable practical experience from the communities where they lived and worked. Evidence for this can be found in G. Aoki's book The Establishment of Drawing Education in Agricultural and Mountain Villages and Y. Nakanishi's Child Education through Idea-Drawing. These various approaches combined and supported individual ideas, enthusiasm, sensitivity, and other abilities. They established many possible directions for the advancement of education in the future. Monbusho, stimulated by such approaches, incorporated the ideas into new schoolbooks, primary school drawing and *Shogaku-zuko*.

However, due to the increase in militarism and authoritarianism in Japan, children were not allowed to express their creativity freely. Under these circumstances, crafts fields increased with the onset of World War II. During the war, the needs of national defense and nationalism overlapped the world of education in Japan, and education was changed in order to indoctrinate students with a philosophy of national defense and device creation. For the first time, crafts schoolbooks for children were written from the practical viewpoint of national defense. Soon Japan's war fortunes were reversed, and the results of this education were not realized because of the mobilization of instructors and labor and the evacuation of children.

Postwar Confusion and the 6-3-3 School System

After the war, the first decade was a period of scrapping and rebuilding in education. The new emphasis was that people should express their thoughts and demands frankly. Postwar directions in art education were characterized by the *Courses of Study for Schools: Arts-Handicrafts.* The distinctive features of this curriculum were that concrete child centeredness was established in art education for the first time and that the objectives and contents of this school subject were available for use as reference by each school. Drawing and crafts started again as a school subject in elementary and lower secondary schools.

A fixed 6-3-3 system began 10 years later. Since then, educational reform has been effected following

reports submitted by official councils at 10-year intervals. The reports have had different features, according to the social situation and the administrative background in education. For example, in revising the courses of study from 1956 to 1960, the public engaged in a lively discussion regarding a new independent course on the grounds of Japan's independence from the United Nations and the expansion of the economy. Following the submission of these reports, course of study changed from being tentative plans into being national minimums. Handicrafts was reorganized so that its scientific content was moved into a new technical school subject, *industrial design,* and arts-handicrafts became fine arts in upper secondary schools. Furthermore, fine arts was divided into two fields; *expression* and *appreciation.*

A New Form of Art Education and the High-Growth Economy

Between 1968 and 1970, while industry and the economy developed rapidly, there was considerable educational reform. From a national viewpoint, education had to emphasize science and be modernized for the purpose of educating human resources to support the high growth of the nation's economy. The tendency was to question the system of learning content and to set economic efficiency as the goal of revision. As art education was pointed out as a weakness in the subject framework, attempts were made to theorize it. In a sense, reform became a game of survival for many school subjects. Although its educational content was enriched and its main body was formed, the high amount of content in the curriculum led to overcrowding. The courses of study were packed with too much content for many teachers to digest, except for those who had significant experience. The number of underachieving children increased, and that phenomenon was pointed out as a social problem.

Comfortable Learning and Reduction of Learning Content

In the first half of the 1970s, significant concern about industrial pollution and environmental disruption emerged. In addition, in reaction to the assumption that economic efficiency took precedence over everything else, a conclusive reduction in learning content was carried out in the latter half of the 1970s. Reform slogans stressed *comfortable learning* and *the reduction of learning content.* As a consequence, the content of art courses returned to *expression* and *appreciation,* and in the case of elementary school, it dropped to one third of the amount in the previous course. This organization of the educational content of art courses seemed to embody the most sophisticated postwar relationship between child development and the overall contents of school subjects.

In 1989, a new education reform was mandated, concerned with a liberalization of education and demands for lifelong education within society. The proportion of elderly citizens within society increased, and the structure of the population and people's consciousness changed rapidly. As a result, the ways of learning of adults, women, and the aged became an issue for Japanese society with its large elderly population. Education reform was carried out for the sake of establishing a lifelong learning society. Following this trend of thought, art education emphasized aesthetic sensitivity, abilities in design, and creative crafts expression and appreciation.

Contemporary Problems and the Future

Art Education as Character Building

So far we have reviewed the development of art education over 100 years in modern Japan. It was a developmental process that the Meiji government established, creating a modernized art education system through a compromise between the importation of Western learning and traditional art teaching methods. Over the years, many practical educators tried to reform the official system and provide different approaches. Moreover, after Japan's defeat in World War II, the role of art education as *kunsterziehung* or *kunstpadagogik* was given priority. This is art education as character building, and it is pursued on the basis that it will cultivate a child's *sentiment* and *spirit.* This formula reflects the fact that individuals were given more priority the various approaches of nonofficial groups were reconsidered after the war. The philosophies of Read (1943), Langer (1953), and Lowenfeld (1947) also had a strong influence on the world of art education, supported by a movement within UNESCO when Japan was rehabilitated.

It was not so easy to emphasize character building through art experiences in the school system, because a child could not get the limited time required for art instruction, given the lack of equipment and teaching materials. Recent problems include reduction to a 5-day school week and the tendency to make subjects optional. These problems increase the amount of stress on children and reduce the opportunity for creativity. Because of changes lifestyle and the influence of the media, society is reducing children's opportunities to experience drawing and handicrafts. Nowadays, peo-

SCHOOL SUBJECT	CONTENT	
	EXPRESSION	APPRECIATION
EXPRESSION (Kindergarten)	Plastic Art Expression	
ARTS & HANDICRAFTS (Elementary Schools)	A: Expression *Plastic art play *To express by pictures or solid what a child wants to express * To make what a child wants to make	B: Appreciation To enjoy To have interests To be familiar with works
FINE ARTS (Lower Secondary Schools)	A: Expression * Painting * Sculpture * Design * Crafts production	B: Appreciation * Painting and Sculpture * Design and and Crafts Production
ART (Upper Secondary Schools) — Fine Arts in ART	A: Expression * Painting * Sculpture * Design (graphic)	B: Appreciation
Crafts Production in ARTS	A: Expression * Design Crafts Production * Practical Crafts Production	B: Appreciation

Figure 1—An outline of the contents in the *Courses of Study* (1989)

Figure 2—Structure of Art Education (Ohashi, K. 1989)

ple ask what original character-building experience art education can offer in the face of a high-technology, computerized society.

Expression and Appreciation as Course Contents

Art education is officially included in kindergartens, elementary schools, lower secondary schools, and upper secondary schools. The contents are outlined roughly in Figure 1. This syllabus is the result of a process of arrangement and elaboration that has been carried out since the education reforms in the latter half of the 1950s. However, it has been changeable because of different viewpoints regarding what the essence of art is or how a child's abilities should be cultivated.

Now there is a strong demand for art education to play an important role in educating people to have an appreciation of art history, general fine arts, and sentiment or sensibilities. It is difficult for teachers to meet such demands because of a lack of time. Solving the problem of content is a serious matter, and the spread of crafts production does not appear to be happening.

Education Reform and the Nonofficial Education Movement

After the World War II, nonofficial educational activities became more animated than ever before. The Federation for Education through Art in Japan (JFEA) was established in 1953.[9] It fostered a nonofficial approach that corresponded to internationalization.

The establishment of the JFEA allowed Y. Muro to attend the Seminar on the Teaching of Visual Arts in General Education in Bristol in 1951, supported by UNESCO. After he returned to the country in 1952, he advocated that the world of Japanese art education should be broadened in step with

international trends. Japan should learn from other nations and contribute to the development of a global art education on the basis of international cooperation. His assertion shocked the art education world. Furthermore, since the UNESCO Seminar on Arts and Crafts in General Education and Community Life was scheduled to be held in Japan, people recognized the necessity for a nationally integrated body of art education groups. As a result, in 1953, eight societies were combined to make the JFEA.

Educational studies and practical activities were supported by independent nonofficial bodies, which were involved energetically with postwar democratization. The period saw the establishment of such representative societies as The Society of Creative Aesthetic Education (1952),[10] The Plastic Art Education Center (1955),[11] and the Society of New Drawing (1951). Then the JFEA held the International Conference on Art Education, Tokyo (XVII. INSEA), in 1965. Its main theme was "Science and Art Education." The 2,000 participants from all over the world discussed theories and practical methods of art education. Art education benefited greatly from a long history of independent movements in Japan.

Studies in Art Education

Serious arguments about the continuance of art education reflect a tendency in education reform throughout the world that is connected to problems of internationalization, liberalization, and the revision of courses of study. As a result, approaches to practical study have become more academic. This corresponds with the nature of postgraduate schools, the rapid increase in the number of researchers in art education, and the expansion and specialization of inservice education by new licensing acts. Approaches are discussed in journals of art education and published reports by postgraduate schools. There are currently 20 postgraduate schools, and the reading of papers and organization of symposiums have become increasingly sophisticated. Influences from studies in social education also feed into the art world. This phenomenon is similar to that in the 1950s in the United States. The tendency for art education to be developed through postgraduate research is changing the methodology and style of practical studies. Art education as a system was formed through the work of individuals and private education groups in the 1920s and in the 1950s and 1960s. Nowadays, the leading force in art education is the universities. In a sense, the present situation whereby university research determines the nature of the school system, in addition to the work of Monbusho and private groups, holds the key to the solution of future problems.

Notes

[1] A. Fontanesi, 1818—1882, was a representative Italian landscape painter. When the Fine Arts School attached to the engineering department was opened, he was invited to be a drawing teacher. The school functioned from 1876 to 1883. It taught Western arts (painting, sculpture, and architecture). But because of

rising nationalism, it was closed. While he was in Japan, Fontanesi taught C. Asai, S. Koyama, and others. He returned home because of illness.
—E. F. Fenollosa, 1853—1908, was an American art researcher. After he graduated from Harvard University in 1874, he took lectures in philosophy, including aesthetics, at Tokyo Imperial University (1878—1886). Furthermore, he lectured on the history of art in the Tokyo Fine Arts School. His lectures fostered a revolution in traditional fine arts and literature. He returned to his country in 1890 and was engaged as the head of a department of the Orient in the Museum of Fine Arts, Boston.

[3]Wegener, 1831—1892, was a German practical chemist. He visited in 1868 after graduating from Georg August University. In 1870, he taught the materials and techniques of ceramics in Arita. By teaching crafts-production fields in various places he tried to improve ceramics, cloisonne ware, glasses, and dyeing. He introduced Japanese crafts production to the West.

[4]Bansho Shirabesho, 1857—1862. The Tokugawa government was increasingly aware of the necessity of Western learning. In 1861, a department of drawing was set up, the first official institution of Western drawing in the country. K. Kawakami was in charge. Kawakami translated and edited chapters I and II of the Illustrated Drawing Book by Robert Scott Burn, an Englishman. Monbusho published the first column in 1871 and the second in 1875 as the textbooks Seiga-Shinan.

[5]The head was H. Takamine: the other members were G. Okakura (1863—1913); Fenollosa; Imaizumi, an Oriental art historian; Koyama, an artist; and others. Takamine introduced Pestalozzism's teaching method for the first time in the country. Okakura was an art administrator and historian, an educator, and a leader in Meiji art. After graduating from Tokyo University in 1880, he was engaged by Monbusho and started to tackle the problems concerning art education and the preservation of the old art. In 1884, he organized a meeting, "Kanga-Kai," with Fenollosa and made efforts to introduce Western drawing into Japanese drawing and to cultivate a new "Japanesque" art. He was a nationalistic idealist who asserted the predominance of Asian and Japanese art culture. He founded a journal of studies in Japanese art called Kokka in 1889.

[6]When we examine the drawing textbooks Monbusho made for official approval from 1892 to 1902, hair-pencil texts number more than 120, pencil texts about 20, instrumental drawing texts 7, and watercolor texts only 1. Many writers were artists in the Japanese style. Teaching methods included works of well-known Japanese artists to encourage children to imitate them and to learn how to draw. Teaching materials, arrangements, and methodologies were the same as training methods for artists.

[7]Textbooks became schoolbooks compiled by the nation after 1904. The system was established in 1903. It resulted from a graft scandal concerning textbook companies and textbook judges. Thenceforth a system began whereby children used textbooks in school. A typical drawing textbook compiled by the administration was Shintei Gacho, which Shirahama and others edited. Characteristics included the abolition of the distinction between pencil and hair-pencil drawing, the frequent use of the pencil in the lower grades, the frequent use of the hair-pencil in the upper grades, the addition of perspective and projection, the widening of the range of color education, the use of the color pencil from the first grade, and the use of watercolor in the fifth grade. Furthermore, imitative drawing was added along with memory drawing in the lower school and drawing from nature in the upper grades. Finally, design drawing was used to develop inventive-creative abilities and a sense of beauty.

[8]K. Yamamoto, an artist, broke his homeward journey, after studying in Paris, at Moscow. He saw works of creative child drawing and peasant art and was strongly impressed by them. After he returned to Japan in 1916, he claimed to have discovered an innovation in drawing education. His work led to a movement for free drawing (1918—1928). Soon 1,000 drawings by children Yamamoto had instructed were displayed at an exhibition in 1920. Their work was free and relaxed, and the exhibition was covered widely by the press. It changed the mood of education in the country. As a result the world of drawing education changed completely. One factor in this development was the adoption of the crayon.

[9]The federation changed into the INSEA, Japan, after the integration of FEA and INSEA.

[10]Chiefly advocating Yamamoto's and Cizec's philosophy.

[11]Taking the opportunity afforded by Gropius's visit to Japan in 1954, the society was set up to open a new path in design education. Studies were advanced in the basic design field, being influenced by the Bauhaus method.

References

Read, H. (1943). Education through Art. London: Faber and Faber.

Langer, S. (1953). Feeling and Form. New York: Charles Scribner's Sons.

Lowenfeld, V. (1947). Creative and Mental Growth. New York: The Macmillan Company.

THE BASIC DESIGN MOVEMENT IN BRITISH ART EDUCATION

■ RICHARD YEOMANS

The Basic Design movement[1] represented a radical change in British art education during the post war period of the 1950s and 1960s. Its impact was felt in the schools of art, polytechnics, and secondary schools even penetrating as far as the primary schools. It represented a loose dissemination of educational ideas and values inspired by the Bauhaus school and European Constructivism, which challenged the prevailing Euston Road style of Impressionist realism that dominated the painting schools as well as the rationale, content, and structure of Britain's major art qualification, the National Diploma in Design.

Origins of Basic Design

The new movement emanated from a number of artists who taught at the Central School of Arts and Crafts in London, but as a teaching philosophy it crystallized in the North of England, where it was led by Victor Pasmore and Richard Hamilton in Newcastle-on-Tyne and Harry Thubron and Tom Hudson in Leeds. Many other leading British artists were concerned, such as Terry Frost, Alan Davie, Hubert Dalwood, Rita Donagh, Maurice de Suasmarez, Ian Stephenson, and William Turnbull. The movement reflected something of the bewildering diversity and creative preoccupations of the artists concerned. It was not a monolithic movement, and it did not set out with any preconceived pedagogical precepts, nor was it advocated as a recipe for British art education. It began as an ad hoc, spontaneous attempt to introduce a more open-ended and experimental mode of teaching that was more in tune with the radical spirit of European and American modernism. It demanded a freedom of action within the art schools that was not easily accommodated within the structures of the centrally directed National Diploma in Design.

A number of leading artists and teachers, like Victor Pasmore, were energetically pioneering a new wave of modernism. Pasmore argued that it was absurd to have an examination and art school system that fostered ideas and values more appropriate to the 19th than they were to the 20th century. Many of the

painting schools offering the National Diploma in Design were propagating a form of Impressionist realism established by the Euston Road painters in the late 1930s, which represented a continuity of objective realism in Britain, that can be traced back through Sickert and the Camden Town painters to Degas. A number of painters and designers felt that the National Diploma in Design was fragmented in its structure and outdated. It failed to address the underlying unity or common ground of the various arts and concentrated more on unrelated crafts techniques. The Diploma had engendered good crafts, but it provided a poor basis for design and failed to nurture any analytical or critical modes of thinking.

These criticisms came at a vital time, when Britain was undergoing a period of revival, innovation, and rebuilding after the destruction and austerity of World War II. One major expression of this spirit was the Festival of Britain, promoted by the Labor government in 1951. This was not simply a celebration of the centenary of the Great Exhibition held at the Crystal Palace in 1851, but an opportunity to promote the latest and best of British art and design. Britain's leading artists, designers, and architects were brought together in an unprecedented collaboration, and the whole event was a celebration of modernism that captured the imagination of the British public. Major commissions were offered to artists such as Henry Moore, Barbara Hepworth, Ben Nicholson, Victor Pasmore, and Eduardo Paolozzi. A number of important related exhibitions were held, including the first exhibition devoted entirely to abstract art.[2]

Although abstract art was 40 years old, this was the first time it had been given any significant platform. Abstraction in art in Britain first appeared during World War I within the work of the Vorticists, David Bomberg and Percy Wyndham Lewis, but it was short lived and had only a very limited influence. Only Ben Nicholson sustained any strong commitment to abstraction between the wars. Despite the fact that Laszlo Moholy-Nagy, Piet Mondrian, and Naum Gabo had arrived in Britain in the mid-1930s, abstraction did

not take root until after the World War II. It was mainly through the conversion of Victor Pasmore from Euston Road Impressionism to abstraction in the late 1940s, that the momentum for change took place. By 1951, there was a strong nucleus of abstract artists consisting of Kenneth and Mary Martin, Robert Adams, Adrian Heath, Anthony Hill, Terry Frost, and Peter Lanyon. It was during this period, when Victor Pasmore began to devise a new pedagogy, that objective ground rules would be established for abstraction. Pasmore was emphatic in wanting to see in British art schools a pedagogy that acknowledged the momentous changes in modern art.

The Festival of Britain also highlighted the shortcomings of British design and its failure to address mass industrial production of good design. In many ways, Britain was still suffering from the legacy of William Morris and the Arts and Crafts movement, which promoted excellent craftsmanship but resisted machine production. The best designers worked not in the world of industry, but in the cozy, gentlemanly atmosphere of the crafts studios of rural Cornwall and the Cotswolds. During the 19th century, British design teaching focused on the South Kensington method, which concentrated on applied art and the grammar of ornament. Design was pictorial in the sense that drawing was considered the basis of training. A historical understanding of style became obsessive, leading to persistent historicism and revivalism. As Adolf Loos (1910) observed, drawing, rather than making, was the basis of design practice. William Morris and the Arts and Crafts movement changed all this with their emphasis on craft—on the understanding of material and the making process. By the end of the century, the Arts and Crafts movement prevailed through the influence of people such as William Lethaby, but as Lewis Day pointed out, they failed to come to terms with a mass-produced, industrial-based design (Frayling, 1987). Single craft skills prevailed, worthy in themselves, but they did not produce the flexible and transferable skills needed for industry. To some extent, the National Diploma in Design perpetuated this skill-based mode of working well into the 1950s. Unlike the Bauhaus in Germany, Britain failed to produce a design school that was capable of uniting the arts under one roof and directing the sensitive study of material and craft processes, as well as new technologies for industrial production.

The Bauhaus Influence

During the 1930s, Walter Gropius, Laszlo Moholy-Nagy, Marcel Breuer, Piet Mondrian, and Naum Gabo settled in Britain, but their ideas were too radical for British taste, and finding the atmosphere unreceptive, they moved on to the United States. Britain's loss was America's gain, but by 1951 there was a thirst for innovation and a renewal of interest in an art education loosely based on the Bauhaus model. Apart from one or two isolated initiatives, the first serious attempt to bring about anything approaching a Bauhaus pedagogy occurred at the Central School of Arts and Crafts in London. This was the initiative of the principal, William Johnstone, who gathered together some of the youngest and most talented artists of the day and appointed them on a part-time basis. Many of these artists had studied in Paris and brought a fresh understanding of European avantgardism that invigorated the insular atmosphere of the British art scene. Among the new appointments were artists who were to become the most influential of their generation. They formed the nucleus of the seminal Independent Group, which initiated a creative and intellectual revolution in Britain.[3] Johnstone adopted the Gropius policy of putting avant-garde painters and sculptors into the craft studios. Sculptors such as Eduardo Paolozzi and William Turnbull, who had studied in Paris, were appointed to teach part time in the furniture and textiles department. Richard Hamilton taught in the department of industrial design; Alan Davie in silversmithing; Nigel Henderson graphic design; Reyner Banham in the history of art; and Alison and Peter Smithson in architecture. Victor Pasmore taught day-release apprentices, and Patrick Heron and Roger Hilton were appointed to the Painting School. Johnstone believed that it was right for artists to teach outside their discipline and that the imagination and flare of the fine artist could animate the conservative and moribund atmosphere of the craft studio. Also, the presence of the artist in the craft studio prompted some kind of interdisciplinary discourse that contributed to a radical appraisal of the common elements of the arts. This search for a common ground coincided with similar probings into the language of abstraction promoted by Pasmore's circle of abstract artists. The precedence of the Bauhaus foundation courses, with their emphasis on the empirical investigation of the formal elements, provided an obvious model, but it was a model of which only a handful of artists were vaguely aware.

Knowledge of the Bauhaus in the early 1950s was only of a generalized nature, and the pedagogical writings of the Bauhaus were not readily available. There was more interest in the Bauhaus artists as artists than there was in their pedagogical theory, and most of the pioneers of Basic Design emphatically disclaimed Bauhaus influence. The impact of the Bauhaus on

Basic Design thinking was paradoxical. On the one hand, the implementation of Basic Design was unimaginable without the Bauhaus's example, and on the other, it is clear that few people had much knowledge of the Bauhaus. Richard Hamilton (1974) pointed out that little knowledge is needed to prompt a powerful response from those concerned. For artists such as Richard Hamilton, Pasmore, and Turnbull, who were exploring the minimal visual elements of pictorial structure within their own painting, sculpture, and construction, the mere title of a book such as *Point and Line to Plane* can have great meaning and resonance. This was certainly true of Pasmore, who since the late 1940s had been seeking a new formal language to underpin his abstraction by reading books by Hambridge (1948), Power (1933), Ghyka (1977), and Le Corbusier (1954) on the mathematical rules of composition. Another influential book, *On Growth and Form* by D'Arcy Wentworth Thompson (1961), dealing with the mathematical explanation of morphology, had a profound influence on a number of artists, architects, and designers and had been the subject of an important exhibition arranged by Hamilton in 1951. For a number of artists, these books suggested an order, mechanism, and dynamics behind surface reality that reinforced their search for a corresponding underlying abstract metaphor for the visual world. Their independent probing of a new abstract order received an added endorsement when they encountered the pedagogical writings of Kandinsky and Klee, and it was in this sense that the Bauhaus acted as a catalyst in an existing creative melting pot.

In one sense it can be argued that both the Bauhaus and Basic Design courses were concerned with teaching the formal elements that constitute the visual reality with shape, color, tone, texture, line, and so forth. It has been suggested that this was essentially an expression of 20th-century formalism. Certainly the Bauhaus courses were concerned with "significant form," and Kandinsky argued for an analytical and synthetic method, subjecting the formal elements to "dissection" and scientific examination. This appeal for objectivity can also be discerned in the writings of Pasmore, Hamilton, and Hudson, but the ideas of Kandinsky, Klee, and Itten ultimately owe as much to metaphysics as they do to science. In *Concerning the Spiritual in Art*, Kandinsky put forward the view that abstract art represents the nonmaterial world, a spiritual order. Along with Mondrian and Itten, the influence of Theosophy is paramount. Kandinsky sees the formal elements as a part of a spiritual reality. Klee advocated an expression of nature's dynamic processes. Klee's Goethian notion of art as an indivisible part of nature's

organic being, operating according to the same laws and processes, in a similar dynamic and open-ended way, provided a modus operandi for the Basic Design teachers. As Pasmore frequently quoted, "art should imitate nature not in her outward appearance but in her manner of operation."[4] This meant that students would not just study the aspects of form in a finite sense, but concentrate on the process and mechanism of the means at their disposal, avoiding preconception and postponing consideration of the end product. Pasmore eschewed the term Basic Design, because it suggested a rule-bound grammar. He described his course as a Developing Process, emphasizing its empirical, open-ended, and experimental nature.

Basic Design Courses

Basic Design courses were as diverse as the individual artists represented, and the content of the courses reflected the creative issues of the postwar period. For several artists, teaching was a natural and indivisible part of their studio art. Pasmore used his course as a testing ground for his own ideas regarding abstraction. His students were co-researchers in this field. Hamilton was pursuing an opposite course, seeking out a new figuration, and much of his course was concerned with issues that were the antithesis of abstraction. Two main strands were common to all participants: analysis of the formal elements and a process-dominant, experimental mode of working.

All the participants followed a Bauhaus procedure of analyzing point, line, plane, texture, color, and all the basics in varying ways. Pasmore was probably the most systematic in his approach. He confronted his students with a series of exercises concerned with simple mark making and point grouping. The exploration of point would begin in a simple way by observing how one point placed off center on a square may destabilize space and prompt a further action that in turn creates another relationship. As the points accumulate on the surface, new directions and axes are formed that create lines, and as the density increases, shapes and masses occur. This concerned going back to first principles, investigating the simple act of mark making. In 1950, Hamilton's painting was concerned with these factors. In his teaching, he used point exercises involving the use of randomness, whereby students would trace and plot configurations based on the throw of drawing pins, matchsticks, darts, and dice. The method reflected Hamilton's interests in Dada, Surrealism, and Marcel Duchamp.

Points, particles, and the diagrammatic exposition of forces formed the content of much of Hamilton's early teaching. Students produced flow diagrams in which shapes were placed on a sheet of paper and currents and vortices on unobstructed particles surged between them. The diagrammatic explanation of force manifest in these works reflected the continuing influence of the naturalist D'Arcy Thompson, whose book *On Growth and Form* (1961) had been the subject of Hamilton's exhibition of 1951. The notion of form being determined by the action of outer and inner forces is central to much of Thompson's writing. The causative relationship between form and function and the inherent beauty of nature's processes revealed in Thompson was to provide a model for the artist and teacher. In his introduction to *On Growth and Form*, Thompson suggested that the immediate concern of the natural scientist was to consider the action or mechanism of nature and postpone considerations of universal truth or teleological concern with final causes. It was a mode of thinking that puts preconception to one side, concentrates on the analysis of process and change, and seeks to penetrate the inner structure of the natural world.

One simple reflection of the notion of form being determined by the action of forces can be seen in some Basic Design shape-making exercises. In the case of Harry Thubron, at Leeds, students were presented with cubes of alabaster and asked to modify the form by a subtle process of wearing the form away with a penknife (Forrest, 1985). The cube would be rotated in the hand so that the student could feel the form and modify it slowly by contemplation through feeling and touch. No dramatic changes were encouraged, and no tools were used that would insensitively intrude into the process. The form would change naturally through the forces acting upon it and not be willed into shape by any preconceptions on the student's part. Likewise, Geoffrey Dudley, at Newcastle, asked his students to carve into wood, gently modifying the shape, working carefully and sympathetically with the form and the grain. From forms, which are the product of external pressure, Pasmore concentrated on fashioning and modeling form from within, encouraging his students to make shapes that were a natural termination of the accumulation of marks on paper, or the three-dimensional build-up of shapes from pellets and lumps of clay.

Thompson's influence was manifest in a number of ways, the most explicit being the transformation and projection exercises of Hamilton's foundation course. The source of these ideas can be found in Thompson's celebrated chapter "On the Theory of Transformation, or the Comparison of Related Forms" (1961). Here Thompson set out a method of explaining the infinite relativity of natural form by means of a series of Cartesian grids superimposed over diverse but related natural specimens. Rather than defining the form, the Cartesian grids mapped out in dramatic terms the subtle changes and relativities between the specimens. In Harry Thubron's teaching, another variation of the idea of transformation would be the observation of metamorphosis, as students recorded the process of decay and withering in natural forms such as chrysanthemums. The influence of Thompson can also be seen in exercises involving the mathematical investigation of natural structure whereby, for instance, students would be asked to analyze the internal divisions and ratios of leaves. The precision of this kind of analysis was offset by a looser, more spontaneous response to natural objects, wherein students were asked by Terry Frost to react to rhythm and color. They were encouraged to make sheets of animated color charts, rendering the proportion and rhythmic structure of specimens ranging from flower heads to stuffed birds, eggs, and coral.

The Influence of Constructivisim

Constructivism underpinned much of the abstraction of the early 1950s. Victor Pasmore, Kenneth and Mary Martin, Adrian Heath, Robert Adams, and Anthony Hill were all involved with Constructivism. They engaged in regular correspondence with Charles Biederman, whose book *Art as the Evolution of Visual Knowledge* had profoundly influenced their thinking. Pasmore and Biederman had major disagreements with regard to art's relationship to nature. Pasmore affirmed art's independence from the visible world, whereas Biederman maintained that all of art's advances occurred only when the artist engaged in some kind of intimate dialogue with nature, building forms that paralleled and corresponded to its structure. What they shared was a belief that Constructivism was a new art, which embraced new materials, methods, and technologies. Pasmore had a modernist vision of the arts in which mural scale painting, monumental sculpture, and architecture would fuse into a new order. It is in this respect that he came close to the Bauhaus concept of unity. This vision of a Constructivist unity was also important in Pasmore's teaching, and it supported the thinking of many engaged in Basic Design because it provided a structure within which a free interplay of ideas could be built on the logical progression of point, line, and plane to construction.

Abstraction was the basis of Pasmore's teaching, and the role of the sculpture studio became paramount. He felt that through the manipulation of plane and solid form, students would experience and understand the concrete nature of the elements they employed. The character of much of the work was architectonic, with emphasis on plane and space enclosure. It reflected Pasmore's own constructions, in which he was exploiting solid and void, transparent and opaque forms. The void, the space, the transparent materials, and line construction indicated a sculptural alternative to the modernist orthodoxy of Henry Moore and Barbara Hepworth, who persisted with the traditional materials of stone, wood, and bronze. The sense of weight, mass, and monumentality, as well as the expressive gravitas of Henry Moore, was challenged by a lighter abstract precision exploiting light, line, color, and space.

Tom Hudson's teaching was also indebted to Constructivism, but he was less exclusively concerned with the fine arts and extended his ideas more ambitiously to new materials and technologies. For Hudson, the elemental point could be viewed not simply as a graphic mark, but as a possible transmitter of light, electric current, or a part of the process of spot welding. Line could be conceived as rods, wires, or drawn and extruded materials, and planes were constructed from sheet metals or solid perforated and expanded materials. Hudson avoided teaching standard procedures that provided ready-made solutions to problems; he encouraged his students to analyze constructional problems and processes rather than apply received techniques (Thistlewood, 1981).

Other Influences

Abstraction was a significant but not exclusive concern of the Basic Design movement. Although Richard Hamilton worked very closely with Victor Pasmore, he was, as an artist and teacher, committed to a different set of problems and issues. He was a figurative artist and founding member of the British Pop Art movement. He was creatively engaged in forming a new representational art expressing contemporary society and values. In his early art, influenced by D'Arcy Thompson, Hamilton explored aspects of the natural world. Partly stimulated by the deliberations of the Independent Group, his interests were extensive, ranging from perceptual psychology, semiotics, and information theory to chronophotography, Marcel Duchamp, and the mass urban imagery that reflected the content of Pop. He was primarily interested in the way humans view the world. One significant part of his course dealt with matters of visual perception, from Gestalt exercises concerned with figure and ground to investigations into problems of illusion and depth perception influenced by books such as J. J. Gibson's *Perception of the Visual World* (1950). Hamilton was able to contribute to color theory his own interests in color association and symbolism in advertising and product design.

Colorists such as Terry Frost preferred a more intuitive approach to color and were able to bring a unique insight into color based on analysis of natural forms and the environment. As an abstract painter, Frost had been obsessed with color, bringing together in his paintings all the color changes distilled from the coastal environment of St. Ives and Newlyn in Cornwall. He would introduce each color to his students, doing a page of reds, blues, and yellows, impressing on them the infinite variety and relativity of each color. These were disciplined exercises, but what emerged from these simple beginnings were studies of great vitality and individual beauty. Tom Hudson introduced into his researches color optics and afterimages, bringing together his psychological and technological interests. As in most areas of his teaching, Hudson seized on the potential of extending color research into new materials and technologies, beaming light through a variety of materials and filters, always underpinning his teaching with theory and discussion.

Hudson and Hamilton brought an intellectual dimension to their teaching that was against the grain of anti-intellectualism that was so endemic in many art education circles in Britain. Both were opposed to the introversion of Neo-Romanticism, which engendered a somewhat precious spirit of exclusivity in British art and art education; they wanted a more generous recognition and affirmation of the changes taking place in urban society. Hudson's great curiosity for taking art into all fields of technology paralleled Hamilton's concern for extending the visual language of art into the world of science and those hitherto-despised areas of urban popular culture. Billboard images provided material for analysis, and head images made from collage and assemblage became one area of invention reflecting not only ideas emanating from Eduardo Paolozzi and the Independent Group, but also the Dada and Surrealist roots of much Pop art. Dada and Surrealism are the antithesis of Constructivism, but even an individual so learned in Constructivism as Tom Hudson would seize on the potential of assemblage and the indeterminate juxtaposition of phenomena in order to generate new material possibilities and pave the way to performance art.

Richard Hamilton's course concluded with analytical drawing, painting, and sculpture, which normally took the form of object analysis. Students were invited to choose objects that had a personal significance to them, ranging from cuckoo clocks, lemon squeezers, paint boxes, and spinning tops to other such categories as the cricket match and Charlie Chaplin's trousers. Unlike Victor Pasmore, who was exclusively concerned with abstract values, Hamilton's course contained a balance of ideas ranging from the purely formal legacy of Pasmore to object analysis, which was concerned with the everyday visual world.

Legacy of the Basic Design Movement

This summary of the Basic Design courses is, of necessity, highly selective, giving an account of the content rather than the spirit of the teaching. Describing a series of exercises in the absence of illustration may project a dull picture, and it is particularly difficult to convey convincingly their originality and sense of innovation from the perspective of the 1990s. Nothing can convey the sense of excitement among Pasmore's students in the 1950s when they felt they were being given the key to the mysteries of abstract art. Much of what happened was successful because of the charismatic nature of gifted teachers and artists who put themselves across with great conviction. When Walter Gropius was asked whether it would be possible to replicate Bauhaus teaching at Birmingham College of Arts and Crafts in the 1930s, he replied that it would be impossible because what really characterized the Bauhaus was its atmosphere. So it was with the Basic Design courses in Britain, which were essentially an ad hoc expression of the creative concerns of the artists involved. Later on, Basic Design became a universally applied method, rather than a genuine creative partnership between teacher and student. Because it was severed from its creative roots, it degenerated into a new academicism.

The influence of Basic Design methods persisted in the foundation courses well into the 1970s, and certain questionable aspects penetrated into the secondary and primary schools. How much of this had enduring value and how much can be consigned to the history of the 1950s and 1960s remains an interesting question. There is still a case for students in higher education to pursue some formal study of the basic elements of color, tone, line, shape, texture, and so forth, but, as in the past, it is up to each generation to interpret this in its own way and on its own terms. Perhaps the most

important distinguishing features of the Basic Design courses were the experimental and critical attitudes they promoted, as well as the paramount factor of appointing committed and creative artists to work alongside their students. These were the factors that defined that special atmosphere and gave the courses their creative impetus, and it is those animating principles that have enduring value.

The most significant challenge facing British schools today is the new National Curriculum, in which guidelines have been established, concerning content and attainment targets, that affect the teaching of art from infants to adolescents. This is the first time that Britain has had a nationally determined art curriculum since Cole and Redgrave established the South Kensington model in the 1850s. Some statements within the new National Curriculum reflect the continuing need to study the formal elements, and there is a lingering Basic Design presence in the following statement: "This objective is concerned with the development of knowledge and skills in order to select, control and use the formal elements of the visual language (line, tone, color, composition, form, and space, etc.) common to most art, craft, and design" (Department of Education and Science, 1991).

Formal values constitute only a small part of the National Curriculum, but in a wider sense the new curriculum shares the fundamental Basic Design belief that art does have a rational content and structure. The National Curriculum document also encourages something of the critical and experimental attitudes of the Basic Design movement. It remains to be seen whether the content and structure will sustain experimentation and freedom, or whether teachers, feeling obliged to teach to attainment targets, unwittingly return to the Gradgrind methods of the old national curriculum perpetrated by Henry Cole and South Kensington.

Notes

[1]Following the publication of Maurice de Saumarez's book *Basic Design*, the term "Basic Design," like "Impressionism," has become common currency, and for this reason I use it with some reservation. Victor Pasmore emphatically rejected the term, preferring to describe his course as a "Developing Process," thus emphasizing its dynamic and changing nature. The term "Basic Design" was never used at Newcastle, where the course was variously described as the basic course or the foundation course or occasionally referred to as basic form studies.

[2]The exhibitions *Abstract British Art* and *Abstract Art* were held at the AIA Gallery and Gimpel Fils Gallery in 1951.

[3]The Independent Group represented a gathering of artists, designers, and critics who formed a subgroup of the Institute of Contemporary Arts in London. Leading members included Richard Hamilton, Eduardo Paolozzi, William Turnbull, Lawrence Alloway, Reyner Banham, Tony del Renzio, Nigel Henderson, Alison and Peter Smithson, Frank Cordel, and Robert Melville. They organized numerous exhibitions, lectures, and seminars on a diversity of topics that expanded the possible content of art and addressed new technologies, as well as affirming the modern urban environment as potential source material for art. The group provided new attitudes that allowed for the emergence of Pop in Britain and challenged prevailing Neo-Romanticism in British art.

[4]Probably derived from Coomeraswamy quoting St. Thomas Aquinas.

References

Biederman, C. (1948). Art as the evolution of visual knowledge. Red Wing, Minn.

Department of Education and Science. 1991. Art for ages 5 to 14. [National Curriculum.] Welsh Office.

Forrest, E. (1985). Harry Thubron at Leeds, and views on the value of his ideas for art education today. Journal of Art and Design Education, 4(2).

Frayling, C. (1987).The Royal College of Art. London: Barrie and Jenkins.

Ghyka, M. (1977). The geometry of art and life. New York: Dover; Le Corbusier, (1954). The modular. London: Faber & Faber; Hambridge, J. (1948). Dynamic symmetry of form; Power, J. (1933). Les elements de Ia construction picturale.

Gibson, J. (1950). Perception of the visual world. Boston: Houghton Mifflin.

Richard Hamilton, interviewed by Peter Sinclare. (1974). National Art Education Archive. Yorkshire, U.K: Bretton Hall.

Kandinsky, W. (1947). Concerning the spiritual in art, and painting in particular. [Originally published in 1912.] New York: Wittenborn, Schultz.

Klee, P. (1934). Handzelchnugen mrt vollstandigen Kutalog hrsg. von will Grohmann. Bergen II: Muller & Kiepenheuer.

Loos, A. (1910). Architecture. Quoted in Sharp and Benton (Eds.). (1975). Form and Function (p.41). London: Open University Press.

Thistlewood, D. (1981). A continuing process. London: I.C.A.

Thompson, D. (1961). On growth and form. Cambridge: Cambridge University Press.

PROJECTS AND PROSPECTS

EDITORIAL

■ READ M. DIKET

Sociological themes predominate in the following chapters concerning projects and prospects in art education in various countries. To varying degrees, the authors investigate art education for the individual, for the appreciation of diversity, or as it pertains to the sociological entity of the country. The relationship between the practical and the meaningful in art education is often precarious, emanating from psychological, philosophical, or political arenas formed by sociological forces in the contemporary world.

The authors report on art education projects as if they were field workers or anthropologists. They observe, interview, record, document, and collect data. They register codes of conduct and conventions or point out compromises between ideal and actual practices. Ideal expectations are often subordinated to the very real needs, motives, and feelings of people.

Barbara Carlisle examines art education in China and her own responses to it, and introduces the reader to a problem in cross-cultural evaluation. Carlisle, an American, was invited by the Chinese to observe and comment on their programs in art education. She speaks of three stages of engagement during her 2-month stay. In the first stage she is inundated with the more obvious aspects of the Chinese culture, those presented in stores and hotel lobbies for the tourists' benefit, and becomes disenchanted with the conventions of Chinese art and its stereotypes. During the second phase, she discovers the freshness and beauty of peasant arts and, at the same time, discerns master teachers in some rural schools. Gradually, in the third phase, she becomes aware of the narrow conventions of so-called *Western painting* that are insinuated into the Chinese art tradition.

Carlisle confronts her own biases in the course of her chapter and moves toward an appreciation for the underlying tradition upon which the Chinese educational system is based. Chinese art, Carlisle suggests, is closely tied to the written form of the Chinese language. Because Chinese pupils must memorize characters in order to read and must be able to duplicate complex pictograms in order to write in their language, art education has a strong pragmatic orientation. China is confronted by a shortage of qualified art teachers, and conditions in the schools vary greatly; yet some teachers address linguistic goals for art and also attempt more recent cognitive and imaginative objectives. Carlisle concludes that it is a mistake to specify outcomes without a consideration of the richness and strength of traditions from which educational goals arise.

Andrea Karpati discusses The LEONARDO Project and sets recent developments in Hungarian art education within a historical and sociological context. Four decades ago in Hungary, art education served to solidify political agendas. The new, progressive art educators, however, intend to carry out large-scale assessments of more diverse programming. Far from advocating a singular model, the Hungarian Research Group on Art Creation and Criticism seeks to validate a number of programs that originate in specified school settings and that complement the central art curriculum. The model programs are designed for children to address their aesthetic, creative, cognitive, and psychological needs.

The research agenda is comprehensive, including an assessment of localized teaching packages, documentation of outcomes after different educational approaches, identification of interactions with socioe-

conomic and psychological factors relative to the model programs, and pilots for teacher training and inservice support of alternative curricula. Because the LEONARDO Project is ongoing, interpretation of its expected outcomes is speculative. The program is based on a strong rationale, and its cooperative ideals and discipline orientation are shared by participants. Given the practicality of the experiment and the expressed determination to make corrections during testing, along with the program's consideration of Hungary's traditional arts, the testing of these models constitutes a major research feat with implications extending beyond the boundaries of one country.

John Lancaster, an external examiner and advisor to the University of Zimbabwe, assesses art education at teachers' colleges. He suggests that, at present, art education in Zimbabwe is inadequate to the task facing it. The inadequacy stems from a scarcity of facilities and materials, from cultural insulation and ignorance of international research in the field of art education, and from a concurrent lack of national support.

The task facing this African nation, as discussed by Lancaster, is to determine how art education can develop locally in schools and top-down from the colleges while maintaining a strong grounding in indigenous arts. Lancaster's solution at the service end is based on individual developmental needs. Problematic in teacher education is the balancing of exemplars. Lancaster specifies Western and African artworks that teachers and their students might connect with both indigenous and cross-cultural sources. He maintains that it is an appropriate goal for art education in Zimbabwe to develop artists and craftspeople who draw upon the old traditions and create new expressions.

Lancaster advises that the role of art in Zimbabwe is far reaching and that aims and philosophies of art education escape the confines of subject area. Art is essential to the continued development of education in Zimbabwe, and it should be included as a compulsory component in the curriculum for "the sake of the children in the schools."

Lois Petrovich-Mwaniki observes the changing status of art education in a unified Germany. After describing the structure of German education and its historical association with class distinctions, Petrovich-Mwaniki explains art education's new prospects. Art education is emerging during reunification as a reform subject given equal status with the other major school disciplines. The West German sys-

tem is the predominant educational model, although there is an intimation that East German theory and practice should also be considered during the restructuring period. German art education has its philosophical foundations in guiding student and teacher acquisition of knowledge; learning and teaching practices; social and academic behavior; career options; and perceptions of social, economic, and political issues.

Art educators in Germany are now addressing multicultural education. In a unified Germany, this includes acceptance of diversity and valuing of differences between East and West German systems, and it supports subcultural variance. An example of this is the Turkish guest workers, who came as temporary workers and were expected to return to their home countries. Most of the guest workers stayed and established families in Germany, and their dual identity must be given meaning. In the same way, it is expedient to focus on East Germans and their prospects in a unified Germany. New deliberations about art theory and practice, Petrovich-Mwaniki says, are leading to the creation of an open, critical, self-reflective attitude in the unified German school system.

W. R. Philip analyzes art and design education in South Africa. Art education in South Africa traditionally has been an activity of the white population that follows the English pattern. Philip, born in Africa, discusses the prospects of a more egalitarian view of art education whereby "art and design are considered in all their forms." Research is needed in curriculum development and modifications for persons within the culture. Philip maintains that less-privileged groups deserve richer mental and physical lives that can be effected through a child art movement and continued opportunities for creative work at the secondary level.

Philip suggests that community involvement is a prime factor in racial harmony. He points to a number of qualitative improvements in South African art education: (a) more art centers that are supported by community funds; (b) a new interest in meaningful art instruction at the secondary level; (c) indications of flexibility in tertiary education for South Africans; (d) growing recognition for nonwhite artists and traditional crafts; and (e) a new, professional spirit of self-sufficiency.

The prospect Philip presents for developing a tradition "beyond the handicrafts" is optimistic, but it depends on the acceptance of new materials and technology. Perhaps because the cultural forms of South African art were not strong in comparison with that of

other black cultures, a tradition is actively growing with interplay between idioms derived from African and Western art. At present, black artists are funded by white patrons and need a wider audience. Philip suggests that a new avenue of opportunity lies in the field of graphic design.

John Steer summarizes new curricular developments in art, craft, and design education in Great Britain stemming from the 1988 Education Reform Act. The new national curriculum includes cross-cultural study, which, as the government expects, will lead to multicultural understanding in Great Britain. It provides assessment of three domains with broad criteria for investigating, understanding, and making art. Art is designated as a foundation subject to be "phased in over a 10-year period." The prospect for delivery of the new curriculum is limited in the primary schools, where it is the province of generalists. Steers is more optimistic about secondary schools, where subject specialists will teach art and design.

Educational policies are based on cost-effectiveness. Art is increasingly seen as a key element in Britain's industrial development. Even as jobs in goods-related industries diminish, opportunities in the media abound. Britain exports many of its designers, to the benefit of its competitors. At present, more students are electing to study design disciplines at the tertiary level, and Steers suggests that the increase reflects the job market. There is strong support for the education and training of designers even as the emphasis shifts away from liberal arts areas.

It is not surprising to find substantial disagreement among art educators in Great Britain regarding the role of discipline-based instruction in the new curriculum. Although British educators demonstrate little interest in the discipline-based art education (DBAE) model, some wish to include more instruction of a critical or contextual nature along with production in the art and design model. Multicultural awareness, a strong cross-curricular theme in the new curriculum, is communicated through critical reasoning. Steers admonishes that a less defensive stance on the part of Britain's art and design teachers, along with clearly defined, rational support from within the field, will be crucial during the next 2 years.

Irena Wojnar, in her exploration of art's socioeducational functions in today's world, reminds us that the question of "What is art?" is centuries old. She maintains that there is no "simple dependence between the social functioning of art and the actual basis of its social origin." Art can be seen as having a dual existence in lived time and in its timeless values. Because possibilities for human creation in the arts are more diversified in the modern world, the possibilities for education in the arts are more numerous.

Four educational as well as social functions of art, as outlined by Wojnar, are (1) the sublimation of life, (2) the establishing of new material facts, (3) compensation and means of escape, and (4) generalized creativity. The first category, *sublimation*, and the fourth category, *generalized creativity*, have powerful psychological associations. *Art as the establishing of new facts*, a philosophical conjuncture of utility and creativity, is a median reality. *Compensation and means of escape* are fraught with political overtones. Art as a phenomenon is both situational and lasting.

Wojnar's article elevates issues in art education to the larger context of contemporary society. Art can transcend sociohistorical reality, extending into a timeless dimension. While she writes about intricate relationships the arts have with new technologies and techniques and with mass media, it becomes evident that the formula of arts is enlarged and opened to previously unknown possibilities.

Through a dialogue across cultures, art education is reflected, refracted, and echoed in the sight and voices of professional counterparts. Educators elaborate and institutionalize the processes they observe in their own counties and those they visit. Interestingly, art educators resist cohesion at both personal and societal levels. Between nationalities there are striking differences in emphases. In varying ways the authors explore systems whereby teachers and students might find rich meaning in the classroom and educational systems grow downward to the level of the individual. Educators seek to talk to one other because art impacts at the symbolic, abstract level of existence and influences what occurs in the jointly-held, physical world.

[THE FOURTH GOOD: OBSERVATION ON]
ART EDUCATION IN CHINA

■ BARBARA CARLISLE

"He sees most clearly who stands at the side." With characteristic Chinese modesty, our State Education Commission host invited the comments of two Americans on China's art education. Ten weeks of close observations had taken us to Beijing, sites in Shaanxi Province including Xi'an, Baoji, Yanan, Fengxian, Ansai and Huxian County, Chongqing, and Qijiang County. Knowing by then that the request for comments was a standard formula for greeting foreign guests, I began my list with some hesitancy. Here, however, our questioner was directly insistent. Would we summarize and critique what we had seen? What I told them, and why I said it, follows.

The Investigators

The two of us came to China with different eyes, Carma Hinton's conditioned by twenty-one years of growing up there, going to Chinese public elementary and high schools, and returning regularly over the past seventeen years; mine trained to observe arts education from serving as a state-level arts education coordinator and on several task forces or committees that took me to schools around the United States. Carma's unique expertise was in the country and the language, mine in school organization and arts teaching philosophy.

Discovering Art in China

As a new person to the country I experienced three basic stages of engagement in the art of contemporary China. The first was the most obvious. Hotel lobbies, shop windows, the Friendship Store—every place tourists are likely to pass—ink on paper, landscapes, primarily, but also figures dancing or ancient warriors in combat. After only a few days the sheer volume devalued them for me, even as curiosities. But I kept looking, and occasionally one artist's work would stand out as fresh and lively, clean, personal, uncluttered, the brush technique applied to a local scene or a unique subject. The accompanying panels of calligraphy held their interest for me long after I grew weary of the paintings, perhaps because my eyes responded to calligraphy's fundamental structure. But I longed for some alternative conventions, something less contrived, something more revealing of the person underneath. I knew it existed in the originators of these traditions. I was not ignorant of the value of repetition for the Chinese, nor of the aesthetic underlying the work. It was relief from the mold and dust, fresh air, that I sought.

I found that freshness in the second phase of our journey, in the charm of peasant arts and crafts. In Beijing my visual field was immediately assaulted by the pervasive Qing Dynasty fondness for elaborate, densely packed, intricate detail. The taste that prevails in the imperial palaces, gardens, and temples dictates the character of modern jade ornaments, cloisonne, lacquer, and embroidery and has its inevitable degenerated consequence in ordinary plastic and metal objects. Not only the horror vacui but the sentimentality stuck to my teeth. My initial admiration for workmanship quickly gave way to a hunger for simplicity and clarity. Once we had left Beijing I found that need fulfilled in the art that has been dubbed in China "peasant painting" and also in its sources in traditional embroidery, woodcuts, paper cutting, and textiles. I learned to be grateful to the regional cultural centers that are preserving the folk arts. I found great personal satisfaction, too, in everyday objects made in the countryside—pottery, baskets, hand-forged ladles and pans, wooden tubs, brooms and brushes, which are universally considered crude and primitive by the Chinese and do not fall into any category of art by their reckoning. Into this picture dropped, at the same time, exhilarating confrontations with the strong, simple, often lyrical forms of Zhou, Han, Tang, and Song ceramics, sculptures, and murals found in tombs and provincial museums but forgotten in the aesthetic of contemporary China.

Reprinted from *Journal of Aesthetic Education*, Vol. 23, No. 1, Spring 1989, (pp. 17-29)

The third layer, coming to understand what the Chinese call "Western painting," was more puzzling to an American. I mistakenly thought that term to mean everything done in the West, as opposed to everything done in China. Textbooks, classroom exercises, and exhibitions soon taught me that "Western painting" is a very narrow subset of Western tradition, frozen just at the pre-impressionist phase, encompassed in China in a program of study that begins with pencil-shaded drawings of still lifes and casts of Michelangelo's *David.* It is defined by the training Xu Bethong received at the French Academy in the early twentieth century and was subsequently both reinforced and restricted by the Soviet school of the 1950s. After tedious thirty-hour cast drawings, students are taught "color" with gouache paintings of fruit and bottles. Finally the artist declaring himself or herself to be a Western painter emerges with basically realistic oil paintings or heroic sculptures. The subjects are categorical: romantic depictions of China's minorities in rural scenes, historical or allegorical figures, or landscapes and still lifes. Dashes of Rouault, early Cubism, Russian Constructivism, Impressionism, and Surrealism occasionally season adult work, but I came to realize that no more recent, nor, indeed, earlier aspects of Western tradition have been absorbed into China. They unquestioningly assume that anything else is either trivial or decadent and not worth discovery. Chinese students and teachers were astonished to hear that the golden mean does not always govern the frame of Western art. Western medieval art, either monumental or personal, was totally unknown. The contemporary movements that have penetrated the armor are summarized as photo realism and pop art, each given a sentence in the basic history text. As soon as I lamented this situation, I winced to think of the equally limited summaries of Chinese art provided to American students.

Art in the Lives of Children

Part of our task as we conceived it was to uncover the context of art for children. I believe that context includes everything in their visual environment, and, more subtly, everything that they have been given to believe is art. For a child that means illustrations in books, magazines, and newspapers; decorations on bowls and vases, knickknacks sold for souvenirs or for decoration in the home; images on wrapping paper, in textbooks, on posters, on billboards and advertisements, on labels and commercial packaging. These are the things that they can see are produced by artists. In addition they are taught that there is a certain set of things that are called traditional Chinese painting and

another set that are called Western painting. Taken as a whole this visual environment constitutes Chinese taste, and it establishes the models that the children attempt to imitate.

In my view the artistic repertoire for children is very limited and highly sentimentalized: cartoon-like ducks, pandas, frogs, squirrels, foxes, butterflies, and rabbits, with daisies, bamboo, and a few wavy lines for water; children with simple round faces, bright red cheeks, and neatly parted hair; fairy-tale women in flowing gowns; Qing dynasty officials in robes; lotus flowers, peonies, and, in the fall, chrysanthemums; landscapes schematically composed with houses, mountains, and lakes; children playing games; Pigsy and the Monkey King.

A few notable exceptions are important. There are the still vital images from traditional Chinese painting, which preschool children are taught the way American children learn pumpkins, black cats, Christmas trees, and snowmen. In China it is cherries, polliwogs, fish, and later magpies, horses, chickens, dogs, and crawfish. We also talked to a number of talented young people, both teachers and children still in school, whose early efforts at art had been influenced by the penny adventure books that are often illustrated with complex line drawings, usually depicting ancient warriors. In many cases good artists make these drawings and fill them with elaborate detail, using interesting perspective views and compositions full of pointed action. In the countryside children may grow up where peasant engravings, paintings, paper cuts, and embroidery have not yet been replaced by mass-produced illustrations on plastic or metal. Where these traditions are alive, parents and teachers have encouraged children to use such images, and the children's drawings depict animated scenes from their own lives or the traditional folk images of animals and plants. These latter are neither sweet nor sentimental, though they are schematic and conventional and highly decorative.

In the city, girls devour new magazines and clothing advertisements and comb store racks for the latest fashion designs. Parents who dress quite soberly do not hesitate to put their children in the brightest new colors and fads. To compensate for the lack of available resources, many Chinese women, especially the young, knit or sew. I became the center of interest on a CAAC flight because I was finishing a sweater in a rather modish style and the stewardesses wanted to see how I had achieved it. As children depict themselves engaged in their favorite activities, what they are wearing occupies fully as much of their attention as what

they are doing. From about the fourth grade on, girls draw endless notebooks of clothing ideas.

It soon became apparent that the crafts, as we have come to think of them in America since the arts and crafts movement of the late nineteenth century, have only the thinnest veneer of support in China. Such practical handcrafts as quilting, basket making, and utilitarian ceramics are not art by Chinese definition. Boxcar loads of embroidered materials and wood, lacquer, or bamboo knickknacks are produced in a prescribed formula for both domestic and foreign consumption. There is a big industry in replicating antique ceramics, and there is an emerging glass-cutting industry. These all contribute significantly to the definition of contemporary taste. Further reduced versions become the curriculum for what unimaginative teachers offer their students as crafts projects. There are crafts departments in the art academies, and some very interesting ceramics are produced there. However, "crafts" in China, as practiced in art classes, means largely making pictures out of materials other than paint, e.g., shells, nuts, seeds, sheets of plastic foam, string or pasted fabric, plus embroidery—reserved for girls—and modeling in plasticene or carving in chalk.

We observed a happy exception in four classes by one master crafts teacher in Beijing, Rong Jingxin, who treats the subjects as an opportunity for children to combine the work of their hands and the work of their minds in a carefully devised system of problem solving and skill building. In a clay modeling class he demonstrated and let the children practice rolling, coiling, pounding, pinching, inserting, and incising the clay, indicating how it is possible to achieve certain effects with each process. He showed them how to connect parts and made an animal. Then he asked them what animals they would like to make, taking time for the children to think and answer, and he encouraged each of them to make something different. While they worked, he observed them closely, guiding individuals when they had difficulty, asking questions, and helping each achieve some success in what he or she had chosen without defining the solution to the problem. All the children's animals had lifelike vitality. All were different. All were successfully constructed using the methods Rong had explained. Rong has created a crafts curriculum that has been distributed throughout the city, but few understand it so well as he. Although the demonstration followed by practice is the standard method of teaching in China, I saw few teachers who could identify with such clarity the necessary skills, involve the children in the learning, and then offer a problem that demanded the use of those

skills in its solution. The process was very conscious for Rong, and he saw crafts as a means for combining hand and mind activity and stimulating problem solving ability.

Another wondrous exception to formulaic crafts work was the clay modeling done in one Xi'an elementary school, where table after table was filled with children's sculptures, manufactured from local mud, some painted, some left brown, and each one uniquely alive. There were animals of every sort, warriors, gods, dragons, fruit, and figures. Some drew their inspiration from the penny adventure illustrations and escaped any sentimentalization. The teacher told us that he urged the children to draw as a preparation for sculpture and to sculpt as part of drawing. School work on the board indicated that his students had done exercises in paper cutting, drawing, and composing with torn and cut paper and that they had used the textbook as a resource, but each child had been encouraged to work independently.

As I learned about the crafts, I had the accompanying realization that the concept of good design, meaning a harmonious relationship of parts, function, and appearance, which is both economical and efficient, is not a term in common use among the Chinese. There is a word for design which means a decorative pattern and another that is translated "surface structure" and refers to geometric patterning of two-dimensional space. There is a word for industrial design, meaning plans for building a machine, and the basic conventions of Chinese painting are seen as design in the sense that there is a concept in the mind that guides the whole. We had difficulty, however, when we wanted to discuss the teaching of design as a component of basic art training, as two- and three-dimensional design are regularly taught in American art programs. Only among some teachers of commercial art were we able to discuss design (goucheng) as an overall concept used in the same way American designers use it. Although there is a national publication that devotes itself to commercial design and identifies both Chinese and foreign examples for its readers, the illustrations seem to be an eclectic collection of objects and samples of commercial art with no guiding principle for selection. It is clear in the production of Chinese goods and crafts that modern design concepts, or, indeed, modern interpretations of the ancient crafts traditions from the Song and Tang, have not penetrated either the factories or the art schools. I believe that until the principles of design are more broadly understood and taught, China will have difficulty creating goods that compete in the international market.

Honestly stated, the report to the Commission must be seen as partner to my staged immersion in art in contemporary China. And it must be acknowledged as flowing from my likes and dislikes. Moreover, the immersion was feet first, seeing art through its interpretation in the education of children and gradually wading into the art of ancient and modern China as opportunities arose. I did not go to China as a student of classical Chinese art, but rather came out of China with a perception of art as I found it in the life of the Chinese.

The Climate for Exchange

Explicit directions from the State Education Commission and the understanding of intelligent, responsive, and persistent hosts at each site made it possible for Carma and me to see a variety of schools, with better and worse conditions, with better and worse art programs, and in a variety of community settings. Without the Commission's sanction and the persistence of our local hosts, school officials would have been adamant about restricting us to "key" schools and may not have allowed us long talks with teachers, repeated classroom observations, and private discussions with parents and students. That insistence of the Commission, which went before us in a long written document, opened the door for a genuine exchange of information and painted for us a broad canvas of art education. We arrived to find already in place a critical mutual understanding with our local hosts, He Dexiang, who worked for the Beijing Educational bureau, Li Ming, of the Shaanxi Provincial Education Bureau in Xi'an, and Wang Jiaji, of the Pedagogical Sciences Research Institute in Changqing.

It would be naive to imagine that nothing was staged for us. We were told that the Baoji Education Bureau had prepared for our three-day visit for two weeks, and our driver, an endless source of valuable insights, reported that the factory school where we spent barely a morning had spent 20,000 yuan to paint the building, get new uniforms for all the teachers, and even uniforms for the school band that greeted us in the courtyard. We saw a thoroughly rehearsed lesson in clay figures, and other than learning something about Chinese pride—a valuable lesson, of course—we did not advance our research significantly. The teacher was lively and animated, using a carefully prepared vocabulary chart and a set of prepared small clay figures. The children called upon to define the terms did so with dramatic pedantic accuracy. And when it came time to model animals of their own, the children did them with great speed. When I asked several of

them if they had made the figures before, they all indicated that they had done so, just last week.

At every school where we spent any time at all teachers were aware of our presence, pictures had been hung, a reception room prepared, a schedule planned for our convenience. We often saw performances of Chinese painting by talented students who, we learned by asking them, had not been trained in school but by private teachers or in the Children's Palaces. I thought of the way American principals and teachers like to offer shows to the school board, with the same promotion of talented kids whose parents have paid dearly for the performances the schools exploit. But for the most part these demonstrations were quickly admitted to and set aside once we began to talk. When we sat through whole classes, when we interviewed the children or asked to meet all the teachers teaching art and insisted on seeing classes of each one, the talk was open, lively, and unguarded. We were able to photograph students at work, and there was no interference, subtle or otherwise, urging us to select anything but our own choices.

In some places the art workers of the district got severely criticized, as did the principals of individual schools, for letting the visitors see schools that "did not have conditions suitable for receiving foreigners." Usually this referred to such irrelevant matters as open pit toilets or the lack of a reception room. It also meant that we saw some of the truly primitive conditions under which Chinese teachers and children work— seeping cement walls and floors, no heat, no electricity, old cracked benches and desks, sixty to seventy children to a classroom, poor-quality paper, pencils, ink, and paints in rationed quantities, and soggy mud playgrounds. Naturally we hope China will be able to put more of her scarce resources into education in general to improve the conditions of the schools and the lot of teachers, but what was much more significant to us was the fact that in spite of primitive conditions, we observed art teachers doing stimulating teaching and children producing high-quality work. Moreover, we did not see dreary, oppressed children, but everywhere found them full of laughter, energetic, playful, as well as focused and attentive. There is a lesson in that for every teacher who complains that he or she would like to do this or that but cannot because of limited time or money. Teachers with imagination, insight, commitment, and understanding, combined with highly disciplined students, are overcoming the most discouraging physical constraints in every town or village we visited.

A New National Direction

The Commission can take real pride in its new national commitment to cultural education, announced only four years ago and reaffirmed in 1986 by the Party Congress. Something is happening in every school. The range of execution is extremely wide, but the message is clear: art belongs in the curriculum. The presence of the textbook, even if it is ignored or misunderstood and has serious limitations, is the tangible evidence of the art requirement. Everywhere school directors began their *pro forma* speeches with the recognition that schools formerly concerned with "the three goods," moral, intellectual, and physical, had now added now a fourth, "cultural good." This national policy change is understood at least rhetorically. For many of the people we met, it is the reestablishment of something in which they have long believed, but which was either forcefully eliminated during the Cultural Revolution or ignored programmatically until its recent official reinstatement. I can say without hesitation that where we found evidence of an imaginative program, we also encountered teachers supported by an intelligent, sensitive principal. He or she was taking the new opening as an opportunity to provide a dimension of education perceived as distinctly missing.

In a small county town, Qijiang, near Chongqing, a principal, a normal school director, and the art teacher revealed with pleasure that they had never eliminated art in spite of the Cultural Revolution. This was also a place where an active cultural center was encouraging some wonderful print making by peasants and townspeople. Likewise here was a teacher, formally trained in a county normal school thirty years ago, whose focus on specific compositional skills and clear and explicit directions accompanied by pointed side coaching of individual students constituted some of the most sophisticated art teaching I have ever seen. He began the class by showing students how to identify and use relationships between large and small shapes by leading them through critiques of their own past work. He talked with them about the subjects of their assignment and guided them to likely topics. As they worked, he helped them take advantage of color contrast and helped them correct the lack of it. He helped them elaborate with appropriate detail and led them to complex and focused organizations of figure and ground. We saw a second grade class create under his guidance original, personal, well-designed, well-composed pasted paper compositions with good contrasts in color and skillful representations of objects. It was also obvious in their aesthetic choices that these students had developed an appreciation for the prints that had become a community preoccupation. The materials were simple, the conditions primitive, but the teaching was superb.

Teachers

If the principal is the critical force in the total direction of the school, a fact borne out in China as it is in the United States, there is, I state presumptuously, still only one interaction that counts in education, the one between the teacher and the student. China's national shortage of teachers in general is magnified exponentially in the case of art teachers. Many inexperienced people are teaching art, both those trained in art but woefully inexperienced in teaching and those trained as teachers and handed the responsibility of teaching art without any perception of the task. It is an acknowledged problem everywhere.

Good art teachers do exist. Most of them have been trained in normal schools and have a natural interest in art to which they have applied good teaching principles. A few are artists on provisional certification documents given teaching assignments. A handful have been trained in provincial art academies, have somehow wound up teaching, and have a natural feeling for it. The good art teachers already at work are China's untapped wealth. In a few cases district-level people are actively bringing experienced art teachers together to work with new teachers, but generally the expertise of those with understanding and sensitivity to teaching art is not being exploited. The fact that we were taken to see master teachers, even when they were teaching in remote rural schools or within the enormous systems of big cities, indicates that someone in charge knows who they are.

The Commission needs to encourage the network possibilities for inservice education that are cheap and effective, using these teachers. Master classes, "each one teach one" apprenticeships, workshops, or exchange classes can be carried out at the local level. It is important to look at the models that already exist—experiments in Xi'an and Chongqing, for example—and are making strides in their own small centers.

There is an enormous hunger for new ideas. When I offered to teach a class in Chongqing for art teachers, using some American teaching methods, the room was jammed, and we could have stayed for hours answering questions and discussing points of view. This was in a town where an hour's bus ride to cross the city is

the rule, and people gave up their one-day weekend for the opportunity to learn something new.

Wherever we were asked to show slides of American children's art and to discuss teaching strategies and evaluation techniques, the rooms were packed, and the questions tumbled over one another in an endless rumble. "What are the main issues in reform in art education in America? What is the curriculum for art education? What is the preparation of art teachers? How do we test and evaluate art education experiments? What evidence is there to support art education as the best subject to develop students' creative thinking? What are the daily lessons? Is there a national curriculum? What textbooks do we use? Can we get examples of teaching materials? How are art teachers organized? How do art teachers get inservice education? What is the status of the art teacher in America? Are art teachers well paid? How many classes do they teach in a day? What kinds of materials do art teachers use? What is your opinion of art education in China? What are examples of art educational practice around the world? I answered as much as my experience allowed. The questions revealed passionate desires on the part of hundreds of teachers—we probably spoke to two thousand in the three sites—for information about their counterparts.

We met Beijing art teachers who associate across the city on their own to help teach each other. We saw a video tape prepared by the master teacher Wang Luping, at Fu Xue primary school, which guided teachers through three classes for children in the technique of fine-line painting. The newly formed Beijing Children's Art Association is assembling both teachers and artists who want to help develop art education. This latter association could be nationalized to serve as a conduit of teaching ideas and as the hub of a network of exchange. We encouraged the Commission to stimulate such interaction without trying to direct it with proclamations. The Director of the Chongqing Education Bureau has 36,000 teachers to administer. Numbers like that defy simple solutions. The answer must be in continually expanding local circles of influence.

Our Education Commission host agreed that the issuance of documents from the state does little to improve actual instruction. She commented that many documents never arrive at remote destinations, and when they do, they are often misinterpreted. More intimate and personalized strategies are more likely to work. All must recognize that it will take time to accomplish the teacher education that they desire. I was reminded that fifty years ago in the United States the typical elementary teacher had two years of normal school education beyond high school and that not twenty years before that, it was common for a teacher in a rural school to be an eighteen-year-old high school graduate, scarcely a year ahead of her students.

Teacher Training

There are impressive efforts in China to train a new cohort of young art teachers. In the cities there are vocational normal middle schools, where students at senior high level take art classes and some psychology classes in preparation for being assigned to elementary schools. The provincial art academies have begun art education programs, most of them only three years old. They are for middle school graduates, to be trained and then assigned to teach in middle schools. They have two-, three-, and four-year programs, the latter leading to college teaching. In the countryside art classes are being emphasized as special areas of concentration in the county normal schools, at the vocational middle school level, and at post middle school as well. The concept is right. The execution still needs development.

Our interviews with students in these programs made it clear that many young people in everything but possibly the county normal schools want first to be artists and are taking these placements in the hope of getting into the art academies. Teaching they regard as a last resort, and they will go reluctantly to their assignments. We saw some of them already in the schools, uncomfortable, rigid, and looking for a way out. If they get out by passing a test to get into a year of university training, they rarely return to teaching. We talked at length with an experienced art teacher in Beijing who supervises the two weeks of student teaching and heard her criticisms of the students' lack of commitment and understanding of either children or teaching.

A better selection process for entering normal schools is desperately needed. Perhaps an application that includes interviews, recommendations, and personal essays, and that might ensure that the desire to teach, the personality for teaching, or at least the willingness to train oneself as a teacher are present, should become a major factor in admission to the programs. At present admission is based on essentially the same set of art tests as admission to an art academy. Students practice cast drawing and the conventions of traditional Chinese painting and submit their portfolios. Those selected to compete further are given a test

"theme" painting to execute on the spot. Their grades on the academic portion of the national exam must be in the top 20 percent. With these two scores, artistic and academic, they can have a place in the art education program of the regional academies. With similar tests at the eighth grade they can enter the art programs of normal middle schools. All they need do is check on a form that they want to be teachers, and they can take one of these coveted opportunities for advancement.

Many of the teachers in the art teacher training schools have very rigid "Western" or "Chinese" academic training and admit to knowing little or nothing about children's art, about teaching young children, or about procedures for teaching teachers. The same forum of exchange that can help with inservice education for elementary art teachers could inform the faculty charged with preparing new teachers. We found one group of art faculty teaching teachers in Chongqing who had never visited art classes in the middle schools for whom they were preparing their students. Another faculty group in Beijing said with pride that they were teaching the same program as that found in the Central Academy of Art. The work of the students bore them out. It replicated everything we had seen at the academy. They had some curiosity about applications of this work for children, but no books or guidance in that area.

However, we also found a faculty group in the art program of the vocational normal school of the Hai Dian District in Beijing that was firmly dedicated to preparing teachers with a love for children, a recognition of the creative aspects of art, a desire to help stimulate children's own thinking, and a great interest in the nature of children's art itself. All their technique exercises had this personal element in them. They all addressed issues of applicability to teaching children. The principal and the chief art teacher were consciously experimental and unafraid of criticism they knew would come to them from other art training schools. Later we discovered that because we let them know about an international exhibition of children's art coming to the National Children's Center, they took a group of their students. They were the only art normal school faculty in Beijing to do so.

The national curriculum for these normal schools consists of three years of art training in the academic mode—in which students elect either the Western or Chinese speciality—with two courses in educational psychology and two weeks of practice teaching coming in the last year. The curriculum needs a set of gradually developing experiences with children and observations of good teaching, a longer practice teaching situation, and more practical teaching suggestions tied to classes in technique. Somewhere there should be a course in the developmental aspects of children's art. Several teachers we spoke with were fascinated by these possibilities and hungry for American art education textbooks and both practical as well as theoretical discussions of teaching art.

Educational Theory and Aesthetic Theory

The world knows that art in China, especially in the last two hundred years, has developed in some highly conventionalized modes. The teaching of art to children, from the national textbook to the parents' expectations, to the Children's Palaces, to the training of kindergarten teachers and art teachers, reflects the feelings generated by these modes. Here is the nerve center of discussions on art education.

For centuries, teaching in China has been based on imitating models rather than learning concepts from examples and applying them to new situations. I believe in part this can be attributed to the nature of the written Chinese language. The system of pictograms follows its own logic, parallel to but separate from the spoken language. There is not a phonetic system which, once learned, like the alphabet, can be applied to the learning of a new word. While there are sophisticated family relationships among the characters, until one has memorized several hundred, or even several thousand, that structure is not readily available. Consequently, the only way to begin to learn to read and write Chinese is to memorize the characters. This becomes the foundation of learning and affects all other schooling. Indeed, the use of the abacus is taught by memorizing rhymes for the addition and subtraction of all numbers from one to one hundred, not by teaching the concepts of fives and tens which govern its use.

There is little provision for teachers or children to conceptualize or analyze. Give a clock to an American child, and he or she is likely to take it apart to see how it works. It would rarely occur to a Chinese child to do that. From my observations of Chinese adults dealing with new technologies I speculate that the memorization system leads to a superficial reckoning of everything on the basis of its appearance. To know it is to be able to reproduce its surface. Only after decades of living might one come to understand the essence of something or to fathom its internal structure. Such wisdom comes intuitively to a few. I suspect that many people, including teachers, believe that this is the nat-

ural order of things and that one simply cannot, even should not, teach analysis, concepts, and application. If teachers themselves have no notion of such approaches, or believe that such things are inappropriate for children, the process is self-perpetuating.

Teachers who have no experience of art and those who do both commonly adhere to the process whereby the teacher provides a model and the children copy it. When art is taught by someone experienced in art and careful to take the children through the process step by step, the children learn the techniques of the model and gain amazing skill in the use of brushes, ink, watercolor, cutting and pasting, and modeling. Some children have, by the end of kindergarten, a repertoire of traditional simple forms—cherries, fish, polliwogs, giraffes, pandas, bamboo—made with the brush. By the end of the second grade many children are careful and quick workers and good observers of finished art work. They know how to measure the right amount of color and water in the brush, how to test it before painting, how to use the right weighting of the brush as they stroke, how to hold and manipulate small sharp scissors, how to follow lines, how to fold paper carefully, how to paste surfaces together accurately, and how to model small figures in plasticene. The manual dexterity of Chinese students at very young ages is universally inspiring. American education can learn from this. No fat pencils or blunted scissors for them. By the fourth grade they can use X-acto knives and gouges for making woodcuts and paper cuts.

Typically, school children's art in China is very small. They use a workbook with 7" x 10" pages, and they have to share about twenty-four inches of desk space with a partner. Their modeling clay comes in 2" x 2" x 1/4" squares. The tiny desks are jammed close together in front and back because of the severe limitations on classroom space, and traditional deportment requires that they remain seated unless spoken to by an adult. They use sharp pencils first in most of their drawings, unless a rare teacher requires them to draw directly with the brush or the crayons. They have harp, pointed felt-tip markers and pointed Chinese brushes. Most drawings, therefore, are linear first and filled in later. This pattern is likely to continue throughout their schooling unless they have a teacher who introduces larger-scale work or develops their skill through calligraphy or Chinese painting to the point where they are confident to put down the brush stroke directly. By this time, however, many children have restricted their imagery to a few predefined, neat models. Only in the after-school groups, where interested children do art work once or twice a week, or in the Children's Palaces, to which only a handful of exceptional children can go on the recommendation of their teachers, are children likely to encounter larger sheets of paper and freedom of movement. For these children with high interest such programs are generally very helpful and critical to their development. For average students, however, I consider the scale of work a severe limitation on their imaginations and on their conception of art. They see and think small, and very few students have any sense of the whole canvas, nor are they given any encouragement to look at space with a goal to defining it with their work.

The textbooks contain lessons showing examples of art work. There are diagrams and drawings for simple craft objects, like making paper lanterns, cutting folded paper, or making standup animals, and drawing lessons using basic shapes of circles, rectangles, ovals, and triangles to draw familiar objects, and samples of landscapes. Many teachers have the students simply copy examples from the textbook into their workbooks. The examples do contain material that could generate an understanding of the concepts behind them, such as the use of overlapping, the use of diminishing scale to indicate distance, or the use of slits and tabs to attach paper to paper. A few teachers use the textbook this way and lead the students to creating their own versions of the models. However, because the textbook is not accompanied by an explanatory handbook for teachers, the model copying is very common.

So far as I can see there is no sequential logic to the textbook for any given grade. Neither the age of the students nor what they have learned before is apparent in the arrangement of the lessons. There is little difference between the material for the first and the fifth grades. Although I learned that Piaget has been read widely in China, I saw no application of developmental theory in the direction of art education. Perhaps the words have been registered without the notion of their application. On reflection, however, I should note that the teachers who told me about Piaget in China were in the vocational training school for kindergarten teachers. The art textbook was created primarily by art-academy trained persons. It would be easy to fault their lack of communication if American education were any less fragmented.

Teachers complain that most lessons in the textbook cannot be carried out in the fifty minutes allotted, but they feel compelled to go on to the next before the ideas in the first one are thoroughly explored. All of these factors are leading to a rebellion against the text-

books, not because the books are so bad in themselves, but because they are not very helpful to an inexperienced teacher and they hinder thoughtful teaching by the knowledgeable, especially if the principal feels all national textbooks must be followed page by page. The Commission has recently issued a statement to the effect that textbooks are only advisory and that they should be guides to teaching rather than blueprints. Even with such a statement from Beijing, the textbook will still perpetuate the model-copying tradition.

I felt, after these months of observation, that a textbook in the hands of every student was less valuable than a teacher training guide to good lessons in art, provided in sequence according to age. Most of all, the teachers need to know what it is they are teaching with these lessons. Is "How to draw a duck that looks like all the illustrations in children's magazines" the goal? The textbook leads one to believe it is all that is going on, and we saw many duck lessons in our travels. Each teacher emphasized slightly different things, but none went much beyond showing children they could draw ducks using an oval and a circle, an appreciation which, so far as I could see, the children possessed immediately upon looking at the example, with or without the teacher.

In an absurd contradiction the child draws "from life" by copying examples instead of doing exercises in observation or composition. However, we did see teachers showing children how to observe shapes in objects, how to create variety in the composition, to use contrast in colors, to create variety in sizes of objects, to use overlapping and diminishing size to show distance, to create a center of interest, to use the full page for the composition, and to expand the composition with detail, all ways to improve the artistic features of children's drawing while encouraging them to do independent thinking. No one is systematically teaching these ideas to the teachers, although there are master teachers available to do so. It is my view that rather than spend money to reform the textbook, a process already begun, the Education Commission should assemble some of these master teachers and create guidebooks for untrained teachers.

Another long-cherished Chinese tradition, one found equally widespread on the refrigerators of American homes, is the desire to provide a neatly finished pretty object. We had a heated discussion in one school after I had given, at the request of the staff, a demonstration of an American art lesson. It was a portrait lesson, actually a lesson in observation and composition, given to second graders. It required the chil-

dren to observe carefully and to solve problems of how to draw by studying observed shapes. It also encouraged the use of the whole page and required a treatment of the background. When asked about my satisfaction with the children's work, I explained that about 10 percent of them got every idea I was trying to teach and about 10 percent of them got only one out of four, but that the remaining 80 percent got three out of four, and I considered that quite successful. Two teachers scoffed and scornfully pointed out that 80 percent of the students getting 75 percent of the lesson was a poor showing. The Chinese expect 100 percent perfect results, and the only way to get that is to copy from models and provide the answers for the children. It takes too long for the children to discover the answers themselves, and what they produce along the way is messy and distinctly artless. This is bad teaching. A third teacher, as well as her principal, was curious enough about the notion of teaching by concept and guidance rather than imitation to invite us back to observe her own use of these principles later in the week. She was intrigued by the results of her own class, which were quite varied and interesting, but the other two teachers remained distinctly hostile and unconvinced.

In the meantime we learned that this one adventuresome teacher was consciously experimenting with art teaching in one second grade class under the leadership of an art education faculty member at the Xi'an Pedagogical Institute. In the guise of experiment her change in point of view was legitimate. I doubted whether such a fundamental contrast in conceptualization would ever be accepted by her colleagues or whether they might even meet on a middle ground. But we saw ample evidence that a current of questioning the model-copying mode is flowing in the land, and if it is allowed to become explicit in the sacred precincts of the writers of textbooks and guidelines, a new stimulant to independent visual thinking will spring up in China's classrooms. As Wang Luping in Fu Xue Primary School told us, "I don't believe in children following a Qi Beishi or Li Kuchan. Some of these traditional Chinese paintings have a complete schema figured out. I don't think this is very useful in developing intellect. The primary concern is daring. They dare to try anything. Don't teach methods that restrict them. There is a third grade student whose parents found him a master. Ask him to do something besides horses—he is lost But there is a turning point now"

When we talked with a group of Chongqing parents of children interested in art, one mother told us that

"you must walk before you can run," and she felt that copying is the walking phase. But most parents were less concerned about finished products than they were about their children's enthusiasm and involvement with art. They often spoke to us about how much fun their children had painting what they had seen at the zoo, or the market, or the park. They would apologize and say that "the work wasn't very good," but they could see that the children had remembered what they had seen and that they had put those ideas in their paintings. The parents put a high value on the children's interest and pleasure and were critical of classroom work that the children found boring.

Art and General Education

There is another aspect of the new attention to art education that could have an effect on all education. This is the notion that art is important to "cultivate children's intelligence." By that the Chinese mean "to stimulate problem solving and individual thinking." One of the questions most frequently asked of us was "How does art cultivate children's thinking?" And one of the most commonly used justifications for experimenting in teaching art was that it made children "use their brains." Here is the ground on which imaginative art education will have to stand. Art for art's sake in China means making versions of standardly understood objects of art. That was especially clear in the curriculum of the Children's Palaces. However, "using your brain" means making individual renditions of solutions to problems presented by the teacher. The Chinese have not found an aesthetic for justifying these solutions as art. But to our eyes, where these individual experiments were going on, we found the most interesting and expressive children's art. And we did find people, particularly in the Children's Palaces and in a few middle schools, who were concerned about how to continue in older children the freedom of thought and creativity they saw in young children, particularly in light of the introduction at the middle school level of the academic curriculum in cast drawing and Chinese painting.

Good teachers found it easy to get the children to draw scenes from their experiences, at home, on the street, at play, watching sports contests, visiting Tian An Men Square during National Day, especially if they began the session by encouraging the children to talk about the subjects. This sort of scene the teachers generally described as "children's painting," which they treated, in the Chinese fashion of categorizing everything, as distinct in their minds from "traditional Chinese painting" or any other kind of art. We found

that there was considerable emotion invested in that term. A conversation with a rather astute sixth grader, whose "children's paintings" had attracted national attention, revealed that she thought it was now time for her to stop doing that sort of personal thing and to start copying the techniques of the Chinese masters and to learn the cast drawing and still life techniques of Western painting. She believed that it was childish to continue to create from her own experience or from what she saw in her own imagination. Furthermore, to do so would not get her into the art academy. All over China we found this separation occurring at the end of the sixth grade. In middle school art education "childish things" were put away, and in their place arrived the academic curriculum.

Nor was this view reserved for middle schools. Because the elements of traditional Chinese painting are introduced in preschool, some children never draw from their own experiences in art class. For some teachers all such children's painting is regarded as of little or no artistic value. A national exhibition of children's paintings from all over the world attracted thousands of viewers, but its organizer, Long Niannan, the gifted and energetic young art teacher at the National Children's Center, indicated that he was severely criticized for such a show by many art teachers and that he had to select the jury for it carefully from among people who were sympathetic to the value of children's art.

To my eyes the most gratifying combinations of traditional material and individual experimentation were to be found in the classes of an art teacher at the First Experimental Primary School in Chongqing. Zhang Nanlin was a well-focused woman who knew the lives of her students well. Her kindergarten class had been taught how to use the brush confidently and were led to experiment in their paintings with imaginative compositions. Children were encouraged to suggest ideas and to discuss how to elaborate on the possibilities of the figures they had drawn in the past. Each child proceeded to paint with enthusiasm, using a standard repertoire of traditional subjects—pandas, bamboo, fish, and polliwogs—but producing a wide variety of individual scenes, skillfully executed in different colors of ink. This same teacher also led classes in careful observation from life by having first graders do self-portraits with mirrors and fifth graders draw outdoors in the chrysanthemum garden. All her children were successful in their work. They captured the spirit as well as the form and color of the subjects; they seemed to inject their own personal character into their work; they composed well. They also exhibited commitment

and enthusiasm for what they were doing. Zhang Nanlin was one of our most persistent questioners and had previously initiated exchanges with Japanese and American art teachers through sister city relationships. Ink paintings of Chongqing street scenes by her fifth grade students were exquisite examples of lively images, childlike in some charming aspects, but observed with care and created confidently with traditional painting methods. This combination—confidence, achieved by acquiring facility in techniques that are culturally familiar and respected, and individual observation based in personal experience—demonstrated an accomplishment that art teachers anywhere would envy. For China her success is particularly significant. This teacher was "cultivating the intelligence" of her students at the same time that she was providing them technical skills. She was helping them to appreciate tradition and to create new and individual works of art that give them and others considerable pleasure. I find in her example a model that can serve American education as well.

The National Exam

There are two subjects which come up in every conversation about Chinese education. One is the devastation of the Cultural Revolution; the other is the dictatorship of the national exam. As any student of Chinese tradition knows, the national exam is deeply embedded in educational history, having served for centuries as the road to success for Chinese officialdom. Few people can imagine an educational system without the examinations, and many are grateful to them because they feel the test is the one avenue that is open equally to all regardless of social or political influence. Consequently parents begin preparing children for the national exam in the cradle. The test is administered on the same day throughout China, and all the postal services and railroads are commandeered to safeguard the security of the examinations. Points scored on the exam will determine admission to middle schools—lower and upper—vocational schools, normal schools, academies, colleges, and universities. Because there are so few places available, the exam is the winnowing screen.

This process has two effects on art education. One is that in the fifth and sixth grade, unless the school is unusually committed to art education, emphasis on art diminishes, and children's attention is devoted primarily to the subjects tested on the examination. Everywhere we went parents lamented that their children had no time to be children, no time to be creative, especially as they got to be nine and ten years old, and

that their homework demands kept them busy from the end of school until bedtime, six days a week. Even Sunday had to be devoted to studying. Furthermore, it is clear in the middle schools which are not vocational in nature that art education plays only a minimal role, and except for a few afterschool groups, affecting perhaps fifteen or twenty students out of a thousand, art disappears into some perfunctory classes which neither the students nor the teachers take seriously.

The second effect is that a parallel examination program has been developed for admission to the vocational art middle schools and art academies. As I described above, it consists of a portfolio of required cast drawings and still lifes and a test for those whose portfolios pass review in still more cast drawings and theme paintings. Consequently, children who want to get into the art academies begin early, even as young as fourth and fifth grades, to work on the tested subjects. Children's painting plays no role in the tests. Creativity is given lip service, but officials at each of the art academies admitted that it is the accuracy of the cast drawings and technical accomplishment in Chinese painting that carry the day. No one who cannot compete in those areas will be admitted on the basis of unusual individuality or creativity. The only exception to this was to be found in the Beijing Academy of Arts and Crafts where the faculty seems to be in rebellion against the traditional rigidities and open to contemporary directions in art and design coming in from abroad.

Conclusions

If I learned anything from my two-and-a-half-month stay in China, it was the fact that every issue is affected by China's austere financial resources. Living conditions are excruciatingly harsh by the standards of industrialized nations. People are justifiably hungry for a few comforts, a little more room. There are disparities between those who have more and those who have less, but the range is not very wide. Every city is grasping for more industry, more housing, more consumer goods. In the countryside the peasants are building rooms on to their houses, buying tractors to transport themselves and their products to market, and replacing handmade objects with commercially produced goods. Access to new jobs is seen as the key to a decent future, and access to new jobs means more education. The demand is powerful, and the places are few. Districts cannot build schools fast enough, cannot train teachers fast enough, and in this squeeze there is little money for improvements of any kind, whether it be for housing for teachers, for classroom supplies, or

for curriculum reform. An improved national economy should affect education first.

It should make nine years of education, now a national law but unachievable in many areas, a reality. It should make twelve years possible for many more children and also raise the number of university places. This should diminish the power of the national exam and provide more options to educational styles and theories. It should also make more teacher-training places available and allow for longer and more effective normal school programs. Physical conditions in the schools should improve. Housing and working conditions for teachers should improve in a way that would invite more people to look forward to a teaching career. If the national economy improves and the educational system does not, the government has a lot to answer for.

In the same way that the "open policy" has allowed economic experimentation and access to Western and external attitudes in other fields, it is stimulating examination of art education. If the experiments are allowed to continue, they will have a healthy effect on the way children are encouraged to think about their lives and to express their ideas. The power of tradition is so great in China that I believe no one need give way to the fear of losing a national identity while exploring new ways of conceptualizing.

In many ways, art education in China can lead the way to bridging two millennia of national experience with the twenty-first century that confronts it. Such is the power of learning to observe, analyze, interpret, and organize the world through its visual manifestations. Can the art of China look to the present and future as well as backward to the past? Can the country as a whole look forward as well as back? That drama is being played out now in the art classrooms of China's schools.

THE LEONARDO PROJECT: PROSPECTS FOR HUNGARIAN ART EDUCATION

Hungarian Research Group on Art Creation and Criticism

■ ANDREA KÁRPÁTI

Positions, Programs, Prospects

From its beginnings around the 1880s, Hungarian arts education has been characterized by a blend of discipline and emotionalism. Rigid sets of studio exercises in the "divine elements and principles" of design, coupled with poetic presentations in art criticism about the religious, cultural, and historical aspects of masterpieces, produced erudite minds and hands in great numbers and finally, in the first decades of the 20th century, a breakthrough toward progressive world art. Laszlo Moholy-Nagy, Marcel Breuer, and other Hungarian artists and architects participated in the formation of the most important school of art and design of prewar Europe, the Bauhaus; others such as Victor Vasarely (originally called Vásárhelyi Győző) initiated internationally recognized visual idioms. However, perhaps because of being the products of a thoroughly discipline-based system of art education (Kárpáti, 1987), even the average Hungarian school leaver manifested deep respect for and genuine interest in the arts. This attitude was expressed in administrative decisions and educational preferences as well. In the first four decades of the 20th century, the Hungarian art scene was characterized by generous school and museum facilities development, state support for artists, and the organization of huge international art exhibitions.

After World War II, however, the situation changed completely. In the 1950s and 1960s, Hungarian art education lost both its discipline and its emotional quality. Educators who had always been in line with international professional developments were now forced to turn their backs on the art-teaching fashions of the age: "man-of-the-world wit" and scholarliness in art appreciation, traditional crafts revived in native folk-art-oriented national curricula, and the cult of innocent, untutored child art. In the 1950s and 1960s, official art in Hungary was meant to serve political ends, and art education was reduced to the visualization of doctrines. Empirical research on visual skills and abilities, once a flourishing field of Hungarian developmental psychology, and assessment of art performance, for many decades a natural companion of curriculum design in this country (Kárpáti, 1984), were replaced by emphatic essays on the overall importance and intrinsic value of education through art. The central curriculum had to be rigidly followed; discipline became the synonym for conformity. The central curriculum prescribed not only sequences of dull visual exercises and preferred ideological topics for freehand drawing, but also names and works of important artists that could and had to be shown to pupils. The list contained few titles from the 20th century and practically none from its second half. Modern art disappeared from schools both in practice and in theory.

In the "skeptic 1970s," there was a reevaluation of slogans and strategies in politics, economies, and finally in education. Art education, a discipline that had enjoyed high prestige as the guardian of cultural heritage of a once glorious nation constantly in need of fuel for her self-esteem, in the first decades of socialism in Hungary degenerated to the level of propagator of an ideology everyone was yearning to overcome. Its prestige declined rapidly, and serious cutbacks in space, staff, and curriculum materials followed. Art education was like a forgotten Sleeping Beauty, with almost no hope for a prince.

The new, relatively less controlled cultural climate of the 1970s, however, quietly produced a series of art circles in houses of culture and museums where innovative Hungarian art education could take root. Researchers who had been doomed to silence could now hold seminars at universities and colleges and breed a generation of "angry young art educators." Our teachers led us back to the international world of art eduction. They shared with us the results of skills research, alternative models of curriculum construction, and their devotion to high-quality art taught in a structured educational setting regulated by scientific control of outcomes. We were brought up to reconquer the educational field our discipline had lost. As the borders of our country gradually opened up, we eagerly traveled to Europe and America to update our heritage. We showed a naive joy over the advances of

international scholarship in our field and perplexed dissatisfaction over the lack of influence of science on teaching practice. When finally the opportunity came to launch a national project with the ultimate aim of modernizing art education in Hungary, we decided to try to do both sensible research and flexible curriculum design that would be evaluated on the basis of its results.

Between 1980 and 1984, our group started out with large-scale assessments of pupils aged 6 to 14 (representing the eight grades of Hungarian compulsory education) to compare their performance in art criticism and creation with the aims and objectives of the central art curriculum. Our major goal was to advocate change, but we also wanted to reveal valuable components of traditional art education in Hungary. First, the number of art classes is satisfactory, at least in comparison to other European countries. Two 45-minute periods per week in grades 1 through 6 and one period in grades 7 and 8 in the elementary school, then two periods per week in grades 1 through 3 of the four grades of secondary grammar school are compulsory. Optional art activities may be chosen in grades 7 and 8 at elementary level and in all grades at the secondary level. However, there is no art instruction in vocational secondary schools.

Traditional Hungarian art education has always focused on drawing and painting; in fact, the name of the subject also means drawing. Art appreciation also used included in the name of this school discipline prior to 1978, when it was omitted because creation-oriented art teachers objected to the emphasis of *looking* over *making*. The rigid exercises that ensure the acquisition of a wide array of drawing and painting conventions have their benefits as well: Young Hungarians who choose professions that require drawing skills surprise their teachers and employers with their excellent performance all over the world. In the early 1980s, when analyzing educational documents in order to construct the tasks for our assessment, we found that even teaching aids developed to foster critical skills emphasized the acquisition of elements and principles of design.

The testing procedure involved tasks in oral and written art criticism; a knowledge test on art history and acquisition of basic aesthetic concepts; nonverbal matching and sorting tasks to test sensitivity to color, structure, and style of works of art; and three drawing tasks. Results were computer processed and correlated with each other, the socioeconomic factors and learning performance of the children, and the quality of the school environment. The following are some of the results of the assessment that were important for the preparation of the LEONARDO Project:

1. The easiest task was the solution of the so-called "visual games." The nonverbal interpretation of problems of space, form, and color did not prove difficult even for fifth graders.
2. The most difficult task was the description of the meaning of concepts broadly used in art criticism. It turned out that even eighth graders misinterpreted a large number of the words commonly used in art appreciation.
3. The major branch of art taught in Hungarian schools was painting. Its characteristics were the best known (or rather, the least unknown) for pupils who looked for two-dimensional qualities in spatial works as well.
4. The dimension of time was completely missing from the pupils' knowledge base. Works and their creators floated rootlessly in time.
5. Fourteen year olds had gained considerable facility in the observation of the usage of visual language. They judged problems of space, form, and color on the basis of their own creative activity.
6. The children generally did not employ the critical strategies of analyzing content (message) and function (of designed objects and buildings). Most of the students were able to perform simple description and interpretation only. Development in this area over the course of the 3 school years was minimal for both age groups.
7. Tolerance for nonfigurative ways of visual rendering decreased with age: Elementary school graduates (14 year olds) despised and turned away from less realistic works or modern architectural shapes in much the same way as uneducated adults do.
8. It appears that, to the children, what we do not know we cannot like: Their lists of well-known artists contained very few 20th century masters.

In order to determine at what age art criticism abilities may be developed, we tested 6 to 10 year olds using the same structure of tasks. We found that basic visual qualities such as the methods of depiction of space, possibilities of color composition, form rendering, and usage of different techniques are already recognized quickly and easily by pupils in the lower grades. Thus, the whole system of art teaching seemed to need refashioning.

Why "Leonardo"?

Project Objectives

The name of the great master first appeared as the logo was being designed, after the research group had been split into five parties to develop five alternative approaches to art education and common methods of curriculum implementation and assessment had been agreed upon. We needed a symbol that clearly hinted at *big art* but was still funny, since a good art program must be understandable and enjoyable for children. Many honorable enterprises use Leonardo's model for the male figure; it is an accepted symbol for both aesthetic order and human values in general. Our graphic artist turned it upside down and, retaining only the basic structure, gave it the stumpy body and smiling face of a child. We all agreed that its message was clear: *Art for children and by children* is at stake.

We subsequently decided to furnish our project's image with the necessary ideological foundation and started reading what Leonardo had to say about art education. We were surprised to find out how close his ideals were to ours. First, he emphasized the importance of the environment in three respects: initially as a world of constant study and admiration; then as a model for creation; and finally as an important influential factor in all phases and activities of life. Second, he considered looking at art almost as important as creating art for the development of vision and refinement of soul. Finally, his flexible, personalized strategies, adopted to revealing to his disciples the rules and secrets of artistic creation, also gave us didactic models to revive. Naturally, we do not intend to recreate Renaissance splendor in tattered Hungarian village art studios, but we do want to encourage teachers to integrate art and local life in exciting and enjoyable ways akin to Leonardo's ideals.

Our major objectives are summarized as follows:

1. To reveal the structure and development of visual skills and abilities both in the creative and in the perceptive sphere of visual communication.
2. To develop and implement five art curricula, markedly different in contents and methodics, complete with teaching packages for the compulsory elementary school (grades 1—8, ages 6—14/15), that could eventually replace the central curriculum.
3. To assess the outcomes of the different educational approaches and thereby reveal to what extent the different sets of visual skills and abilities may be developed through certain curriculum contents by means of a given teaching strategy.
4. To assess the relative effect of several socioeconomic factors and personality traits on the creative and critical performance of the pupils.

Parallel with the five curriculum design and implementation subprojects, all the participating groups organized special teacher training or inservice training programs to see how would-be and practicing teachers may be familiarized with the objectives and methods of the alternative curricula.

Subprojects and Research Parties

As indicated above, five alternative teaching programs are being elaborated and tested in the LEONARDO Project. The unifying principles that all participating research parties share are as follows:

1. Creative and critical activities must constitute a harmonious whole in the art programs; artmaking should not predominate.
2. The concept of *art* should incorporate folk art and crafts, architecture, design, and environmental planning as well.
3. The school environment, as the primary place of aesthetic experiences and education, should be investigated, documented both verbally and visually, and evaluated by pupils and teachers in the course of special, interdisciplinary projects. Some functional and aesthetic mistakes should be corrected, if possible, in cooperation with the pupils, their parents, the teaching staff, and experts invited by the research party of the LEONARDO Project.

The central topics that are the focus of the alternative curricula and the institutions backing the subprojects are briefly outlined and the major characteristics of these programs are described in the following paragraphs.

Integration of Art and Environment Education

This research group, headed by Emil Gaul, Associate Professor and Deputy Director of the Institute for Cultural Theory and Teacher Training of the Hungarian Academy of Crafts and Design, Budapest, develops an integrated curriculum for two subjects: art education and technology for the four upper grades of the Hungarian elementary school (grades 5—8, ages 10—14/15). The integration of these two subjects yields four periods per week (45 minutes each) for the

study of the cultural history of humankind. Art, crafts, and the manmade environment, are shown as products of certain lifestyles and manifestations of the level of technology, scientific knowledge, religious beliefs, and moral standards of the ages, from ancient times up to the present day.

Art and design education of this type requires a special awareness of technology as well as the ability to demonstrate and teach a wide series of crafts and construction techniques and model and maquette making. Graduates of the Institute, who receive a double degree in art education and a selected area of design, undergo a basic training in all of these areas at the beginning of their studies and also learn special didactics developed by members of this research group (Gaul & Kárpáti, 1990).

Color in Art Education

Creation and perception of color are the focus of this subproject, co-headed by the well-known specialists in color theory Dénes Horváth, graphic artist and associate professor, and Sándor Rétfalvy, sculptor and head of the Department for Art Education at the Janus Pannonius University, faculty for Teacher Training, Pécs. They, their associates, and members of the students' circle for the study of color have developed several visual games that playfully communicate knowledge and enhance creativity in this field (Horváth, 1988). They test these games in the framework of a curriculum with a strong focus on color but including all major areas of the language of vision. They also survey visual games and art-related, creative toys available on the Hungarian market; assess their educational value; develop lesson plans for using the best of them, and show how the new color games can be integrated.

Photography and Videotape in Art Education

Sporadically and in an improvised fashion, these two technologies have found their way into the art programs of Hungarian schools, mostly on the secondary level and for special circles and optional art classes. It was time to develop an art curriculum in which these modern media would constitute an integral part of both creative and critical activities. In Szeged, the art teachers of the Attila József Elementary School undertook this work, headed by Éva Lázár, art consultant for the city and responsible for the higher grades (6—8, ages 12—14/15) with János Miháczi, a video artist who serves as consultant and also gives video classes to pupils. An introductory program in photography is now being offered for first through third graders (ages 6—8) by Lőrinc Popovics, art teacher. Textbooks and work sheets are being developed for both age groups by photography and art education students of the Hungarian Academy of Crafts and Design, who have selected this task as their diploma work.

The new National Core Curriculum now being compiled in Hungary includes as one of its major emphases for art the acquisition of modern media of visual communication to broaden the creative repertoire of pupils. Materials developed by this subgroup and their teaching experiences will yield important data for this work.

Interdisciplinary Aesthetic Education for the First Grades of Elementary School

In Hungarian kindergartens, the arts co-exist in a natural harmony: Young children are encouraged to illustrate tales and poems just heard, or invented, performed, or dramatized; singing and dancing inspires creation in painting and clay. All these activities may occur parallel to or following one another, with hardly any time limits. In the first grade of the elementary school, however, these all become disciplines. A singing class will be followed by a more serious subject, say mathematics; a reading class is over before the slower students have grasped the essence of a tale, and there is hardly ever time to visualize impressions. The arts are divided in the curriculum, even though they are not divided in the minds and normal free-time activities of 6 year olds. Art and music classes lasting only 45 minutes do not satisfy the still-intensive need for creative self-expression, and they leave no space for motivation through the sister arts.

Integration of aesthetic disciplines (art, music, dance, and literature) has frequently been the topic of innovative experiments that usually have ended with a statement of success but no follow-up. Youngsters enjoy these interdisciplinary classes, but most teachers feel unprepared to plan and execute them on a regular basis. Endre Kaposi, director general of the Vitéz János Teacher Training College of the ancient bishop's seat Esztergom, has launched an aesthetic education project in one of the model schools of the college, teaching internships for teachers in training (who graduate with a diploma to teach in grades 1 through 4). The college also offers a special training package that prepares its students for the interdisciplinary teaching of art, music, folk dance, and literature. It includes basic theoretical courses such as Introduction to Aesthetics, Integrative Curriculum Planning, and

Developmental Psychology of Creative and Perceptive Skills, but the main emphasis is on practice. Students do studio art, sing in a chamber choir, learn the basics of folk dance, and have more literature classes than their peers. Applicants for this training are selected through a special entrance examination that tests skills in the arts involved in the program. Although this version of teacher training is demanding, there are always volunteers who want to modernize aesthetic education in the primary grades. They want to show how a *normal* classroom teacher can offer the same high-quality aesthetic education that is usually available only from a group of specialists who, when employed at all in the junior grades, meet the children only once or twice a week, require constant adaptation, and thus make the first encounter with school for first graders immensely difficult.

The aesthetic education curriculum is developed for the first three grades of elementary school (ages 6—8 years). For higher grades, we consider discipline-based education more appropriate, although interdisciplinary projects of similar character could be included in the form of optional classes. Our program focuses on our folk art heritage which naturally coordinates the language arts with music, dance, drama, and crafts. The children get acquainted with the folk customs around the calendar year and revive some of them. They produce paraphernalia and all sorts of verbal and visual documentation and illustrations; collect still-available crafts, songs, and tales from their elders; visit local craftsmen, old houses, and museums; see how changes in lifestyle affect the form and content of customs and how folk culture influences the fine arts; and so forth. One day a week is devoted to interdisciplinary activities, not only in the morning, in classes, but also in the afternoon, when 90% of the children stay at school in the daycare center until 4:00 p.m. This arrangement allows for longer performances, excursions, inspired creation in several media, and a constant transfer of effects of the sister arts.

Creation and Criticism in Art Education: A Model for Harmonious Co-existence

Our last subproject is aimed at testing a book intended to be an art criticism textbook for grades 4 through 6, (ages 10—12) of the elementary school: Depiction and Art by Zsuzsa Sándor (1988). Five very different types of schools in Borsod county are participating in this work, among them small and simple village schools and excellently furnished county seat schools. The art teachers, all creative artists themselves, intend to develop not a brand-new alternative but only an adapt-

ed version of the existing national curriculum, which integrates, in a structured manner, studio art activities with exercises in art criticism and the basics of aesthetics and art history. While testing the book, which seems to help realize these objectives, they are developing a teacher's manual and several teaching aids to facilitate its introduction as a national educational resource. A series of inservice training courses help practicing teachers acquire the new methodology developed by this research party and give the new textbook a broader critical audience.[1]

Ildikó Rézmuves-Nagy, chief art consultant for Borsod county, who leads this working party, heads one of the best professional organizations for art teachers in Hungary. Eighty-six local art specialists meet in studio and study circles once every second day—a time that is granted by their principals as a *creative day* for all art teachers—and exchange ideas about the profession. This group also serves as one of the consultant bodies of the new National Core Curriculum for Art Education.

The "Visual Model School" Campaign

The five working parties participating in the LEONARDO Project share not only common objectives but also two groups of activities. All of the children who study according to the newly developed curricula undergo the same assessment procedures to identify their personality traits, their visual skills and abilities, and their development in the course of the project.[2] The other activity they share is the visual documentation and analysis of their school and its neighborhood as environments for learning and recreation. Assisted by a group of teachers and invited experts (mostly parents whose jobs involve the analysis, design, and reconstruction of the environment), they make a visual documentation of all the important inner and outer spaces of their school. The photographs, videotapes, drawings and paintings, models and maquets, depictions of color schemes, characteristic textures, and spatial arrangements also serve as motivational materials to be used during interviews with teachers and other school personnel, parents, and peers who are invited to criticize the well-known places and give suggestions for improvements. Questionnaires are also distributed and collected, and their data are analyzed by older students, who thereby learn the methods and observe the strengths and weaknesses of a public opinion survey.

The LEONARDO Project, of course, is basically funded for developing alternative teaching packages

for a multifaceted art education program, so it may not provide the necessary finances for major school reconstructions. Still, we try to do something to combat ugliness in the schools, because we think it is ridiculous to speak poetically about the endless possibilities of education through art when the environment of these studies gives countless examples of antiaesthetics and dysfunctionalism, "kitsch," and plain poverty. One thing our project was able to do was to invite experts, practicing artists, designers, and environmental planners, as well as several of our art education and design students, who provided the following support:

1. Analyzed the visual and verbal documentations provided by the children and their teachers about their learning environment and identified most important obstacles to effective teaching and learning.
2. Calculated the costs of these improvements, contrasted them with local needs and intentions to cooperate in a project to reshape the parts of the environment identified in the documentations, and suggested a series of actions.
3. Participated in the planning and execution procedure as sources of information and co-organizers of environmental education activities for school boards, principals, and teachers; guides and motivators for children; and presenters of new design ideas, and suggested possibilities of action for parents.

Our project lasted for 5 years (1988—1992) and the Visual Model School Campaign was intended to run concurrently for at least the same length of time in all the participating schools of the LEONARDO Project. Of course, old buildings designed for a different purpose will not be turned into palaces of learning. We do not want to act as Potemkins of art education, building fake facades to hide the inhuman reinforced concrete barracks of the dwelling quarters typical of the 1960s in European countries. But we will develop, for example, new color schemes for school interiors; series of pictograms; installation and storing devices; and more economical and functional arrangements of the existing furniture for classrooms, teachers' working spaces, and recreation areas. For their degree work, our design students provide designs of simple but solid and good-looking pieces of furniture that are missing from the market or are expensive imported products. The design and art education students of the Hungarian Academy of Crafts and Design enthusiastically take part in such enterprises, which lead not only to educational practice (acknowledged with credits), but also to the marketing of their ideas.

Schoolyards in rural Hungary usually must be multifunctional. They are supposed to include an area for recreation in the schoolday and also in the afternoon, when Hungarian schools turn into daycare centers. Schoolyards must include a sports ground and also a "practicing garden" for learning to grow vegetables. These areas are usually structured in an ad hoc manner that is not only ugly to look at but dysfunctional. We formed a group of teachers who use the schoolyard for different activities and invited a garden-building engineer, a landscape planner, and a gardener to help them formulate designs and elaborate models for schoolyards. Now these models are being realized in some of our schools, and hopefully, experiences with their usage will facilitate the creation of a collection of plans for creating more aesthetic and functional school neighborhoods. Building a new schoolyard is an expensive enterprise. Fortunately, more and more authorities realize the importance of a healthy environment for children and set up foundations that the schools, with the backing of our group of experts, may successfully apply to for funds.[3]

We expect that the efforts of our experimental schools will create a more human environment, one that is more appropriate for aesthetic education, along with models that we can carefully document and publish in a series of booklets. These booklets will describe not only our objectives and results, but also the entire working procedure, from the organization of the project to the final execution of plans. We will furnish a calculation of costs and outline do-it-yourself, cost-reducing possibilities. Since most of the school buildings where these experiments were run represent typical Hungarian schools of average quality but differ in style, age, and location, we hope that many Hungarian educational institutions will find useful hints in our booklets.

Of course, it is not the role and capacity of an art education project to consider all the problems of the learning environment, but it seems to be the task of every educator concerned with the development of taste and sensitivity for the values of art to do what she or he can to alter the visual culture most of our schools offer today. In an antiaesthetic environment it is impossible, even ridiculous, to preach the rules of beauty.

Evaluation Methods

Our intention is to prove the efficacy of our alternative programs for art education in two respects. First, we want to see whether students develop important visual

skills and abilities beyond those developed under the central curriculum. Moreover, since all our teaching programs have a special focus, we want to determine the extent to which our pupils are successful in mastering special knowledge and skills. Because the correlations of distinct personality traits such as creativity and selected factors of intelligence and visual skills and abilities are important variables in educational planning and assessment, we decided to administer a battery of psychological tests. The following three groups of measuring devices are used in the pre- and posttesting of our experimental schools. These tests were collected, pilot-tested, and, if necessary, slightly altered for Hungarian use by the project coordinator.

1. Visual skills tests include an assessment of visual creation test, the Wilson Narrative Drawing Task,[4] and a technical drawing conventions task.[5]
2. The assessment of visual perception includes the Clark Visual Concept Acquisition and Generalization Test,[6] the Visual Aesthetics Sensitivity Test (VAST),[7] and art criticism tasks.[8]
3. Psychological tests include the Raven Intelligence Test[9](Grades 4 and up), the Hawik Intelligence Test,[10] a version of the Wechsler test (Grades 1-3), a concentration of attention test called RIFA,[11] memory tests,[12] the Torrance "Circles" Creativity Test,[13] and two spatial vision tests.[14]

By using such a wide variety of tests to assess the developmental level of both visual skills and psychological characteristics, we hope to reveal correlations within and between the structures of these two sets of personality traits. It is impossible to teach everything given the limited time, space, and financial parameters of art education classes, so art teachers must be enabled to make well-founded, intelligent choices. They must select curriculum objectives and suitable contents for their classes, and they should be aware of the consequences of their choices. They should be informed as to what a program is unlikely to teach and for which area of skills development it will probably be most effective. The LEONARDO Project is an initiative to offer such alternatives and to explain what these programs can and cannot promise for teachers and students of art in Hungary.

Notes

[1]In the past, school textbooks had hardly ever been subjected to trial and were introduced only on the basis of critics' opinions. Thus, this subproject also gives a model approach for innovation in art education.

[2]See notes relative to specific evaluation instruments.

[3]Examples of such groups are the Foundation for the Promotion of Architectural Culture (under the Ministry of Building) and the Foundation for Ecology Education (the Ministry of Agriculture). The Ministry of Culture has an Innovation of Education Fund.

[4]Originally a task to reveal cultural differences in children's art, successfully used in several cross-cultural research projects by Brent and Marjorie Wilson (1985), it requires the invention of a short story and its depiction in six frames. Titles must be given and texts may be used as in comic strips. With the authors' guidance, we added new criteria for testing the level of technical and expressive drawing skill. The size of the paper is 60 cm x 25 cm, and color crayons or felt-tipped pens are used.

[5]Children are given models of a cube, a cylinder, a block, and a pyramid of coordinated sizes. Their task is to design the main square of their town or village of the future using each shape at least once. The essence of the task is to measure the ability to draw geometric shapes in perspective. The topic adds motivation to a boring exercise and allows for the assessment of compositional skills. The size of the paper is 35 cm square, and black drawing pencils are used. Administration time is 25 to 30 minutes.

[6]This slide test first shows four works of art on one slide that share a common visual quality such as color scheme, compositional structure, or style. Children are invited to identify the common characteristic of the four works and then select one work from a group of three, shown in the next slide, that exemplifies the same quality. Two equally difficult sets of 25 choice arrays have been developed. One set should be used at a time (Clark, 1984). The author of this standardized assessment device invites the teacher to discuss similarities of the first sample with the children, a method we adopt for our subjects from grades 1 through 3. Older children are asked to work individually and select both the criterion and the work that exemplifies it best. Administration time is 40 to 45 minutes. This test is easy to use and is liked by both pupils and teachers.

[7]A preference test of 50 items that requires the selection of one of two black and white graphic works executed by a German artist. It was standardized on European and Far Eastern populations (Eysenck, Iwawaki, and Götz, 1979). The quality of the pairs of works is superior to any assessment device used in empirical aesthetics that we know of; and the frontal administration through slides that we employed by

individual images or booklet seems not to alter the results. The test requires 40 to 45 minutes to solve for first through third graders and 30 minutes for older subjects.

[8]Two works of art must be analyzed in writing. For the first one, a classic painting, the aspects of analysis are freely chosen by the subject. For the second one, a modern painting, the subject is asked for a preference judgment and its justification. Both works are shown in slide format, and a 45-minute art class is used to write both criticisms. This task will be administered to subjects below fourth grade at the end of the experimental teaching period. The answers will be tape recorded.

Two-dimensional works of the participants of the curriculum testing experiments are to be carefully collected and stored, with the date of production and name of the project indicated on the reverse for analysis of individual drawing development. Several three-dimensional works will be documented on videotape or photographed for similar purposes.

[9]The adult version of the Raven was selected for use when the children's version proved too easy in the pilot testing. This is a broadly used nonverbal measuring device characterized as a capacity test, since its subtasks mobilize important spheres of the intellectual domain.

[10]This version of the Wechsler was standardized for Hungary. It contains both verbal and nonverbal subtasks and assesses different cognitive operations (comparison, reasoning, problem recognition, etc.). To compare the intellectual performance of the older children, who solve the Raven, with the younger children of our experimental groups, who solve the HAWIK, we use the total points achieved, and for comparison of individual items only the nonverbal subtasks of the HAWIK.

[11]The RIFA was developed by the German psychologist Achim Hoffmann of the Leipzig, Institute for Youth Research, and is presently being standardized for Hungarian use at our Institute for Educational Research. It requires the selection of the faulty image from sample arrays.

[12]For younger children, we use the MOEDE Charts, which contain words, numbers, or images in different combinations. After a short viewing time, subjects must draw from memory as many of them as they can. Fourth graders and older subjects use a Hungarian device elaborated by Katalin Besson and her associates at Semmelweiss University of Medicine, Budapest. Subjects are shown 10 picture boards as samples and then 30 slides. Their task is to recall whether or not they saw the images on the picture boards earlier on the slides.

[13]The Torrance tests are widely used to test the ability to think creatively. A modified version of the TTCT, used with fourth graders, was developed by the Hungarian psychologists Ilona Barkóczy and S. Oláh, Eötvös Lorand University, Budapest. It contains two verbal and one nonverbal subtasks. The verbal subtasks require the unconventional usage of words and objects; the nonverbal subtask is to design a pictogram using three lines of equal length.

[14]For all age groups, we use the same two assessment devices: the first is the RYBAKOFF test, and it requires the matching of a missing part to the appropriate incomplete image. Two subtasks are used from the MC QUERRIE test: The first requires the drawing of a given image in a dotted square; the second, more difficult subtask, requires spatial imagination. The subjects must determine the number of blocks touching in a complex perspective drawing. This task was too difficult for the younger children and will probably be replaced by an easier subtask during the final assessment.

References

Clark, G. A. (1984). Establishing reliability of a newly designed visual concepts generalization test in the visual arts. *Visual Arts Research, 10*(2), 73—78.

Eysenck, H., Iwawaki, S., & Götz, K. O. (1979). A new visual aesthetic sensitivity test (VAST): II. Cross-cultural comparison between England and Japan. *Perceptual and Motor Skills, 49,* 895—862.

Horváth, D. (1988). *Visual games and colour composition games.* Pecs: Janus Pannonious University. (In English and in Hungarian, with illustrations.)

Gaul, E., & Kárpáti, A. (1990). Art and technology education in Hungary: Conflicts and compromises. *Leonardo Magazine, 2.*

Kárpáti, A. (1984). Art, arts or culture? An educational dilemma from a Hungarian perspective. *Studies in Art Education, 26*(1), 14-19.

Kárpáti, A. (1987). Based on the disciplines: Research and practice in Hungarian art education. *Canadian Review of Aesthetic Education, 15*(1), 35—40.

Sandor, Z. (1988). Depiction and art. Budapest: Tankonyvkiado.

Wilson, B. (1985). The artistic tower of Babel: Inextricable links between culture and graphic development. *Visual Arts Research, 11*(1), 90—104.

ART EDUCATION IN ZIMBABWE: A REVIEW OF THE PRESENT POSITION AND SUGGESTIONS FOR DEVELOPMENT

■ JOHN LANCASTER

This review was written following a visit to Zimbabwe in November 1981 as an external examiner and adviser in art education for the University of Zimbabwe. The visit was sponsored by the British Council, and I am indebted to its representatives in London and Salisbury for their encouragement and support in what proved to be an illuminating and educational experience.

My involvement entailed visiting five teachers' colleges in various parts of the country, namely the Hillside and United Colleges in Gwelo. The Salisbury Polytechnic was included in my tour, also. So that the advice expected of me would be more pertinent, I traveled to the Losikeyi and Lobengula government primary schools, the Tshaka preschool, the Mzilikazi secondary school in Bulawayo, and a rural primary school near Umtali. I also had interesting and informal discussions with colleagues from the university, as well as with a number of teachers, the head of ZINTEC, college tutors, the education officer for art and crafts at the Ministry of Education and Culture, the British Council representative, the director of the National Gallery of Zimbabwe, and the Gallery's education officer. I met groups of students in the colleges, but the brief nature of the visit gave me fewer opportunities than I would have wished to discuss the aims and philosophies of art education and its role in a balanced school curriculum with these young people, from whose ranks will emerge the educational leaders of the future. However, I gained a fairly comprehensive picture of the nature of art education in the

> The first requirement in any civilization with pretensions to cultural values is a system of education . . . which not only preserves the innate sensibility of the child, but makes this the basis of mental development.
>
> *Herbert Read (1955)*

> Art Education contributes to the development of sensibility, imagination and the manipulative and co-ordinating facilities . . . and is an important factor in the child s total education.
>
> *UNESCO (1972)*

schools and colleges, and I sincerely hope that the comments and suggestions I express—resulting as they do from personal observations and inquiries in Zimbabwe and a commitment of some 30 years to art teaching and teacher education—will amount to a sensitive synthesis. This is my aim, but I also trust that the ideas expressed here and the recommendations I make will be helpful to the development of art and culture in this delightful and friendly country.

Art Education and Training in Zimbabwe at Present

It is apparent to an observer such as myself that art education in Zimbabwe is not very strong; in some respects, it could be compared to a neglected and undernourished child. The majority of children in the primary and secondary schools appear to have few, if any, opportunities to be involved in creative art activities, which means they are being denied an education in art—an aspect of their schooling that is vital to their well-being and, as Read (1955) notes, to the development of their sensibilities. This is not a good situation, and it is certainly at variance with the view expressed by UNESCO (1972) in its *International Survey on Art Education*, which stated emphatically that art "is an important factor in the child's total education" (p.2).[1] My first plea would be that this be considered as a primary aim by those concerned with educational developments in Zimbabwe and that art be included as a compulsory curriculum component as a matter of the utmost urgency and for the sake of the children.

This edited review of art education in Zimbabwe appeared in the *Journal of Art & Design Education, 1*(2) (1982) by the permission of Professor S. F. W. Orbell and his colleagues at the Institute of Education of the University of Zimbabwe, Salisbury.

The situation in the teachers' colleges is slightly better than that in most of the other schools, for some student teachers take "main" and others "applied education" courses in art. Nevertheless, there are weaknesses and problems that undoubtedly affect these courses adversely. The main ones are as follows:

1. A fundamental scarcity of art/craft materials.
2. A lack of art and design *and* art education qualifications by some of the lecturers, which must weaken this teaching force.
3. Ignorance on the part of some art lecturers of what is actually being done in other colleges.
4. An apparent lack of national interest and policy with regard to the purpose, aims, and sequential developments of the subject in the education of young people—which points to the need for an overall national framework or structure in art education at *all* levels.
5. The difficulty lecturers and teachers appear to have if they wish to pursue advanced studies in art/design *and* art education—where can this be undertaken? It is a crucial factor in developing a strong lecturing/teaching force.
6. Related to No. 5, the fact that *no* research is being done in art and art education. People concerned with this aspect should be pursuing investigations—possibly for publication—and pushing at the boundaries of the subject in order to maintain and increase its vitality in a meaningful fashion. Opportunities and financial backing are needed for this.
7. A rather frightening dearth of substantial resources—books, slides, films, filmstrips, art reproductions (i.e., prints), and original examples of art and crafts—that are so necessary to develop aesthetic understanding and artistic appreciation of both historical and current trends in art and crafts.
8. The fact that *one* of the teachers' colleges does not even have an art department, while a second does not offer "main" art courses, is a serious matter that could have a deleterious effect upon the education and training of teachers in those colleges and, subsequently, upon art and craft curriculum work in schools.

As I see it, *the main weakness is that teachers and lecturers in arts and crafts have no point of reference such as that which could be provided by a university, polytechnic or specialist institution. There is no centrally based agency to act as a pace setter for curriculum innovation and teaching strategies: a unit that could initiate, monitor, and develop new ideas while providing opportunities and facilities for further study.*

I am aware that Zimbabwe has emerged from a period of internal strife that must have had a profound effect on the educational system, with the result that art education has not been seen as a priority. This is understandable, though regrettable, and I hope that as the dust settles it will receive a little more attention.

In the past, it would appear that there was a great deal of dependence upon established educational links with the United Kingdom, South Africa, and other Western countries, with the old Rhodesia relying upon external universities and colleges to train many of its graduates and teachers. Art education is still suffering from this system, for it appears impossible for students to undertake a formal, specialist training in art and design in Zimbabwe. The Salisbury Polytechnic has an excellent department of printing, and it is attempting to establish a recognized course in graphic design, but *there is no department of fine art and design or faculty of art in the Polytechnic. In view of this, I would suggest that an institution at the higher education level be established.* I intend to comment further on this and to outline specific ideas.

What I consider are the fundamental aims of art education (and culture) appear in the Appendix of this chapter. It is important to establish these as a basis for discussion in Zimbabwe and subsequent progress there.

A Point of Departure and Development?

In 1963, Frank McEwen, the first director of the National Gallery in Rhodesia (now the National Gallery of Zimbabwe) pointed out that Zimbabwean artists were not bound up in ancient customs as were artists and craftsmen in West Africa, where there exists a strong artistic heritage. Rather, they were in a situation of great *artistic freedom* (McEwen, 1963) in which, as I perceive it now, both traditional and newly emerging forms of African art can flourish in an unrestricted fashion.

Is this an ideal point of departure, I wonder, from which changes and developments in art education could grow? Should it, indeed, be the starting point, or what could be termed the *core* training of art teachers and lecturers in the teachers' colleges? To pose the question in another way: *Should art education and training actually develop from the locality of the*

schools and the arts, crafts, and culture that are indigenous to Zimbabwe?

My view is that this could be a good, perhaps the best, starting point, and yet the bulk of artwork by student teachers and children that I saw tended to be a rather pale imitation of what students and pupils would do in the United Kingdom, a quite different culture in Western society. Some of those I discussed this point with agreed with me; others responded by saying that Zimbabwe must strive to be as good as Western countries and that art education in schools and colleges should use Western approaches. This left me somewhat disturbed for I have always been of the opinion that the true artist is an individual who makes art, whether it be through painting, pottery, sculpture, graphics, or other media, that is personal to himself or herself and therefore indigenous in character, although the worldwide communications of today have led to the blurring of some national characteristics. Nevertheless, I have felt that art teaching should take account of the individual's needs, expectations, desires, and abilities. In my own teaching in a Western country, I have striven to involve my pupils and students with, first of all, experimentation with "found" materials such as *clay*, which they dug up from the ground themselves, *charcoal*, which they made, *paints* made from natural earth pigments, *painting implements*, and so on (Lancaster, 1977) and then to produce art forms that were the results of their own thinking and innate sensibilities. I felt my job was to create a learning environment in which students could be artists and craftsmen in their own right, and I did not want them to ape those of the United States, Australia, Europe, or Africa.

I must remain sensitive to the opinions of the many people I met in Zimbabwe, and in no way am I prepared to be dogmatic. Perhaps flexibility is a key word, and I wonder whether the starting point I have proposed should be balanced—or at least tempered—with some Western methodologies and approaches. If we return to McEwen for a moment, we find him stating that the Europeanized art school had a deleterious effect upon African art, and he maintains that it suppressed latent talents. This may be true, for he had more experience of the African scene than I to lend support to his point of view. Nevertheless, I would maintain that there is an abundance of natural, creative talents in any race of people just waiting to burst forth with tremendous vitality, and that these must be tapped. But as I have stressed earlier, it might be important to maintain a balance between (a) the study of traditional art forms and artistic expression from both cultures, and (b) the origination and development of new idioms in the arts. I would not deny that artists and craftsmen have always copied earlier expressive forms, a necessary experience as a foundation for the development of their own ideas, skills, and techniques. Herbert Read lends weight to my argument in saying that every human being, from the earliest childhood years, has an innate aesthetic sensibility and is, at heart, an artist/craftsman. As such, even the young child can appreciate good form, rhythm, and harmony, Read maintained, while possessing a natural instinct to design and make things (Read, 1985, p.101).

Art and design, in any culture or period of history, depend on an understanding of basic criteria such as *shape, proportion, form, tone, texture, balance, line,* and *color*, and nowhere is this better understood than in African art. Such knowledge often stems from intuition, although it can also be taught. The Shona sculptors have a well-established tradition, and these artists display a profound understanding of visual criteria—or what has, in academic terms, become known as Visual Grammar—coupled with a mastery of manual skills and techniques.

Much of the art of 20th-century Western society has looked for its inspiration to Africa, and even such world-famous artists as Picasso and Modigliani, to name but two, reflect its forms, shapes, distortions, and feeling in their paintings and sculptures. Therefore, when I suggest that the art and culture of Zimbabwe—or of Africa generally—could be employed as a point of departure in the teaching of art, I am suggesting that here is an established and proud tradition that is second to none. *It must be used as an inspiration!* But in order to maintain a *balanced* course, students should also be encouraged to study aspects of Western art—not, I suggest, so much the High Renaissance artists such as Michelangelo (which was happening in one of the teachers" colleges in parrot-like fashion), but the work of artists and designers selected by individual students themselves. This will establish an immediate connection between "African" and "Western" artistic modes of expression.

I put this idea forward for consideration in the belief that young people in Zimbabwe would then (a) realize with pride that the art of their own culture is strong and the equal of any in the world, (b) have an immediate empathy with indigenous art forms that are meaningful to them, and (c) extend their studies of world art through the study of Western artists whose mode of expression is parallel to that of the African continent, even though materials may differ. From

such a base further and more extensive studies would be much more meaningful.

Conclusions and Recommendations

As far as this chapter is concerned, the important emphasis lies more on the wider implications for the development of art education (and culture) and curriculum planning than on my personal opinions. It is inevitable that my opinions play a role, of course, in the conclusions I have reached from the investigations undertaken during my visit to Zimbabwe, and they must also be colored to some extent by my experience in secondary and higher education. In this section I intend to outline the main problems and then state my recommendations.

The Main Problems

1. The apparent lack of a national policy regarding the *purpose and aims of art education* in colleges and schools.
2. The lack of both initial *art qualifications* and advanced qualifications in art or education and, in fact the lack of actual experience of teaching art by some college lecturers—in consequence an unevenness in the number of qualified staff among the five colleges.
3. The lack of sufficient *materials and equipment*, which is obviously detrimental to the effective development of education curricula in art, design, and culture in Zimbabwe.
4. The lack of *retraining facilities and opportunities* for lecturers and teachers.
5. The lack of opportunities for lecturers and teachers to do *advanced study in art education.*
6. The lack of *good resources* such as books, films, slides, art reproductions (prints), and original works of art.
7. The general tendency *to produce art objects* as a class-based activity rather than the encouragement of individual work—both experimental and in the form of solving sound design problems.
8. The tendency for art teaching to ape Western approaches rather than using it to encourage the art and culture of Zimbabwe itself to flower.
9. The apparent lack of a soundly conceived and sequential development of art education.
10. The general lack of good display facilities.
11. The fact that *not all* the colleges have an art department, which is a serious omission in a teachers' college.
12. The fact that ZINTEC does not appear to have an art component, which is a serious omission.

Recommendations

I would suggest, as a matter of the utmost urgency and the main priority:

1. That a Department, College or School of Art (or of *Art Education and Culture* or of the *Visual and Performing Arts*) is needed in Zimbabwe. The aims of such a department would be (a) to give purpose and direction to a national system of art education in Zimbabwe; (b) to act as a focal point for lecturers and teachers; (c) to raise, stimulate, and develop the level of thinking about the aims of art education for children and in training teachers; and (d) to act as a coordinating and monitoring agency for curriculum planning in arts and crafts. Further, this department would (e) provide an art advisory service for schools and colleges in coordination with the education officer for arts and crafts at the Ministry of Education and Culture; (f) validate and examine teacher education courses in arts and crafts; (g) enhance the teaching capabilities of lecturers and teachers through conferences, practical art courses, study groups, research, and advanced, award-bearing courses (MA, MEd, PhD); and (h) act as a resource center for lecturers and teachers in the field, providing curriculum ideas, teaching aids and materials, and mounted exhibitions. The department would (i) train art lecturers for the colleges; (j) foster links with institutions abroad for the interchange of staff, ideas, and teaching aids; (k) publish and distribute a newsletter for schools and colleges; and finally, (l) synthesize both Zimbabwean and Western ideas on art and design education so that they are relevant to the needs of the country.

 Such a centrally based agency would give a real sense of purpose to an important national system of art education, while providing it with a strong structure—like the pyramid in shape—in which the national threads of art education could be drawn together in a meaningful way. At the moment I suspect that the whole field of art education in Zimbabwe is without direction and in a rather amorphous state. It is going nowhere and tending to flounder somewhat like a ship without a rudder. *Nothing really worthwhile will be achieved until this problem is tackled head-on!*

2. That large *study conferences* be established to draw together art lecturers from the teachers' colleges to (a) meet to talk over common prob-

lems and interest; (b) meet visiting specialist lecturers; (c) determine the basic aims and purpose of art education; and (d) determine new curriculum strategies to suit changing needs and developments taking place in teacher education.

3. That similar *conferences* be planned for teachers and/or teachers and lecturers together.

4. That *practical art courses* be planned for lecturers and teachers so that they can (a) pursue their own practical specialties further and (b) experience other areas of the subject.

5. That developments in items 2, 3, and 4 should be considered in relation to (a) *the local and traditional culture of Zimbabwe* and (b) *the needs of young people as future citizens as related to developments elsewhere in the world.*

6. That it should be possible to involve the National Gallery of Zimbabwe in possible developments as a most useful and pertinent resource. Some work is already being undertaken on a limited basis, and it is based on sound educational principles.

7. That lecturers and teachers in arts and crafts should be encouraged and provided with facilities to pursue advanced studies and research. This is vital if any subject is to be enhanced and kept abreast of developments in other countries.

8. That *all primary school children should receive an education in art and culture, and therefore have facilities to do art in school with workers who have themselves had some experience in this curricular area,* to provide them with coherent aesthetic experience (intuitive, emotional, and rationally considered) and development in the early years.

9. I would even go so far as to suggest that *secondary pupils would also benefit from an art education* at school.

10. That *all students in the teachers' colleges taking Certificate of Education and ZINTEC courses should undertake a compulsory art program,* to give them (a) an awareness of the value of visual experience in the education of young children; (b) experience and growing self-confidence in using materials and making satisfactory two-dimensional and three-dimensional work; (c) a consideration of art as an important cultural aspect; (d) an understanding of the role of art as an important element in curriculum work embracing a number of subjects; and (e) the use of art and design in creating a lively and stimulating classroom and school environment.

11. That one area to explore might be *the possibility of encouraging practicing artists/craftsmen* (i.e., painters, textile-designers, sculptors) *to work for short periods alongside children in schools and students in the colleges.* In this respect, the Mzilikazi Arts Centre in Bulawayo might be the kind of institution to provide help to schools and colleges nearby.

12. That *more attention be paid to the idea of using and developing art education programs based much more on the art culture of Zimbabwe,* or at least making this as important as Western approaches so that students and children receive a balanced and sequentially structured art education. It should be one that has real meaning with its roots in this country and should be developed basically from the locality and the materials of the country.

Appendix: The Aims of Art Education

I must stress, first of all, that as Buber (1978) so cogently put it, ". . . education, conscious and willed, means *a selection by man of the effective world*" (p. 89). And the Warnock Report (1978) stated that education has *two* long term goals, namely:

1. To enlarge a child's knowledge, experience, and imaginative understanding, and' thus his or her awareness of moral values and capacity for enjoyment.

2. To enable the child to enter the world after formal education is over as an active participant in society and a responsible contributor to it, capable of achieving as much independence as possible.

Obviously, all curricular subjects feed into these goals, and art cannot be excluded. Warnock's concern was with the whole curriculum: a curriculum embracing *all* the learning that goes on in a school—both "academic" and "social" (known as the hidden curriculum)—and many art educators would feel that their specialization should actually take a central place in this, particularly as it contributes to knowledge, stimulates the imagination, and provides enjoyable creative experiences. What is more, it can develop the individual's manipulative skills and better prepare him or her for aspects of adult life and work.

Every person—young or old—has a natural, creative instinct and an ability to make things from materials. There is evidence of this all around us in the form of buildings, forms of transport, household artifacts, clothes, and so forth. The most primitive of our ancestors led the way in "making" and "designing."

Today we have reached a highly sophisticated level where art, design, and technology combine to produce such superb examples of design as the Concorde aircraft, and television, but such expertise is out of the reach of ordinary folk—folk whose basic need is to make simple things themselves. Art in school or college can, and must, contribute to fulfilling this need while being a vehicle for personal creativity and expression. "Children," I have written myself, "must continue to have the means and opportunities for creative enjoyment in simple artistic activities which allow them to form inanimate materials into articulated forms which have been infused with life and feeling (Lancaster, 1971, p. 130).

Young people need to make things with their hands, for, as Krishnaumurti (1968), the Indian philosopher, has said, through such experiences they will create a new world—often a world of the imagination and inventiveness. This, too, can sometimes be a necessary escape from the problematic realities of the real world.

In discussing the development of the child's creative powers, Buber (1978) pointed out that those involved in teaching are concerned first and foremost with *the child*—a unique being endowed with creative powers that are straining to be released and developed. He maintained that art is the means by which "a faculty of production . . . reaches completion," that "Everyone is elementally endowed with the basic powers of the arts, with that of drawing, for instance, or of music, these powers have to be developed, and the education of the *whole* person is to be built upon them as on the natural activity of the self (pp. 84—85). The important points in this argument are (a) that every individual learner has an innate creative potentiality and (b) that it is the duty of teachers to develop this as far as possible.

Buber argued that the individual has an "autonomous" or "originator instinct" that is absolutely unique, and that the child therefore wants to make things by being given opportunities for creative activity. He was supported in this viewpoint by John Dewey's concern for "experience" and "expression." Buber also maintained that the "Instinct of origination," as he puts it, "is autonomous and not derivatory" (p. 85), and this is why it is important that the curriculum should provide opportunities for young people to invent, to make, to originate in creative aspects such as art, music, dance, drama, and crafts.

What I have written so far in this section obviously embraces some of the goals of art teaching. Let me now draw these together, including others not mentioned so far, into a composite list of what I regard as the *nine* fundamental aims of art education. These are

1. To create a stimulating and visually exciting learning environment in which art experiences can be pursued with passion, discrimination, enjoyment, and a sense of satisfaction.
2. To develop manipulative skills and techniques (and therefore control) in the use of tools and materials in doing creative artwork.
3. To encourage individual sensitivity to visual relationships through experimenting and designing with shapes, forms, colors, lines, textures, and so forth, including critical observation, analysis, and subsequent refining.
4. To provide opportunities for the pursuance of inventiveness (originality), imaginative work, and personal expression through artistic media.
5. To sharpen perception and understanding of visual and plastic forms—both natural and man made—in the environment.
6. To develop innate aesthetic sensibilities and the appreciation of the work of artists/craftsmen of past and present societies.
7. To foster decision making, as confidence and creative abilities develop, through the posing and solving of art and design problems.
8. To propose and encourage art activity and thinking that moves away from the narrow confines of the subject and across other subject boundaries.
9. To be a vibrant and vital motivating force in an educational institution in which art helps to create and control an aesthetically pleasing, cultural environment.

I feel these are legitimate aims, although in cultivating the "aesthetic," or feeling for beauty, pupils will develop a clearer appreciation of aesthetic qualities in their own culture and might even contribute something worthwhile to it (Lancaster, 1978, p. 50). They must be encouraged by their teachers to do creative artwork with confidence, courage, and sincerity—a difficult task that makes strenuous demands of the most skilled and highly qualified art educators—so that they will grow in sensitivity and personal awareness and be able to communicate with others, while also learning to appreciate other people's efforts (Schools Council, 1974, p. 19). Art education should help to develop "seeing" and "thinking" eyes as its participants explore their complex visual environment with inquisitiveness. Its strategies must be carefully considered and well organized as an important component in the life of a school or college and its curriculum. Art is one educa-

tive factor that caters to the acquisition of experience through the senses,[2] and art teachers are helping to educate the citizens of tomorrow—the workers who might be swallowed up in the mass-production milieu of this impersonal, technological age. In partnership with their colleagues, they must educate young people to be decision makers in a world of change. They must provide students with opportunities to make things, to think in terms of materials in activity-based workshops, and to do art so that they begin to realize their inner creative potential in the hope that they will be encouraged to continue with their personal creativity as adults (Lancaster, 1978). Buber, whom I often quote, wrote that "Man, the child of man, wants to make things. He does not merely find pleasure in seeing a form arise from material that presented itself as formless. What the child desires is its own share in this becoming of things: it wants to be the subject of this event of production" (1978, p. 85). And he went on to explain that the important element provided by art is that "by one's own intensively experienced action something arises, that was not there before." This is the power of the subject—a subject that does not rely upon copy, repetition, and dogma but acts as a liberating vehicle for personal creativeness and the development of the creator instinct. This, Buber also maintained, is "significant for the work of education" (1978, p.86)—reason enough for the maintenance of arts and crafts in the curriculum. Such aims are endemic to art teacher training courses, too, although these would include a consideration of related educational theory and practice (school experience) embracing *teaching and learning, educational philosophy, child development, group interaction, control and discipline, scheme and lesson planning, classroom organization, school curriculum, and display and presentation* (including *the making of visual and teaching aids*), and finally, their prime concern would be *to develop the student teacher's confidence and skill as a teacher.*

Notes

[1]See also DES, *Art in Schools: Education Survey II* (London: Department of Education and Science, 1971), p. 2.

[2]See Rhoda Kellogg, *Analyzing Children's Art* (San Francisco: National Press of California, 1970); Rudolf Arnheim, *Art and Visual Perception* (London: Faber, 1955); Herbert Read, *Education Through Art* (London: Faber, 1943); Terence Wooff, *Developments in Art Teaching* (London: Open Books, 1976); and John Lancaster and Joan Gaunt, *Developments in Early Child Education* (London: Open Books, 1976).

References

Buber, M. (1978). *Between man and man.* New York: Macmillan.

Dewey, J. *Art as Experience.* pp. 35-81.

Krishnamurti, 1968.

Lancaster, F. (1971). A case study of student participation in a college of education. *Studies in Design Education & Craft, 3*(2), 130.

Lancaster, F. (1978). Art in primary teacher education: A comparative study of an integrated and non-integrated professional studies course. (Unpublished masters thesis, University of London).

Lancaster, J. (1977). *Painting.* London: Hodder & Stoughton.

Lancaster, J. (1982). Art education in Zimbabwe: A review of the present position and suggestions for development. *Journal of Art and Design Education, 1*(2), 295-307.

McEwen, F. (1963). *New art from Rhodesia: Catalogue.* London: Lund Humphries.

Read, H. (1955). *Education through art.* London: Faber.

Schools Council. (1974). *Children's growth through creative experience: Art and craft education 8—13.* London: Van Nostrand.

UNESCO. (1972). *An international survey: Art education.*

Warnock, H. M. (Chair). (1978). *Special educational needs: Report of the Committee of Enquiry into the Education of Handicapped Children and Young People.* London: HMSO.

PRESENT TRENDS IN GERMAN ART EDUCATION

■ LOIS PETROVICH-MWANIKI

Since the unification of East and West Germany, the social, economic, and political conditions affecting the cultural fabric of these two countries have changed significantly. In particular, the adoption of the West German school system as the educational model for the newly unified Germany has serious ramifications, not only for East German students, parents, and teachers, but for the fields of education and art education as well. Not only does the West German school system become the educational model, but West German educational theory and practice become the philosophical foundation guiding student and teacher acquisition of knowledge; learning and teaching practices; social and academic behavior; career options; and perceptions of social, economic, and political issues.

Given the collapse of the former East German society and the triumph of West German ideology in shaping the united Germany's socioeconomic, educational, and political fabric, a study of former West German models is necessary for understanding the current situation and its consequences for the future. In this chapter, the organizational structure of the German school system and the development of West German art education curriculum theory are examined to better understand the current German situation and anticipate future developments in a united German art education.

The Structure of the German School System

The structure of the former West German school system has its roots in the educational reforms of the 1920s that occurred during the Weimar Republic. At that time, a 4-year common elementary school (*grundschule*) was established for children from all socioeconomic classes. At the age of 10, students were permitted to transfer to one of three possible secondary schools. The *gymnasium* (academic secondary school) offered an academic program that included languages, advanced mathematics, biology, chemistry, physics, history, and geography and prepared students from the elite class for university studies and white-collar professions in law, medicine, philosophy, government,

and higher education. The *realschule* (commercial/technical secondary school), offered a vocational/technical curriculum emphasizing mathematics and science and prepared the middle class white-collar jobs in commerce; industry; agriculture; and the social, welfare, and technical professions (Weiler, 1973). The *hauptschule* (general secondary school) offered a vocational/trade curriculum that included basic mathematics, general science, history, and German, and prepared working-class children for jobs as skilled laborers. This basic structure remained unchanged even during the Third Reich (Hearndon, 1974; Robinsohn & Kuhlmann, 1967).

This tripartite division of German secondary education concealed an ideological assumption that strongly influenced German class relations, namely, that the elites were more intelligent than the working class (Kuhlmann, 1970). The elites propagated this myth by ensuring that mostly upper class children attended that secondary school, the *gymnasium*, which prepared students for occupations befitting their class. This was one of the mechanisms used to perpetuate and sustain the German class system that is still in evidence in West Germany today.

After the World War II, the Allied occupying forces (the United States, France, Great Britain, and Russia) aimed to democratize, "denazify," and decentralize German society. The Allies achieved their denazification and decentralization programs rather quickly by eliminating all reference to Nazism in books and the printed word; by expelling Nazi proponents from government, teaching, and the civil service; and by centralizing German government and social institutions. However, the democratization process proved to be more difficult. One of the ways the Western Allies proposed to accomplish democratization was by introducing a comprehensive school system that would combine the three traditional secondary schools into one (ACC, 1947). West German politicians and educators resisted this move, arguing that this would destroy rather than rebuild German society and introduce more instability into an already chaotic postwar situation.

After many heated debates, the traditional German school system was reinstated in West Germany.

The Current School Structure

It was not until the 1970s, after years of critical public debate about the need for educational reform (Hamm-Brücher, 1972; Picht, 1964; Weiler, 1973), that West German educational reformers instituted the reformed *gymnasium* upper level (grades 11—13) to make needed changes in course content and teaching approaches and to ensure that a common form of the upper level would be maintained by *gymnasien* in all West German states (*Länder*). Later, the orientation stage for grades 5 and 6 was introduced, which provided students 2 more years of common school education at the elementary level before they were tracked into one of the three secondary schools. There were also some experiments made with comprehensive schools, primarily in the state of Hesse, although this type of school structure has not been universally adopted in the country.

The reformed upper level consists of the 11th, 12th, and 13th grades. The 11th grade is the introductory phase, in which students take only basic courses (*grundkurse*) in each subject. In the 12th and 13th grades, students take basic as well as proficiency courses (*Leistungskurse*). The proficiency course requires 6 teacher contact hours a week in contrast to 3 teacher contact hours for the basic course. Students choose their proficiency courses based on their selected future profession.

Over the 3 years, students plan their class schedules based on their choice of basic and proficiency courses. The choose courses from the following three broad subject areas:

1. The language-literary-art field: German, music, art, literature, French, Russian, Italian, English, Latin, Greek, Hebrew (basic course).
2. The social science field: history, geography, philosophy, sociology, economics, education, law (basic course), home economics.
3. The mathematics-science-technical field: mathematics, physics, biology, chemistry, engineering (basic course), computer science (basic course) (Kulturministerium des Landes Nordrhein-Westfalen, 1973).

In addition, religion and physical education must be taken, but they do not belong to any one of the above-mentioned fields. There is a predetermined number of hours that must be taken in each of the three subject areas, religion, and physical education for a student to be eligible for *abitur* (Gymnasium graduation) (Kulturministerium, Baden-Württemberg, 1972). For the *abitur* examination, students are required to identify two proficiency courses for the written examinations and two basic courses for the oral examinations. The four chosen subjects must represent the three broad subject areas and may include religion or physical education. In most states, it is generally required that one of the four subjects be German, mathematics, or a foreign language. In addition, the student must fulfill basic requirements either as basic courses or as proficiency courses in German, a foreign language, music or art, a social science, mathematics, a natural science, religion, and physical education.

Prior to the initiation of the reformed upper level, course schedules were determined for an entire class of students. There were few choices except for elective subjects such as music, art, or a third language. In addition, students participated in written and oral *abitur* examinations in those subject areas where a one-grade discrepancy existed between their final written examination and their overall class work. Students had no way of knowing in which subjects they would have a written and oral examination until the first day of the week-long examination schedule.

The importance of this change for art education cannot be overlooked. Previously, students were rarely examined in art since it was considered an elective, rather than a major, subject. Most important, this reform ensures art an equal position with the social and natural sciences, a position it has not enjoyed since its inception as a school subject. Since the reform, art can be one of the four subjects students choose for the *abitur* examination. This is particularly critical for students seeking to enter art academies or art teacher colleges after graduation.

Closely related to the structure of the school system is art teacher education. College students who wish to teach art at the *grundschule* or *hauptschule*, complete six semesters at a teachers' college and student teach in the seventh semester. Students who wish to teach at the *realschule*, complete seven semesters at a teachers' college and student teach in the eighth semester. Students who wish to teach at the *gymnasium* complete nine semesters of study at the fine arts academy, including pedagogical studies, and student teach in the tenth semester (Kläger, 1990, personal conversation; President of the Hochschule der Kunste, 1989—1990; Tebben, 1982).

Student art teaching is completed with a cooperating art teacher at the type of school for which the student teacher has been trained. The student art teacher slowly assumes the role of art teacher at this school, develops lessons, and teaches them. Once every 2 to 3 months, the student art teacher visits, with three or four other student art teachers, a seminar conducted by one or two seminar leaders. They bring with them student artwork that was executed under their tutelage. This work is discussed along with other pedagogical matters during a day-long seminar. Students are asked to critically analyze their own lessons and those of their colleagues. They brainstorm ways to change the lessons. Issues of child development, classroom discipline, and assessment in the arts, as well as their upcoming teaching test are discussed. Each student teacher is also required to undergo two teaching tests during this semester. These are written evaluations of the student's in-class teaching performance by a representative from the Ministry of Culture (Education) and the student's seminar leader. After 2 years of teaching, teachers take a second state examination, which, when passed, gives them permanent certification (Dandler, 1990, personal interview).

Art Education Curriculum Theory

Although the Allied proposals for democratization were transformed into guidelines for educational policy in all the West German *länder* (states) after World War II, they failed to be implemented for two reasons. First, Germany's speedy economic recovery and the establishment of a new German nation brought stability to the country and lessened the urgency for educational reform. Second, the Allies soon realized the futility of imposing democratic educational reform on a system that inherently fostered society's elitist values and social prestige.

Immediately following World War II, groups of liberal German educators, politicians, and businessmen aligned themselves with the Allies and attempted to rekindle the sentiment for educational reform that had existed in the general public prior to 1933. Realizing that postwar Germany could not compete with industrial nations at that time, these reformers provided the financial and political support for educational research, and eventually, educational reform. Even though their efforts met with indifference and even resistance from conservatives in the country, their influence eventually prompted government policymakers to draft educational reform plans.

The Reemergence of Pre-war Art Education Movements

Concurrent with the Allied and West German educational reform efforts was a movement to reform the practice of art education as well. Although the Allies encouraged experimentation with school programs, most German art educators sought to meet these challenges through the revival of art education practices that had existed prior to 1933. Four prewar art education trends reemerged at this time as a response to the Allied mandate and the German reform movement: *musische* education, the *Kunsterziehung* (art education) movement, the Britsch theory, and the Bauhaus theory.

Musische education proponents such as Georg Götsch (1953), Wolfgang Grözinger (1952/1955), Otto Haase (1951), and Wilhelm Pierzl (1957) identified two contexts for teaching art: the personal and the social. In the personal context, students explored and strengthened through art the feelings that comprised their inner emotions (Götsch, 1953). The emphasis was on developing students' individual personalities, rather than their technical abilities (Ott, 1949). In the social context, students were instructed on the importance of the "whole person" who could interrelate knowledge from a variety of subjects, was well rounded physically and mentally, and enjoyed a social harmony with others. Ideally, *musische* educators advocated the importance of the arts, that is, music, dance, literature, drama, and the visual arts. They viewed the arts as the core of the school curriculum from which all other subjects could be taught. *Musische* educators attempted to address reform issues by promoting (a) a sense of national loyalty through the use of traditional German and folk art, (b) personal achievement through art's cathartic properties, and (c) social harmony through group work (Petrovich-Mwaniki, 1989).

The *kunsterziehung* (art education) Movement was created in the beginning of the 20th century to increase economic growth by improving the aesthetic quality of consumer objects. Art education proponents sought to educate all of society to appreciate and value good craftsmanship as well as to distinguish mediocre from fine art. After World War II, *Kunsterziehung* proponents sought to develop national and international partnerships primarily through the use of group activities in art lessons. Josef Soika (1962) and Max Kläger (1962) particularly promoted the importance of group work as a means of developing interpersonal relationships and group harmony. These aims were similar to those proposed by educational reformers at the time.

The Britsch theory of art education, formulated by Gustaf Britsch in the early 1920s, postulated that the artist's mental development proceeds according to a particular ordering process that is present and innate in the structure of the human intellect (Betzler, 1949). Britsch identified five stages in the child's intellectual thought processes for interpreting pictorial form: the distinction of figure/ground, the extension of marks into shapes, the recognition of directional marks, the incorporation of the background, and the development of more complex differentiations between figure and ground (Britsch, 1952/26). All later interpretations of Britsch's theory were the efforts by his close associate, Egon Kornmann (1931), to relate his ideas to art education. This was a controversial undertaking, one that Munson (1971) felt prematurely relegated Britsch's ideas to the field of art education and limited their use for aestheticians and art historians. Britsch's ideas were disseminated widely through the *Gestalt* magazine, edited initially by Britsch's student, Hans Herrmann, and subsequently by other Britsch students. Britsch's preference for German folk and traditional fine art was reemphasized after the war as a way of promoting national loyalty.

The Bauhaus theory of art education reemerged as a result of the efforts of Max Burchartz (1953), Hans Röttger (1958—67), and former Bauhaus student, Kurt Schwerdtfeger (1957) to develop various aspects of Paul Klee's and Johannes Itten's Bauhaus design courses into elementary and secondary school art curricula. They based their curricula on the Bauhaus Theory of Formation, consisting of certain design elements and principles, and on the theory of creative play or experimentation, which consisted of problem solving with specific art media. Bauhaus proponents stressed the importance of the art-making process rather than the finished art product. Students were encouraged to reflect on the problem statement and to analyze the appropriateness of their ideas to the final solution. This method of structured play reveals the underlying concept of the Bauhaus theory of art education: that experimentation and learning are interrelated.

However, Bauhaus proponents also seemed to address reform efforts by encouraging the use of traditional German art and the making of art as a means of catharsis in the classroom. Given the reputation of the 1920 Bauhaus as a leader in contemporary art education theory and practice, it seems contradictory that its former students, in the 1950s, would promote traditional art forms. However, rather than emphasize their role as leaders in the contemporary art movement, Bauhaus followers in the 1950s must have felt that the

revival of traditional values in a situation where traditional political, social, and economic structures had crumbled was more important (Petrovich-Mwaniki, 1987). Bauhaus support for the cathartic qualities of art instruction seems to have emerged from Itten's oftentimes untraditional teaching methods, which included spontaneous drawing, meditation, and breathing exercises.

Proponents of the prewar art education movements tried to address the Allied mandate for democratic reform within the context of their traditional educational philosophy, but their attempts were unconvincing. They merely emphasized those aspects of their philosophy that implied democratic ideas, or a suggested relationship to research in educational psychology. An inconsistent approach to curriculum revision evolved that failed to produce a sequentially designed curriculum across all school levels by any one of the four traditional movements. Instead, proponents of each movement selectively addressed those Allied or West German reform initiatives which shared similarities with their particular philosophies. West German art educators thereby made the reform initiatives fit their own philosophies instead of revising their philosophies to fit reform initiatives (Petrovich-Mwaniki, 1987).

The Kunstunterricht Movement

By the end of the 1950s, the need for reform in art education was acute (Picht, 1964). Proposed educational reforms such as the 1959 *Rahmenplan* (Skeleton Plan for the Reorganization and Standardization of the Academic Public School System), which would reduce the required hours for art, and the 1960 *Rahmenvereinbarung* (Skeleton Agreement to reform the upper level of the Gymnasium), which sought to reduce art to an elective in the upper grades of the gymnasium, seemed likely to be implemented (Senator, 1962), yet West German art educators appeared reluctant and unable to address this pressing concern. A number of art educators sensed the urgency to respond. Impressed with research by a number of agencies (Johann & Junker, 1970), the government's Central Institute for Education and *Pädagogische Arbeitstelle* (Pedagogical Work Center) (Hilker, 1960; Kuhlmann, 1970), and the Ettlinger *Kreis* (Circle), an independent research agency (Hylla, 1958; Springer, 1965), and, excited by contemporary trends in the fine arts, they were eager to apply these ideas to art education.

The genesis of the new movement in West German art education can be traced to a book by Reinhard Pfennig (1959), *Bildende Kunst der Gegenwart: Analyse und Methode* (Contemporary Art: Analysis and Method). Pfennig was the first to call the teaching/learning activity he proposed *Kunstunterricht* (art instruction) rather than the popular term *Kunsterziehung* (art education). He designed his curriculum around six principles of formation based on his analysis of contemporary art, an experiential net system of instruction based on the interaction between students' previous and new learning experiences and problem solving. Another art educator, Gunter Otto (1964), influenced by educational psychological research and especially the theories of Paul Heimann (1976), incorporated these into his theory of *Kunstunterricht*. Otto (1969) based his curriculum on the crucial decisions teachers make about aims, content, methods, and medium, as well as the interrelation of these with art production and reflection.

Kunstunterricht differed from *Kunsterziehung* in two major ways: (a) it drew upon contemporary art forms as the basis for art learning processes, and (b) it emphasized a systematic approach to teaching art that involved the interaction between student learning objectives, the role of the teacher, and the evaluation of student learning (Burmeister, 1976). Other writers in this movement included Peter Heinig (1969), Klaus Kowalski (1968), and Hans Ronge (1968).

The introduction of *Kunstunterricht* had a divisive effect on West German art education. Unlike proponents of Britsch, the Bauhaus, *musische* education, and *Kunsterziehung*, who merely reinterpreted traditional practices and related them to social issues, *Kunstunterricht* proponents combined then-current theories from various disciplines to design a specific and relevant response to social concerns. This was particularly evident in Pfennig's and Otto's theories. It was clear that Pfennig (1964) was influenced by the socioanthropological studies conducted by the German educator Heinrich Roth (1957), who believed that if education were to become socially relevant, it had to emphasize individual relationships rather than individual potential. This is reflected in Pfennig's assumption that students can learn to relate to others socially by developing an understanding of pictorial relationships. Otto (1969) also emphasized the importance of art to social relations when he stated that "art had a part in the social process because it brought people in contact with each other" (p. 84). Although he failed to define this social process, Otto implied that it was a communicative one in which the viewer, as a member of soci-

ety, dialogued visually and verbally with the artwork, which was a product of society. Pfennig's and Otto's ideas about society reflected a renewed awareness by West German art educators of the individual's social importance and of art's function as communicator of social values, attitudes, and prejudices, which had been lacking in prewar art education. Most important, Pfennig and Otto sought ways to educate students about their contemporary society and to develop their problem-solving skills so that they would become responsible decision makers within that society and learn to adapt to society's ever-changing sociocultural and political realities.

Curriculum Reform in the 1970s

Around 1970, intense discussion broke out in art education circles that was part of a national concern for curriculum reform in West Germany (Giffhorn, 1978). Axel von Criegern (1972), Diethart Kerbs (1970), Helmut Hartwig (1971), Hans Giffhorn (1972), and Heino Möller (1970a) criticized *Kunstunterricht* and other art education movements for emphasizing art-making processes and traditional, elitist art rather than political emancipation and nontraditional art forms. They argued that the purpose of art education was to prepare students for the mastery of their present and later life situation (Giffhorn, 1974). To that end, they rejected the goals and methods of conventional art instruction and experimented with the interrelation and relevancy of political and social issues in the art classrooms (Giffhorn, 1972).

Two trends emerged from this socially engaged art pedagogy: Visual Communication (*Visuelle Kommunikation*) and Aesthetic Education (*Ästhetische Erziehung*) (Giffhorn, 1974; von Criegern, 1972). The primary goal in Visual Communication was to educate students to the critical consumption and emancipated use of mass media. Heino Möller (1970a, 1970b, 1971) argued that although mass communication was part of modern daily life, there was widespread visual illiteracy. Mass communication as curriculum content was nonexistent in the schools. He sought to rectify this by having students in art class analyze only contemporary mass media, which he felt were more relevant to the needs of modern society in that they were reproducible and egalitarian (Möller, 1970a). Actual art production was reduced to a minimum. Giffhorn (1972), in particular, advocated an art instruction that developed aesthetic and political behaviors in all subjects, thereby promoting the accountability of art as a subject in the school curriculum. Giffhorn's particularly Marxist ideas were highly criticized by his col-

leagues, as was his lack of instructional methodology (Theunissen, 1980). However, he did promote art production and the use of any type of art whose intention was explicitly hedonistic or socially explanatory in nature (Schütz, 1978).

Visual Communication was viewed as a revolutionary approach to teaching art in that it focused more on society at the expense of art (Rech, 1978; Ruhloff, 1976). This was evident in seven theses proposed by the Frankfurt Ad Hoc Group for Visual Communication. The group pointed out that art processes and objects were class oriented, and therefore advocated an analysis of the communication and art forms promoted by the ruling class as the primary goal in art education. It called for the abolition of the then-contemporary methods of art education and proposed a socially critical subject called Visual Communication, which had as its goal the social reconstruction of German society.

In 1970, Diethart Kerbs (1970) called for a theory of aesthetic education that emphasized four functions: (1) the critical, in which contemporary cultural objects are analyzed for their economic, ideological, and political purposes; (2) the utopian, in which experimentation, creativity, and fantasy are used to design possible physical and imaginary realities; (3) the hedonistic, which cultivates the sensitive enjoyment of all the physical senses; and (4) the pragmatic, in which the use and manipulation of art and mass media are practiced (Schütz, 1978).

In West Germany, aesthetic education includes the visual arts, music, dance, and theater, and refers to the ways and means that aesthetic objects are made (production) and viewed (reception). The methods of making art are not the same as, but are part of, the methods for teaching aesthetic education. The methods of aesthetic education are derived from (a) the experience of the learner, (b) the conditions of the learning situation, and (c) the function these conditions serve for the learner (Eucker, 1982a). Aesthetic education is also believed to be political education, because the critical function of art in today's society demands that students become aware of the socioeconomic, political, and ideological implications of art making and art viewing if they are to participate as emancipated citizens in a democratic society (Kerbs, 1975; Otto, 1975).

In spite of the bitter criticism proponents of Visual Communication leveled against the *Kunstunterricht* movement, the theories and practices of both Visual

Communication and Aesthetic Education were actually conceived in the 1960s when Pfennig (1964) and Otto (1969) emphasized art making and viewing as social and communicative processes. Otto expanded his ideas further in the 1970s to postulate a philosophy of aesthetic education in which the production, communication, and distribution of aesthetic objects were the three large areas of learning. He felt that the aim of aesthetic education, which viewed students as social beings, was to emancipate students to realize the freedom they have in personal and political self-determination (Otto, 1974).

The Current Situation

In the 1980s, West German art education theory reached a plateau. Art educators worked at defining and redefining the ideas of Visual Communication and Aesthetic Education (Diel, 1982; Eucker, 1982a, 1982b; Giffhorn, 1987; Junker, 1984; Otto, 1984; Staudte, 1986) which are still evident in the goals and aims of each state's art curriculum guidelines (Bayern, 1984; Schütz, 1978). The strong criticism leveled against the "traditional" art education movements mellowed in the 1980s. Art educators reexamined the ideological, philosophical, and methodological ideas advanced by the *Kunstunterricht* movement (Brög, 1990; Otto, 1984; Selle, 1990), *musische* education (Patt-Wüst, 1980; Schütz, 1981; Wienecke, 1981), the Bauhaus (Klein, 1981; Wick, 1985), and Britsch's theory (Reindl, 1988).

Art educators also began to pay more attention to multicultural concerns (Scholz, 1990). This is evidenced in articles examining the definition of culture and its relation to education (Jentzsch, 1981; Selle, 1990) as well as articles about Turkish guest worker children in the art class (Boos-Nünning, 1983; Manthey, 1983). Wienhöfer (1983) admonished art educators in the public schools to be open to differences among children and to realize that foreign children often suffer a lack of identity because they are in the minority. Boos-Nünning (1983) delineated the specific problems that Turks who migrate to Germany face, such as enculturation, assimilation, social and religious prejudice, and social and familial disorientation. She believed that the aim of education should be to make foreign (Turkish) children feel secure, succeed in school, achieve social and communicative abilities, achieve a psychoemotional stability, and participate in the German social and political system. Boos-Nünning warned that the Turks need not accept the entire German culture but should retain those particular parts of their culture which make them unique. More impor-

tant, their culture should become part of classroom instruction by using their art forms, literature, history, geography, and so forth. In this way, all the children in the class will be prepared cognitively and emotionally for accepting other cultures.

Jens Thiele (1985) claimed that there is a crisis in art pedagogy that purports to teach culture yet has no understanding of the student or the student's subculture. He encouraged teachers to acquire an understanding of the popular media students watch and listen to and to incorporate this into art instruction. Thiele distinguished between what he called "culture education," the participation in and promotion of cultural activities, and "art education," art studio and criticism activities grounded in an art historical definition of art. In spite of the common interest in culture shared by these two types of education, Thiele advised that art education remain a distinct process of aesthetic experiences and reflection with its own aims and teaching/learning approach. However, art educators now need to go beyond the traditional focus on the principles of artistic design to emphasize a more open, critical, and self-reflective student behavior.

Art Education in a Unified Germany

Although Germans had longed for the unification of Germany since the end of World War II, its reality created a number of pressing social, economic, political, and educational problems. Some of these, which affect the field of art education as well, include the lack of qualified teachers and materials in the former East Germany, the redesign of teacher education programs in the former East Germany, the retraining of former East German teachers in the theory and educational practice of their West German counterparts, the need for communication among educators in all of the new German states, and an understanding of the multicultural educational issues facing East and West Germans alike. In spite of the dominance of West German social, political, and economic views on the restructuring of a united German society and economy, West German art educators realize that East German art educators have much to teach them about art education theory and practice (Scholz, 1990).

German art educators sought to address some of these issues by establishing a dialogue between art educators in the 16 new German states. One of the first goals was to found, in each of the former East German states, art education associations similar to the West German *Bund der Deutschen Kunsterzieher* (BDK) (Association of German Art Educators). In June, 1990,

these state associations met for the first time. Shortly thereafter, in November, 1990, the art education associations from all of the unified German states met in Berlin to elect officers for a unified German art education association (Böhme, 1990; Schulz, 1990; Wolters, 1990). Currently, the organization is discussing some of the pressing issues facing art education in Germany, including the effect of the 1992 unification of Europe on the art teacher market in various countries, art teacher certification standards, and European standards for the preservation of culture in each country. It is hoped that a European lobby for art education will be established, perhaps with the help of INSEA (The International Society for Education Through Art) (Frenzel, 1991).

The other issues will take some time to be resolved. In October 1991, the Institut für Kunstpädagogik der Humboldt-Universität Berlin (Institute for Art Education of the Humboldt University, Berlin) discontinued its art teacher certification program and instituted a new program preparing teachers for professions in the united German school system (Minow & Sack, 1991). The migration of teachers and other professionals to West Germany immediately preceding unification left East Germany with a lack of qualified teachers in the schools. Given the present socioeconomic conditions in East Germany, it is difficult to convince West German art educators to relocate. In addition, the economic situation has deterred the acquisition of needed educational supplies and equipment. School textbooks are currently being revised, but it will take some time before they are distributed to all the schools and teachers learn how to use the new, democratically oriented material in the classroom.

Multicultural concerns are particularly crucial at this time. Since the 1960s, West Germany has provided work for *gastarbeiter* (guest workers) from less-developed European Community nations such as Turkey, Greece, Italy, Spain, Portugal, and Yugoslavia. Initially, the Germans felt the guest workers would come, earn their money, and return home to further develop their own nations' economies. On the contrary, the guest workers stayed, brought their families with them, bore more children, took advantage of the German welfare and child support system, and became a social and political group to be reckoned with. Although many guest workers do not have German citizenship (children born in Germany assume the citizenship of the parents), they are second and third generations who have lived only in Germany, attended German schools, and become enculturated into the German society. They identify more with

Germany than with their native country. Germans are beginning to realize that they must address the educational needs of this population better than they have in the past. This is evidenced at universities, where one can now study Education for Foreigners (*Ausländererziehung*), aimed primarily at the education of Turkish children. Ironically, West Germany must now focus on educating former East Germans and enculturating them into West German society as well.

The time is now ripe for a change in German art education. Traditionally, Germans have regarded the aim of art education to be the preservation of German culture and the development of students' creative expressiveness through art media. The most recent events are challenging the German definition of culture. German society, although long regarded as homogeneous, is and has been racially and ethnically diverse. The guest workers and their families, as well as other immigrants, may not have German citizenship, but they have influenced and will continue to influence the development of German culture. This requires art educators to redirect their focus to the students as individuals who represent various cultural and social milieus within the German society. Although German art educators have emphasized society since the 1960s, the emphasis has been on material culture and its message rather than nonmaterial culture and its meaning within that culture. The art education theory and practice that grows out of these new deliberations will more than likely incorporate the best of past art education trends with multicultural views.

References

Allied Control Council (ACC). (1947). Basic principles for democratization of education in Germany: Control Council directive No. 54. In U.S. Department of State, *Germany 1947—1949, The story in documents* (p. 550). Washington, DC: U.S. Government Printing Office.

Bayern. (1984). *Amtsblatt des Bayerischen Staatsministeriums für Unterricht und Kultus. Lehrplan Kunsterziehung für die Jahrgangstufen 8, 9, und 10 an den Gymnasien. 19. Juli. 1984 Sondernummer 8* [Official bulletin of the Bavarian Ministry for Education and Culture. Syllabus for art education for grades 8, 9, and 10 on the gymnasiums. 19th of July, 1984, special number 8]. Munich: Government Printing Office.

Betzler, E. (1949). *Neue kunsterziehung* [New art education]. Frankfurt/Main: Hirschgraben Verlag.

Böhme, G. (1990). Zur gründung eines verbandes der kunsterzieher und kunsterzieherinnen in der DDR [The founding of an association of art educators in the German Democratic Republic]. *BDK-Mitteilungen, 25*(2), 4–5.

Boos-Nünning, U. (1983). Problem oder chance? [Problem or prospect?] *Kunst und Unterricht, 79,* 11–13.

Britsch, G. (1952). *Theorie der bildenden kunst* [Theory of art] (3rd ed.). Ratingen: Aloys Henn Verlag. (Original work published 1926).

Brög, H. (1990). Kulturelle kompetenz [Cultural competence]. *Kunst und Unterricht, 141,* 42–43.

Burchartz, M. (1953). *Gestaltungslehre* [Theory of formation]. Munich: Prestel Verlag.

Burmeister, P. (1976). Die konzeption kunstunterricht [The concept of art instruction]. *BDK-Mitteilungen, 11*(1), 11–18.

Dahrendorf, R. (1967). *Society and democracy in Germany.* Garden City, NY: Doubleday.

Diel, A. (1982). Krise der ästhetischen erziehung? [The crisis of aesthetic education?]. *Kunst und Unterricht,* SH, 11–12.

Eucker, J. (1982a). Die methoden ästhetischer erziehung [The methods of aesthetic education]. *Kunst und Unterricht,* SH, 108–128.

Eucker, J. (1982b). Ästhetische erziehung—Dem eigenen fach auf die spuren [Aesthetic education—On the track of its own subject]. *Kunst und Unterricht,* SH, 108–128.

Frenzel, R. (1991). Kassel, mitten in Deutschland [Kassel, in the middle of Germany]. *Kunsterziehung, 38*(4), 74–76.

Giffhorn, H. (1972). *Kritik der kunstpädagogik* [Critique of art pedagogy]. Schauberg: DuMont.

Giffhorn, H. (1974). *Modeverhalten—Asthetische normen und politische erziehung* [Fashionable behavior—Aesthetic norms and political education]. Schauberg: Verlag M. DuMont.

Giffhorn, H. (1978). Ideologies of art education. *Studies in Art Education, 19*(2), 50–60.

Giffhorn, H. (1987). Wege zu einer theorie der ästhetischen erziehung [Paths to a theory of aesthetic education]. *BDK-Mitteilungen, 22*(3), 11–15.

Götsch, G. (1953). *Musische bildung I: Besinnung* [Musische education I: Contemplation] (2nd. ed.). Wolfenbüttel: Möseler Verlag.

Grözinger, W. (1955). *Kinder kritzeln, zeichnen, malen.* Munich: Prestel, 1952. [Scribbling, drawing, painting], trans. Ernst Kaiser & Eithene Wilkins. New York: Praeger.

Haase, O. (1951). *Musisches leben* [Musisches life]. Hannover: Schroedel.

Hamm-Brücher, H. (1972). *Unfähig zur reform* [Unable to reform]. Munich: R. Piper.

Hartwig, H. (1971). Zur ideologiekritik von sehen-lernen [Concerning the ideological critique of seeing-

learning.] In H. K. Ehmer (Ed.), *Visuelle kommunikation* [Visual communication] (pp. 340—366). Schauberg: Verlag M. DuMont.

Hearndon, A. (1974). *Education in the two Germanies.* Boulder, CO: Westview.

Heimann, P. (1976). Didaktik als theorie und lehre [Didactic as theory and doctrine]. In K. Reich & H. Thomas (Eds.), *Didaktik als unterrichtswissenschaft* [Didactic as science of teaching] (pp. 142–268). Stuttgart: Ernst Klett Verlag.

Heinig, P. (1969). *Kunstunterricht* [Art instruction]. Heilbrünn-Obb: Verlag Julius Klinkhardt.

Hilker, F. (1960). Comparative education in the documentation and information center in Bonn. *Comparative Education Review, 3*(3), 13–15.

Hylla, E. (1958). Recent developments in education in the Federal Republic of Germany. *Comparative Education Review, 2*(1), 12–16.

Jentzsch, K. (1981). Kulturpolitik–Stellungnahmen und forderungen [The politics of culture—Positions and demands]. *BDK-Mitteilungen, 16*(2), 32–34.

Johann, E., & Junker, J. (1970). *German cultural history of the last hundred years.* Munich: Nymphenburger Verlagshandlung.

Junker, H. D. (1984). Subjektorientierte ästhetische praxis [Subject-oriented aesthetic practice]. *BDK-Mitteilungen, 19*(2), 5–18.

Kerbs (see editors handwritten note on p. 15)

Kerbs, D. (1970). Zum begriff der ästhetischen erziehung [About the concept of aesthetic education]. *Die Deutsche Schule, 62,* 562–570.

Kläger, M. (1962). Die gemeinschaftsarbeit [Group work]. *Kunst und Jugend, 24*(2), 60–61.

Klager, M. (1984). Germany: Decentralization in the Federal Republic. In A. Hurwitz & R. Ott (Eds.), *Art education: An international perspective* (pp. 78–84). State College, PA: Penn State University Press.

Klein, H.-J. (1981). Paul Klee und die kunstpädagogik heute [Paul Klee and art pedagogy today]. *Zeitschrift für Kunstpädagogik,* (5), 43–48.

Kornmann, E. (1931). *Die theorie von Gustaf Britsch als grundlage der kunsterziehung* [The theory of Gustaf Britsch as the basis for art education]. Düsseldorf: Verlag L. Schwann.

Kornmann, E. (1962). *Grundprinzipien bildnerischer gestaltung: Einführung in die kunsttheorie von Gustaf Britsch* [Basic principles of pictorial forming: Introduction to Gustaf Britsch's art theory]. Ratingen: A. Henn Verlag.

Kowalski, K. (1968). *Praxis der kunsterziehung* [The practice of art education]. Stuttgart: Ernst Klett Verlag.

Kuhlmann, C. (1970). Schulreform und gesellschaft in der bundesrepublik Deutschland, 1946–1966. [School reform and society in the Federal Republic of Germany, 1946–1966]. In S. B. Robinsohn (Ed.), *Schulreform im gesellschaftlichen prozess, Band I* [School reform in the social process, Vol. I] (pp. 7–206). Stuttgart: Klett Verlag.

Manthey, 1983 (see editor's note on p. 16)

Minow, M., & Sack, U. (1991). Lehramtstudium bildende kunst an der Humboldt-Universität, Berlin [Art teacher education at the Humboldt University, Berlin]. *Kunsterziehung, 38*(4), 68–70.

Möller, H. (1970a). *Gegen den kunstunterricht* [Against art instruction]. Ravensburg: Otto Maier Verlag.

Möller, H. (1970b). Kunstunterricht und visuelle kommunikation [Art instruction and visual communication]. *Bildnerische Erziehung, 6,* 210–211.

Möller, H. (1971). Zur didaktik der visuellen kommunikation [Concerning the didactic of visual communication]. *Kunst & Unterricht, 14,* 1–3.

Munson, R. S. (1971). The Gustaf Britsch theory of the visual arts. *Studies in Art Education, 12*(2), 4–17.

Ott, R. (1949). *Urbild der seele* [Prototype of the soul]. Bergen: Mueller and Kiepenheuer Verlag.

Otto, B. (1984). *Untersuchungen zum paradigmenwechsel in der ästhetischen erziehung* [Examinations of the paradigm change in aesthetic education]. New York: Peter Lang.

Otto, G. (1964). *Kunst als prozess im unterricht* [Art as process in instruction]. Braunschweig: Georg Westermann Verlag.

Otto, G. (1969). *Kunst als prozess im unterricht* [Art as process in instruction] (2nd ed.). Braunschweig: Georg Westermann Verlag.

Otto, G. (1974). *Didaktik der ästhetischen erziehung* [The didactics of aesthetic education]. Braunschweig: Westermann.

Otto, G. (Ed.). (1975). *Texte zur ästhetischen erziehung* [Texts about aesthetic education]. Braunschweig: Westermann.

Otto, 1984; see editor's note on page 15

Patt-Wüst, K. (1980). *Alternative: Musische bildung* [Alternative: Musische education]. Frankfurt/Main: Rita G. Fischer Verlag.

Petrovich-Mwaniki, L. (1987). *The Bauhaus and its influence on post World War II West German art education.* Paper presented at the NAEA National Convention, Boston, MA. April.

Petrovich-Mwaniki, L. (1988). An analysis of *Kunstunterricht* in the writings of West German art educators: Reinhard Pfennig and Gunter Otto. *Dissertation Abstracts International, 49,* 1038A. (University Microfilms No. 8814504)

Petrovich-Mwaniki, L. (1989). *Musische education: Its origins, influence, and survival in West German*

art education. Paper presented at the Second Penn State Conference on the History of Art Education, State College, PA. October.

Pfennig, R. (1959). *Bildende kunst der gegenwart: Analyse und methode* [Contemporary art: Analysis and method]. Oldenburg: Verlag Isensee.

Pfennig, R. (1964). *Gegenwart der bildenden kunst: Erziehung zum bildnerischen denken* [Presence of fine art: Educating pictorial thinking] (2nd ed.). Oldenburg: Verlag Isensee.

Picht, G. (1964). *Die deutsche bildungskatastrophe* [The catastrophe of German education]. Freiburg: Walter-Verlag.

Pierzl, W. (1957). *Kunsterziehung als wesentliches mittel zur menschenbildung* [Art education as essential means of human education]. Leoben: Fritz Loewe Verlag.

President of the Hochschule der Künste, Berlin. (1989/90). *Studienjahr, Studien und Hochschulführer.* Berlin: Hochschule der Künste.

Rech, P. (1978). Visuelle kommunikation zwischen kunst und kunstpädagogik. *BDK-Mitteilungen, 13*(2), 27–35.

Reindl, R. (1988). Einige grundsätze bildnerischer erziehung [Some principles of pictorial education]. *Die Gestalt, 50*(3), 74–75.

Robinsohn, S. B., & Kuhlmann, C. J. (1967). Two decades of non-reform in West German education. *Comparative Education Review, 11*(3), 311–330.

Ronge, H. (1968). *Kunst und kybernetik* [Art and cybernetics]. Cologne: Verlag M. Dumont.

Roth, H. (1957). *Pädagogische psychologie des lehrens und lernens* [Pedagogical psychology of teaching and learning] (3rd ed.). Hannover: Hermann Schroedel Verlag.

Röttger, H. (1958–67). *Das spiel mit den bildnerischen mitteln* [Playing with pictorial means]. Ravensburg: Otto Maier Verlag.

Scholz, O. (1990). Personal conversation with the author.

Schütz. H. (1978). Kunstpädagogik. In Helmwart Hierdeis (Ed.), *Taschenbuch der Pädagogik, Teil 2,* (pp. 518-524). Baltmannsweiler: Burgbücherei Schneider.

Schütz, O. (1981). Musische erziehung: Einmal hin und zurück? [Musische education: Now there and back?] *Zeitschrift für Kunstpädagogik,* (2), 7-9.

Schulz, W. (1990). Hauptversammlung des BDK-DDR am 30.6.1990 [The general meeting of the association of art educators in the DDR on June 30, 1990]. *BDK-Mitteilungen, 25*(3), 5.

Schwerdtfeger, K. (1957). *Bildende kunst und schule* [The visual arts and school] (4th ed.). Hannover: Hermann Schroedel Verlag.

Selle, G. (1990). Der Kunstpädagoge als "sinnstifter" [The art educator as the founder of taste]. *BDK-Mitteilungen, 25*(2), 18-22.

Senator für Volksbildung. (1962). *Denkschrift zur inneren schulpolitik* [Memorandum concerning national school politics]. Berlin: Kulturbuch Verlag.

Soika, J. A. (1962). Umweltgestaltung–eine aufgabe der kunst- und werkerziehung [Environmental design: A task for art and crafts education]. *Kunst und Jugend, 3*(6), 252–261.

Springer, U. K. (1965). West Germany's turn to bildungspolitik in educational planning. *Comparative Education Review, 9*(1), 11–17.

Staudte, A. (1986). Primarstufe: ästhetische erziehung in der schule für alle kinder [Elementary grade: Aesthetic education in the school for all children]. *Kunst und Unterricht,* (107), 35–37.

Tebben, M. (1982). Kunststudium an der universität [The study of art at the university]. *BDK-Mitteilungen, 17*(2), 16-20.

Theunissen, G. (1980). "Problemorientierte" ästhetische erziehung ["Problem-oriented", aesthetic education]. *Zeitschrift für Kunstpädagogik,* (5), 58-59.

Thiele, J. (1985). Kunstpädagogik und kulturpädagogik [Art pedagogy and pedagogy of culture]. *BDK-Mitteilungen, 20*(3), 5-11.

von Criegern, A. (1972). Die entwicklung der kunstdidaktik aus wissenschaftstheoretischer sicht [The development of art didactic from a scientific theoretical point of view]. *Zeitschrift für Kunstpädagogik, 3*, 121-128.

Weiler, H. (1973). *The politics of education innovation: Recent developments in West German school reform.* A report to the National Academy of Education. Stanford University.

Wick, R. (Ed.). (1985). *Ist die Bauhaus pädagogik aktuell?* [Is the Bauhaus pedagogy relevant today?]. Cologne: Verlag der Buchhandlung Walther König.

Wienecke, G. (1981). Ideologische wandlungen musischer erziehung [Ideological changes of musische education]. *Zeitschrift für Kunstpädagogik,* (2), 2-6.

Wienhöfer, F. (1983). Übergangspädagogik oder unterrichts-prinzip? [Transitional pedagogy or instructional principle?]. *Kunst und Unterricht,* (79), 8-11.

Wolters, P. (1990). BDK-DDR landesverbände gegründet [State associations of art educators-DDR founded]. *BDK-Mitteilungen, 25*(3), 4.

ART AND DESIGN EDUCATION IN SOUTH AFRICA

■ W. R. PHILIP

Art and design as it has been practiced and taught in South Africa has been predominantly an activity of the white man, carried out in the European tradition. Earlier settlers found traces of indigenous art in the rock paintings of the Bushmen and in prehistoric rock engravings, but this art is only of historical interest. White immigrants from England and every country of Europe naturally looked back to their countries of origin in all things pertaining to education and culture. Today, however, we are witnessing the beginnings of greater awareness of art and design on the part of the other peoples in South Africa, together with an expansion of educational services to all sectors of the population, and this will bring a new challenge to those concerned with art and design in all its forms.

The Republic of South Africa occupies a small slice of Southern Africa, much of which is arid and sparsely populated. There are roughly five million whites and twenty-five million others, of whom the black races are in the great majority. These people are mainly concentrated in the industrial centers grouped about the mining areas of the Reef and the seaport towns of Cape Town, Durban, and Port Elizabeth, where the principal schools of art and design are also to be found. Port Elizabeth, which was the scene of the landing of the 1820 settlers from Great Britain, claims to have the oldest art school in the country and is this year celebrating its centennial. In the Southern Transvaal, Pretoria and Johannesburg are the main cities, but the industries are spread along the Reef to the east and the west and include black satellite cities such as Soweto, housing millions of black workers continually migrating to the city areas from their homelands. There are areas which traditionally belong to different black races; for example, the Transkei and the Ciskei are in the Eastern Cape; Venda, Leboa, and Bophuthatswana are in the Transvaal, and Kwa-Zulu is in Natal. These are not yet industrialized and are without large urban complexes, and life proceeds in a traditional tribal manner, in contrast to the bustling black cities like Soweto.

For me it is an interesting exercise to write about art education, as I have been an art teacher since 1946 and have experienced some changes and some growth during this time. My ancestors were settlers in the Eastern Cape, brought out to help stabilize a border area where cattle thefts and land disputes were a cause of worry to the British administration. The settlers were proud of their cultural heritage, and the old military outpost of Grahamstown became an educational center, with the Rhodes University Campus and the 1920 Settlers Memorial Foundation carrying on the tradition. In 1939 I went to art school there. My professor and senior lecturer were both associates of the Royal College of Art, so some of their tradition of excellence was passed on to us as students. From 1946 to 1949 I taught at the Pretoria Art Center, where we had to do with art groups of children from 4 years to 16 years of age. After this I spent twelve years as an art teacher in a high school, and thereafter 20 years in a tertiary school of art and design. During the war I spent some leave in England, drawing at the St. Martins School, and I visited art schools in England and in Europe in 1962, 1972, and 1978. I think that the pattern I have followed is fairly typical of my colleagues and will explain why many of our courses follow the British pattern. Although my background is English, South Africa is a bilingual country, and there are a greater number of Afrikaans-speaking descendants of Dutch, German, and French settlers. Those of them who are art teachers generally also find their way to Europe for further study, and in recent years more South Africans are going to the Americas for postgraduate study than ever before.

Art Centers in South Africa

I would like to mention something that most people have forgotten. That is a visit to South Africa, circa 1934, of Arthur Lismer from Canada. His vigorous support for child art and for free expression was an influence in my own childhood, and led to the establishment of art centers in Pretoria, Cape Town, Worcester, Grahamstown, and other cities. The accep-

Reprinted from the *Journal of Art & Design Education*, 2, (3), 1983, (pp. 303-323).

tance of free expression on the part of children and the encouragement of child art generally has had a liberating influence on generations of South Africans. I believe that the child art movement should be vigorously supported everywhere in the world and more particularly among less privileged children. By enabling them to express themselves in color and design in a way that comes naturally to all children I believe that they find a richer mental and physical life, which is surely of great value. I am glad to see that the art center idea is spreading among the black townships on the Reef with outstanding results. More neighborhood art centers supported by community funds can do so much to encourage creativity and harmony among different population groups.

Secondary Education

Attendance at school up to age 16 is compulsory for whites, and after this many go on to complete their 10th grade to qualify for admission to tertiary education. High school has always been regarded as a preparation for a job rather than an education for living, and for that reason more emphasis is always given to the nitty-gritty subjects than to more creative ones. Thus, there is a limited number of schools that offer art as a subject at the higher level. Happily, there is a growing number of schools and teachers interesting themselves in a broader kind of art curriculum that opens up the young mind to problem solving in all sorts of different media. From the articles so far published in *JADE* it is clear that the United Kingdom is taking a leading role in bringing back meaningful art and design education into the schools. Fortunately, within the framework of a very dull curriculum a perceptive teacher can always achieve fantastic results, especially with children who are possibly natural designers but not good at the three R's. There is clearly a need to cater to the child with exceptional talent, and for this reason there are a number of special high schools for art, ballet, and music in the various provinces to cater to selected students. Those who follow the art subjects may take up employment or go on to the art schools to specialize in a particular field.

In high school art departments the emphasis is usually more on painting and graphic design, the greatest weakness being three-dimensional design. It is not necessarily the art teacher, but often the woodwork man, the stage manager of the drama club, or a science buff who carries out a constructional project above and beyond the normal curriculum. We feel that if more attention could be given to that part of the brain that visualizes a design solution in terms of contrasting and interrelated parts in two and three dimensions, the design professions would benefit a great deal.

In education for the black races there is a great effort underway to overcome the backlog in high school facilities. There is also a good deal of research needed to determine what kind of art curriculum is best suited to their needs. Seeing that in the end all persons, irrespective of racial background, will have to contribute to the needs of society as a whole, it seems to me that there is *no need to differentiate in the contents of the curricula* so long as we address ourselves to the reality within the framework of the student's own experience at his successive levels of development. The important thing is to provide the opportunity for original creative work in art and design at the secondary school level in order to complement the emphasis on technical training.

The Design Institute

The work of the British Design Council in promoting design and education is well known in South Africa. Happily, our own version of the Council has been in operation for about 16 years. It is called the Design Institute of the South African Bureau of Standards. It is charged with the promotion of design in industry and also with the encouragement of design education at all levels and in various areas. This is a big step forward, because industrial design as a profession is only now becoming recognized by the captains of industry. At present there is only one college, the Technikon Witwatersrand, that offers an industrial design course. This was started in 1963 and at present produces ten to fifteen qualified designers every year.

The Design Institute holds seminars on design education, promotes design competitions and makes awards, has a small in-house design staff, advises industry and commerce on design problems, liaises with the local and international societies of designers, issues a monthly publication, and runs the Design Bookshop to promote knowledge of design.

The Society of Designers of South Africa is the professional body to which local designers in all fields of two- and three-dimensional design may belong. It is affiliated to overseas bodies and has branches in all the different provinces. The fact that it has a growing membership attests to the fact that this country is rapidly becoming design conscious. Self-sufficiency in design and production is of course also due to necessity in the face of hostile world forces, and it is also evident in the huge civil engineering, chemical, mining,

and mechanical engineering projects currently being undertaken.

We also realize that South Africa, in common with other developing countries, poses interesting problems for the designer, as there is a need for a labor-intensive kind of industry suited to the rural areas and to conventional methods of mass production. For example it could be possible to produce products for home consumption on a "cottage industry" basis in the homelands. A number of factories are being opened in rural areas to take advantage of native skills, particularly in the textile and ceramic industries.

Black Artists

Historically there is no background in South Africa to compare with the West African Benin culture. Traditionally the blacks have a background of the crafts behind them; carved wooden bowls, spoons or weapons and walking sticks, clay pots, animals and figures, beadwork, and geometrically patterned huts. Nevertheless, in recent years there has been a blossoming of talent and recognition for nonwhite artists.

Since the end of World War II, when the process of urbanization brought sprawling squatter townships into being, naive painters have been depicting the life of these slums. Thus was born what is now universally known as Township art. The doyen of these artists was Gerard Sekoto, who subsequently went to Paris, where he lost all the characteristic quality of the untutored artist. Subsequently a number of others, like Maqhubela, interpreted the township scene either with humor, protest, or caricature until the theme was played out.

Initially it was not due to any art school or establishment that black artists stepped into the public eye. It was due to the encouragement they received from sympathetic white artists and gallery owners. Cecil Skotnes was one who taught them without imposing European concepts on their work. The boot was in fact on the other foot, for a number of white artists were influenced by African concepts and sought identity and acclaim using an idiom derived from African art. The versatile Walter Battiss is a case in point.

Further development has occurred along more individual lines, including Expressionism and Protest art. There is talk at present of establishing some kind of Township academy where techniques can be learned. The Swedish Mission at Rorke's Drift and Fort Hare University are established schools in the Eastern Cape.

It still remains to be seen whether the black man will be able to create a tradition of design that goes beyond the handicrafts. Obviously this depends on the way in which he comes to terms with materials and technology. New technikons have been established in the Transvaal and Natal, but they have not yet started schools of art and design. This will happen very soon, and I think that black artists are going to astonish us all. From the great talent shown in illustration and drama it seems likely that graphic processes, advertising design, and television productions will offer a big opportunity for black artists in the future. South Africa now has three television channels, two of which cater to nonwhites. One wishes to see the artist remain ethnically black, but it looks as if he will have to become technically white!

At present the black artist looks for support from a white patron, and he is like a prophet without fame in his own land. I think, however, that once he is sought after among his own people rather than by a small white audience his art will really become established.

Museums and Galleries

Support for art can be divided between the public and the private sectors. South Africa has always been fortunate in having wealthy patrons of the arts who have supported individual artists, provided donations, and initiated exhibitions and educational projects. This form of patronage has varied from individual benefactors to commercial galleries and industrial companies, offering generous bursaries, scholarships, prizes, exhibitions, and awards of all kinds. To mention names would be impossible within the scope of this chapter.

In terms of the public sector, there is not sufficient money available from municipalities or central government to make as great an impact on the visual arts as has been the case in the United Kingdom through patronage of the Arts Council. Such possibilities are, however, being investigated by a national commission at the present moment.

There are subsidized galleries in all the major cities, all of which have educational programs. In Johannesburg, for example, the Art Gallery has introduced the practice of holding one-man exhibitions of the work of talented younger artists, who are in attendance to talk about their work to the public. This has proved to be a very valuable educational contribution. Heated debates have been known to occur between the more conservative city councilors and the Friends of the Gallery over the spending of the limited funds

which a wealthy city like Johannesburg sees fit to allocate to the Art Gallery!

Tertiary Education

There are two main types of institutions offering tertiary education. These are universities, offering degree courses, and the technikons, offering National Diploma courses. In this respect we are similar to the United Kingdom, which has both universities and polytechnics. In art and design education, the universities generally offer the BA fine arts degree followed by the honors and the masters options, with the possibility of obtaining a teacher's qualification. They are thus more academic, while the technikons offer National Diplomas in art and design that qualify the student for practice in commerce and industry.

Government policy at present is to provide, where possible, separate and equal facilities for the main different ethnic groups in the country. For example, in Natal, where there is a large Indian community, they have their own university and technikon.

For the black peoples there are four universities, one in Natal, two in the Transvaal, and one in the Eastern Cape. Unfortunately, of these, only Fort Hare in the Cape offers a fine art degree course at present. There is a university for colored persons near Cape Town, and also a technikon in the same area, which has recently introduced a School of Art and Design offering graphic design, photography and clothing design.

An increasing degree of flexibility is now being introduced whereby South Africans of any race may apply for entrance to institutions for tertiary education not normally catering to their racial groups, when this can be motivated due to lack of facilities in which the applicants may reside. This is a small step forward in the implementation of new principles in tertiary education for this country.

Technikons

The most significant thing that has happened recently was legislation passed in 1967 elevating the former technical colleges to colleges of advanced technical education, now called technikons. These can now develop parallel to universities, with matriculation as the entrance level and their own hierarchy of awards as follows:

Entrance +1 year: National Certificate

+2 years: National Higher Certificate

+3 years: National Diploma

+4 years: National Higher Diploma

+5 years: National Diploma in Technology

+6 years: National Laureatus

Courses in art and design for the National Diplomas are offered in the following areas: Fine Art, Photography, Ceramics, Interior Design, Industrial Design, Textile Design, Graphic Design, Jewelery Design, Clothing Design.

The first year of most of these courses is of a basic nature and approximates the Foundation Course in the United Kingdom. A fourth year of specialized study brings the National Higher Diploma, and after this there is the option of continued research at fifth-year and sixth-year levels. In the technikons, the head of the school is the assistant director for art and design, assisted by heads of department, senior lecturers, and lecturers.

Together with these improvements in status and qualifications, there is a very comprehensive building program for all the main centers. For example, all the technikons have embarked on new building programs at a mind-boggling cost. In my school of art and design, we are preparing to double our student numbers as soon as new accommodation becomes available.

The number of students wishing to enter courses is largely determined by the demands of commerce and industry, but, as these demands are continually expanding with the increasing urbanization of all population groups, I can foresee considerable expansion in the next decade. This demand will continue to escalate to an extent that nobody could have predicted ten years ago, because of the increasing sophistication and buying power of the black races. Given a reasonable political dispensation among the various racial groups, parties, and aspirations of the people of South African, a favorable future is inevitable. If this is not realized, then the state of art and design education will be very perilous indeed. In the light of present developments I must say that I have very optimistic opinions for the future.

The Universities

As one would expect, the universities have played a major role in art education in the past and continue to do so in view of a government regulation that requires secondary school teachers to have a university degree and a teacher's qualification.

Formerly the technikons could offer a National Teachers' Certificate course in art, but this has now been discontinued. This is a retrogressive step in terms of design education, as the universities are not particularly concerned with the applied arts. Generally, the university art schools tend to adopt the policy of the particular professor of art who occupies the chair. One of the most famous is the Michaelis School of Art of the University of Cape Town, which has produced many important painters and sculptors in South Africa.

When I was a schoolboy I used to attend classes there on Saturdays, when all the full-time students and teachers were not there. I used to sneak into the figure painting studio to see what progress was being made on the particular model of the moment. There were the great volumes of Rubenesque flesh, built up in impasto after impasto, rubbed down and duly glazed, which process took so long that every week would reveal a new stage in the work. What I did not understand at the time was the appearance of the easels, which, with all that Flake White around seemed to be covered in pigeon droppings! Times do change, and if the academic methods used in those days seem to be laughable, then many more bizarre events must surely have happened since in the formerly staid studios of the schools of fine art.

I am unable to do justice to all the university schools of art, and personalities that have influenced our art, in a short essay like this. The University of the Witwatersrand should have a special mention if only for the reason that it is at present the richest and most influential of them all.

Recently this university arranged a National Fine Art Student Exhibition, which took place in their excellent exhibition galleries. Ten university art schools and six technikons were represented, and prizes to the value of R4 600 (or 2,300 English pounds) (approximately US $3,900) were donated by commercial firms. The work selected was extremely varied, representing influences of almost every style from Expressionism to Punk. The last thing that can be said about this exhibition is that it represented anything remotely local or South African in flavor. Also

there was hardly anything that could be called joyful or seductive in color or theme. Mankind was denigrated and nature was used to present a sinister image, with the exception of two Neo-Impressionistic paintings by a black artist.

The major prizewinner was a girl who produced two lifesize hanging skeletons in which animal bones and deteriorating human forms were intermingled to produce a powerful and macabre sculpture. Technical qualities were notably excellent.

Coda

We like to think of art and design as a real animal; like a donkey, it has four legs, two ears, and a tail. Sometimes it stops and sometimes it goes. Unfortunately it seldom goes together all in one piece! The thing that continues to surprise is the strength and volume of art activity, which seems to increase in parallel with every advance of science and technology, reaffirming as it were the essentially human twist that we give our situation in the inscrutable universe.

ART, CRAFT, AND DESIGN EDUCATION IN GREAT BRITAIN

■ JOHN STEERS

General Background

In a recent submission to a government agency, the National Society for Education in Art and Design (NSEAD) identified the broad parameters of art and design in general education thus:

Experience of art and design is a crucial element in a balanced, broad and relevant curriculum. The subject of art and design provides students with a means of investigating and increasing their understanding of both the physical world and the world of the imagination. The study of relevant theory about art and design together with direct participation in practical problem-solving activities affords the individual the opportunity of heightening his/her visual and intellectual awareness. It develops students' ability to observe, select and interpret images and visual forms and to utilize imagination and feeling in critical response, discussion and understanding.

The search for suitable techniques and expressive forms and the application of media and appropriate technologies which are central to art and design practice encourages experimentation and increased inventiveness. In particular, design awareness offers a key to understanding why the made environment and artifacts are the way they are; design experience affords insights into how the future may be shaped. Design studies educate the individual to make judgments–judgments about degrees of utility or quality for example. They encourage the development of entrepreneurial skills and the ability to make well-informed critical appraisals of mankind's cultural heritage and the made and natural environment. Not the least, art and design provides a particular kind of pleasure and an interest which lasts throughout life (NSEAD Newsletter, 1988).

Art and design teachers in England and Wales (the Scots have a different education system) are currently concerned with how to ensure that this broad range of activities, from fine arts to design education, is maintained within the rapidly changing climate created by the 1988 Education Reform Act (ERA).

Structure

Compulsory education starts in Great Britain at age 5 and continues to age 16. The ERA designated art as a *foundation subject* in the new national curriculum, which is being phased in over a 10-year period. Beginning in September 1992, art was expected to be a compulsory element of the curriculum for all children in state-maintained schools in the 5 to 14 year age group. At the time of writing, arrangements for 14 to 16 year olds were still uncertain.

Although there are regional differences, the term *primary education* is generally taken to include 5 to 11 year olds. Secondary education is normally from 11 to 16 years, at which age compulsory schooling stops, although about 20% of pupils stay on at school to age 18.

Teachers in primary schools are usually generalists, and consequently their own education in art, crafts, and design is likely to be limited–a problem identified in the recent report *The Arts in the Primary School: Reforming Teacher Education* (Gulbenkian Foundation, 1989). All new secondary art teachers now have to hold a degree in an art and design discipline. They take a 1 year foundation course, followed by a 3 year degree course in which they specialize in, say, painting, graphic design, or industrial design. This is followed by a 1-year Post Graduate Certificate in Education (PGCE) course, which is a 1 year, full-time course in one of twelve national centers. Most secondary school art departments have a tendency to reflect the subject specializations that the members of staff studied at college, usually an aspect of fine art or one of the crafts where a fine art rationale predominates, rather than a design discipline. It seems probable that more art and design teachers will have to be trained to meet the needs of the new national curricu-

lum at both the primary and secondary levels of education.

Until September 1989, when the first provisions of the ERA came into effect, most secondary school students took art and design until the age of 14, when examination options intruded. At this point the subject usually became an option. Even so, close to 40% of secondary school students studied art and design until age 16 (232,000 sat for the General Certificate in Secondary Education (GCSE) examination in art & design in July 1988), this figure having risen from 33% at the beginning of the 1980s. Since 1989 all students have been expected to continue to take art for a reasonable time sufficient to enable worthwhile study. By 1992, when the legislative program is more or less complete, it is anticipated that a majority of students will take the GCSE examinations in the subject at age 16+. A further 10% continue to take art and design in school to age 18, when they are entered for the General Certificate in Education (GCE) A-level examination (27,000 in 1989).

Considerable change is also taking place in tertiary education. The numbers of students studying fine arts have increased slightly in recent years, and at the same time there has been a marked increase in the numbers studying the design disciplines. The provisions of the ERA determined that major institutions be directly funded by the central government, and they are expected to be much more cost effective than in the past. The government has called for wider access to courses and for greater student numbers, but commensurate funding is not available. After age 16, a number of options are open to young people. They can leave school and find a job, although for many this is becoming very difficult since early school-leavers are most often the least qualified and the least employable. One option is to go to college to pursue nonadvanced further education. These courses are of two principal kinds; those that prepare the way to a higher level course or those that offer a terminal qualification. These courses are frequently vocational in character.

There are two main routes to a higher level course. One is the traditional route to a first degree course in the *art school* system—a title that includes the few remaining freestanding art schools; the more numerous departments of art and design in the polytechnics and colleges of higher education, many of which will soon be designated as universities, and the very few departments and courses in the existing university sector. The other route is through a Higher National Diploma course. These subdegree design courses are predomi-

nantly vocational in character and do their utmost to develop close industrial ties. Most students entering the advanced further education courses first follow a 1-year diagnostic foundation course that helps them decide which of the 80 or so degree-level specializations to apply for. Opportunities to take masters degrees are increasing not just at traditional centers such as the Royal College of Art but also at the regional colleges.

Political Initiatives

The ERA provisions are having a profound influence on all sectors of education. The changes are set against a background of financial cutbacks in all areas of public sector spending and a fall in school rolls of 1.5 million pupils between 1979 and 1990. For the first time in British history the government has taken steps to introduce a national curriculum. Schools are expected to do more by way of preparing all young people for work, a major reform of the public examinations taken at age 16 and 18 is nearing completion, and progress is being made toward a national system of pupil assessment at ages 7, 14, and 16. At all levels there are demands for raised standards of education, for greater accountability, and for the curriculum to be more relevant to the government's perception of national economic health, rather than the educational health of the nation.

ERA identifies three core subjects in the national curriculum: mathematics, English, and science. Another seven foundation subjects are also to be studied by all students in state-maintained schools throughout the period of compulsory education. Art is identified as a foundation subject, as well as technology, which includes design. Over the next few years, special working groups will identify programs of study, attainment targets, and assessment procedures for all the core and foundation subjects. The Working Group for Art completed its task in August 1991, and legislation followed early in 1992.

Particular Curriculum Concerns
Design Education

There is a growing realization that there is a design dimension to the curriculum, not unlike literacy or numeracy, which is cross-curricular and to which the normal subject boundaries do not apply. This philosophy is apparent in the national curriculum reports for technology, and it is clear that art and design teachers are expected to make a major contribution to this new, essentially cross-curricular field. In a seminal article in

the *Journal of Art and Design Education*, Ken Baynes (1985) proposed a number of basic assumptions about design education that undoubtedly influenced national curriculum thinking for technology. Perhaps the most important of these is that it is the primary aim of design in general education to develop students' design awareness so that they can (a) enjoy with understanding and insight the man-made world of places, products, and images; (b) take part in the personal and public design decisions that affect their lives and the life of the community; (c) design and criticize design at their own level for their own material and spiritual needs; and (d) bring an understanding of design into their work.

There is a commonly held view that government education policy is primarily motivated by often conflicting concerns such as the cost effectiveness of the education system, increasing parental choice, and a desire to improve standards of education. Training often appears to be favored in preference to the notion of a broad, liberal education, and priorities are often determined by the supposed demands of the job market. The situation was summarized in the mid-1980s by a senior member of Her Majesty's Inspectorate who wrote:

> The government wants to bring about a shift of emphasis . . . away from what have been described as the *soft* subjects, that is the arts and social sciences, and towards the *hard* disciplines of the natural sciences and the new technologies. There is, however, considerable interest in the education and training of designers—both as a key element in the hoped-for resurgence of manufacturing industry and as entrepreneurial artists/craftsmen/designers who will create new markets and generate income (Baynes, 1983, p. 93).

Lecturers and students alike are aware of the changing pattern of employment opportunity in design-related occupations. There has been a dramatic contraction of the ceramics and textile industries, for example, and reduced opportunities in the fashion world. At the same time there has been a rapid expansion of some areas of graphic design, photography, and television. British designers are in demand throughout the world, and it is ironic that these designers, the cream of the British art school system, head the design teams of some of our strongest economic competitors in Italy, Germany, Japan, and the United States.

Critical and Contextual Studies

The discipline-based art education (DBAE) movement has had little direct impact in Great Britain. However concurrent with developments in North America, a considerable amount of thought has been focused on the introduction of critical and contextual studies as part of the art and design curriculum. This is most clearly seen in development work for the 16+ examinations and in the publications of Rod Taylor (1986). In 1985 the first National Criteria for the GCSE Art and Design Examinations at 16+ were published and the first steps were taken toward defining grade criteria for art and design examinations. This development is potentially of considerable significance, although for the time being it has been shelved to await national curriculum documentation. The aims of art and design education, as expressed in the GCSE National Criteria, include to stimulate, encourage, and develop

> . . . awareness and appreciation of relationships between art and design and the individual within the historical, social and environmental context;

> . . . the acquisition of a working vocabulary relevant to the subject (Department of Education and Science, 1985).

Consideration of these aims led to the identification of the following three domains for assessment purposes:

1. *A conceptual domain* that is concerned with the formation and development of ideas and concepts.
2. *A productive domain* that is concerned with the abilities to select, control, and use the formal and technical aspects of art and design in the realization of ideas, feelings, and intentions.
3. *A contextual and critical domain* that is concerned with those aspects of art and design which enable candidates to express ideas and insights that reflect a developing awareness of their own work and that of others (Secondary Examinations Council, 1987).

More specifically, the contextual and critical domain requires candidates to show evidence of their knowledge and understanding of the differing contexts in which work may be produced (e.g., historical, social, cultural, technological) and a developing ability to make informed critical judgments. Candidates can provide evidence of their engagement in these aspects in a variety of ways: through their own practical work

as well as by using other visual, written, and oral forms of response. Candidates will need to develop an appropriate vocabulary to enable them to participate in these activities.

This broad approach is reflected in the proposals for art in the national curriculum, wherein three attainment targets *investigating, understanding*, and *making*, and accompanying programs of study, have been defined. There is not unqualified support for this aspect of the curriculum, and it is perhaps pertinent to quote David Thistlewood's editorial in the *Journal of Art and Design Education* in which he warned:

> If critical studies is the potent force for educational good we all maintain it to be, then ill-applied, it will be an equally potent force for harm.

The danger is of course that a simple equation will be made between looking at works of art, however thoroughly, and appreciating them. If works of art are merely subjected to naive analysis they may become thoroughly known as things-in-themselves, but little will be understood about the aesthetic, material, theoretical, religious, historical, social, political, economic, and other motives which may have given rise to them. On the other hand, if such contexts are entered into, then there is potential for misinformation, even disinformation. Misinformation is the likeliest outcome because . . . our population at large, our teaching force in general, and even our art and design specialists, understand so little of contemporary art (1987).

Thistlewood then went on to discuss the role of museum-directed programs of art education. He summed up his essay by saying that one of the purposes of critical studies is to educate in the most enduring symbols of civilization: "One of the purposes of *critical studies* is to educate in these symbols; another, co-equally, is to proffer the alternatives which are originating in contemporary art. The former requires the co-operation of art museums; the latter demands the collaboration of museologists, educationists, and contemporary arts practitioners" (1987).

Nevertheless, it seems that there is widespread support among art teachers for the introduction of the critical studies element, and this aspect of art and design education is most likely to be firmly embedded in the national curriculum legislation for art.

Multicultural Issues

One of the national curriculum's cross-curricular themes is to develop an awareness of multicultural issues. Critical and contextual studies can both illuminate and celebrate the cultural diversity of British society by ensuring that the art and design of a range of ethnic cultures, past and present, are encountered. It is probable that the national curriculum for art will build on the best of current practice by encouraging the classroom use of art and artifacts from diverse sources. These should enable a variety of cultural attitudes, values, and beliefs to be closely examined and discussed. Specific programs of study should enable students to develop a greater understanding of British society and the cultures within it and increase their understanding of issues such as race and representation in the arts. Valuable collaborations with other media specialists will require further development—with those who are attempting to develop pupils' understanding of cultural stereotyping and bias in visual imagery in television, radio, photography, advertising, and film, for example.

Art and the Arts

Recently there has been some pressure in schools for art and design to be integrated into *combined arts* or *expressive arts* faculties. A national curriculum development project, The Arts in Schools, has been mainly responsible for this trend, which has generally found little favor with art and design teachers.

The present state of the debate may be characterized thus: There are those who argue that the arts are a generic area of the curriculum and that each of the main art forms should have equal provision, and there are those, including most art and design teachers, who argue that there is a clear educational case to be made for occasional collaboration among art forms but that the degree of commonality among the arts claimed by the other group is vastly overstated. To date, this matter is unresolved, but it should be noted that only art and music are national curriculum foundation subjects. Furthermore, art and design is by far the biggest subject of all the arts subjects in terms of numbers participating. It cannot be denied that there are vested interests on both sides of the argument, but it is probable that the legislation and market forces, in terms of the popularity of art and design with students, are likely to prevail in the long term.

Conclusion

In the United Kingdom arts, crafts and design have been firmly established in the general curriculum for a long time. Evidence of the buoyancy of the subject may be seen in the increasing student participation in the subject and the recent upsurge of publications in the field (a list of some of the more significant is appended).

In 1984, in a speech to the British Academy, Sir Keith Joseph then the Secretary of State, said, "The culturally important aspects of . . . education equally provide a public benefit. They contribute both to the refinement and transmission of the great moral, social and scientific ideas, and to the sharpening of the intellect; and they can thereby help significantly to maintain our liberal society by sustaining our intellectual and moral standards. This is a benefit of inestimable worth." Sir Keith went on to present a challenge. He said that the government was justified in using public funds to support these aspects of education "... but only where the standards are sufficiently high to make the cultural advantage real." The national curriculum is intended to raise standards in education, and there is little evidence that the government, while not giving the highest priority to the arts, wishes to reduce its role in the curriculum. Although the next 2 years certainly will be a crucial time, British art and design teachers could probably afford to be less defensive than they often are. As the national curriculum plans are developed and implemented, art and design teachers must be prepared to continue to present, in rational and unemotional terms, what their subject has to offer. At the same time, if they ensure that they really are providing a balanced, broad, and relevant curriculum, art and design education should continue to prosper in the United Kingdom.

References

Baynes, K. (Ed.). (1983). *Young blood: Britain's design schools today and tomorrow*. London: Lund Humphries.

Baynes K. (1985). Towards defining a design dimension of the curriculum. *Journal of Art and Design Education, 4* (3), 237–243.

Department of Education and Science. (1985). *GCSE: The national criteria*. London: HMSO.

Gulbenkian Foundation. (1989). *The arts in the primary school: Reforming teacher education*. London.

NSEAD Newsletter (1988, November/December). Corsham: NSEAD.

Secondary Examinations Council. (1987). *Draft grade criteria: The report of the Working Party for Art and Design*. London: SEC.

Taylor, R. (1986). *Educating for art: Critical response and development*. London: Longman.

Thistlewood, D. (1987). Editorial: Critical studies and the museum of contemporary art. *Journal of Art and Design Education, 6*(2), 123–129.

Bibliography

Adams, E., & Ward, C. (1982). *Art and the built environment: A teacher approach*. London: Longman.

Allison, B. (Ed.). (1986). *The index of British studies in art and design education*. London: Gower.

Barrett, M. (1979). *Art education: A strategy for course design*. London: Heinemann.

Best, D. (1985). *Feeling and reason in the arts*. London: Allen & Unwin.

Clement, R. (1986). *The art teacher's handbook*. London: Hutchinson.

Department of Education and Science. (1985). *Better schools*. London: HMSO.

Design Council. (1987). *Design and primary education*. London: Author.

Gentle, K. (1985). *Children and art teaching*. London: Croom Helm.

Journal of Art and Design Education. (3 issues per year). Abingdon: Carfax.

Lancaster, J. (Ed). (1987). *Art, craft and design in the primary school*. Corsham: NSEAD.

Mason, R. (1988). *Art education and multiculturalism*. London: Croom Helm.

Reid, R. A. (1986). *Ways of understanding and education*. London: Heinemann.

Robinson, K. (Ed.). (1982). *The arts in schools*. London: Calouste Gulbenkian Foundation.

Taylor, R., and Taylor, D. (1990). *Approaching art and design*. London: Longman.

DIVERSITY OF SOCIOEDUCATIONAL FUNCTIONS OF ART IN THE MODERN WORLD: VIEW FROM POLAND

■ IRENA WOJNAR

Discussions about the essence of art have been going on for centuries. Successive generations of scholars have asked "What is art?" since ancient times. Although this has been disquieting at times, one thing remains stable and unalterable: Art, both as a creative achievement of human beings expressed through diverse means and as a faculty allowing them to establish new values, is connected with the essence of human beings and contributes to the creation of their universe. A perpetual exchange between humankind and this universe—through expression and creativity on the one hand, and human development resulting from individuals' own creations on the other hand—constitutes a lasting phenomenon. This phenomenon is manifested in social life, and it plays a crucial part in human development which is influenced by receptive experiences as well as by acts of generalized creativity.

In contemporary times, discussions on art seem to be even more heated, since the arts themselves are wider and more diversified than ever before. The arts are intricately related to technologies and new techniques and to the mass media: The very idea of art is becoming wider—*swelling* in a certain sense. In an age when scientific passions and technocracy dominate, we speak of the crisis and even death of art, but, paradoxically, we enlarge the formula of art, including different modern phenomena (e.g., *impure* art, intermedia) and attribute to art previously unknown possibilities.

Thus, in our age, diversified domains of human creation are given the name of art, and these domains are much wider than the artistic universe preoccupying scholars of the past. Whether one is a catastrophist or an optimist, one must agree that phenomena of a more or less artistic character play an important part in the life of societies and individuals; that they perform important, although sometimes ambiguous, functions. The enlarged formula of contemporary art may be decoded through a detailed analysis of its real socioed-ucational functions. Putting aside the research on art carried out from a *professional* point of view—above all, aesthetic research—and considering the lasting categories that determine the status of artistic phenomena, we can aim at a tentative, more personal analysis of art as defined by its functions in contemporary life.

This attitude is important not only from a purely cognitive point of view, but also, and maybe above all, from an educational point of view. If one wonders what the formative role (in both the positive and negative sense of this word) of art is for humankind in our age, one cannot think only of undeniably artistic creations, of timeless values, but must also consider the intricate universe of art in its wider sense, including art, anti-art, and lack of art (*Kunstlösigkeit*), according to Werner Hofmann's formula. The opinions of modern thinkers who are preoccupied with the present situation of human beings in their generalized artistic universe serve to emphasize the necessity of reflecting upon art in this way, a little apart from aesthetics. According to Edgar Morin, "In modern societies the whole domain of exchanges between the real and imaginary is performed in the aesthetic manner, through art, spectacles, novels, works of imagination. Undoubtedly, mass culture is the first culture in the world history that is so entirely aesthetic" (1962, p. 102). And as Jean Duvignaud stated, "Never has the imaginary life been more diversified than today. Never since the idea of Beauty faded away" (19??, p. 84).

Yet, I want to underline an important trait of art (always understood in the sense of its varied branches): its double existence in time. This concept comes from the ideas formulated in the 19th century by the first sociologists of art. It is true that art is rooted in social life, that it would not exist without society, but it is also true that certain works of art, notwithstanding their social origins and their appropriate functions, surpass sociohistorical reality and take on a timeless dimension. Such works of art also have influence in conditions very different from the original ones. This

Translated by Bozena Szymanska

paradox was observed by Karl Marx, who, alluding to the analysis of social origins of art, stated: "The difficulty does not consist in understanding the fact that Greek art and epos correspond to determined forms of social development. The difficulty consists in the fact that they always endow us with artistic pleasure and that they serve as an incomparable model" (1857, p. 733).

Thus, there is no simple interdependence between the social functioning of art and the actual basis of its social origin. The question of the double life of art in time and its so-called lasting, even eternal, values suggests an important pedagogical dimension: It is art that is vindicated and confirmed by the ordeals of history that seems to serve best the loftiest and most grandiose educational aims.

Yet, from the socioeducational point of view, one more duality of the social functioning of art must noted. Art always remains integrated with life, both expressing human needs and satisfying them. However, at the same time, art always contains the germs of novelty—stronger or weaker attempts to oppose a dominating order. Art that only expresses and affirms a given social order would finally lead to conformity and thus to stagnation. Such was most often the destiny of art defined as "official" or "academic." The essence of art always consists in creativity, movement, change, foretelling of what is to come. Albert Camus (1965) was right when he emphasized that creation is a quest and an incompatibility with the world. But it is an incompatibility with what the world lacks and, sometimes, on behalf of what the world is.

The oscillation of art between adjustment and transcending, affirmation and flight from the world, which is rooted in the essence of human nature, characterizes the mobility of relationships between art and society. In certain epochs, one of the two alternative tendencies dominated, which does not mean that the opposing alternative did not exist. Affirmation and revolt as lasting characteristics of art may be rediscovered in the course of history; they may be an expression of creators' attitudes, of their sensitivity to necessary ties with tradition and susceptibility to novelty.

Let us now turn to an analysis of the arts in contemporary society. There are four different definitions of art based on its four functions:

1. Art as sublimation of life.
2. Art as the establishment of new material facts.
3. Art as compensation and a means of escape.

4. Art as generalized creativity.

In proposing these definitions of art, I want to emphasize that the first three functions correspond to the experiences lived through art by amateurs, and so to some sort of receptive activity, whereas the fourth function is expressed by the creative activity of a non-professional.

Art as Subliming Life

Confidence in art as a medium guiding human souls was present in Greek antiquity. Pythagoras authored the first educational definition of art. It concerned the art of music, which, by reflecting celestial harmony, could inspire the same kind of harmony in a human being. Later theorists defined the very idea of the human being's inner harmony and the correlation between the content of art and this inner harmony, or they contemplated the inspiration of man by cathartic experience. However, art always seemed to be a subliming medium, the human being's chance to achieve the ideals of beauty and good at the same time. It is possible to depict a short history of the thinking on subliming art that proposes a model of a better human being guaranteeing at the same time the improvement of social life. At least three great names should be recalled here, the names of men who, in different historical and social conditions, manifested confidence in art and its socioeducational role: Friedrich Schiller, John Ruskin, and Herbert Read.

Schiller, a poet and playwright, is of interest here as the author of *Letters on Aesthetic Education of Man* (1795). Starting from the principle of the duality of human nature torn between two instincts (sensitive and formal), Schiller proposed a new harmony based on the principle of play, and thus, of expression and creativity (called a "living form"). He wrote, "In so far as its form [the form of a work of art] lives in our feeling and takes shape in our understanding, it is a living form, and will be one in every case when we shall think it is beautiful" (1943, p. 199). In this way, the reciprocal influence of two opposing instincts and the union of two opposing principles create beauty, whose supreme ideal will have to be sought in the most perfect possible association and equilibrium between reality and form. According to Schiller, it is through beauty that sensitive man is guided to form and thought, it is through beauty that spiritual man is taken back to the material and given back to the world of senses. The same equilibrium spreads over the social plan, the aesthetic state being the equivalent of the human principle of play and surpassing dangerous oppositions of other

social structures. "In the bosom of the formidable empire of powers and sacred kingdom of laws, the plastic instinct of beauty works imperceptibly to establish a third and radiant kingdom, the one of pretense and play, where it liberates man from the chains of all circumstances and sets him free, both in natural and moral realms, from everything that is called fetters" (Ibidem, p. 351).

The ideas expressed by John Ruskin, distinguished by the universalism of the aesthetic factor, have been defined as the *religion of beauty*. Ruskin was against all *barbarous industrialism*, against urban and industrial landscapes, against all modifications introduced by modern life that were contradictory to genuine beauty, beauty of nature and of certain types of art. Art that expresses nature, thought Ruskin, is a deep expression of spiritual life of the nation and addresses the whole creature ("all great art... addresses the whole creature. All your faculties, all that is in you of greatest and best, must be awake in you". *The Stones of Venice*, Vol. III, ch. IV, par. 21). Aesthetic feeling being also a moral feeling, understanding of beauty turns into understanding of good, and therefore, it leads to the improvement of man and society. We read in Ruskin: "Wherever art is practiced for its own sake, and the delight of the workman is in what he does and produces, instead of in what he interprets or exhibits— there art has the influence of the most fatal kind on brain and heart, and it issues, if long so pursued, in the destruction both of intellectual power and moral principle; whereas art, devoted humbly and self-forgetfully to the clear statement and record of the facts of the universe, is always helpful and beneficent to mankind, full of comfort, strength, and salvation" (*The Two Paths*, Lecture 1, par. 15).

The same utopian attitude characterizes Herbert Read's theory, mainly as an author of the book *Education Through Art*, whose title has become a known pedagogical definition and the name of an educational movement in the world scale. The real function of art, thought Read, is to express feelings and transmit understanding. Sensitive to the evil influences threatening the human condition in our age, Read emphasized that education through art is the only type of education that leads to the formation of psychic equilibrium in modern humankind. Education must teach individuals to live their lives in a spontaneous way: naturally and creatively, and in emotional and intellectual harmony. Claiming that this harmony is weakened in our days, Read insisted on the necessity of developing the individual's sensitive and emotional faculties, on the importance of the imagination. In the

educational process, Read suggested, one-sided development of intelligence is emphasized. Development of rational and discursive thought has weakened humans' inner harmony, making them like birds flying with one wing. To make them fly in a harmonious way, two aspects of human nature must be reconciled: intuition and intelligence, imagination and reasoning—a similar harmony finding its best example in a work of art.

Read, a partisan of the idea of *universal harmony*, imagined that art was capable of saving the threatened human essence. He underlined the role of feeling in an age that "practices brutalities and recommends ideals" (1958, p. ?). His creed was expressed in the following manner: "Idealism would . . . no longer be an escape from reality; it would be a simple human response to reality" (1958, p. 302).

Mulling over the history of European culture, we can observe some tendencies to translate utopian ideas into social reality. Such was the case of Greece in the age of Pericles, promoting letters and arts; of Florence in Quattrocento, filled with artistic spirit. Similar tendencies can be found in the social and cultural experience of the Soviet Union in the early 1920s, when an attempted was made to prove that the union of socialism and genuine art must be an evident thing. Artists were considered *organizers of human happiness* and art a force contributing to the transformation of the existing society. It was believed that the idea of homo aestheticus must be achieved.

These ideas, linked by the principle of confidence in art, make us think of art as a grandiose phenomenon incarnating great achievements of humanity. It was not accidental that art was compared to a *sacred tenet* of some sort of religion, that it was conceived as a patrimony of values of humanity as a whole.

In the light of such ideas, art seems to be the equivalent of an unquestionable masterpiece, a symbol of both aesthetic harmony and moral good. Thus, the definition of art as a subliming of life is purely pedagogical and optimistic. Art as a reflection of the creative forces of humankind was considered as an invitation to realize values, to protect human beings against brutality and mediocrity.

Art as Establishing New Material Facts

The second idea of art is not so old, although the discrimination between *magic* and *production* suggested in ancient times can be referred to. What is most striking is a definition of art in the Age of Industrialization

that is sensitive to its actual presence. This definition refers to art in a more limited sense than in the case of subliming art. It concerns art that is closely related to technology and is expressed by the effort of the artist to enrich the actual universe and human life.

The beginning of industrialization in the 19th century seemed incompatible with art and beauty, since the first effects of mass production resulted in ugliness and with the new conditions of urbanized life people became estranged from aesthetic values. More and more stress was laid on the opposition between art and technology, beauty and usefulness. The partisans of beauty looked for it in nature and in the magic universe of poetry. The partisans of technology pleaded for the integration of creativity into social life.

Toward the end of the 19th century the movement toward reconciliation between art and industrialization, between art and machine, was born; it was suggested that artistic principles could be applied to production and to life. Little by little, the concept of industrial aesthetics was formed. The design movement was its main guiding principle. The idea of beauty as useless was abandoned, and new definitions serving mechanization, modern civilization, and mass society were formed. The aesthetics of Art Nouveau concerned, above all, the forms of everyday life, architecture, objects, interior decoration, fashion, and even a certain style of life. The unity of plastic arts and technology became evident, and the integration of art and life was written in the programs of artistic groups at the beginning of the century, not to mention futurists and the Bauhaus. These futurists looked for the subordination of art to the demands of modern life, above all to technology. They contributed to a definition of art that participates in the creation of the human environment.

In our age, the design movement and industrial aesthetics have become the factors of growing importance. Thanks to the application of the principles of art to the production of different objects, a new phenomenon was born, median reality (Van Lier, 1962), which in concerned with the particularly aesthetic character of the human environment. This second nature is sometimes considered an aspect of modern alienation, but sometimes also an expression of creative forces ("der Mensch verdoppelt sich," according to Hegel's definition).

The median reality in which modern humankind lives is composed of different objects—architectural and industrial creations—fulfilling people's needs; it is also a universe of images, plastic signs, advertising, visual information. The whole visual universe of things constitutes a mixture of many different elements; however, the presence of art cannot be denied—industrial art or advertising art, art entangled in different phenomena of civilization. Most often the median reality concerns the civilization of consumption.

Modern humans do not live in the natural environment any more; they form their new environment themselves by building cities, highways, the universe of objects and images. The definition of art as establishing new material facts by no means concerns a subliming through sacred art; it concerns an amelioration of the form of life, fulfillment of always-growing needs. By this definition art discovers its utilitarian dependent aspect, while preserving its essential creative one.

Art as Compensation and Means of Escape

The contradictions of modern life are at the root of an ever more prevailing feeling of anxiety and restlessness. Art—a means to sublime the world and, at the same time, an instrument of its material enrichment—still can play a social role, the role that arises from the conditions of life in the industrial civilization and mass culture. Humans get a chance to escape from the realities of life, to compensate for its exigencies in a ludicrous and imaginary universe. The problem seems to be of immediate interest, in view of the increase of leisure time and the prolongation of life freed from the constraints of work (i.e., the "third age"—biologically and intellectually active but outside professional activities).

The definition of escapist art is rooted in the dualism of human life at the beginning of the Industrial Age. Forced work, being only a means to live, made people dream of a "right to idleness." Modern civilization aggravated the problem by depriving working people of personal contact with the products of their work. Leisure time and its advantages are still dreamed of, since humankind is always far away from the idea proposed by William Morris that art is the joy of a man at work. As a result, the functions of compensatory art are stressed—art as a means to escape from reality through passive entertainment.

There is a direct connection between the 19th century attempts to leave reality for the benefit of imagined arcadias and the current problem of escape into the imaginary stimulated by modern technologies. The

imaginary universe constitutes a sort of projection system, born in the sphere of the unreal world that permits projection-identification of a magic, religious, or aesthetic character. This opinion, expressed by Edgar Morin, suggests that art—above all the art of cinema—perceived in a deeply emotional way, confronted with dreams and personal experiences, becomes a way of escaping from reality for certain spectators. Sometimes reality is confused with the imaginary, with fiction becoming quasi-reality and reality being perceived as fiction.

The fascination with cinematographic art is a new problem, both for specialists in aesthetics and for those who analyze the social and educational system. We have to deal with this third aspect of art approved in the kingdom of modern muses, which has been defined as the most important art of the 20th century. Cinematography, constituting nourishment for the imagination, fascinates spectators who more or less consciously project their own psychic states onto it. In it, they rediscover some styles of life or affirmation of their own personalities. The "man of the street" borrows his own ideas of happiness from this excursion into the imaginary universe, which is most often far from everyday reality, the universe of fascinations and victories. The hours spent at the cinema allow the ordinary citizen to broaden experiences, to surpass limits of time and space. The advantages, as well as the dangers, of this art form are well known.

This aspect of the functioning of art seems the most obvious in the civilization of consumption, where industry aims at inciting the most suggestive entertainment, using the cinema to play on the feelings of the public on a mass scale. The values of art are often mixed up in productions of bad taste, productions that belong to pseudo-art and contribute to cultural alienation. This problem must be discussed, since modern technology offers both an opportunity for and a menace to the art of moving images. On one hand, an opportunity to enrich imagination and multiply human experiences through unlimited journeys in time and space is appealing. Yet, on the other hand, art itself seems to be threatened by the aggressiveness of entertainment that is too easy and too exciting, sacrificing sensitivity and encouraging brutalism and intellectual passivity. Violence is increasing, largely intensified by the corrupted taste of the public as it demands more and more imaginary excitement.

The modern civilization of imagination (*Moderna civiltà del'immagine*—the title of Enrico Fulchignoni's book) has discovered a dangerous ambiguity of art in

its realest and most fascinating aspect. For the first time in history, art (here the art of cinema) has become its own means of dissemination, thus multiplying its presence. It can disseminate and transform other artistic branches such as painting or theater, opening them to completely new artistic phenomena, those of the second rank. The eye of the camera permits us to penetrate the root of more traditional artistic phenomena, to discover and reveal their mysteries, thus providing the viewers with new satisfactions. In this case, the function of art as a means of escaping from reality can approach the function of subliming.

Art as Generalized Creativity

Speaking of art as a means of subliming, as a phenomenon establishing new material facts, compensating for and allowing us to escape from reality, I have, above all, thought of the experiences of amateur artists, readers, visitors in museums, theater and cinema goers, and concert audiences. Each of these examples concerns a sort of reception, contact of a person who is not an artist with a work of art created by a professional expressing himself or herself through artistic means. When the fourth function of art is dealt with, the situation changes, since art is considered here as a sort of personal activity, expression, or creativity on the part of nonprofessionals. Based on experimentation, I am convinced that creativity signifies something different from creation. The term creation makes us think of successful masterpieces, undeniable values, and artists' efforts. Creativity, a recent term, corresponds to an open and sensitive attitude, a state of mind, and it can be expressed through activities of an artistic character as well as through any other kind of activity including active participation, social behavior, and play. (It must be added that the duality of terms also exists in other languages: *creation* and *creativité* in French, *creazione* and *creatività* in Italian.) There is a certain analogy between creativity in this sense and the modern tendency of artistic creation to become more and more estranged from the notion of a masterpiece in favor of art that appeals to creative participation of the audience invited to complete an artist's proposition.

It is here that the phenomenon known as "the death of art" must be alluded to. I am not thinking of Hegel and other critics, convinced that the modern epoch is no longer favorable to art in its grandiose and metaphysical aspect. I am thinking of the modern anarchists, who, through aesthetic experiences, looked for the new art of living. Schiller and his idea of an aesthetic state (taken up by Herbert Marcuse in his idea of

a nonrepressive state), as well as the romantics, looking for an ideal of free life, and Friedrich Nietzsche, maintaining that the existence of the world is justified only by the quality of an aesthetic phenomenon, have prepared the ground for the search for a new art of living. The first artistic movement that contemplated "changing the world," as Karl Marx wanted it, and "transforming life," which Arthur Rimbaud dreamed of, was the surrealism.

The search for a new art of living, reclaim everything that is new and spontaneous, that constitutes an opposition to the past and opens up to the imagined future, characterizes the movement of confrontation that appeared in Europe and the United States in the 1960s. The movement originated from a revolt against the rigidity of the civilization of consumption, against its institutionalization and bureaucracy. The aims of this movement, and its sensitivity, bring it close not only to surrealism and the Dada movement but also to some trends of the artistic avant garde in music and theater (Willener, 1970). A correlation exists between the experiences of contemporary humans, the content of their dreams and imagination, and an idea growing from art and its functions. The traditional definition of art, the formula of a masterpiece being passively contemplated by a viewer, is being questioned. Art appears instead as a creative act of an open character (cf. Eco, 1962) appealing to ceaseless acts of re-creation, to audience participation, and to the active role of imagination.

When a new theory of the dissemination of art and culture is being advanced, cultural policies based on keeping a distance between so-called superior values, which only constitute a superstructure of life, and a passive audience are criticized. Art must go to the street, must join the culture of everyday life, declared Pierre Gaudibert, and he added, "An atmosphere of generalized and permanent creativity must be created anew" (Casterman, 1972, p. 138). Thus, cultural experience is thought of as an existential act surmounting a gap between creators and amateurs. In the course of this experience art changes; however, life, ceaselessly intensified by the activity of imagination, changes as well. Active, spontaneous participation gives birth to new genres of art. Dramatic games, experimentations of the new theater, street shows, "happenings," and rock and pop music all illustrate well the new tendencies and quests, whereby psychic capacities and imagination dominate the creation of a work of art. The sense of both art and life is found in the transient character of the moment, in a dramatic act, in active participation, in the intensity of the experienced moment.

Experiencing this genre of art (which is close to children's games and *commedia dell'arte*) sometimes evokes the feelings of community felt by participants, creators and active audience included. The music of the young is a relevant example, although it is somewhat ambiguous from the educational point of view.

In *To Hell with Culture*, Herbert Reed expressed the opinion that life should be identified with culture, since culture other than life itself is condemned to nonexistence. Henri Lefebvre, one of the animators of the confrontation movement, wrote: "In order that art may become an art of living, art must perish to find itself later in the very life."

The sensitivity of the young sometimes reacts in a violent way against the contradictions of the contemporary world, and above all against the process of alienation that threatens the very human core. Once more art seems to be a means of saving this core, an invitation to experience our lives according to the formula of creativity, sensitivity, and imagination. Thus, the idea of the *death* of art finds an optimistic, even utopian example: Art becomes a symbol of the future that is ours to create.

The four definitions of art together constitute a new and multiform definition, embracing varied creations and suggesting diverse socioeducational functions. Nevertheless, it is true that we deal, in fact, with art seen through different artistic branches. Art as subliming life seems to be the most complete definition, since every artistic discipline can belong here; art as constructing median reality seems to be limited to plastic creations; and art as a means of escape is dominated by its visual aspects. In the latter two cases technology plays the main role. Thus, the artistic universe cannot be separated from any other human creation.

In the beginning of this chapter, I proposed a definition of a *swollen* idea of art, a formula that stresses the open and sometimes ambiguous character of the phenomenon. Thus, art is what people consider as art, keeping harmony with human situations that constantly change. And art is what lasts and what confirms our human identity at the same time.

References

Camus, A. (1955) *L'homme revolté*. Paris: Gallimard.
Duvignand, J. (1972) *Sociologie de l'art*. Paris: Presses unniversitaires de France.
Eco, U. (1962). *Opera asperta*.
Fulchignoni, E. (1972). *L'Immagine nellsera cosmica*. Rome: A. Armando.

Hofmann, W. (1928). *Turning points in twentieth-century art: 1890-1917.* (Translated by Charles Kessler) New York: G. Brazilller [1969]

Lefebvre, A. (1979). *The new frontiers of interior decoration....* Albuquerque: Gloucester Art Press.

Marx, K. (1857). *Einleitung zur kritik der politischen oekonomie.* Work, Band XIII.

Morin, E. (1962). *L'esprit du temps.* Paris: Grasset.

Read, H. (1958). *Education through art.* New York: Pantheon Books.

Read, H. (1963). *To hell with culture.* New York: Schocken Books.

Schiller, F. (1943) *Letters on aesthetic education of man* (bilingual edition). [First published 1795].

Van Lier, H. (1962). *Le nouvel age.* Tournai: Casterman.

Willener, A. (1970). *L'image action de las societe ou la politisation culturelle.*

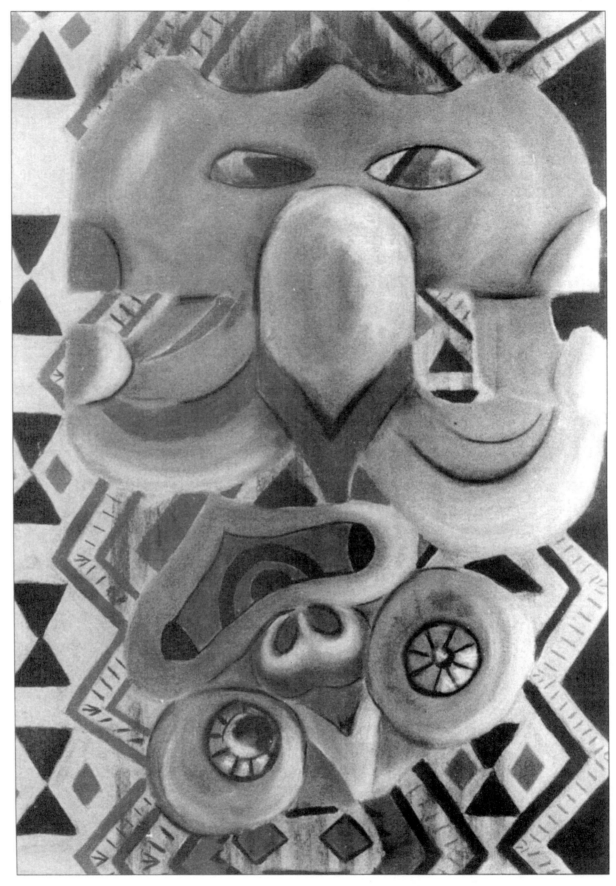

Elizabeth Hogg, *Tiki*, based on a Maori stone carving.

MULTICULTURAL AND CROSS-CULTURAL ISSUES

EDITORIAL

■ HETA KAUPPINEN
■ READ M. DIKET

As documented in the historic perspectives, cross-cultural influences have been vital in the development of art education. The authors in Part III indicate the significance of the continuing cross-cultural exchange in the progress and renewal of art education. In many cases, cross-cultural exchange now takes place in the cooperative projects art educators from different countries or cultures undertake. Increasingly, art educators are realizing that cross-cultural contact in the study of works of art is important. This contact has transcended the importation of formal or technical aspects of artworks to a plane on which meaning assumes importance in the art forms and the nature of the producer. We find qualities we have in common with others of different cultures through art forms, especially traditional crafts. Techniques and structures exist that have a common origin deep in human history.

When cross-cultural influences can be selective and intentional, multicultural influences are present to the degree that each country has cultural diversity represented by various ethnic and cultural groups. At times, multicultural art education means a celebration of diversity that contributes to the cultural strength of a country. At other times, multicultural stances sustain weakened cultures so that people will not lose touch with their ancestral memory of form and place. A goal for multicultural art education can be increasing the individual's own cultural repertoire in the visual arts and developing skills to acquire an understanding of a wide range of visual art forms in other cultures. The outcome may be the reconciliation of two or more cultural systems and the development of a new and unique culture, individual or societal. Multicultural issues are as old as humankind. The question is how to balance diversity with unity and how to form attitudes

and behaviors to survive with dignity in concert with our neighbors.

Brian Allison examines the arts in a multicultural society. He argues that efforts of establishing multicultural education lack coordination and are inconsistent and misguided, although well intentioned. He calls for an art curriculum that would reflect the complexity of art in diverse societies and the diverse needs of individuals. Allison relates developments in multicultural education to his own experience. Some 20 years ago, he was dissatisfied with the narrow confines of child art and the emphasis on creativity. Like Wojnar (see Part II), he seeks to conceptualize a more complex basis for instruction in art. In the 1970s, he developed a Four Domains Model for the arts, including the Expressive/Productive domain, the Perceptual domain, the Analytical/Critical domain, and the Historical/Cultural domain. Analytical/Critical activity has become crucial in his subsequent study of art objects, cultures, and culturally pluralistic curricula. Through the critical domain, all other domains contribute to a complex understanding of the arts as human activity with "culturally determined dispositions, attitudes, beliefs, and values." The Four Domains Model appears to be equally descriptive of and applicable to other art forms such as dance, music, and drama. One problem lies in the nature of culture and the ways in which a particular culture sets a framework through which any member of that culture perceives other cultures. Allison discusses the relevancy of multicultural art education in monocultural schools. Art activities and outcomes from the study of non-European cultures may be principally European in kind and concept because curricula are based on the European conception and production of art.

Hanan Bruen contributes a profile of cultural integration in modern Israel. He develops a comprehensive picture of current patterns for the transmission of knowledge within the Jewish state. The influx of Afro-Asiatic refugees in recent years has resulted in significant revisions in the educational system. Bruen's chapter relates educational revisions and the resolution of Jewish ideals across cultures to interdisciplinary practices in the arts and sciences. In Israel, enculturation occurs as members of the culture, both old and new, acquire a *collection of traditions*. Art is an essential expression of the culture of modern Israel.

The learning process is integral to the acquisition of the new tradition. Changes called for by Bruen, an "integrative, polyaesthetic" approach, have recently been pilot tested in Israel with artistically talented students at the secondary school level. In essence, Bruen's chapter encompasses the present and predicts future directions in Israeli education.

He reviews the concepts and definitions widely used in literature emanating from cross-cultural research. As the profile develops, he undertakes to discuss the present timbre of arts education in a nonjudgmental fashion that provides the reader with a clear insight into the present situation in Israel. Bruen approaches culture as a "concept with a descriptive rather than an evaluative purpose." In effect, his chapter serves as a prototype for the examination of cultural change.

Marie-Francoise Chavanne presents cultural plurism accompanied by the greatest possible diversity as the most important issue in art education. This requires the fullest development of each discrete culture as the means of symbolizing national, regional, or ethnic identity and self-esteem, as well as a concerned exposure of these identities to one another. It also requires cooperation. The enemies of such an enterprise are cultural uniformity, the mass culture's tendency to homogenize diverse cultures by extolling a simplified system of values and symbols, cultural oppression and one-sided interaction, and unfounded nostalgia for past or lost cultures.

Symbols undergird the conception of both individual and universal states. Chavanne encourages teachers to move beyond stereotypes, to base their instruction on children who are acknowledged and welcomed for their diversity. Yet, she finds that teachers must allow students to choose "where they belong," which may be in "a new culture built of new values."

Arthur Hughes, Nick Stanley, and John Swift edited the book *The Art Machine* to mark the opening of an exhibition organized jointly by Glasgow Art Museums and Art Galleries. The exhibition and related events and publications were planned with children, young people, and families in mind. The editors focus on the scope and importance of art and design education for children and young people now and in the future. They argue that art is indispensable for the healthy growth of feeling, imagination, and intelligence. They are concerned about how art teachers will respond to the culture and environmental issues that seem set to dominate the first decades of the 21st century. On a planet seeking to have both a world view and strong cultural and national identities, the arts will be in the center of things. Arthur Hughes, Nick Stanley, and John Swift proclaim that the arts are a process through which people learn about themselves and the world in which they live. An essay from The Multicultural Curriculum features several projects for art and design education that provide strategies for multicultural and cross-cultural study.

Heta Kauppinen explores peace education in art and peace education projects generated in cooperation with Nordic art teachers. Peace education is a response to the developing understanding that environmental, sociocultural, and economic problems are not localized but global. Making the planet an ecologically healthy as well as just, righteous, and peaceful place for people and their cultures requires a universal effort and education for universal responsibility. Contrary to what is sometimes believed, peace education does not mean political agitation or propaganda. It represents a study of conflict and harmony in the present and past experiences of humankind and operates within the major categories of the global community and global environment. Peace education concerning the global community advances multicultural and cross-cultural understanding, human rights, social and economic justice, and political freedom. It aims to eliminate discrimination that can occur on the basis of gender, age, ethnic and social background, and nationality. Peace education concerning the global environment includes study of ecological balance; world resources; and the preservation, protection, and development of the natural and cultural environment.

Peace education aims to develop social responsibility and citizenship to foster a system of positive human interdependence based on a respect for human dignity and universal human rights. It aims to foster stewardship that would direct efforts toward caring for the natural and cultural environment. The capacities needed

are care, concern, and commitment. The capacity to care means to care about the issues and problems of the world community and about the lives and well-being of all people. The capacity of concern means informed attention to the issues and necessary action. The capacity of commitment means sustaining efforts toward improvement as a fundamental civic obligation.

Art education can make a unique contribution to peace education. Central issues of humanity and the environment can be studied through observing works of art and through expression in art. An important channel of action for peace is good communication skills. Art education can develop skills in visual communication and the use of the contemporary media. The art education project for peace *Nordic Paradise,* created by art teachers from Finland, Sweden, Iceland, Denmark, and Norway, dealt with human relations and the environment. Because of pupils' interest and their commitment to study the issues, many of the project's programs extended over semesters and school years.

Akio Okazaki uses the allegory of ambivalence in figure-ground relationship presented in Christo's projects of huge blue umbrellas on the land of Japan to illustrate the clash between two cultural values in art. The scene symbolizes the Japanese cultural history in art and art education, which has continually taken and transformed diverse influences from other cultures. In Japan, textbook-based art instruction and the centralized educational system are essential in transforming and assimilating cultural influences. The texts are revised every 3 years and renewed every 12 years. Okazaki argues that the Japanese art education system has benefited by periodically discarding old practices and introducing new ones through the nationally distributed texts. A method for art instruction through the fourth grade is "play activity." It uses body movement, material assemblage, space transformation, earthworks, formative plays, thinking, and planning in various locations of the school and playground. Okazaki sees cross-cultural influence as a two-way street. Just as Japanese art influenced Impressionism and Post-Impressionism, European modernism influenced Japanese artists and art educators.

Mary Stokrocki interprets art teaching in a Navajo public school system. She conducts microethnographic research as a *participant observer*, committed to understanding interactions between Navajo students and their Anglo teachers. Stokrocki describes the Navajo as caught between two cultures, being both American and Indian. For the Native American child,

enculturation historically meant cultural deprivation and separation from adults and settings through which traditional native customs and art forms were transmitted. After several generations, the cultural forms have become confused, and much of the complexity of traditional Navajo life is obscured.

Mary Stokrocki, an Anglo, witnesses the revival of the Navajo way of life. She spends a year visiting in the Running Water school system where she validates many previous observations of research colleagues. Stokrocki also finds the Navajo taking an active role in the reenculturation of the children of the tribe. Today the Navajo participate in the administration of their schools, and the schools are fine cultural centers for the community. The old crafts and ways are being revived in *culture classes*, and Anglo art teachers are adapting their teaching styles to the students with whom they work.

This revival is recent; as late as 1984 Navajo children in public schools were taught the "American way." This way, as described by Saville-Troike (1984), was not conducive to Navajo learning because it offended the sensibilities and values of the students. Traditional Navajo time differs from Anglo time in that it incorporates contemplation; a seasonal and cyclic rhythm predominates. The Navajo believe that thinking is valid work. At the same time, they are incorporating new concepts of the environment and new ideas of beauty into their lives. Stokrocki believes that it is a time of transition. Perhaps a new identity is emerging for the Native American.

Soloman Irein Wangboje, employing an African context, cautions against a relentless elimination of smaller cultures by the more dominant ones. He finds the concept of identity "the most pervading and intractable" problem in the modern world, brought about by technological advances, a global monetary system, and even by demands for global unity. It is natural that the most developed nations practice cultural imperialism.

Wangboje maintains that *spiritual disorientation* can be balanced through the arts. We should not wish diverse groups to lose their spiritual connection, for that would result in a monotonous monoculture. Art educators can assist in the preservation of diversity as they encourage cultural sensibilities even when in other ways the cultural identity is lost. Cultural sensibility is an external expression of identity that is manifested in traditional crafts, although it is most powerful in the performing arts. Underlying the performance

arts is a consciousness of belonging that may not be as strong for craftsmen. Wangboje reiterates that educators should consider the festival example; this model might further all the art forms, ensuring cultural connection.

Reference

Saville-Troike, M. (1984). Navajo art and education. *Journal of Aesthetic Education, 18*(2), 41—50.

THE ARTS IN A MULTICULTURAL SOCIETY

with particular reference to the situation in Great Britain.

■BRIAN ALLISON

The issue of the arts in a multicultural society is a relatively new phenomenon. It is unlikely that the topic would have been on the educational agenda 20 or even 10 years ago, or that some of the concepts to which I will refer, and even some of the vocabulary I will use, would have been part of educational discourse at that time.

Much has happened in recent years to adjust educational endeavors to a recognition of the culturally pluralistic nature of the arts, and much has been achieved in developing curricula for schools that take into account the multicultural nature of present-day society. Nevertheless, such efforts have had little coordination or consistency, and a great deal of well-meaning activity promoted under the heading of "multiculturalism" has been somewhat misguided. We still may be a long way from either achieving an appropriate understanding of the cultural nature of the arts or devising appropriate educational methods that reflect that understanding.

In terms of educational developments in the arts, the increasing attention given to the cultural dimension has been paralleled by, and is similar to, the recognition of critical discourse and historical understanding as appropriate and necessary parts of the arts curricula. Attention to the development of critical abilities is a necessary, if not sufficient, condition for excursions into understanding the cultural nature of art.

In order to provide a perspective for some of the issues that need to be addressed, I would like to review matters that have led us to the present position in Great Britain and describe experiences that have stimulated and fashioned my own thinking. I will focus particularly on my own area of specialization in art and design, although I believe that developments in cultural plurality in the visual arts reflect those in the arts as a whole.

A Personal Exploration

Like that of many other individuals who have worked in this area, my own involvement in and commitment to what is known as multicultural education originated in a number of personally related events.

Underpinning these was the increasing belief that the way in which school subject matter is taught should reflect the nature and meaning of the subject areas in terms of the society or societies of which the schools are part. In the late 1960s and early 1970s, my dissatisfaction with the then-current conceptions of art education, based predominantly on peculiarly western notions of child art and creativity, led me to look to art as it was produced and experienced in the "real world," that is, the world outside of schools as I felt that it was on this that an education in art should properly be based. This view came from the recognition that art is a major form of culture, along with language, literature, dance, music, drama, science, and so on. Cultural forms contribute to the identification, maintenance, and development of societies in terms of the formation and expression of particular ideas, attitudes, values, and feelings, as well as relating to a variety of economic and political matters. People's actual and potential involvement in or experiences with art are diverse. In a nutshell, art is not only something that is made, with manifold possibilities for personal expression, but also something that is looked at, talked and written about, responded to, thought about, and felt about. Any art experience, whether it involves production or response, is located in time and in a culture, either that in which was produced or that in which was responded to.

The Four Domains Model

Attempting to grasp this diversity in a way that might provide a basis for an art curriculum that reflects the complexity of art in diverse societies and addresses future needs was both a theoretical and a practical problem. The development of a theoretical model into which this diversity could be structured presented a solution. The model was derived from an analysis of everything concerned with artistic production; the essential role of artistic perception; the importance of an appropriate vocabulary to underpin both perception and discourse about art; the nature of critical abilities; and the placing of all art and encounters with art in historical and cultural contexts. All of these factors are interactive and interdependent, and their interaction

and interdependence were fundamental to locating, describing, and understanding the complexities of making, perceiving, responding to, and appreciating art while recognising their historical and cultural determinants. The model, which encompassed all these elements and their complex interrelationships was named the "Four Domains" model, and the four domains identified were the Expressive/Productive domain, the Perceptual domain, the Analytical/Critical domain, and the Historical/Cultural domain. The model endured stringent scrutiny in terms of its applicability across the range of disciplines encompassed by the field of art and design. It also appeared to be equally descriptive of and applicable to other art forms such as dance, music, and drama.

If the elements and interactions in the Four Domains model applied to art and design as it existed in societies and cultures, then the model was an appropriate one on which to base art curricula for schools.[1] It seemed to provide a basis for an education in art.[2] It is worth recalling that notions of curriculum theory and terms such as *aims, objectives, assessment,* and *evaluation* were not then a normal part of everyday teacher discourse in Great Britain and that the art education practices prevailing in schools at that time were almost exclusively located in the Expressive/Productive domain. The justifications for the *making of art* constituted the principal *raison d'etre* for the presence of art in schools. Little or no attention was given to understanding the art of non-European cultures and to developing any understanding or appreciation of the European or even English cultural heritage. Only now is some measure of regard for the historical dimension of art becoming an element in schools' art curricula. The Four Domains model, which shifted the focus from an exclusive attention to making art to a curriculum that included response to art, was first submitted to the Schools' Council as part of the ill-fated N and F proposals (Schools Council, 1976). The concept of the Four Domains was extended and explicated further in a paper published later under the title "Identifying the Core in Art and Design" (Allison, 1982). This paper elicited negative reaction at the time (e.g., Povey, 1983), although currently even the most vociferous of its earlier critics seem eager to embrace its basic principles.

Overseas Development Activities

A further and most opportune stimulus to my thinking came from a source seemingly far removed from the arts. Almost concurrent with the Four Domains curriculum initiative, various activities under the heading of "Development Education" were being promoted by the British government's Overseas Development Administration (ODA) as a way of encouraging international understanding as well as justifying and supporting the government's investment in overseas aid, particularly to Third World countries. The ODA, through the Voluntary Committee for Overseas Aid and Development (VCOAD), published a range of support materials for schools, including a resource book called *The Development Puzzle* . In about 1970, I was invited to contribute a chapter to this book on "Art Education and the Teaching about the Art of Africa, Asia and Latin America," because this was a curricular area that had previously received no attention. The book's publication by VCOAD in 1972 provided a splendid opportunity to focus on the issues of teaching about non-European art, and it led to the formulation of a set of coherent objectives for the Cultural domain.[3] These objectives were concerned with understanding the nature and role of images and art forms in diverse cultures, to enrich one's own experiences of the world and to promote the recognition and formation of cultural identities.

A major point that emerged from this consideration of cultural diversity, which seems all so obvious now, is that art forms are not facts of life but particular phenomena of particular cultures. It seemed evident that, in order to recognize and appreciate the culturally determined nature of any particular art form, including one's own activity or experience in it, it is necessary to know about and be sensitive to the art forms of other cultures.

INSEA Involvement

A third stimulus to my thinking about the arts in multicultural societies came from my involvement with the International Society for Education Through Art (INSEA) since the INSEA World Congress held in Coventry in 1970. INSEA is a UNESCO Category B world organization with members in over 40 countries. Through opportunities created by INSEA, including a period as world president, I have met with art educators from all over the world and visited many countries. These experiences have supported and reinforced my thoughts on the cultural determination of art forms and enabled me to challenge the widely held notion about the universality of children's art (Allison, 1980), a notion that still prevails.

These experiences helped to clarify a distinction between the arts as practiced in the country of cultural origin, where, for the most part, they are a celebration of the culture, and the arts when practised by ethnic

minorities in countries which have strong and often racist majority cultures (Allison, 1985a). In countries such as the latter, which some would argue might include the UK and the USA, the ethnic minority arts can often be characterised as forms or expressions of protest which may bear only a superficial resemblance to the expressive form of the arts in the culture of origin. The misunderstandings which can be engendered by such art forms are all too obvious when presented as exemplary of overseas cultures. This matter is of extreme importance in determining curriculum content and particularly so when drawing upon the work of artists from local ethnic minorities as exemplifications of cultural forms and expressions. The culmination of my period of office as President of INSEA was the promotion of a Regional Congress for Europe, the Middle East and Africa organised by the National Society for Edication in Art and Design, held in Bath in 1985 with the title *Many Cultures, Many Arts* (Allison, 1985b), a title which I coined from Manchester Polytechnic's motto "*Many Arts, Many Skills*".[4] Although the themes put forward for the Congress reflected some of the main problems and dilemmas affecting art education provision in this country, the attendance by British art teachers was small compared to the number of art educators who came from over thirty other countries. It is difficult to know how much has changed in four short years in the extent to which English art and design teachers are prepared to address the problems and dilemmas of multicultural education, which are social as well as academic. On an issue such as this, the aphorism 'those who are not contributing to solutions are part of the problem' might ring true.

Training Teachers in Leicester

In 1975, I became responsible for the initial teacher education of graduate specialists in art and design in Leicester. Although the students were introduced to the Four Domains curriculum model as part of their coursework, which gave some emphasis to the cultural domain, their profoundly Western European backgrounds and training in art and design created perceptual and cognitive blocks to their understanding and valuing of non-European art forms. I believe this applies also to the initial teacher training of specialist students in other arts disciplines. Because many of the schools in which they taught had large ethnic minority populations, the students' Eurocentricism caused some major problems. Leicester is a multicultural city with large numbers of immigrants from the Indian subcontinent and the Caribbean and had become the home for a large proportion of Ugandan Asian immigrants who

came to Great Britain during the Amin regime. To help alter the student teachers' perceptions, as well as our own, about the cultural nature of art, we promoted a number of efforts that included extensive exhibitions of non-European artworks at the beginning of each year and visits to significant exhibitions elsewhere. Although we considered ourselves to be liberally minded as far as cultural issues were concerned, our own perceptions were inevitably strongly European oriented. Consequently, in order to keep a watchful eye or ear on our deliberations, we appointed a non-European to an Islamic Foundation Fellowship, which was funded by the international Islamic Foundation based in Leicester. This specialist contributed to all coursework and planning, as well as to interactions with the ethnic minorities and schools in Leicester. This monitoring of our thinking seemed essential and was a valuable learning experience for all of us.

Multicultural Education Projects

We were asking many questions about art, culture, and the curriculum, and in 1982 we formally launched the AIMS project — "Art and Design in the Multicultural Society" — with funding from the local education authority.[5] Over the years, the AIMS project has been very productive, and it has attracted a lot of attention from art educators from both England and overseas. The project has resulted in a variety of initiatives at both the local and national levels. An AIMS research project completed in 1986 (Allison, Denscombe, & Toye, 1986a,b) reported a number of surveys of parents, teachers, pupils, and ethnic minority leaders regarding local authority policies and attitudes toward culturally pluralistic curricula. There was diversity in the ways both individuals and groups were prepared to respond to the challenges of the multicultural society. According to a survey, some head teachers, particularly in rural areas, felt that multicultural issues were of no relevance to them because they had no children in their schools who were from ethnic minority groups. An early version of the multicultural policy of Leicestershire, which is widely regarded as a progressive local education authority, made no reference to the nature, role, or importance of the visual arts. This "unintentional bias" was corrected when my suggestions for extensive amendments and additions to the cultural policies, expressing the importance of art in any cultural context, were included in the cultural policy of Leicestershire (LEA, 1984). I also produced multicultural policies for both INSEA (1982) and the UK's National Society for Education Through Art and Design (1986).

To resolve the problem of the cultural authenticity of artists from ethnic minority groups, we established a Non-European Visual Arts Research (N-EVAR) project as part of the AIMS project.[6] This was funded by the Leicestershire local education authority and the East Midlands Regional Arts Association and continued until 1988, when it ran out of money. We appointed the distinguished Nigerian sculptor Emmanuel Jegede as project artist. His primary task was to continue working as an artist in his own cultural tradition. His very presence, as well as his work, was intended to be a constant influence on our understanding of the cultural nature of art and art forms, in a way similar to that of the Islamic Foundation Fellow. An informative video tape was made to record and describe the N-EVAR project (Leicester Polytechnic, 1986a). At the same time, recognizing the problems as well as the values of artists working in education and the dilemmas faced by both artists and schools when organizing residencies, we devised an Artists-in-Schools training program (Leicester Polytechnic,1986b). A report (Taylor, 1987) and video informed artists, schools, and funding agencies, (Leicester Polytechnic, 1987). Many of the ideas from these works were published in the book *Artistis in Schools* Sharp and Dust, 1990, which came out of the Artists in Schools project sponsored by the National Foundation for Educational Research.

Along with a feasibility plan (Leicester Polytechnic/Concorde Festival Trust, 1986), a national directory of non-European and ethnic minority artists available to work in education was published, supported by the Arts Council of Great Britain and the Gulbenkian Foundation. A similar directory was included in the current Arts Council/Gulbenkian Foundation/Commission for Racial Equality (1987) project Arts Education in Multicultural Society (the AEMS project), established as part of the Arts Council Ethnic Minority Arts Action Plan launched in 1987 (ACGB, 1989).

Given all the developments over these years and the increased profile many agencies have been giving to multicultural matters, including the recently completed Arts in Schools project,[7] most art and design teachers may now be aware of the implications of developing curricula for a multicultural society. There are indicators of the extent to which the issue has taken root. For example:

- Books and other published materials are now available that address some of the most pertinent issues.
- Many local education authorities have devised policy guidelines, some specifically referring to art and design in the multicultural society. The move is not restricted to England, and many states in the USA, as well as some in Australia, have developed curriculum guidelines that take cultural diversity as a basic premise.
- Art advisers in many English counties have given courses and drawn in a variety of contributors, including artists from minority cultures.
- Black and Asian artist groups have increased in number, and many artists from minority cultures have been hired as artists-in-residence in schools and colleges. An increasing number of exhibitions of work by non-European artists are held in many parts of the country.
- Her Majesty's Inspectorate (HMI) recognized the particular art education concerns of schools with substantial proportions of pupils from ethnic minority groups and carried out an inspection of 10 such schools in London (DES, 1986).
- The issue has been seen to be of importance at all levels of education. The Further Education Unit of the Department of Education and Science has published various documents relating to the need to address such issues. The National Association of Teachers in Further and Higher Education's national conference in 1991 took "Art, Culture and Consumerism" as its theme (Allison, 1988).
- A number of staff in higher education addressed the multicultural issue in relation to undergraduate courses in the Seminar on Tertiary Art and Design in a Multicultural Society.[8]
- The recently created London Institute, comprising several of the former independent London art schools, appointed an Asian lecturer to coordinate multicultural approaches in the colleges.
- Many local education authorities have set up multicultural resource centers, some specializing in the arts and crafts of particular ethnic minority groups. The Bangladeshi Resource Center established by Inner London Education Authority in Whitechapel is a notable example.
- Museums and galleries throughout the country have appointed specialists in non-European arts, both as curators and education department staff, and have formed collections of non-European resources to be used for exhibitions and for loans to schools.
- In many large cities in England, the majority of schools with substantial numbers of students from ethnic minority groups consider the cultural backgrounds and religions of the pupils in devising art and design programs.

What Remains to be Done

There are a number of problems that have yet to be fully addressed and may account for the less-than-adequate ways in which the multicultural issues in art and design are being pursued. The first problem lies in the nature of culture and the ways in which any one culture sets a framework through which the members of that culture are able to perceive other cultures. Such a framework might be characterized as "cultural prison" in which, Whorf (1956) argued , we are inevitably captive and which only allows a window through which we are able to view other cultures. The firm but different stances taken by Iran and other countries in the case of Salman Rushdie are good examples of this. "

We can readily find examples of the effects of the "cultural prison" in art and design education if we look at some of the ways that art curricula in Great Britain, as well as in other countries, have been moving to take account of the cultural diversity in classrooms. Many such moves have been principally concerned with adding images and ideas from other cultures without achieving any real understanding of those cultures. Such images and ideas have been restricted to those relating to local ethnic minority groups as local solutions to what have been seen as local problems. For example, the 1986 HMI survey on 10 schools with substantial populations from the ethnic minorities came to the conclusion that the schools successfully related art and design work to the different forms and images indigenous to those communities (DES, 1986, p.13). The report concluded that "In all the schools visited, the art and design departments make a significant contribution towards promoting racial harmony by teaching pupils to be aware of and to understand the value of many different forms of cultural expression"(p.13). The following are just a few examples of many similar activities that the inspectors described in their report:

> In one school a Japanese garden, developed by the art department, continues to be a resource for drawing from observation... All the art departments stress the importance of drawing as a starting point for almost all the activities undertaken. Drawing from direct observation features strongly... An obvious, easily available source of reference for cultural diversity, self portaiture, is used extensively in all the schools... Most of the teachers are convinced of the fundamental need to teach drawing through direct observation and direct experience. Accepting the great diversity of pupils' backgrounds, many teachers provide culturally diverse scenes and subject matter within their studios, ensuring, for example, that, when drawing directly from fruit and vegetables and other foodstuffs, items associated with Indian or Caribbean or Turkish cooking are included... Another common practice is to use pupils as models, dressing them in costumes from different cultures and posing them against often elaborately built "associated" backgrounds... In one school a further cultural dimension was included by visiting London's Chinese quarter and attempting to capture colourful impressions of the location... Encouragement to be selective with subject matter leads to some sensitive work as witnessed in the photograph of a boy of Afro-Caribbean origin peeping through a chain link fence... (pp. 10 and 12).

These examples, in my view, demonstrate some of the ways in which the nature of the multicultural curriculum can be missed. Two points stand out. First, a curriculum that addresses the nature of art as a culturally diverse phenomenon is not the preserve of any one sector of the community, it is as important an issue in the monocultural school as it is in the multicultural school. The activities reported would have been as appropriate in monocultural schools as they were in multicultural schools. Second, even though attention was given to the cultures of the local ethnic minorities, the ways the schools approached the task were reinforcing the European cultural model. This situation may be partly explained by the observation of HMI that "Only one art teacher from an ethnic minority group was working in the 10 schools," (DES, 1986, p. 7) In the case of drawing, for example, it is not commonly the subject matter that identifies its cultural significance. Drawing directly from observation is peculiarly Western European. It may not matter to a Western European artist whether he or she is drawing a plate of bacon and eggs or a plate of chicken chow mein, making a portrait of an English duke or a Turkish concubine; drawing a scene in the Lake district or a backstreet in Cairo — the drawings would all be European drawings. Not all cultures see or represent the world in this particular way, as is evident from the many exhibitions of non-European art works that have been shown in Great Britain in recent years[9]

Although in these schools there was an emphasis on exploring the art forms of different cultures, the activities and outcomes were principally European in kind and concept because they were pursuing an art and design curriculum that had the European conception of production as its *a priori* basis. Although the curricu-

lum now includes art and design criticism and historical studies, learning in art is still primarily conceived as taking place through the *making* of art. The HMI survey of schools (DES, 1986) indicates that the studies of non-European art works were undertaken principally as stimuli or starting points for producing artwork that was essentially European in concept and not because the works were worth studying in their own right as manifestations of the cultures they represented.[10]

This may be where a major part of the problem lies. Concepts of art differ from culture to culture. Each culture has its own rules and conventions, its peculiar roles and purposes within particular societies, its particular social status, its particular religious or other values, and so on. Perception is culturally determined, and the interaction between language and perception is well recognized. For example, in a study of vocabulary as part of the AIMS project, we found that some of the English vocabulary fundamental to artistic perception within the Wester European concept of art does not have equivalents in Urdu or Gujarati, and vice versa (Eldridge, 1984). A current comparison of English and Japanese vocabulary shows similar results (Allison and Iwata, 1989; Iwata, 1988).

If the rules of art from the European cultural framework do not apply to other cultural conceptions, then activities that are exemplary of those rules may not be the most appropriate way of studying conceptions from other cultures. This seems to be the main problem area in devising art activities for schools. It may be necessary to embrace other strategies or even other disciplines to provide a more appropriate means of study.

An Example from Dance

In the arts, there may be an appropriate way of addressing cultural pluralism.[11] In a paper presented to a dance conference in Lisbon in 1987, I applied the Four Domains model to establishing a coherent set of aims for dance education that addressed the cultural and other aspects of dance (Allison, 1989).[12]

- The *Expressive* domain refers to the development of skills and abilities that contribute to an understanding of the nature, purpose, and process of dance as well as providing the means to use dance performance as a form of expression and communication.
- The *Perceptual* domain refers to the development of skills that expand the capacity to see, feel, and comprehend the form, rhythm, and movement of dance.

- The *Analytical/Critical* domain refers to the development of skills in describing, analyzing, and evaluating aesthetic qualities as a basis for both experiencing and being able to communicate meaningfully about the content and form of dance.
- The *Historical/Cultural* domain refers to the development of the understanding and appreciation of the changes and effects brought about by the influence of historical and/or cultural contexts and roles played by dancers and choreographers in different societies in relation to their contributions of forms, ideas, and values.

The *dance* referred to in each of the domains is not any particular dance form. It refers to all forms of dance, developed at different times throughout history and by peoples in different world cultures. Dance is regarded as a humanistic activity through which individuals, groups, communities, and societies find expression, illumination, and enjoyment for ritual, religious, ceremonial, celebratory, political, and many other purposes (Allison, 1989).

It is evident from this example that, the core in the arts is culturally determined. Although practice and performance are of great importance, the strategy for understanding that core — even for oneself as a practitioner in a particular culture —is through forms of critical activity that take place within historical perspectives. *Critical activity,* as the term is used here, draws heavily upon the field of anthropology. It recognizes that all behavior can be seen as an exemplification and manifestation of culturally determined dispositions, attitudes, beliefs, and values. This view of behavior applies whether it is in production or performance in the arts or in their perception and response. It provides a major perspective from which one can look outside and inside one's own culture. An essential prerequisite to appreciating the art forms of any culture, including one's own, is to understand that one's own way of engaging the arts, either as a practitioner or performer, takes place within a fairly well structured and identifiable cultural framework, that has its own particular rules and conventions. The multicultural curriculum in the arts, therefore, needs to have both cultural diversity and critical activity as interrelated and interdependent elements at its root. According to such a conception, performance and the production of art forms and images, have two important but different functions. The first function provides a vehicle of expression, using the rules and conventions of one's own culture and adopting or adapting those from other cultures in ways that subscribe to one's own cultural intentions. The second function production acts as a means of

understanding the art forms and intentions of another culture. In the latter sense, it is important at the same time to acknowledge and respect the authenticity of the forms and expressions of that culture, which, by definition, cannot be one's own.

Need for a New Approach

Considering the recent progress in addressing challenges and problems presented by a multicultural society and a multicultural view of the arts, it may be timely to undertake some rethinking of directions and reevaluation of purposes. A number of issues might be addressed, including the following:

1. The ways the cultural dimension — that is cultural plurality, as well as particular multicultural issues — permeates all aspects of education in the arts. *Cultural plurality* refers not only to those cultures represented by the ethnic minorities but also to the diversity of cultures thoughout the world.
2. The ways the development of critical skills and strategies are seen as essential to any growth in understanding, enjoyment, and participation in the arts.
3. The ways curricula at all levels of education are developed that take production and performance, perception, analysis and criticism, history, and culture as essential, interactive, and interdependent elements.
4. The ways artists and performers from non-European and European cultures, representing particular cultural conceptions of the arts, contribute to education in order to illuminate the cultural plurality of the world, and not simply the multicultural nature of a particular locality.
5. The ways teachers at initial and inservice levels of education are assisted in expanding their cultural conceptions of the arts.
6. The ways, in which the various efforts of educators across all the arts address the issues of cultural plurality can be capitalized upon through collaboration and cooperation. The problems and challenges presented by the recognition and acceptance of cultural plurality are of such a large scale and of such profundity that only through open collaboration and cooperation can primary advances take place.

If we are to move forward, rather than sideways, in coming to terms with cultural pluralism and achieving a relevant multicultural view of curricula, I believe we have to make a radical shift in our positions on a num-

ber of matters relating to the nature of culture and the arts of diverse cultures; the role of criticism; the development of curricula for the arts; the nature of the potential contributions of artists in education; the content of teacher education; and, last but not least, our own willingness to share and support each other's endeavors.

Notes

[1] A "coherent" set of aims implies that all the aims in the set are of equal importance and relevance. A set of such aims for art education were drawn up initially for the Schools Council (1976) N and F proposals. The major goals for art and design education can be summarized as follows:

i. The development of a broad understanding of the meaning, significance, and contributions of art, craft, and design in contemporary culture.
ii. The development of perceptual skills leading to to sensitivity to visual and tactile qualitiies, together with an enhancement of experience of art, craft, and design.
iii. The development of bases for informed aesthetic judgment at both personal and community levels.
iv. The ability to value and and experience meaningfully the cultural heritage of this and other societies, past and present.
v. The ability to hold, articulate, and communicate ideas, opinions, and feelings about arts, crafts, and design.
vi. The development of particular individual aptitudes and interests in the field of art and design that are not necessarily those in production and expression.

[2] A broad definition of what it means to be "educated in art and design" was put forward to provide a descriptive goal for art and design education:

> To be 'educated in art' means considerably more than being able to manipulate some art materials, however skillful and expressive that manipulation might be. It also means to be perceptually developed and visually discriminative, to be able to realise the relationships of materials to the form and function of art expression and communication, to be able to critically analyse and appraise art forms and phenomena, to be able realise the historical context of what is encountered and to be able to appreciate the contributions to, and functions within, differing cultures and societies that art makes. (Allison, 1972).

[3] This text offered the following objectives for the Cultural domain:
To develop understandings about

i. the ways different cultures embody and communicate their beliefs in the visual symbols they produce.

ii. the sources of imagery and symbolism, and that these sources vary from the ritualistic, mythical and magical to representations of visual responses to the environment.

iii. the variety of ways art forms or symbols to be found in a culture influence the lives of the people in that culture.

iv. the ways in which art forms and materials used in different cultures influence, and are influenced by, the particular kinds of imagery and symbolism.

v. the ways in which both the art critic and the anthropologist can help in providing ways of undertanding the art forms of different cultures.

vi. the differing criteria that need to be employed in responding to, comparing and contrasting the art forms of different cultures.

vii. the ways in which artists in one culture derive symbols and images from the art forms of other cultures and attach new meanings to them. (Allison, 1972).

[4]More information on the Congress is given in the *Journal of Art and Design Education* , 1986, 5, 1, 2 and 3,303—305.

[5]Leicester Polytechnic. (1981). *Art and Design in a Multicultural Society (AIMS) Project.* Many publications, list available from the Polytechnic.

[6]Leicester Polytechnic. (1983—1988). *AIMS Project. Non-European Visual Arts Research Project.*

[7]SCDC/NCC. (1983—1988) *The Arts in Schools Project.* Various publications.

[8]National conference held at the University of London Institute of Education 1986.

[9]Some of the exhibitions of culturally diverse works shown in Britain in recent years and some of the possible issues to be considered in addressing non-European art forms, particularly those by other than ethnic minority artists, were indicated in Allison (1985).

[10]It is important to note that practical activities, particularly those involving production or performance, can make vital contributions to the study of art works as well as being modes of individual or personal expression.

[11]The move toward culturally oriented curricula is international. This can be seen in B. Allison (Ed.). (1987). International bibliography on art education and creativity. *Bulletin of the International Bureau of Education,* Nos. 244/245, Paris: UNESCO.

Various curriculum guides or documents produced in different parts of the world stress the importance of criticism and/or culture in curricula - for example, in the United States, notably the states of California and Ohio and, more recently, the work of the Getty Center for Education in the Arts on Discipline-based Art Education (DBAE) and Australia, notably the State of Victoria Arts Framework. The DBAE disciplines are defined as production, aesthetics, criticism, and history.

[12]In this paper, the coherent set of aims for art education listed in Note 3 were transcribed for dance education as follows:

i. The development of a broad understanding of the meaning, significance, and contributions of dance in contemporary culture.

ii. The development of perceptual skills leading to sensitivity to visual, aural and kinesthetic qualities, together with an enhancement of experience of dance.

iii. The development of bases for informed aesthetic judgment at both personal and community levels.

iv. The ability to value and and experience meaningfully the cultural heritage of this and other societies, past and present.

v. The ability to hold, articulate, and communicate ideas, opinions and feelings about dance.

vi. The development of particular individual aptitudes and interests in dance but not exclusively in performance.

The activities implicit in these aims could be taken to include performing, looking at, thinking about, talking about, feeling about, knowing about and responding to dance.

References

Allison, B. (1972). Art education and teaching about the art of Africa, Asia and Latin America. London: VCOAD.

Allison, B. (1980). The relationship between child arts and their cultural foundations. Journal of Aesthetic Education, 14, 59-79.

Allison, B. (1982). Identifying the core in art and design. Journal of Art and Design Education, 1, 59-66.

Allison, B. (1985a). Cultural dimensions of art and design. Journal of Art and Design Education, 4, 217-223.

Allison, B. (1985b, April). Many cultures, many arts. Arts Express, pp. 9-10.

Allison, B. (1988, November). Art culture and consumerism. Paper presented to the NATFHE Art Section Annual Conference, London.

Allison, B. (1989). Dance in the curriculum: A perspective from the visual arts. Australian Art Education, 13, 20-24.

Allison, B., Denscombe, M., & Toye, C. (1986a). Art and design in a multicultural society. Studies in Design Education and Craft Technology, 19, 39-40.

Allison, B., Denscombe, M., & Toye, C. (1986b). Art and design in a multicultural society. [Research Report]. Leicester: Leicester Polytechnic.

Allison, B., & Iwata, Y. (1989). A croscultural study of colour in Japan and England. Bulletin of the Yamaguchi Jossi University, 15, 9-27.

Arts Council of Great Britain (ACGB). (1989). Towards cultural diversity. London: Author.

Department of Education and Science (DES). (1986). A survey of multi-ethnic art and design education in 10 ILEA secondary schools. A report by HM Inspectors. London: HMSO.

Eldridge, P. (1984). Cultural orientation and aesthetic functioning. Unpublished masters thesis, Leicester Polytechnic.

International Society for Education Through Art (INSEA). (1982, July/August). Art education and culture: Review and policy. Paper prepared for the Unesco World Conference on Cultural Policies, Mexico City.

Iwata, Y. (1988). Allison Art Vocabulary Test in Japan. Bulletin of the Yamaguchi Jossi University, 14, 29-38.

Leicestershire LEA. (1984). Report of the Working Party on Multicultural Education. Leicestershire County Council.

Leicester Polytechnic. (1986a). Artist in residence: Non-European Visual Arts Research Project. [Videotape]. Leicester Polytechnic AIMS Project.

Leicester Polytechnic. (1986b). Artist in residence training programme. Leicester Polytechnic AIMS Project.

Leicester Polytechnic. (1987). Artists in residence. [Videotape]. Leicester Polytechnic AIMS Project/CETD.

Leicester Polytechnic/Concorde Festival Trust. (1986). Project proposal: Multi-ethnic arts in Britain — A director of sources and resources. Unpublished manuscript, Leicester Polytechnic.

National Society for Education in Art and Design. (NSEAD.) (1986). Policy on art and design in the multicultural society. Corsham: Author.

Povey, D. F. (1983). Letters to the editor, Journal of Art and Design Education, 2, 117-120. See also response: Allison, B. (1983) Letters to the editor. Journal of Art and Design Education, 2, 231-234.

Schools Council. (1976). 18+ Research Programme report (N and F proposals). Craft Commissioned Group — NSAE. London: Schools Council.

Sharp, C., & Dust, K., (1990). Artists in schools. London: Bedford Square Press/NFER.

Taylor, P. (1987). Non-European artists in residence: A survey of policies and practice. Leicester Polytechnic AIMS Project.

Voluntary Committee for Overseas Aid and Development (VCOAD). (1972). The development puzzle. London: Author.

Whorf, B. L. (1956). Language, thought and reality. Selected writings of Benjamin Lee Whorf. (Ed. John B. Carroll). Boston: MIT Press.

"OLD-NEW LAND": CULTURAL INTEGRATION AND POLYAESTHETIC EDUCATION IN MODERN ISRAEL

■ HANAN BRUEN

This study will be devoted to a few selected questions in the following four problem areas: the nature of culture, the traditional culture of the Jews, cultural changes in the Jewish people and particularly in the State of Israel, and the implications of these developments for art and aesthetic education in Israel.

Culture

The concept of culture can be understood in two different ways: as a basis for evaluation or as a framework for description. During the nineteenth century, philosophers generally used *culture* as a criterion for evaluating individuals and social groups; for measuring, that is, the extent to which the individual or group had achieved a certain ideal and how far they had liberated themselves from the state of primitivism or *lack of culture*.

On the other hand, *culture* can be seen as a concept with a descriptive rather than an evaluative purpose. This is the way the concept was used by the modern empirical behavioral sciences, particularly anthropology, which have understood culture as the sum of the behavioral patterns accepted, though not biologically inherited, by members of a social group.[1]

According to the evaluative way of thinking, culture was a historical principle; it was regarded as a process of improvement that finally resulted in perfection. Political demands were derived from the level of culture achieved, and national ideologies were developed that were based on the results of the evaluative process.

On the other hand, the descriptive attitude—defining culture as the sum of behavior, i.e., as patterns that reflect the material, intellectual, and emotional activities of human beings—provides a basis for objective examination. Edward Barnett Tyler, the British anthropologist, was one of the first scientists who tried to define culture in a way that can be used as a framework for the examination of the particular problem that is our concern. Culture, according to Tyler, is "that complex whole which includes knowledge, belief, art, law, morals, custom and any other capabilities and habits acquired by man as a member of society."[2]

Although it was stated that culture is generally seen as comprising a number of behavior patterns that are not biologically inherited, the concept is perhaps best understood as denoting a *social* inheritance, a collection of traditions. Other conceptions consider culture to be a set of adaptations and adjustments, approaches that strongly emphasize the process of learning. Yet social inheritance and learning do not constitute a contradiction in terms. Rather, these concepts complement and complete each other. They allude to an integration of the old with the new, of tradition with creative openness.

There were behavioral scientists who tried to construct an integrative definition of culture that would encompass, for example, "explicit and implicit behavior patterns, which are acquired and transmitted by means of symbols and which constitute the most meaningful achievement of a human group, including the concretizations of these patterns in the form of products."[3] In this definition, four key concepts can be distinguished: *tradition, acquisition, symbols,* and *products*, which may be further defined as follows: (a) Culture patterns are the fruits of *tradition*; they are transmitted from one generation to the next. (b) Culture patterns are *acquired*, they are learned; because acquisition is involved, the teaching-learning process is of central significance to the concept of culture. (c) Culture patterns are expressed in *symbols*; the capacity to create symbols and to transmit their meanings to the next generation is of greatest importance for understanding the concept of culture. (d) Culture patterns find their concretization and crystallization in the form of *products*; these products are important as manifestations of a culture.

Reprinted from *Journal of Aesthetic Education*, Vol. 18, No. 2, Summer 1984.

Two additional problems remain to be emphasized: (a) The first is the question of attitudes toward the past, present, and future. Clyde Kluckhohn raised the issue of time orientation, among others. There are groups that prefer the past, others the present; still others are oriented toward the future as the time period contributing the principal influence to the direction of their cultures.[4] (b) The second, and final, general question of importance in this context is the problem of cultural change. Among the main reasons for change are usually listed population moves, rapid population increase, contacts with other cultures, and intra- and inter-cultural conflicts.

The implications of the above general concepts and questions as applied to some major problems of Jewish culture will be examined next.

Traditional Jewish Culture

The *descriptive attitude* may help us to form a basis for our investigation. Tyler's aforementioned definition included knowledge, beliefs, laws, and morals among the chief factors giving content to culture. Indeed, these four factors delineate the central culture idea of the people of Israel throughout the millennia: the Jewish religion. In an objective description of Jewish culture, we would thus see religion as the central factor that, until very recently, influenced every aspect of the nation's spiritual life.

Judaism as a distinctive monotheistic religion has emphasized mainly the *belief* in an abstract, invisible, supreme deity who determines, as the one Lord of the Universe, the fate of the world. Judaism stressed the *knowledge* of its history by the Jewish people who had been "chosen" to undertake and to propagate the Lord's will. It found particular expression in a *moral code* defined by a number of *laws* that are binding upon and that oblige each member of the Jewish nation. The religion of Israel regarded its main objective not as the defining of an extensive theoretical framework of theology, but as the interpretation of the Law which took the form of a few hundred prescriptions and prohibitions that served as a practical basis for daily life. Consequently, the main *symbol* expressing cultural ideas has been the abstract word. There were of course additional symbolic expressions in the long history of Jewish culture, such as musical sounds, rhythmic movements, and pictures, all devoted to the supreme objectives of religion. These symbols, however, in contrast to those of other nations, were not the predominating ones. Additionally, it should be emphasized that with regard to iconic expression, Israel

waged a permanent battle whose principle was expressed in the second commandment of the decalogue: "Thou shalt not make unto thee any graven image . . ."[5]

Likewise, a condemnation of the ideal of physical beauty, as expressed in the cult of athletics, can be distinguished as an important element in the Jewish culture in many periods of its history—for example, in the Hasmonaen revolt against the predominance of Hellenistic civilization in the Middle East in the second century B.C. Judaism's contribution to world culture in the past was mainly by means of the verbal symbol, through abstract language. It follows, then, that the principal *products* of the Jewish culture in the past took the form of great works of literature, namely, the Bible and the Talmud, containing the essence of Israel's faith, history, law, and morals.

Throughout all periods, *learning* was one of the central features of Jewish life. The transmission of the Word was a condition of existence for Jewry and for Judaism, for the nation and for its culture. It is not surprising, therefore, that the Jewish people developed a system of compulsory education in early times. This was particularly true during the almost two thousand years of diaspora (dispersion). Having been driven out of their land, from the economic basis of their soil, and having been deprived of the political rights of statehood, the Jewish people saw the only chance for their survival in the systematic pursuit of the educational process, in the transmission of their culture. As for the question of the orientation toward time raised by Kluckhohn, it must be said that in the religious culture of the Jewish diaspora, the entire emphasis was placed on the *past*.

Enclosed by the walls of the ghetto, persecuted by followers of other, more powerful religions, and suppressed by their host nations, Jews longed for the lost glories of the past. The knowledge of their history was stressed, the periods of relative security and prosperity of bygone days were nostalgically *remembered*, holy days of the past were celebrated. An example is the prayer for rain that was recited on the last day of the holiday of Tabernacles in the fall. Such a prayer in the autumn of Berlin, Warsaw, or Amsterdam was meaningless, as these regions always have rainfall during the summer months. But the nation remembered that in the old country, in Eretz Israel (the Land of Israel), there was no rain at all between May and October. The praying for rain in the fall was a natural, organic, and sincere wish, of which fulfillment was a condition for a prosperous agricultural year. This prayer was not

merely an expression of the link with the past, but also of an anachronistic battle against the present. Cultural life was characterized by a complete devotion to tradition and by an escape from the present, contemporary life. Aesthetic education in traditional Jewish life and in the traditional Jewish school of the past was by and large limited to the learning of the sacred word.[6]

Cultural Changes

The ideologies of the Enlightenment, of liberalism and democracy, which found their expression in the slogans of the French Revolution and which spread in the wake of Napoleon's armed expeditions throughout Europe and beyond, brought about far-reaching developments in the fate of the Jewish people that entailed changes in their culture. The process of political and social emancipation opened the gates of the ghettos. The Jewish people drew closer to the nations among whom they found themselves, which resulted in a wave of assimilation and secularization. The unequal distribution of opportunities for freedom among the different countries led to huge population movements, bringing, for instance, great numbers of Jews from Eastern Europe to the New World at the end of the last century and the beginning of the present.

A new approach to Jewish fate within a changing world engendered the Zionist ideology, which was a modern political expression of the Jews' age-old longing to return to Eretz Israel, a land they had never forgotten or renounced throughout all the centuries of exile and diaspora. As alluded to earlier, a rather interesting relationship may be seen between this dream and the *evaluative attitude* with regard to culture. This attitude toward the concept of culture was of considerable importance in the emergence of the ideology of *political Zionism* at the end of the last century and in its battle for realization in the twentieth century.

Like other national movements, Zionism saw one of the main justifications for its demands in its judgment and evaluation of Jewish culture. According to this view, the Jewish people had, over the centuries, attained a high standard of culture comparable to that of any other nation that existed as an independent state and was settled in its own country, with borders protected by its security forces. Because of the coincidences of history, the Jewish people (similar in some ways to the Italians, Hungarians, Poles, and Czechs) had been deprived of its right to nationhood and independence, a right which was regarded as strongly related to its cultural level and to its contribution to world culture.

The Zionist dream found its realization in the waves of mass immigration to Palestine from all the countries of the diaspora and, finally, in the establishment of the State of Israel in May 1948. Not only did these far-reaching events bring with them political, military, social, economic, and vocational developments of major significance, they were also intimately interwoven with cultural changes of great dimensions. New socioeconomic trends and processes such as democratization, secularization, return to the soil and manual vocations, and industrialization and urbanization had immediate effects on all facets of life and culture.[7]

Theodor Herzl, the founder of political Zionism, titled one of his books *Alt-Neuland* (Old-New Land). A new type of Jew was to arise in this old-new land, building for himself a synthesis of "old-new culture." On one hand, he regarded himself as the latest link in the long tradition and history of the nation. Largely on purpose and by choice, he had come to Palestine, to Eretz Israel, the land of his fathers, and not to other countries like America or Australia. He adopted ancient Hebrew as his national language, he saw in the Bible the greatest work of Hebrew literature, and he celebrated the Shabbat and the other traditional holy days.

On the other hand, he felt himself open to modern life, fully accepting and utilizing the achievements of contemporary science and technology. He had come to Israel in order to live here a natural, normal life. Having formerly been restricted by the host nations of the diaspora to a limited number of vocations, mainly in the fields of trade and commerce, he chose manual occupations and agricultural work in his own country. In many respects he tried, and still tries, to give the country a politically progressive character, endeavoring to find solutions for political and socioeconomic problems in free democratic competition between liberal and socialistic views. A large proportion of these new Israelis regard themselves as *secular* and celebrate the holidays as historic memorial days or as expressions of a link to nature, soil, and crop.

In addition to the synthesis between the old and the new, another link should be mentioned: that between East and West, between Orient and Occident. As said before, Jews from all the countries of the diaspora had returned to Israel in accordance with Zionist ideology. As a consequence of the holocaust and the establishment of the State of Israel, the waves of immigrants became increasingly larger and broader in scope. In addition to the remnants of European Jewry, there also arrived in Israel hundreds of thousands of Jewish

refugees from oriental countries. Very soon it became clear that this Ingathering of the Exiles would fail were it to be managed as a one-way process of *absorption*, that is, through the assimilation of the oriental new-comers to the social norms and cultural experience of the established population who had arrived from the countries of the West a few generations earlier. Instead of a static adjustment to the existing framework and standards, a dynamic process of sociocultural integration was attempted. The need to supplement the *vertical* time link connecting the old and the new with an integrative *horizontal*, spatial link between East and West, between Orient and Occident, has been vehemently emphasized.

To these dominating factors should be added the strong attachment of the people to the country, to landscape, nature, and soil. The long absence from *the land*, the longing for its mountains, deserts, and cities during all the centuries, had built up to an enormous emotional tension that had already found its expression in the traditional culture of the diaspora: the Jew in exile had always built his synagogues facing Eretz Israel; he had said his prayers turning toward Jerusalem. He had finished the Pessach-eve service by singing "Next Year in Jerusalem." He had called the movement of political renaissance destined to reestablish Jewish statehood by the name of *Zionism*—Zion having been the fortress of Jerusalem in ancient times. He had rejected each suggestion which offered as a secure haven for his persecuted brethren a country other than Eretz Israel. He would accept as a solution only this particular land, situated between the Mediterranean and the desert, the country of King David and Yehuda Maccabi. It is not surprising that the returning Jew, who had finally solved the problems of his age-old longing, had realized his hopes, and had come home to his native soil, has tried to express this attachment to the country in all cultural media.[8] The old-new Jew, living in the Alt-Neuland, creating an old-new culture, has established for his children an educational system which reflects to a large degree this cultural synthesis.[9]

After a battle of languages in the second decade of this century, Hebrew was accepted as the only official language of the Jewish school, all other suggestions having been rejected. The Bible is the main subject in all schools, secular and religious. Jewish history is one of the pillars of the curriculum. On the other hand, mathematics, the physical sciences, technology, and modern languages are also taught. Schools are organized, new curricula developed, and modern teaching methods introduced on the basis of contemporary research in the fields of education, psychology, and sociology. Old and new elements are integrated in order to find an appropriate education expression for the particular cultural situation of the Jew who has returned to his homeland. One new subject that has been introduced into this new school expresses attachment to the country and is called *Moledet*—homeland. It integrates the fields of geography, history, natural history, folklore, civics, and even archeology into one curricular unit.

The aforementioned meeting of East and West has created a rather complex and difficult problem for those responsible for the educational system. The mass immigration of Jews from Asia and Africa brought into the schools thousands of children who, from the point of view of academic achievement, motivation, and support from parents, were significantly inferior to their classmates whose parents had come from Vienna, Berlin, or New York. Very soon it became clear that those portions of the population that had arrived in great numbers also had the highest birth rate. In the sixties, the children of oriental origin had already formed a majority in their age groups, yet because of a lack of motivation and because of poor academic achievement, only a small number attended high school, while even fewer subsequently enrolled in the universities. There was the great danger that the Jews, having returned to their ancient homeland and realized their dream of two thousand years, would create a nation whose leadership would be drawn from a small European minority, while the Afro-Asiatic majority would become the "woodcutters and waterdrawers" of this society.

Recognizing this danger, the Israeli parliament decided on a far-reaching educational reform in the late sixties. Among its features was the establishment of an integrated comprehensive high school. These changes, and other steps in the same direction taken by the army (which is a factor of great educational importance in Israel) as well as by community centers and adult education projects, have facilitated integration. The vertical axis ranging from old to new, the horizontal link between East and West, and the strong attachment to the country characterize to a large degree the society and culture of modern Israel.

Art and Aesthetic Education

One of the central questions arising from the unique sociocultural situation described is the role played in it by art and by aesthetic education. Here again we witness a rather special synthesis between, on the one

hand, a regard for the tradition of the past as a foundation and, on the other, a search for an aesthetic expression appropriate to contemporary life.

The Hebrew language, the verbal symbols that more than two thousand years ago served the poet of the Psalms and the writer of *Job*, is the literary medium of the modern Israeli writer.

In addition to literature, interesting developments can be seen in all other arts: composers express their ideas in all the areas of music; instrumental and vocal artists, soloists, and ensembles perform modern Israeli music along with works from the internationally accepted repertoire throughout the country and abroad; an Israeli folk song has emerged. Painters and sculptors use their media freely; their works are exhibited in dozens of modern museums in the cities, villages, and collective settlements. Architects plan and construct new buildings, streets, and parks, taking advantage of modern ideas of environmental aesthetics. As a parallel to the Hebrew folk song, the Israeli folk dance is evolving.

Instead of limiting himself to the rather narrow aesthetic range of traditional Jewish culture, which had expressed itself in a comparatively small number of media, the contemporary Israeli endeavors to find his way into all fields of art. But even more important than this quantitative increase in aesthetic activity is the qualitative change in the role of the aesthetic domain. Instead of serving mainly religious objectives, of being frequently ornamental in character (as in the great number of ceremonial accessories), and of being a "decoration of life," art has increasingly become regarded by the contemporary Israeli as one of the important aspects of life, as one of the essential expressions of Israeli culture. In the place of the fairly restricted *monoaesthetic* culture of the past, modern Israel has adopted a broad and deep *polyaesthetic* approach.

In addition to the number and range of the media employed and to the vital importance attached to the role of art, the integrative character of the polyaesthetic approach finds its expression in other directions. As stated before, the culture of modern Israel is a synthesis of old and new, of ancient tradition on the one hand and, on the other, openness to the contemporary world as well as readiness for a free, uninhibited expression. This modern creative expression frequently looks for its roots to the traditions of the past. Thus contemporary poets not only write in the ancient medium of the Hebrew language but also often select Biblical themes

for their work. Composers make frequent use of the old Bible cantillation (Taamei Mikra), the ancient motives and signs according to which the Pentateuch and other books of the Old Testament have been read in Jewish synagogues throughout the centuries.

Examples of this integrative approach are the novel *Yemei Ziklag* (The Days of Ziklag) by S. Yishar, which creates associations with the period of King David (Samuel I, 27), and Moshe Shamir's *Kivsath Harash* (The Hittite must die), which tells the story of the letter of Uria (Samuel 2, 11).[10] In the area of music, Ben Zion Orgad's *Mizmorim*, taking for its text a number of psalms and linking traditional musical elements with modern twelve-tone techniques, could serve as one of hundreds of examples.[11] In the field of plastic art, from Abel Pan and Jacob Steinhardt in the first half of the century to the present day, painters and sculptors have depicted themes from the Bible and from history.[12]

Examples of the additional linkages established by contact between East and West are musical compositions that achieve a synthesis between oriental elements like the *makam* (nuclear motive) and Western compositional methods (e.g., A. Ehrlich's "Bashrav") and the dance works created by the Inbal group that combine traditional Yemenite elements with contemporary choreographic techniques.

The influence of the land and its distinctive landscape features and atmosphere should also be mentioned in this context. Israel's mountains, desert, and seacoast are not only frequent subjects in painting and motives in modern literature, but also elements affecting the emotional essence of works and the details of artists' techniques. Painters speak about the colors and the light of the country as factors influencing decisively the atmosphere of their works. When designing new buildings, architects attempt to adjust their style to the lines, forms, and colors of the surrounding landscape.

Another feature of the polyaesthetic attitude that to a large extent characterizes Israeli art is the emphasis on relationships among the various media. While this integrative aspect is evident in many cultures, it seems to be especially common and intense in the aesthetic expression of modern Israel. The reason for this may be the extraordinarily strong attachment to the past and the verbal medium as counterposed to the equally intense wish of the contemporary Israeli to express himself freely in all the media and to address himself to the existential problems of modern life. This intermedial link may take many forms—the synthesis of

two or more media like literature and music or the transformation of one medium into another, as in the metamorphosis of a verbal text into a picture, and so forth. A few examples of this trend have already been mentioned (Orgad's compositions, linking not only old and new, but also word and music; Steinhardt's illustrations, bridging not only past and present, but also the world of the word and that of the picture).

One work may serve as an example of the integrative character shared by a comparatively large number of Israeli works of art. It combines in itself most of the above-mentioned polyaesthetic trends: the integration of media, the link between present and past, East and West, nation and land of salvation. The work is *Midnight Vigil*, an oratorio by Mordechai Seter.[13] It presents a worshipper engaged in a solitary midnight prayer in a synagogue. He sees a number of visions: the dispersion, the high priest in the temple, Jaacob's dream, a song of praise to the Lord. The story of these visions, describing the fate of the nation from the punishment of dispersion up to Israel's salvation and return to its land, is told by a soloist (the worshiper) and three choirs. One choir represents the Heavenly Voice and is characterized by lyrical, polyphonic music. The second represents the Talmudic legend and is characterized by oriental, liturgical recitative. The third represents the People and is characterized by Yemenite folk songs.

It should now be asked how this attitude toward aesthetics, its role in life and culture, and its particular products are transmitted to the next generation. We have thus arrived at the question of the general direction of aesthetic education in Israel.

The role of aesthetic education must, of course, be understood within the context of the general situation of Israel, a country beset by great military, political, and economic difficulties. Israel has lived in a virtual state of war with most of the countries of the region since the day of its birth. As is well known, *silent Musae inter arma*. Hence it is only natural that these difficulties have affected some aspects of the role of the aesthetic within the general school system and that they are evident in the problem posed by the preference for certain subjects and in the organization of the curriculum. Not surprisingly, in this situation much emphasis is placed on realistic and technological subjects, the study of which might be of decisive significance for the very physical existence and material survival of the state. Nevertheless, great efforts are made to give aesthetics an appropriate place in the general

framework of the educational process and in the school curriculum in particular.

Although all the aesthetic media are taught within the curriculum, they are stressed especially for the lower levels of education (kindergarten and elementary school), while the whole field is less developed in secondary education. The objectives of aesthetic education have been articulated by E. A. Simon, who suggests that the general goals should be free creative expression and evaluative, critical appreciation.[14] On the basis of these aims, curricular guidelines for all levels and all types of schools have been prepared. For the comparatively neglected by important high school level, we would like to suggest a curriculum emphasizing the integrative, polyaesthetic tendency which has already been described as characteristic of art expression in our culture.

Polyaesthetic education is regarded here as the idea of emphasizing integrative elements within the realm of aesthetics and of stressing links between the general area and other fields of human experience. This does not mean abandoning specific knowledge and skills for the sake of some nebulous, generalized, and superficial entity. Rather, polyaesthetic education aims at the comprehension of common elements and relationships in order to enhance meaning and improve understanding.[15] The approach will be briefly demonstrated by two curricular examples.

The first is a curricular unit comprising three parts: (a) some passages from the Bible; (b) a work of a great Jewish painter of our time; (c) a composition by an important contemporary Israeli composer.

a. The first part of this unit is devoted to some selected sentences from Jaacob's blessing and Moses' blessing.[16] The characteristic form of these words will be emphasized in their general character of being partly historic memories of the past, partly prophetic visions directed toward the future, the integration of individual incidents in the lives of Jaacob's sons with the collective history of the tribes; the honesty and straightforwardness of the Biblical narration which does not conceal the negative qualities and criminal acts of the story's protagonists; the literary characteristics of the ancient text, such as parallels, alliteration, etc.

b. The second part of the unit is devoted to Marc Chagall's *Jerusalem Windows*.[17] The twelve vitrages in the synagogue of the Hadassa Hospital in Jerusalem are shown as a transformation of some of the sentences

of these blessings into the medium of the stained glass window. Trying to comprehend the process of translating the Biblical word into the special medium of painted glass may help the student to understand and to appreciate Chagall's particular expression in plastic art: his attachment to the stories of the Bible, his memories of the little Jewish town in Eastern Europe, the influence of the light and the colors of Eretz Israel on his paintings, the retreat from physical reality, the bypassing of the laws of perspective, and the dominating influence of dream, vision, and phantasy.

c. The third part of the unit is devoted to *The Twelve Jerusalem Chagall Windows* by Jacob Gilboa,[18] an Israeli composer of Czech origin. This work tries to express Chagall's visual ideas in twelve instrumental and twelve vocal musical miniatures. This product of yet another transformation is characterized by a synthesis between ancient Jewish elements like the Bible cantillation, oriental characteristics like continual repetition, and contemporary musical conceptions like the atonal twelve-tone techniques of Stockhausen.

One more integrative aspect should be mentioned: the understanding and appreciation of art should receive supplemental meaning through creative expression. Reading the texts, viewing works of plastic art, and listening to music should be complemented by the student's creative efforts. Challenged and imbued with ideas by the appreciative process, he should be encouraged to express himself in his own productive and creative way in writing, singing, playing, performing, dancing, drawing, composing, and in the integrative medium of creative drama.[19]

It has been reported from a kibbutz that students of the upper grades were encouraged to create a new ceremony for the Festival of First Fruits. This holiday is itself synthesizing in nature, for it includes an historical element—the arrival of the people of Israel at Mount Sinai; an agricultural aspect—the harvest of wheat and the gathering of the first fruits; and a moral component—the receiving of the Ten Commandments as the ethical basis of Judaism. Children of the kibbutz live in permanent and intensive contact with nature. Since expressions of the enjoyment of the harvest and first fruits are an organic part of their lives, they find it natural to celebrate these events, while also stressing the historical and moral aspects of the holiday. It is equally natural for them to select texts, music, and movement; to add their own writings, compositions, and dances; and in a large group consisting of soloists, choir, orchestra, and dancers, to perform a comprehensive, creative, dramatic oratorio.

All these curricular suggestions and experiments represent an extensive model of polyaesthetic education that combines the integrative dimension of time (ancient and new), space (East and West, attachment to country), media (verbal, visual, auditory, and movement), and pedagogical direction (appreciative perception, reproduction, and creative expression).

It is hoped that in the old-new land, in the framework of sociocultural integration, polyaesthetic education will help the young generation to assign art to its appropriate role as one of the central expressions of human life.

Notes

[1] Cf. Zvi Lamm, "Culture," in *Encyclopedia Hebraica*, vol. 32 (Jerusalem: Encyclopedia Publishing Co., 1981) 1055-59.

[2] Edward Barnett Tyler, quoted by William A. Haviland, *Anthropology* (New York: Holt, Rinehart and Winston, 1978) 278.

[3] Clyde Kluckhohn and Alfred L. Kroeber, quoted by Lamm, *Encyclopedia Hebraico*, 1057.

[4] Kluckhohn mentioned in ibid.,1057.

[5] Exodus: 20, 4.

[6] Cf. Louis Finkelstein, ed., *The Jews: Their Religion and Culture* (New York: Schocken Books, 1971).

[7] Cf. Arthur Hertzberg, *The Zionist Idea* (New York: Harper and Row, 1939).

[8] Cf. Amos Elon, *The Israelis: Founders and Sons* (London: Sphere Books, 1970).

[9] Cf. Aharon F. Kleinberger, *Society, Schools and Progress in Israel* (Oxford: Pergamon Press, 1969).

[10] Cf. Simon Halkin, *Modern Hebrew Literature* (New York: Schocken Books, 1970).

[11] Cf. Zvi Keren, *Contemporary Israeli Music* (Tel Aviv: Bar Ilan University Press, 1980).

[12] Cf. Ran Shechori, *Art in Israel* (Tel Aviv: Sadan Publishing Company, 1974).

[13] Mordechai Seter, *Midnight Vigil, Oratorio for Tenor, Mixed Choir and Orchestra* (Tel Aviv: Israel Music Institute, 1962).

[14] Akiva Ernst Simon, "Aesthetic Education," *Educational Encyclopedia*, vol. 1 (Jerusalem: The Ministry of Education and Culture and the Bialik Institute, 1961) 168–71.

[15] Cf. Curt Sachs, *The Commonwealth of Art* (New York: Norton, 1946); Philip H. Phenix, *Realms of Meaning* (New York: McGraw-Hill, 1964); Wolfgang Roscher, ed., *Polyaesthetische Eriehung* (Koln: Dumont Schauberg, 1976); Hanan Bruen,

"Integrative Musikpadogogik and gesametasthetische Erziehung." *Zeitschrift fur Musikpadagpgik* no. 6 (October 1978): 60—63.

[16]Genesis, 49, and Deuteronomy, 33.

[17]Marc Chagall, *The Jerusalem Windows*, text and notes by Jean Leymarie (New York: George Braziller, 1975).

[18]Jacob Gilboa, *The Jerusalem Chagall Windows* (Tel Aviv: Israeli Music Publications Ltd., 1966).

[19]Cf. Ursula Bode and Gunter Otto, *Education for Creativity*, trans. Timothy Nevil (Bonn-Bad Godesberg: Friedrich Verlag Velber in conjunction with Inter Nationes, 1979).

MANY CULTURES, MANY ARTS: A FRENCH EXPERIENCE

■ MARIE-FRANCOISE CHAVANNE

As I have the pleasure of opening this congress, I would like to take the opportunity of thanking you for being so numerous and for having traveled so far for the sake of collective research. And without boring you with my own personal theories on the subject, I wish to share with you questions I pose myself, and to raise a number of problems; and I hope that here, in this international exchange, solutions will be found to some of my queries. *Many Cultures, Many Arts*: this theme is certain to be amply defined and greatly illustrated. This is why, without offering any definitions of these concepts, I wish to stress the following three aspects:

1. The PLURAL; it guarantees multiplicity and diversity, and assures us of a broad view without hierarchal ordering of cultures or arts;
2. INTERACTIONS between arts and cultures—the phenomena of osmosis and cultural contacts have for centuries accompanied the life of civilizations;
3. Permanent EVOLUTION of cultures and arts, which bear witness to the past but which remain perpetually active and in constant development.

However, I ask myself, just how far from reality are these three concepts "plurality," "interaction," and "evolution"? How may we speak of diversity when we perceive a uniformity of cultures and symbols (the major stereotypes), when exchanges are only one-way, and when we confuse the value of a culture with the persuasive strength of power and money? How can one talk of interactions of cultures, if, when they meet, they are occasions for looting and cultural oppression? And if the culture seems vigorous and immune to oppression, can one then forget all those cultures which have disappeared as their exponents have been exterminated? As regards our present cultures, do we not afford privileged positions to cultures of the past? What is our attitude toward profound changes that have taken place? Do we not harbor fond nostalgia;

and are we prepared to receive new artistic and cultural forms?

Hence the theme of this congress: original diversities, multiple riches, and profound tempos of change are evidence of the symbolic foundations of cultures and arts. Symbols underline the sacred values and universal aspects of humanity. If this "universality" provides man with a feeling of belonging to humanity and supports his claim for equality, his "individuality" permits him to be different.

Recently many countries and cultural minorities have begun to realize a need to save their cultures and defend their cultural identities. Welcome this rebellion—a necessary revolution. This new slogan unites many voices, all victims of oppression, all the descendants of oppressors. We ourselves (I am myself in the second category), who have colonialist pasts, consider it pointless to ignore this fact, but must assume responsibility and act in favor of the future. How? Is it not easy to elaborate theories, establish statistics, make verbal denouncements and suggest reforms? Do we not see too often good intentions remaining intentions, being alibis of good conscience, and words becoming the coffins of actions? Let us leave to the leaders the political cooing! Our field of action demands more realism and concrete responses.

What will be the teacher's role, and why should multicultural problems be his concern? The schools of today, and particularly the classrooms, are places where children of many origins make contact and mix with one another. It is not particularly original to remark that this poses, acutely, a certain number of problems. These include adapting taught subjects to particular pupil needs, realizing appropriate pedagogy for ethnic and cultural diversities, resolving conflicts collectively, and being aware of potential inequality of opportunity for education and for quality of life.

Opening Address by the INSEA *President translated by* Veronique Caroline Varry Watson. Reprinted from *Journal of Art & Design Education* (1986) Vol. 5, Nos. 1 & 2, 19—21.

Problems are daily and reality is immediate, and the teacher is the one most often ill-prepared to respond. His outlook, though often "cultured" and brimming with goodwill, may be stereotyped. If in his enthusiasm he assimilates his pupils to some imagined stereotype, he will certainly be on the wrong track. A child's identity is cultural, of course, but if his origins or roots are disregarded he will suffer prejudice and feel rejected. Perhaps deprived of his mother tongue, he will ill-accept being made conspicuous and will, on the contrary, try to mingle with the crowd and be forgotten. With respect and attention, however, it will be possible to make him more confident, accept his cultural differences with a certain pride, and give him a sense of personal and family identity. Listening to the pupil means being attentive to such sentiments and to his reticence. It also offers him the occasion to bring to the group *his* knowledge, *his* way of life, and a sense of *his* own background. In this respect art and artistic expression offer unequaled opportunities for encouragement and recognition, favoring the discovery of cultural diversities.

But eight years of teaching pupils from fourteen different ethnic groups have taught me to be careful and wary of making assumptions regarding cultural identity. By offering them the means of *choosing* where they belong, of establishing their own senses of identity within a new culture, I allow pupils to reject any differences based upon sentiment. By developing their critical and creative faculties, by letting them accept responsibility over their own choice, I attempt to guarantee their autonomy, and to allow them to take part in the elaboration of a new culture built on new values.

My utopia might perhaps be the first victim of a racialist, intolerant social reality. This matters little. The actors of tomorrow's society will have particularly vivid views on solidarity, mutual understanding, and liberty of expression, and they will carry our hopes. We are all committed-this is why we meet today, eager to exchange arguments and points of view. A congress (such as this) can, at regional, national, and international levels, provide the groundwork for research which will support our future theories and practices, affirm freedom of identification with cultural ideals, and encourage participation in cultural life.

A MULTICULTURAL CURRICULUM IN SCOTLAND

■ ARTHUR HUGHES
■ NICK STANLEY
■ JOHN SWIFT

The arts emerge as a process through which people learn about themselves and the world in which they live. This is a rapidly changing world in which new communities of ethnic, cultural, and religious groups are still joining those many that now contribute extensively to the life of the major cities and towns of Britain. This does not, unfortunately, mean that Scottish, English, or Welsh traditions have automatically taken aboard fresh ways of seeing, doing, or thinking. As Rasheed Araeen[1] and Paul Gilroy[2] have pointed out, the long tradition of minority presence in Britain is one of exclusion often giving rise to the creation of a form of cultural apartheid with minority arts marginalized and therefore absent not only from the art world but also the school curriculum. The culture of the school has emphasized the transmission of traditional family values and attitudes, many of which have developed within the context of colonialism and racism. The arts have, therefore, a key function in helping us all reexamine our values, attitudes, and practices.

Multicultural and antiracist initiatives are designed to encourage the investigation, knowledge, and appraisal of cultures outside one's own upbringing in order to foster a mutual respect among the variety of individuals and communities living in the same environment. Such proposals may take the form of exploring the arts of a particular culture in some depth, or they may deal with the artistic solution to a particular question across a number of traditions (for example, design or construction in clay, textiles, or metal). We may have yet another objective—the development of intercultural competence in the arts. Of course we may well operate with more than one of these perspectives at the same time.

The "Elephants and Peacocks" package developed by the Strathclyde Region employs the strategy of exploring a culture in depth. In March 1987 the Convenor of the Education Committee sent one of the art advisers to Pakistan for a four-week intensive study of the arts and crafts of that country. Such varied forms as embroidery, ceramics, carpets, paintings, and architecture were studied and photographed. In August a team of art teachers, who had no special training in the arts of Pakistan, explored the materials brought back to Scotland by the adviser and assisted in the devising of the excellent "Elephants and Peacocks" package. This provided a public demonstration of the importance accorded to Pakistani traditions within the curriculum of Strathclyde. Pupils and teachers within the region have used "Elephants and Peacocks" as a starting point and gone on to make more intensive studies into various aspects which particularly interested them. The great virtue of this scheme is that it enables pupils to apprehend the richness and quality of another cultural tradition. Whether in the middle class suburban school or the inner ring school where many pupils would themselves have more than one tradition to draw upon, all have enjoyed the expansion of cultural reference that the project provides. The new approach has led to further exploration of the concept of cultural identity and Celtic heritage.

The second teaching pack, called "Paper and Light" (based on the lanterns of China and Japan), compares two contrasting Asian design traditions and their approaches to the making and decorating of lanterns. The technical basis for this package provides a ready way for pupils to undertake comparative cultural exercises. The project further reinforces a basic tenet of multicultural and antiracist education—we do not necessarily need to undertake major expeditions to the furthest reaches of the world to gain a vivid sense of other ways of seeing and constructing our ideas and environments. The liberation that these approaches provide springs from the ability of the pupil in Britain, in Glasgow, Birmingham or elsewhere, to make personal sense of cultural exploration.

One project undertaken by a group of fourteen year olds in Bromsgrove Worcestershire in the Spring of 1990 illustrates the normality and non-exotic character

Reprinted from A. Hughes, N. Stanley, and J. Swift (Eds.). (1991) *The Art Machine*. Glasgow Museums & Art Galleries, Birmingham Polytechnic Department of Art, National Society for Education in Art & Design, 37-40.

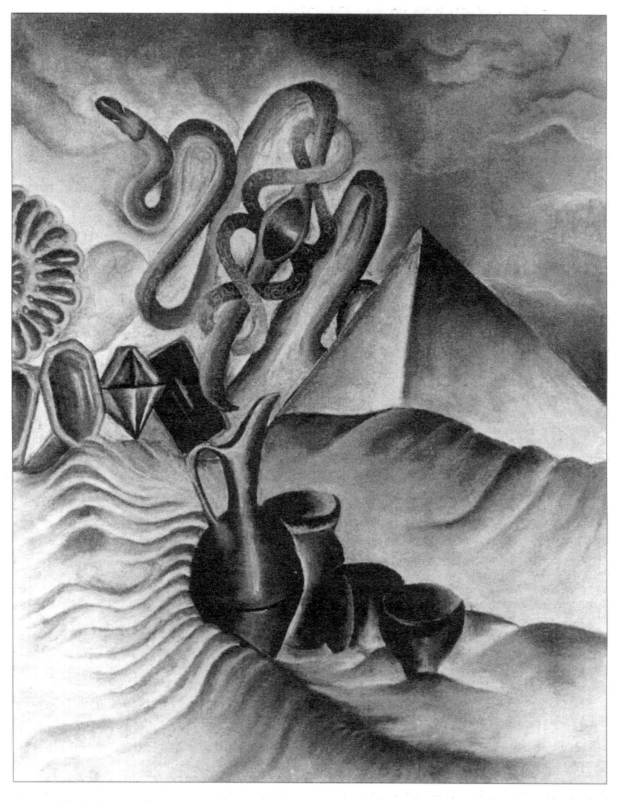

Hermamal Bahia, *Sands and Sapphires,* contrasting the decorative aspects of Egyptian artifacts with the harshness of the desert.

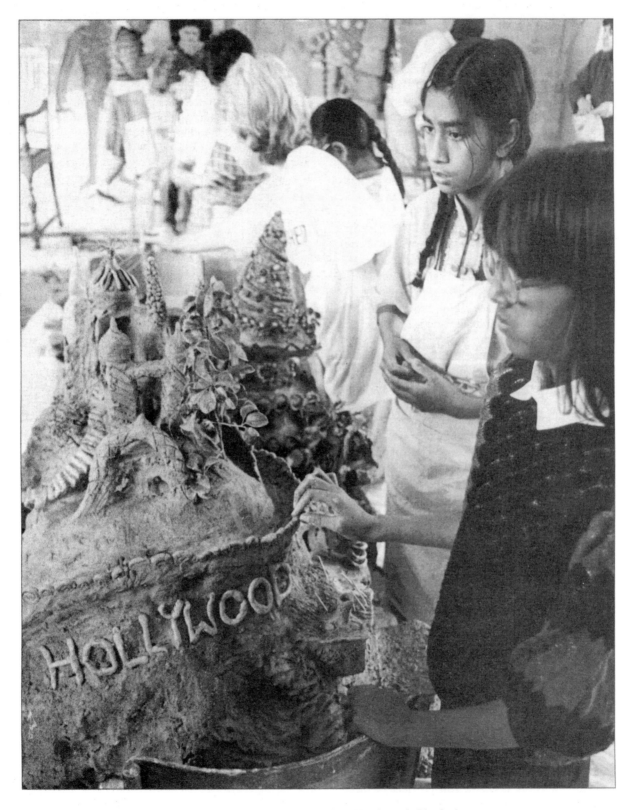

City of the Mind, The Westminster Project, Handsworth, Birmingham.

of cross-cultural exploration.[3] The teacher introduced pupils to the 1909 diaries of a visitor to China from Birmingham, Miss Helen Caddick. The teacher then showed illustrations of the materials, particularly embroideries, that Miss Caddick had brought home with her. The teacher emphasized the symbolic nature of the designs in the embroidery. Dragons and butterflies particularly appealed to the pupils, who were then invited to construct a list of animals, birds, insects, and fish to discover their traditional symbolic significance in Chinese culture. Pupils consulted a couple of available texts[4]. This personal investigation was a prelude to the pupils making their own designs.

One pupil, Stuart, chose a pair of fish (symbolic of marriage and as a charm against evil). His initial design emphasizes the yin and yang of mutual correspondence in the paired fish design. The embroidered square that he made from this design situates the motif within a decorative frame skillfully stitched to emphasize the design within abstract patterns. Another pupil, Jayne, considered the range of possibilities open to her: "Chinese culture is not just one aspect but many. The Chinese put their designs into many categories. Colors are important and also designs which coordinate with one another." This self-assurance, and the willingness to venture statements and judgments, is the basis on which genuinely cross-cultural work is constructed. It involves risk (she may be wrong in fact or detail but she's prepared to attempt a description of Chinese culture). Jayne goes on to explain the basis for her selection of butterflies;

My own design was chosen by me when I saw a pair of earrings I liked. The earrings involved two butterflies in a heart shape. I looked up what the meanings of butterflies were and found out that they meant love, peace, and marriage. From this I centered my design around two butterflies joined together, supposedly in marriage, and partnered them with colorful flowers. I took my design and put it into the Chinese style. My final design changed slightly from my drawn design by color and stitches. Some of my stitches changed from what I had planned because the stitches I did seemed to fit into the design as I went along.

Jayne's work exemplifies the contemporary search for authentic cross-cultural research in a practical form. It demonstrates that multicultural, antiracist, and cross-cultural work is not the sole province of specialists; it is also an approach that offers us all an exciting new range of possibilities in art and design education.

Multicultural initiatives have continued to characterize Glasgow's European capital of culture. To entertain artistic performances, exhibitions, and school work from a range of cultures requires those undertaking such an exciting program to work towards multicultural competence. This is not something abstract, rather a competence developed through hard work with a constant recognition that intercultural reference always implies a continual shuttling backwards and forwards between the culture under exploration and that of the explorer. The prize at the end of the day is mutual enrichment.

Notes

[1] R. Araeen (1989). *The Other Story*, Hayward Gallery.

[2] P. Gilroy (1987). *There Ain't No Black in the Union.* Jack Hutchinson.

[3] We are very grateful to Jane Harris and pupils of North Bromsgrove High School for permission to cite their work here.

[4] U. Wilson (1986). *Chinese Dress.* Victoria & Albert Museum. Y. Y. Chung (1980). *The Art of Oriental Embroidery, History, Aesthetics and Techniques.* Bell & Hyman.

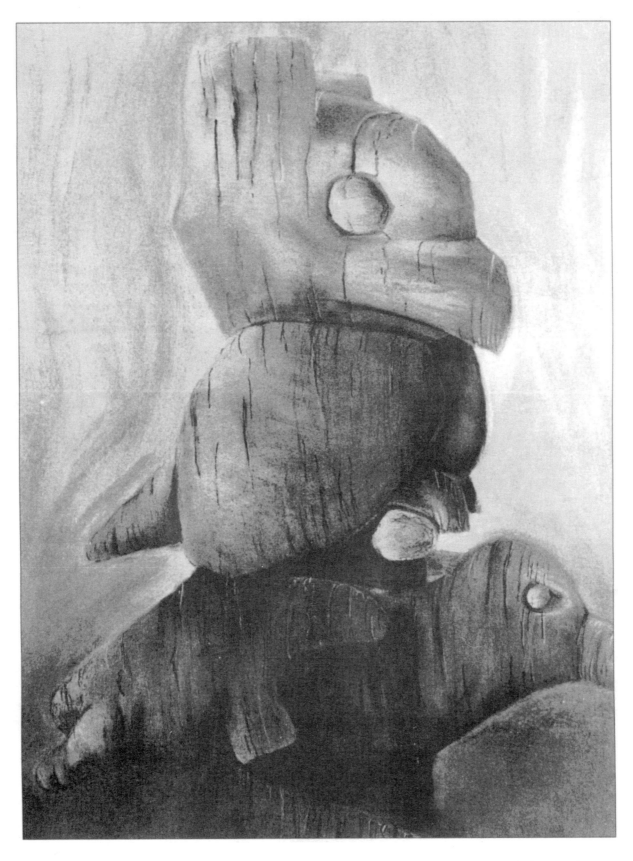

Martin Chiles, *Erosion,* based on a development of the concept of environmental erosion from a Haida bone carving. Queen Charlotte Islands, Canada.

Courtesy of Ulla Bonnier, Sweden

PEACE EDUCATION THROUGH ART: STUDY OF CONFLICT AND HARMONY AND NORDIC PARADISE

■HETA KAUPPINEN

Peace education is a response to the developing understanding that environmental, sociocultural, and economic problems are not localized but global. Making the planet an ecologically healthy as well as a just, righteous, and peaceful place for people and their cultures requires a universal effort and education for universal responsibility. Peace education fosters the ability to recognize conflicts when they occur between the human endeavor and the environment and among nations, cultures, groups of people, and individuals. It develops the care and commitment to resolve conflicts and bring them to harmony.

Peace education can be integrated into all curriculum areas at all grade levels (Reardon, 1988a). According to a survey conducted by the World Policy Institute in 1984—1985, peace education is included most frequently in social studies, English and language arts, and sciences. In the arts, peace education is rare. The conclusion of the survey calls for a vigorous development of peace education programs in the arts.

This chapter explores strategies for organizing and sequencing peace education programs in art. Several questions need answering. For example, how did peace education develop? What is peace? How does the concept of peace translate into peace education programs in art? How are peace education programs implemented in art? What kind of unique contribution can art education make to peace education?

The Development of Peace Education

Studies in international understanding preceded peace education. A pioneer organization is the Council for Education in World Citizenship (CEWC), founded in 1939 in Great Britain (Heater, 1984). The organization sees peace as synonymous with justice and emphasizes three concepts. One is structural violence, which refers to conditions of injustice, domination, and exploitation in which many people live and in which full human development

is impossible. Another concept refers to people's coming to understand the causes of suffering and to rectify the situation, if necessary, by a violent assault. The third concept, conscientization, refers to teaching people about the causes of oppression and suggesting remedies (Heater, 1984). In the 1950s, peace and educational organizations included education for international understanding in their activities. This meant distributing information about nations.

The concept of peace education began to appear in the educational literature when UNESCO distributed a recommendation to all member governments to increase their efforts in peace education and cooperation (UNESCO, 1974). It further recommended that member states provide peace education programs and support teacher education and research in the field. The women's rights movement has advanced peace education since the United Nations declaration of the International Women's Year in 1975 and the consequent International Women's Decade (Reardon, 1985). The decade's three basic themes—equality, development, and peace—yielded research and educational applications for the field of peace education (Reardon, 1985). UNESCO began documenting model programs for peace education from various countries in the 1980s (Harris, 1988).

In the United States, the World Policy Institute collected peace education programs in 1984—1985 and established the Teachers College Peace Education Curriculum Bank (Reardon, 1988a). Such national organizations as Education for Social Responsibility (ESR) and the National Education Association (NEA) have published collections of curriculum materials for peace education. Peace research agencies, school districts, and religious denominations have their own curriculum materials for peace education. Currently, there is an abundance of literature and curriculum materials on the subject. The preparation of most peace education projects is still being done by individual teachers who devise their own courses and units (Harris, 1988; Reardon, 1988a). A number of reports in news media

indicate that these efforts increased during the Gulf War.

In art education, an overture for peace education was the influence of Ruskin's (1843) ideas that art is based on national and individual morality. Art educators assumed that the study of art would develop spiritual and practical virtues in students (Stankiewicz, 1984). The picture study movement developed Ruskin's ideas further. Adherents of the movement believed that great artists were exemplars of high moral character and that works of art could be used to build students' character (Stankiewicz, 1984). Munro (1956) set the foundations for peace education in art. He argued that art could and should be used as a means to international understanding and sympathy. This would lead to peace and active cultural cooperation. The International Colloquies "War and Peace in Art Education" in 1985 and 1987 explored peace education for the purposes of art education (Schirmer, 1987). A major peace education program in art was designed and implemented cooperatively by the Nordic countries, Finland, Sweden, Iceland, Denmark, and Norway (Bonnier, 1987; Kauppinen, 1989; Pimenoff, 1987; Rathenow, 1987).

What Is Peace?

The concept of peace is often thought of as the absence of war or as the tranquillity of order. In peace research (Aron, 1979; Woito, 1982) and peace education (Harris, 1988; Heater, 1984; Hinde & Parry, 1989; Reardon, 1988a, b; Wehr, 1979), peace means action. Peace involves cooperation for life, justice, and freedom. As an affirmation of life, peace implies struggle against endemic poverty and famine that shorten life and deprive the majority of people in the world of a decent quality of life. It implies the prevention of lethal conflict in war, the preservation of the Earth, and an ecologically healthy planet. As an affirmation of justice, peace implies efforts to achieve human dignity for all people and humane relationships based on equity, mutuality, and the inherent worth of all persons. It seeks to develop appreciation of cultural differences, whether individual or social. As an affirmation of freedom, peace means defending civil and political rights when they are denied or abused. It means confronting structural violence caused by inequitable economic structures, political and institutional oppression, and circumstances that preclude personal freedom and self-fulfillment.

Strategies for Peace Education in Art

The affirmation of peace as life, justice, and freedom contains four areas of study for art education: (1) *human relations*, (2) *cultural diversity*, (3) *environment*, and (4) *global awareness*. The study of *human relations* deals with interpersonal relations, the links between person and person, between person and group, and among different groups. It includes issues of human rights, gender, and age. The study of *cultural diversity* deals with various cultures and relations between major and minor cultures. Peace education in art aims to develop understanding of and respect for different cultures. The study of the *environment* involves themes of students' consciousness of their relationship to the whole natural order and the development of the human-made environment. It deals with problems of reversing the damage done to the natural and human-made environment by irresponsible human intervention. It includes acquisition of skills for the preservation and protection of both environments. Study of *global awareness* includes topics dealing with the interdependence of all human groups. It aims to promote a view of the world as a unity where many human problems are global and require global solutions based on global cooperation.

"Nordic Paradise": Implementing Peace Education in Art

"Nordic Paradise" is a peace education project in art generated by Nordic art educators in 1985. Nordic art educators have cooperated in various projects since the turn of the century, and in 1978, the founded the Nordic Society for Art Education (NSAE). "Nordic Paradise" is a recent, ambitious undertaking of NSAE. The project was based on the principle that pictures are a form of language. The proper use of pictures can provide heightened knowledge of reality. Students should feel that the study of pictures is meaningful and necessary and that it is important to study well. Art teachers in each Nordic country—Finland, Sweden, Norway, Denmark, and Iceland—implemented the peace education project in their own unique ways (Bonnier, 1987; Homlong, 1987; Kauppinen, 1989a, b; Mustonen, 1987; Pimenoff, 1987; Rathenow, 1987; Schirmer, 1987).

In Finland, the project had environmental overtones. A theme was "Understanding Oneself and One's Environment." Another theme, "Paradise and Hell," provoked exploration of ways and means leading to harmony and peace and those leading to vio-

lence and destruction. Students focused on young persons and their future. They examined works of art that represented human relations, environment, war, political situations, social issues, and other relevant subject matter. Similarly, students analyzed pictures from mass media. They recorded their findings and ideas in murals and other works. For the public, students organized a slide and film show with a poetry reading and the Secretary of Education gave a speech on the occasion. A project called "A Week of Life" followed, along with other subject matters. Many classes "adopted" classes from developing countries and raised funds for their friendship exchanges.

In Sweden, a major theme for peace study was "Violence." The focus was street violence in King's Garden Park in the center of Stockholm. Students recorded street violence in drawings, photos, slides, and videos. They interviewed people and wrote about violence. In the Svecia Antikva archives, they found historic pictures and articles about King's Garden Park. They collected pictures and text about violence from newspapers and magazines, and they built a miniature clay model of the place. In several discussions, they analyzed reasons for violence and evaluated its consequences. They listed confrontation between major and minor cultures, violence in mass media, threats to one's personal identity, racism, political issues, crime, group pressure, drugs, and unemployment as reasons for violence.

In Norway, a project focused on misbehavior among students. Students made murals about good and bad behavior when people meet each other. From individual confrontation, the theme expanded to world politics and large issues between ethnic and cultural groups. An indication of the importance of peace study for students was the long duration of the projects. Students wanted to work on their peace projects over semesters. Some projects continued during the following school year.

Conclusion

Peace education is a lifelong, continuous process. As it is currently practiced, peace education means developing in students global responsibility and the understanding of global interdependence, willingness to work for a just and peaceful world, concern for the environment, skills in constructive human relations, and the ability to envision and plan for the future (Harris, 1988; Hinde & Parry, 1989; Reardon, 1988a, b; UNESCO, 1974). These general concepts can be dealt with in a variety of ways in art education. Peace

education can be implemented in units. Any of the four study areas—human relations, cultural diversity, the environment, and global awareness—can be the focus of a unit. As the examples from the Nordic countries imply, it was not difficult to meet the goals and objectives of the art education curriculum even in year-long peace education projects. Cooperation with teachers of other subject areas makes in-depth study of aspects of peace possible. For example, peace education in history can focus on teaching about the history of wars, peace making, and the relation of political systems to conflict and peace. Study in science may emphasize ecological aspects. In mathematics, mathematical analysis can be applied to world resources, military and armament conditions, and demographic changes. Study in social studies can include issues of social justice, human rights, and cultural diversity. Much of what is studied in various subject matters can be reexamined through pictures in art education. Art education can make a unique contribution to peace programs just by the examination of relevant works of art. Another unique contribution is the pictorial recording of factors related to peace.

Art education should take not only an active role but a leading role in organizing peace education programs. We ought to keep in mind that peace education has been an important issue in the Eastern European countries. Peace is heralded in songs, poems, and speeches. We do not know the sincerity of those efforts, but the people's strength and will stopped tanks and artillery, and the world changed.

References

Aron, R. C. (1979). Peace and war: *A theory of international relations.* New York: Doubleday.

Bonnier, U. (1987). "You sit and dream; Reality plays hide and seek." In K. Jentzsch, R. Lehman, & P. Wolters (Eds.), *Das Bild der Welt in der Welt der Bilder.* Hannover: Bund Deutscher Kunsterzieher, 344-347.

Harris, I. M. (1988). *Peace education.* Jefferson, NC: McFarland.

Heater, D. (1984). *Peace through education.* London: Palmer.

Hinde, A., & Parry, D. A. (Eds.), (1989). *Education for peace.* Nottingham:
Bertrand Russell House.

Kauppinen, H. (1989a). Two hundred years of art criticism in Finnish art
education. *Stylus,* 82(4), 15–18.

Kauppinen, H. (1989b). Architecture as design study. *Art Education.* 42(5), 46–52.

Munro, T. (1956). *Art education.* New York: Liberal Arts.

Mustonen, C. (1987). Mural project. *Nordic Paradise.*

Pimenoff, M. (1987). Bilder enhuellen bewusstes Wissen ueber die

Ungrechtigkeit in de Welt-und unbewusste Vorurteile. In K. Jentzsch, R.

Lehman, & P. Wolters (Eds.), *Das Bild in der Welt in der Welt der Bilder.*

Hannover: Bund Deutscher Kunsterzieher, 356-360.

Rathenow, H. F. (1987). Friedenerziehung in Staaten West- und Nordeuropas. In K. Jentzsch, R. Lehman, & P. Wolters (Eds.), *Das Bild in der Welt in der Welt der Bilder.* Hannover: Bund Deutscher Kunsterzieher, 361-367.

Reardon, B. (1985). *Sexism and war system.* New York: Teachers College Press.

Reardon, B. (1988a). *Comprehensive peace education.* New York: Teachers College Columbia University.

Reardon, B. (Ed.). (1988b). *Educating global responsibility.* New York: Teachers College, Columbia University.

Ruskin, J. (1843, 1905). *The works of John Ruskin.* London: George Allen. [Originally published in 1843.]

Schirmer, E. (1987). War and peace in art education. In K. Jentzsch, R.

Lehman, & P. Wolters (Eds.), *Das Bild der Welt in der Welt der Bilder.*

Hannover: Bund Deutscher Kunsterzieher, 368-371.

Stankiewicz, M. A. (1984). "The eye is a noble organ": Ruskin and American art education. *The Journal of Aesthetic Education. 18*(2), 51—65.

UNESCO. (1974). *Recommendation on education for international*

understanding, cooperation and peace, and education concerning human

rights and fundamental freedoms. Paris: Author.

Wehr, P. (1979). *Conflict regulation.* Boulder, CO: Westview.

Woito, R. S. (1982). *To end war: A new approach to international conflict.* New York: Pilgrim Books.

Creating harmony in life and nature. Student 13 years old. Children's Art School, Espoo, Finland. Elisa Rovamo, teacher. Courtesy of Liisa Piironen.

AMERICAN CONTEMPORARY ART INTO JAPANESE SCHOOL ART: PLAY ACTIVITY IN THE 1980s

■ AKIO OKAZAKI

Figure-Ground Relationship: Huge Umbrellas on the Earth

E. Rubin, a Gestalt psychologist, presented the now-famous "double representation" figure as the relationship of positive and negative spaces. If the white area is thought of as positive space, a vase can be seen against a dark background, but if the dark areas are thought of as positive spaces, two profiles can be seen facing each other against a white background. Both perceptions can be discovered while viewing the figure, but not simultaneously. The ambivalent perception of figure-ground relationship illustrates the clash between two concepts, between conventional and contemporary arts within one culture, and between two cultural values in art. A good example of such a clash might be Christo's earthwork. The Umbrellas Project of Christo opened for display in October of 1991 in two places. Seventy-five miles north of Tokyo, in Ibaragi, Japan, 1,340 huge blue umbrellas were settled in a 12-mile range. Simultaneously, 1,760 huge yellow umbrellas were settled in an 18-mile range north of Los Angeles. The project was exhibited for 18 days, and about 540,000 people enjoyed it in Japan alone.

The project was designed to help us see "an enigmatic relationship" (Christo, quoted in Garoian, Quan, & Collins, 1977, p. 19) of ambivalence in three ways. First, it made viewers of both countries aware of natural and human-made environments. Their attention was caught by huge umbrellas while they suddenly discovered the earth itself. Second, it provided a dynamic tension between modernist art and postmodernist art. Viewers could enjoy the display as a nonartistic event, while ideally, they changed their conventional ideas of modern art in order to recognize it as art. Last, it reflected on the seemingly incompatible foreign cultural value of art. Japanese viewers welcomed it while at the same time they were reminded of how their culture of art stood in contrast to it. In these ways, the project forced viewers to redefine what is environment, art, and cultural value by providing double representation in a figure-ground relationship.

Understanding Art Through Christo-Like Projects

Christo's projects in the past three decades have been making an impact on the world of art. They have also been incorporated into school art practice in both the United States and Japan. American students respond to Christo-like projects not as creating art, but as understanding art. Borgmann (1986) of Indiana University, for instance, coordinated a program enabling students and teachers to deal with contemporary art. Christo was invited to this special Art-to-School Program, and public school students (grades K—12) and their teachers were involved. Transforming human-made and natural environments into aesthetic sites with wrappings, "sixth graders gave keen insights into society, why man creates today, and what makes it art. They discussed materials, techniques, ideas, philosophies, and aesthetic effects, all on their own level" (Borgmann, 1986, p. 20).

Christo-like projects for children were used as the texts of discourse to promote looking at and talking about art in the artroom, which provided balance to the major conventional approach to making art in a studio. Seeing the old familiar object or space in a new context was of primary importance, while the end result of wrapping was secondary. Thus "the actual studio project was not necessary to promote understanding of Christo's work" (Borgmann, 1986, p. 20).

Experiences gained through Christo-like projects were important factors in developing dialogue in the classroom. These programs were also intended to expose both art teachers and classroom teachers to contemporary ideas in art through a nonstudio approach to art. Teachers were expected to teach nonstudio disciplines in the curriculum (art history, art criticism, and aesthetics). Awareness of contemporary art is more focused than the invention of another earthwork. Raising questions on art and talking about art, therefore, became the prime concern for the Art-to-School program (Borgmann, 1986).

Christo-like projects are not ready to be incorporated into the daily art education practice of U. S. schools. They remain summer holiday art.

Play Activities in Japanese Art Textbooks

In contrast, the textbook-based art curricula of Japanese elementary schools have included Christo-like projects since the 1980s. There are five versions of commercially developed art textbooks, all of which adapt to the national guidelines of 1977 (effective from 1980 to 1991). They are approved by the Ministry of Education. Yet, textbook writers have responsibility for what content should be included in the art curriculum and for structuring learning activities from grade to grade. Art is a required subject (2 hours per week) throughout the first 9 years of compulsory education. Each of the 476 school districts has the power to select one of the five versions. The government then purchases textbooks from publishers and distributes them free of charge to children across the country (Ministry of Education, 1989).

Foster (1989), describing one version of a 1986 edition, said that it "shows three categories for art lessons—'Drawing Activities or Making Pictures,'

'Making and Constructing Activities,' and 'Making Functional Objects.' The third through sixth grade books have pagespreads developed to historical knowledge while the first and second grade books include an additional category of 'Playing Together and Making Friends'" (p. 12). The additional category belongs to Christo-like environmental projects through which students are encouraged to draw play activities with their friends.

The earlier (1980) version, Zugakosaku (Art and Handicrafts) (Karata, Hayashi, & Saikoji, 1980/1983/1986/1989), which has supplied about 70% of the textbook market, first included six lessons on play activity. The first three, for the first grade, consist of "Play with Dirt" activities, in which children draw pictures with a stick or water on the playground of their school; "Paper Streamers," in which students think about interesting ways to play; and "Play by Arranging a Lot of Things" (making a circular castle with sand and sea shells). The last three, for the second grade, include "Play with Grass," in which children think about ways to play with grass, fruit, and flowers (making a mustache or a flower crown); "Play with Newspaper," in which they think about interesting playful activities or games that they make up out of

newspaper (making costumes with pieces of paper, flying paper in the sky); and "Stack Things," in which children think about playing on the classroom floor (making a mountain and playing with a rolling ball). These six lessons were given minor revisions in 1983, 1986, and 1989.

Downsizing Behind Nature

The prescribed outcomes of dealing with Christo-like projects in Japanese elementary schools are different from those of U. S. schools. Japanese teachers encourage their students in the early grades to invent spontaneous earthworks with emphasis on team effort, while U. S. teachers help their young students gain individual understanding of art in a sociocultural context. Christo's projects are downsized to young Japanese children's basic group play, while they are used to promote the Getty Center's discipline-based art education programs in the United States.

The downsizing of Christo's projects reflects the Japanese attitude toward nature. Christo-like projects become catalysts that relate basic human activity to nature itself. Small Japanese landscape gardens, for example, contrast to the huge Western gardens with geometric arrangements of objects. The scenic composition of Japanese gardens represents the concepts of "borrowed view" and "abstract symbolism," both of which make the gardenmaster regenerate the inherent qualities of natural raw materials for use in downsizing real landscape.

Today's Japanese artists still regenerate these qualities in their own works. A college instructor of mine described how he created his work for the first Japan Art Festival of New York in 1966. He "cut large canvas into hundreds of square pieces and affixed them at the center onto a black plate, leaving the edges free to curve for themselves according to nature, in temperature, humidity, and . . . the property of [the] . . . painted linen [matter]" (Takasaki, 1980, p. 33). He envisioned that hundreds of white parabola antennas against the black plate would make the viewer feel "as if for a moment he had been taken to another world" (p. 34).

Although the style of Takasaki's work reflects American Minimal Art of the 1960s, it still preserves the traditional concept of "reality/illusion" of Japanese gardens. His contemporary work is reminiscent of the famous gray rock garden of Ryoanji Temple, Kyoto, in

which five groups of rocks on fine white gravel symbolize the small islands in the water of the sea. We call its symbolization Mitate. It means "'as if' play," which is the same as young children seeing a piece of wood as a train (Nagamachi, 1988, p. 119). Japanese teachers consider Christo-like projects not as fashionable contemporary art but as foundations for basic "as if" activities, so they have gained popularity in Japanese elementary schools. The downsizing of contemporary U. S. art into Japanese school practices is consistent with the earthworks of Japanese gardens behind nature.

Filling the Gap: Project "Do"

Yet, Japan and the United States make similar efforts to include Christo-like projects in art education. Both have tried to fill the gap between the real art world and the conventional school art style, which can still be found in present-day artrooms. Japanese efforts to fill the gap became apparent in the 1970s. There were several insightful young elementary school teachers in Osaka, the second largest city in Japan, who did not wish to follow the ready-made content in commercial art textbooks. Sharing a perception of the gap and an interest in contemporary U. S. art such as Pop, Op, Environments, Earthworks, and Happenings, they founded Project "Do" in 1972.

The declaration of Project "Do" clearly states their intentions to create a new foundation of art education: "Art education lets children act. Formative education starts from action and ends with action. . . . Art education . . . lets them acquire the ability to control the energy of their activities. It lets children be free from desk work and lets them see 'environment' and 'material.' Art education is . . . for the art-making activity itself free from any traditional criterion of knowledge of art works . . . We would like to be donors of time, space, and materials, rather than teachers" (Nagamachi, 1988, p. 217).

Such statements about the principles of art education enabled them to define their mission. In using every resource of the school environments they were able to create new teaching and learning methods: "digging holes" by students, "cutting wood" of old electric poles, "covering a jungle gym with newspapers," "taking hens and cocks for a walk," "copying a newspaper," "gathering air" in a large bag made from newspapers, "floating a wire on water," "making a spider's web" with paper tape all over the classroom, and "making the space of classroom like the inside of our body" with paper constructions (Nagamachi, 1988, pp.

218—219). The familiar old childish play was seen in a new educational context.

Educators at all levels recognize that turning theory into practice is not an easy task. Yet, Project "Do" has been meeting with great success since the 1970s. Christo was invited to the 10th Tokyo Biennial in May 1970, and he presented a project of wrapping space. Japan had been experiencing the student power movement, oil-related economic depressions, problems of pollution, concerns for preservation of the environment, concerns for the ecology of natural resources, and the beginning of the global information science society. A variety of these outside factors contributed to the success of the project. Other important factors were the energy and inventiveness of the teachers of Project "Do." They had the insight to include supplementary teaching materials that enhance the content of the prescribed art curriculum. They were able to embrace the expansion of the contemporary art world, and they translated its artistic phenomena into the art program. This new approach to art education was carried into the field through books, journals, magazines, conferences, and workshops. Similar efforts to create a variety of play activities also made their way across the country. The Ministry of Education, therefore, included the Project "Do" activities in the 1977 edition of the national guidelines (effective from April 1980), and authorized them as new subject matter for art education in the first two grades.

Play Activity in the National Guidelines

The objectives of play activity are indicated in the guidelines of 1977. In the first grade, the objective is "to enable pupils to perform with pleasure formative activities, utilizing different materials" (Ministry of Education, 1983, p. 85). Three outcomes are prescribed: "to perform formative activities using the whole body, being familiar with materials"; "to have an interest in the colors and forms of natural and artificial materials, and to perform formative plays such as thinking of what they want to make out of them, and enjoying putting them on their bodies"; and "to perform formative plays such as arranging natural and artificial materials, piling them up and copying them by making a print" (p. 85). These objectives and the outcomes are advanced in the second grade.

In July of 1978, some of the teachers of Project "Do" published a book on play activities (Tujita, Itarashiki, & Iwasaki, 1978). At that time, the 1977 edition of the national guidelines was not yet in effect. Other textbook writers and classroom teachers were

inexperienced in play activity. They welcomed the book as a useful reference because of its inclusion of hundreds of visual presentations with few descriptions. The book encouraged them to understand how body movement, material assemblage, space transformation, and earthworks were essential to play activity in such places as the classroom, the school building, the gymnasium, and the playground.

The 1977 version of the national guidelines for art education has been updated and appears in the July 1989 edition. It has been in effect since April 1992. This edition suggests that the content of the play activity be extended to the fourth grade. Several kinds of commercially developed textbooks are already slated for use. These include three lessons in each of the first four grades, responding to numerous past decades of practice of play activity across the country. The 1978 book by the teachers of "Do" is still invaluable in providing ideas for play activity.

Play activities in driving have become an important part of the Japanese textbook-based art curriculum. This is a validation of the insightful teachers who explore new frontiers to discover and translate ideas that will be found in future curriculums. Art textbooks are renewed every 12 years and are revised every 3 years. The Japanese art education system has profited by periodically discarding old art education practices and introducing new ones through nationally distributed textbooks. Yet, our guidelines for art education should be open to interpretation and constantly revised (Okazaki, 1985a).

Conclusion: Grains of Grit into Pearls

Cross-cultural research is seen as a "two-way street" (Okazaki, 1985b). "Just as Japanese art had influenced Impressionism and Post-Impressionism . . . the idea of European modernism influenced Japanese artists and art educators" in the 1920s (Okazaki, 1991, p. 196). According to Thistlewood (1991), the importation of western modernism has been "a deliberate tactic" of Japanese art educators aimed at "counterbalancing a normal tendency to didacticism" (p. 128). This continues to the present (Shields, 1990). The regulation of guidelines for art education and the imported concepts of contemporary U. S. art effectively counterbalance one another.

The story of incorporating contemporary U. S. art in Japanese school art practice is reminiscent of Christo's project, the huge blue umbrellas on the land of Japan. This visual scene can illustrate the Japanese

cultural history of both art and art education, which have continually taken and transformed diverse influences from other cultures. New waves of art from the outside have challenged Japanese artists and art educators to find alternatives missing from their current practices. They are "no longer safe in the old and not yet fully adapted to the new" (Muro, 1953, p. 109).

The transformation of seemingly incompatible foreign cultures into art is a gradual process. "Japanese culture in general, " according to Stanley-Baker (1984), "may be likened to an oyster, opening itself up to repeated onslaughts from the ocean and transforming grains of continental grit into pearls" (p. 7). Yet, without diverse influences as grains of grit, no country regards its inherent cultural values as pearls. They provide a prime field of cross-cultural and multicultural research in art and art education.

References

Borgmann, C. B. (1986). As Christo wraps the art scene . . . Are educators ready? *Art Education, 39*(1), 19–22.

Colbert, C., Taunton, M. (1985, 1989). *Discover Art.* Mass.: Davis.

Foster, M. S. (1989). Art education in Japan. *School Arts, 89*(9), 12–15.

Garioan, C., Quan, R., & Collins, D. (1977). Christo: On art, education, and the running fence. *Art Education, 30*(2), 16–19.

Kurata, K., Hayashi, K., & Saikoji, T. (1980/1983/1986/1989). *Zugakosaku* [Art and handicrafts] (6 vols.). Osaka: Nihon Bunkyo Syupan.

Ministry of Education. (1983). *Course of study for elementary schools in Japan.* Tokyo: Author. (Japanese edition published 1977).

Ministry of Education. (1989). *Education in Japan.* Tokyo: Gyosei.

Muro, O. (1953). East and West. In E. Ziegfeld (Ed.), *Education and art* (pp. 108–110). Paris: UNESCO.

Nagamachi, M., (1988). Teaching in the eternal present: Art education as radical support of art-making. (University Microfilms No. 88-26796).

Okazaki, A. (1985a). What American art educators learned from the Japanese: A response to Carson and Dobbs. *Art Education, 38*(4), 6–10.

Okazaki, A. (1985b). American influence on the history of Japanese art education: The case of Akira Shirahama. In B. Wilson & H. Hoffa (Eds.), *The history of art education* (pp. 59–66). Reston, VA: National Art Education Association.

Okazaki, A. (1991). European modernist art into Japanese school art: The Free Drawing Movement

in the 1920s. *Journal of Art & Design Education, 10*(2), 189–198.

Shields, J. J. (Ed.), (1990). *Japanese schooling.* University Park: The Pennsylvania State University Press.

Stanley-Baker, J. (1984). *Japanese art.* New York: Thames and Hudson.

Takasaki, M. (1980, Summer). A hare and a tortoise. *Chit-chat*, pp. 14, 30–34.

Thistlewood, D. (1991). Editorial: Modernism and modernization of the curriculum. *Journal of Art & Design Education, 10*(2), 125–128.

Tujita, K., Itarashiki, S., & Iwasaki, Y. (1978). *Jissenrei niyoru zokeiasobi no pointo* [Teaching materials of play activity]. Osaka: Sanko Syobo.

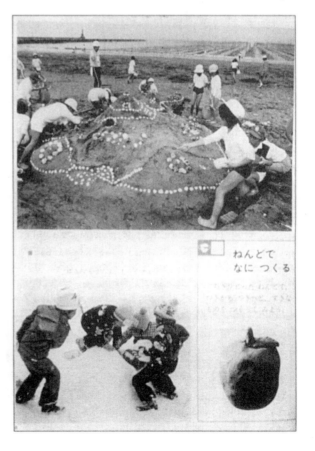

An Exploratory Microethnographic Study of Art Teaching in One Navajo Public School System: The Anglo View of Running Water

■MARY STOKROCKI

Native Americans, particularly children, are currently confronted by two rapidly changing cultures: American and Indian. Accordingly, in this chapter the term *Amerindian* combines both those elements in a single reference to American tribal groups in general. As a consequence of overgeneralizing, data about various Amerindian tribes are usually grouped indiscriminately and individual tribal differences are often ignored.[1] Outside exploitation and interference have caused many Amerindians to hinder any exploration of their culture by curtailing access to their lives. Thus, the everyday realities of Amerindian students today remain relatively unknown.

In art education, published information is focused on teaching resources such as Noffz's (1984) cross-cultural survey, Kellman's (1985) bibliography, and Wardle's (1990) articles on symbolism. Researchers have raised a variety of pedagogical and aesthetic issues concerning Amerindian art education (Kolber, 1974; Kravagna, 1971; Stuhr, 1986; Zastrow, 1980). These issues include the need for culturally relevant curricula based on indigenous tribal values, the use of appropriate teaching strategies to target varied learning styles, and the necessity of free choice to become assimilated or to remain distinct.[2]

Purpose, Significance, and Limits of the Study

The microethnographic pilot study reported here examines (a) contextual considerations, (b) cultural perspectives that affect instruction, (c) instructional practices and beliefs, and (d) student social behaviors and art strategies in one Navajo public school system, the Running Water Unified School District.[3] The study is both historically and educationally significant because it reveals everyday realities of the Navajo educational life through art teaching and learning in a reservation school system during a period of transition. The transition involves the hiring of new art teachers and the development of new programs. The primary research question is "What are the changing characteristics of present-day Navajo art education?"

The pilot study focuses on instruction at the primary, junior high, and high school levels. The study combines the views of three Anglo art teachers,[4] the perspective of one Navajo culture teacher, and related findings in the literature concerning Amerindians. Results from the pilot study are compared with preliminary findings from the second-year study. Initial insights are idiosyncratic to this setting and should be respected for their uniqueness. In addition, the initial analyses are crucial for future comparisons in which cultural biases are checked and new propositions generated for this extended 3-year historical study.

Microethnographic Methodology

Microethnography is a multimethod, multiconceptual, and multiperson research paradigm (Pohland, 1972) in which data accumulate through participant observation, time sampling, and content/comparative analysis. Participant observation, in this study, includes note taking, photography, and informal interviewing of participants.[5] Time sampling, a method of timed note taking with a stopwatch, records instructional behaviors and their frequency (Barker, 1968). Content analysis, following data collection by participant observation and timed note taking, searches for dominant known themes or emerging concepts, which are then coded in the margins of daily notes.

Managerial, substantive, appraisal, and nonfunctional behaviors (Schmid, 1980) are the primary themes considered here. Managerial behavior consists of distribution, cleanup, and discipline practices. Substantive instruction is the formal teaching of a new art concept or skill. Appraisal is the process of evaluating student product or process. Nonfunctional instruction is behavior not related to the art lesson, such as interruptions. Comparative analysis interrelates themes and emerging concepts drawn from the observed behaviors. Glaser and Strauss (1967) proposed that these tentative insights may be compared to data and interpretations from other studies (i.e., Amerindian research), for the purpose of generating theory.

Above: An example of technical in-process appraisal at the primary level constant correction of individual student's watercolor technique.

Below: At the junior high level, Mr. K points out the relationship of shoe to chair in a introductory figure drawing lesson.

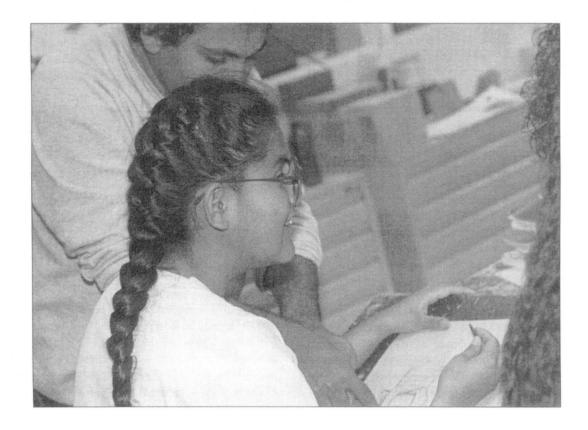

This study contains the viewpoints of many people: the participating teachers, some students as key informants, the new principal and assistant superintendent, experts' opinions gleaned from the review of literature, and my own interpretations. External teachers' comments on the study provide further clarification.[6]

Nine visitations, each an observation of a full school day, were made (usually on Fridays, one per month) during the academic year.[7] During the visitation in May, observations were made during two full school days and extended into the weekend arts festival. Fridays, perhaps atypical in the week as to the pace of instruction, reveal the understructure of teacher/student relationships.

Cultural Perspectives: Navajo Art Education

The Navajo are the largest tribe in the United States and the most frequently studied of Amerindian groups. The Navajo nation has the largest acreage, roughly 14,500,000 acres dispersed throughout three states in the Southwest (Loh, 1971). Historically, education in the once-nomadic communities of sheepherders and weavers was experiential, involving skill repetition, demonstration, and adult critique. Until the late 19th century, Navajo children were educated by their immediate and extended families about Navajo ways, rules, and taboos. The adult role model was an essential element of pre-20th-century education. Through daily communal work and ceremonies, traditional cultural and artistic values were imparted to young Navajo. Schoolcraft (1851) noted that the performing arts dominated Navajo interests during this period.

Because of the scattered living patterns of the Navajo, boarding schools were introduced to civilize the Navajo by removing the children from their home culture. Presbyterian missionaries began the first of these schools in 1878. In contrast to traditional Indian ways, American education advocated assimilation, acculturation, strict discipline, and the separation of adults and children. Due to the assimilation of European materials, manual labor schools, and modern farming, Navajo traditional arts were nearly destroyed. Young Navajo students became separated from the elements of their culture that had been so carefully transferred from generation to generation in the past. In the boarding schools, such vocational training in areas such as farming, beadwork, and weaving dominated the curriculum. In the current study, many of the parents of the students are graduates of boarding schools (Acrey, 1988). It has become the role of the

school to introduce their children to Navajo traditions and arts.

School System Demographics and Philosophy

The Running Water Unified School System serves over 4,271 children in three towns of northeastern Arizona. The school system is state affiliated, with a Navajo-dominated school board. The employment rate is high (77%), and the school system is a major employer. The area is designated as a major growth center by the Tribal government. Tourists provide a growing source of income, attracted by a nearby canyon that has been proclaimed a national monument.[8] The new goals of Navajo education centers around students: (a) promoting self-esteem, (b) encouraging a parent/community partnership, (c) maintaining the Navajo language and culture, and (d) developing the tools and skills to live in a dual society. A good economy with high employment and growing monies from tourism, along with strong administrative participation by the Navajo, increases the validity of the current study as a true evaluation of Navajo children's performance in an otherwise Americanized school system.

Participants

Compared to the Navajo art teaching situation of two decades ago reported by Bryant (1974), the quality and quantity of art teachers appear to have increased. Each school level now has a certified art teacher. Most of these are new teachers.[9] This pilot study focuses on the high school art teacher (Mr. T), married to a Navajo teacher and recently transferred to the high school, and includes the junior high (Mr. K) and primary (Mr. D) art teachers, both new to the district. Observations of the newly employed Navajo culture teacher are a part of the report.

Teachers seem pleased with administrative support, higher wages, new faculty housing, and their new, committed, enthusiastic art colleagues. Their students are bilingual, of primarily low socioeconomic background. Although many students still live on welfare, the economic situation is improving.

Findings: Understanding Navajo Art Education

The following tentative findings, which are interrelated concepts, are a result of my own adjusted understandings as well as participants' opinions. A finding

This award-winning collage of faces in 12' chalk drawing done by one of the high school students in the Annual Arts and Academic Showcase.

is presented first, followed by supporting evidence, discussion, and comparison with other studies.

Contextual Considerations

Spectacular but Harsh Environment, Environmental Aesthetics, Exceptional Art Facilities

The picturesque canyon environment of red clay, stratified color, running water, and low brush contrasts with other areas of flat, dusty, or muddy, overgrazed terrain. Besides the canyon and a small shopping center, the attractive modern school buildings with their latest architectural facades are the center of attention in the reservation. Snowstorms and dust from high winds are frequently major obstacles to transportation. Whereas some Navajo have traditionally ignored materialistic culture (Anderson, 1990), they are becoming more aware of its intrusion and the resulting environmental problems.[10] Environmental aesthetics are an encroaching educational issue. Although environmental problems are considered to be an American rather than an Indian problem, the Amerindians face the issue from the standpoint of their tie to nature.

Both the high school and junior high school display elegant professional murals painted by local Navajo artists. The large high school and junior high art rooms have display and storage facilities, an art office, a ceramics area, and more than ample supplies. Only the primary school art room, a facility for a new program, is small, with narrow windows and limited resources.

A School System in Transition, Rapidly Expanding Art Programs, a Vocational and Studio Emphasis

The school system has a separate vocational building and program in which high school students learn silversmithing and the graphic arts—photography, bookbinding, computer graphics, and small-scale printing operations. The fine arts program includes four drawing courses, one painting course, and one ceramics course at the high school level. The junior high art program consists of a daily 45-minute, 9-week rotation of art courses. In the elementary and primary schools, art is offered once a week for 40 minutes. The school system also employs Navajo culture teachers, who instruct students about their traditional history and arts.[11] Art teaching is predominately studio oriented and encourages student self-expression.[12] Lack of higher-paying jobs is still a major problem, and graduates often need to leave the reservation to find suitable employment or to become self-sufficient in some art-related field.

Contests, Publications, and an Academic/Fine Arts Festival Promote Navajo, School, and Community Pride and Involvement

A positive sense of Navajo and personal identity is sought amidst learning to live in a modern world (see Gilpin, 1978).[13] Numerous opportunities are afforded the students to design covers and posters for special events. Talented high school students are given extramural assignments to complete in the instructor's back room. A published calendar and journal feature student artworks from all levels. Careers in both the vocational and fine arts are promoted.

During the week of May 8—12, an Arts and Academic Showcase was held in the district featuring the performing arts as well as visual displays. Twenty-four categories of visual art, including photography, welded sculptures, silver jewelry, pottery, graphic arts, and fashions, were displayed. The exhibits were well attended by the Anglo as well as the Navajo community. Local teachers, university professors, professional Navajo artists, the state art consultant, and politicians were asked to judge the high school and junior high artworks. Cash prizes from famous Navajo artists provided incentives to students. Sixteen-foot murals hung from the gymnasium ceiling, and artworks were attractively displayed. The events appeared to promote student self-esteem, parent education, community pride, and social exchange.[14]

Cultural Perspectives

Patience, Flexible Pacing, and Speaking Softly as Solutions to Enculturation Conflict; the Slow Pace of Native American Time; Seasonal Influences

Traditionally, Navajo time is cyclical, revolving around nature. The pace of life on the reservation is slow. Hall (1956) distinguished between American time as monochronic—(fixed), and Native American time as polychronic—(flexible). In Navajo time, things happen when they are ripe for harvest. This means much time is spent in thought and psychological preparation before outward manifestations are seen.

Although the primary school art teacher's schedule (40-minute classes of 27 students) was hectic for a neophyte teacher, both the primary students and this teacher adapted to schooling and to each other.[15] Initially the primary school teacher (Mr. D) had expectations derived from the materialistic and behavioral manifestations of American education. He began to initiate activities gradually with his students, sensing

their activity rhythms. The students were more comfortable when their rhythms and the teacher's expectations more closely matched. From the culture teacher, Mr. D learned to adjust his pace, to wait patiently for students to calm down, and to soften his voice. The readiness and pacing pattern most comfortable to Amerindians is described in a study of a Native American teacher conducted by Erickson and Mohatt (1982/1988).

Secondary Students' Tardiness, Frequent Interruptions, Free Time, and a Relaxed Atmosphere

In comparison to the other days of the week, Friday instruction seems to be atypical, more relaxed, and tolerant of unusual tardiness and interruptions, and it includes more free time.[16] On Fridays, Navajo high school students were unusually tardy. They seemed slow, quiet, and sleepy during their first-period class. Throughout the day, classes were often interrupted by administrative announcements and dismissals for various reasons. A time analysis of art instruction at the junior high level on Fridays revealed that 10 minutes of each period were reserved for free time and nonfunctional instruction. The time was used by some students for extra drawing or homework.

Instructional Practices and Beliefs

High School Laissez-Faire Instruction and Independent Learners

Because of the slow pace at the high school level, teaching seemed more laissez-faire to the Anglo observers. Each day, the instructor reviewed the ongoing lesson or briefly introduced a new project. Instructions were written on the board and art examples displayed. Some time was used for coordinating extracurricular events. Advanced students were further challenged by lessons that were copied from Hubbard and Zimmerman's *Artstrands* (1982). The instructor confessed, "I am laissez-faire because someone told me not to interrupt these kids so much when they are working. They are independent learners. I have an open-door policy; if they need help, they ask." The high school instructor was not comfortable with this mode of teaching; nevertheless, he adopted this teaching style in response to the needs of his students.

High school students usually sat quietly and worked independently during the art class. At times they stared into space for the entire period or flipped through a book for an idea. Hall (1956) pointed out that the Navajo regard just plain sitting as doing something,

and in the Running Water schools teachers accept these behaviors as an integral part of the cycle of learning. Saville-Troike (1984) has suggested that these students are not slow paced; rather they are self-paced.

Technical and Perceptual Appraisal

In-process appraisal is the informal everyday monitoring by the teacher of student process and product (Sevigny, 1978). Gray and MacGregor (1987) referred to this teaching form as responsiveness to persistent demands and more specifically as engagement. An example of pedagogical in-process appraisal was observed during Mr. D's primary-level lesson in preparation for a visit by a Navajo watercolor artist. During the lesson on watercolor, he explained, "Use lots of water. Easy, don't go hard. Slow down. Watch me." To a small advanced group, he demonstrated how to use salt to form a textured effect. He wrote on the chalkboard, "Use lots of water!"

At the secondary level, appraisal was usually brief and consisted of an adjustment of technique or student perception.[17] Mr. T usually circulated through the high school classroom once or twice with quick appraisals and suggestions for students in need of assistance. Erickson and Mohatt (1982/1988) videotaped and then analyzed communication differences between Native American and Anglo teachers. They found that Native American teachers spend most of their time circulating through the room and giving individual attention. They noted that Anglo teachers began to do the same when teaching Native American students.

Promoting Self-Esteem and Counseling Students

The high school teacher is often called upon to counsel students during the school day. Some students need extra encouragement to stay in school. Mr. T listens to personal problems and helps with solutions.[18] Roessel (n.d.) has advised that *personal association*, as in listening to students and working with them to effect solutions, may be the most important variable in improving teacher instruction with this group.

The Culture Teacher and Navajo Art and Values

The school system employs a Navajo elementary school culture teacher to instruct students in their history and traditional arts and to promote ethnic pride. As a role model, he promotes the ethical values of persistence, gift-giving, and sharing and the aesthetics of nature. He has occasionally been frustrated with nega-

tive popular imagery observed in the art of Amerindian students. Recognizing the Ninja knuckle-breaker in a Mother's Day clay project, he reprimanded, "This is not a weapons class. We teach culture here."

Art History; Navajo Guest Artists; Written Questioning; Motivation

Art history is not taught at the high school level due to a lack of appropriate strategies. The art teachers, however, often invite professional Navajo artists into the schools. These professionals serve as contemporary role models for the young students.

If art history is to be included in the Navajo curriculum, some modifications are appropriate for this population. Wax, Wax, and Dumont (1964/1989) have suggested that Navajo students do not like to recite publicly or be placed in competitive academic situations with classmates. These researchers have recommended motivation by peer groups rather than individuals. The Navajo are extremely sensitive to shame or ridicule (Kluckhohn & Leighton, 1962), so art history lessons should be structured so as to be nonconfrontational and should probably utilize alternative evaluation methods.

Erickson and Mohatt (1982/1988) warned against the teacher's acting as "a switchboard operator—one who allocates turns" (p. 14). In their study of interaction etiquette in a Navajo class, they found that "overt authority that would interfere with the autonomy of the individual is rarely or never exercised" (p. 13). McCarty, Wallace, Lynch, and Benally (1991), on the other hand, reported that Navajo children respond to open-ended questions when prompted by local photographic scenes and by writing personal experience stories. These findings suggest that Navajo students might write descriptive/interpretive stories in response to local art forms with which they are familiar. Students can be coaxed to answer orally. This phenomenon was noticed in the teaching of the Navajo art instructor who constantly mumbled to students, "You can do it!" and "You know the answer."

Preferred Independence and an Observational Learning Style

Through a learning style survey, La Pointe (1980) confirmed that Amerindian students are more independent than Anglo students in regard to teacher contact, but less independent than Asian students. This preferred independence is coupled with an observational learn-ing style evolved from the Navajo nomadic way of life. Troeh (1982) reported that Native American students have a superior power of perception in recognition memory tasks, which require the identification of images and retention of visual information.

Recognition memory may be helpful in rendering images as well. For instance, one student won an award for his 12-foot chalk mural of faces in the annual arts and academic showcase. He worked on the mural all semester and mentioned various feelings and memorized faces that came to his mind as he drew. His lengthy work time can be interpreted as occurring in Navajo thinking time. Intense observation, along with aloofness, is characteristic of the Navajo search for meaning.

Peer Teaching

At various times, students observed each other drawing for as long as 15 minutes. They told me of their admiration for the drawings—even marks in clay—of certain talented students. The Navajo value good craftsmanship in their art (Anderson, 1990). Imitation and observation are their primary modes of learning. Such learning is informal, unconscious, and based on imitation of a model (Hall, 1956).

Students Depict Traditional and Popular Imagery

At all levels, students frequently employ such traditional Navajo imagery in their artwork as landscapes, dwellings, and animals, especially horses and the sacred eagle. In their testing of Navajo children nearly five decades ago, Leighton and Kluckhohn (1947) reported the frequency of traditional imagery in the children's free drawings. Landscapes were observed in 38% of the drawings in that study, dwellings in 17%, and animals in 11%. The persistence of this imagery reveals a strong desire to preserve traditional symbols. Crapanzano (1972) noted that some of the children's traditional drawings are skillful, some are not. The Navajo have their stereotypes too, but wish to expand their techniques and ideas for making these symbols more meaningful today.

Students are also fond of popular Anglo imagery—pickup trucks, dinosaurs, and cartoons. Popular cartoon influences were also noted by Leighton and Kluckhohn (1947). Primary children portray popular child art stereotypes such as the sun in the corner of a paper, hearts and flowers, triangular houses, lollipop trees, and rainbows.[20] Most noticeable in the first year of the study, however, were the young children's

drawings of Ninja Turtles. According to Mr. D, "They're nuts about them!"

Older students prefer to copy two-dimensional pictures, often borrowing motifs from masterworks on display. Apparently such mimetic drawing starts in the early years. Kravagna (1971) noted the prevalence of copying by Navajo high school art students. Wilson and Wilson (1977) clarified the value of young people's copying behaviors as a primary means of expanding visual signmaking.

Discussion

This exploratory study relates rich contextual information about a transitional period in Navajo schools today. Unlike the teaching situation in Navajo boarding schools two decades ago (Bryant, 1974; Kolber, 1971; Kravagna, 1971), Navajo art education today is centered around the student as a Navajo and as an American.

Saville-Troike (1984) illuminated conflicts in the meanings of education within Amerindian and American cultures. For the Navajo, education is a process of cultural preservation, while for the dominant Anglo culture, education denotes cultural change. Enculturation is an individual's process of adaptation to a culture through formal and informal education. This process includes the Anglo art teachers' adaptation to Navajo culture. Navajo students are dualistically enculturated.

The Navajo educational system of today is a changing combination of Amerindian acculturation practices. Public school practices on the reservation are modified by Navajo contextual differences: student tardiness, seasonal time, and slow pacing habits.[21] Teachers recognize the need for free time and a relaxed atmosphere.

Even though the art teachers observed in this study are Anglo,[22] they exhibit adaptive teaching characteristics. They are patient, flexible, and gentle. They use more in-process appraisal, objective criticism, and at times, a laissez-faire approach. The Anglo teachers offer individual technical and perceptual guidance and assist with vocational and life counseling. Based on a cross-site analysis of several studies of pedagogy in small-scale remote communities, Osborne (1991) has postulated that culturally responsive teachers need not come from the same minority group as the students they teach. Reichard (1934) explained that the Navajo word for teaching is showing, which implies technical

formation rules. Kravagna (1971) found gradual, individual, technical change a promising teaching strategy.

Studio art dominates the Navajo art curriculum, and it has a vocational emphasis that now includes careers in the graphic and fine arts. Drawing is the most popular art activity and course offering, especially with males. Professional Navajo artists offer models of vocational success and exemplars of contemporary art history. The Navajo culture teacher, who stresses values clarification and knowledge of the traditional arts, is an important presence in the system. This teacher conveys a feeling of acceptance and security through the study of Navajo traditional arts.

Navajo students seem to be independent, are less verbal publicly than Anglo students, and appear to avoid public attention.[23] They learn from each other through intense observation, and they prefer to write about their reactions to art rather than participate in oral discussions. Females appear to need more encouragement.

Navajo students demonstrate a preference for copying two-dimensional images. Their already keen observation skills require further training, especially in drawing three-dimensional relationships. As dominant-culture children, Navajo students need encouragement to expand popular and stereotypical imagery with Navajo and American contemporary master models.

Throughout the education of the Navajo child, the tribal self-image must be maintained (Kravagna, 1971). Navajo students feel secure in repeating forms that are harmonious with their tribal world view. The visual expressions of some students, however, exhibit considerable skill and idiosyncrasy as they begin to pattern their work after more contemporary Navajo artists.

Concepts of beauty and expression are changing. The Navajo idea of beauty is a total way of harmonious spiritual living, focused on the appreciation of nature—the land, seasons, walking, good character, and ancestral stories. Gonzales (1989) reported on the pervasiveness of the idea of land and the journey of consciousness as motifs in Amerindian literature. As the flying garbage on the reservation suggests, some Navajo are not harmonious with nature all the time. Their experience of beauty is more conceptual than perceptual (Anderson, 1990). In art classes, however, the perceptual nature of beauty is being introduced and explored. This Western idea of beauty as something outside of oneself contradicts the Navajo concept of

internal beauty. The Navajo does not look for beauty, but generates it from within and projects it onto the universe. Men and women experience beauty by creating it (Saville-Troike, 1984).

The aesthetic concept of self-expression coming from the dominant culture, the demand for idiosyncratic form and imagery, at times conflicts with the Navajo concern for cultural preservation of its symbolic expression. In Navajo sand painting, for instance, symbols are copied, highly patterned, and rule governed. Navajo weaving, however, tends to be more expressive. Navajo art and education are not aesthetically confused as Bryant (1974) has suggested, but consist of a collage of influences.

The Navajo maintain the right to self-determination. For example, the public display of student artworks promotes student self-esteem, Navajo pride, parent education, and community socialization. Navajo children are not more talented in the arts than children of other cultures, but the arts are more supported and valued by the Navajo culture and public school system. Clifford (1988) has described the modern Amerindian identity as a multivocalic, surrealist collage of ideas continually negotiated in the dynamic context of tribal, pan-Indian, and dominant-culture experience. These combined influences reflect the Navajo's keen abilities of adaptation and accommodation.

Notes

[1] Review of the ERIC literature, 1972—1987.

[2] Bryant (1974), characterized Navajo aesthetics in education as "confused."

[3] This research is sponsored by an Arizona State University Arts/Social Sciences/Humanities Grant. The Running Water Unified School District was highly recommended by Arizona State University and the state art consultant. Permission to conduct this study was obtained directly from the school district. Data collected in the study will become a part of the art program in the district.

[4] The Anglo art teachers were initially studied because they were the individuals most amenable to this project in the beginning. The study is limited by their views.

[5] Audiotaping did not prove successful because participating teachers and students felt uncomfortable with the microphones and students spoke so softly that their voices were inaudible.

[6] One art education professor, one elementary art teacher, and two graduate students, all of whom visited the reservation with me on different days, also offered their reflections.

[7] From January through December of 1991, 72 hours were logged on site. The drive to and from the reservation is approximately 12—14 hours. Limited time and inclement weather curtailed visitations to once a month, rather than once a week as originally planned.

[8] This information was compiled by the Arizona Department of Commerce in 1991.

[9] One new female Cree elementary art teacher preferred not to be studied.

[10] My first day's experience of flying garbage due to dust storms was counterbalanced by students filming a recycling commercial in the school hallway. On the walls was a posted notice, "Navajo walk in garbage?" Earth Day, recycling, and "Pride in Our National Parks" posters adorned the school walls.

[11] Such instruction was not permitted historically in the boarding schools.

[12] In the past, cut-and-paste activities dominated at the elementary level. The art teachers in this study regard the old program aa culturally irrelevant and have been invited to develop a model curriculum by the State Department of Education.

[13] The school system advocated designs for Native American Week. Both high school and junior high school teachers directed their students to design covers for graduation invitations and schedules.

[14] It was noted that the elementary art teachers found the idea of competitive awards for young children's artwork ridiculous. Other educators feel that events like the Showcase reaffirm the American ethnocentrism ideal of self-expression, media mastery, and formal elements and negate some of the Indian traditions (Freedman, Stuhr, & Weinberg, 1989). In response to these allegations, the coordinator of the festival maintained the Navajo right to determine their Indianness, education genre, and art styles beyond the market demands as specified in the Indian Self-Determination and Education Assistance Act of 1975.

[15] Mr. D. found that discipline was his most difficult professional problem. He clarified, "Spring fever hits these children, who would rather be outdoors." Sindell (1988) wrote of the dilemma of young children, usually self-reliant and independent in amusing themselves, forced to submit to school rules and nonexploratory behavior.

[16] This observation needs to be verified in the second year.

[17]Perception, in this instance, refers to the ability to discriminate visual relationships.

[18]On one occasion, I accompanied Mr. T to juvenile court at his invitation that I see what his day was really like (2/28/91). He drafted a letter in support of one particularly talented student who had been arrested. Later, after his graduation, this student was to be hired by the school system to work in the print shop.

[19]He was also highly influenced by his grandmother's colorful weavings and his sister's drawings.

[20]Mr. D found that the children learned these images from their teachers.

[21]The recent hiring of a new principal who worked with Los Angeles inner-city youth may change this pattern. He found, "Because no one checked on them, the kids got the message that no one cared about whether they were wasting their educational time. Most of the parents were educated in BIA schools that wrested control away from parents. I'm trying to get parents used to the idea that they are now responsible. We care that our kids don't fail. Students' tardiness rate has changed from 500 tardies a day to 500 since the beginning of the year" (Personal interview, August 30, 1991).

[22]Rigid certification requirements continue to bar the Navajo from easily entering the teaching profession. The culture teacher, a paraprofessional, seems to be a workable temporary solution. The researcher was recently allowed to document the art teaching of the new female elementary art teacher, whose teaching will be the focus of the second major study—the Navajo viewpoint.

[23]My presence in the classroom may have prompted students to be quieter than usual. The Navajo prefer to get to know someone well before revealing themselves. The research project may also have made the high school art teacher more cautious and shy.

References

Acrey, B. (1988). *Navajo history: The land and the people.* Shiprock, NM: Central Consolidated School District No. 11.

Anderson, R. (1990). Navajo aesthetics: A unity of art and life. *Calliope's sisters.* Englewood Cliffs, NJ: Prentice Hall.

Arizona Department of Commerce. (June 1991). Navajo Nation community profile. Phoenix: Author.

Barker, R. (1968). *Ecological psychology: Conceptual methods for studying the environment.* Stanford, CA: Stanford University Press.

Bryant, B. (1974). Issues of art education for American Indians in the Bureau of Indian Affair's schools (Doctoral dissertation, The Pennsylvania State University, 1974). *Dissertation Abstracts International, 35,* p. 7523.

Clifford, J. (1988). *The predicament of culture.* Cambridge: Harvard University Press.

Crapanzano, V. (1972). *The fifth world of Forster Bennett: Portrait of a Navajo.* New York: Viking.

Erickson, F., & Mohatt, G. (1982/1988). Cultural organization of participation structure in two classrooms of Indian students. In G. Spindler (Ed.), *Doing the ethnography of schooling* (pp. 132—174). Prospect Heights, IL: Waveland.

Freedman, K., Stuhr, P., & Weinberg, S. (1989). The discourse of culture and art education. *The Journal of Multicultural and Cross-Cultural Research in Art Education, 7*(1), 38—55.

Gilpin, L. (1978). *The enduring Navajo.* Austin: University of Texas Press.

Glaser, B., & Strauss, A. (1967). *The discovery of grounded theory.* Chicago: Aldine.

Gonzales, D. (1989). Because of the blood in the water: A novel (Doctoral dissertation, University of Minnesota, 1989). *Dissertation Abstracts International, 50,* 2453.

Gray, J., & MacGregor, R. (1987). A report on the status of art teaching: PROACTA plus. *Canadian Review of Art Education, 14,* 23—33.

Hall, E. T. (1956). *The silent language.* New York: Doubleday.

Hubbard, G., & Zimmerman, E. (1982). *Artstrands: A program of individualized instruction.* Prospect Heights, IL: Waveland.

Kellman, J. (1985). Meditations. *Art Education, 38*(5), 33—37.

Kluckhohn, C., & Leighton, D. (1962). *The Navajo.* New York: Doubleday.

Kolber, J. (1974). An investigation of Navajo culture with implications for Navajo art education. Unpublished masters thesis; Arizona State University, Tempe.

Kravagna, P. (1971). An ethnological approach to art education programming for Navajo and Pueblo students. (Unpublished doctoral dissertation, University of New Mexico).

La Pointe, C. (1980). Cross-cultural learning: The relationships between cultures, learning styles, classroom environments, and teaching procedures (Doctoral dissertation, University of California, Los Angeles, 1980). *Dissertation Abstracts International, 51,* 89.

Leighton, D., & Kluckhohn, C. (1947). *Children of the people.* Cambridge: Harvard University Press.

Loh, J. (1971). *Lords of the earth.* New York: Crowell Collier.

McCarty, T. L., Wallace, S., Lynch, R. H., & Benally, A. (1991). Classroom inquiry and Navajo learning styles: A call for reassessment. *Anthropology and Education Quarterly, 22*(1), 42—59.

Noffz, R. C. (1984). Art education in a Native American environment: Phenomenological approaches. Unpublished masters thesis, Arizona State University, Tempe.

Osborne, B. (1991). Toward an ethnology of culturally responsive pedagogy in small-scale remote communities: Native American and Torres Strait Islander. *International Journal of Qualitative Studies in Education, 4*(1), 1—17.

Pohland, P. (1972). Participant observation as a research methodology. *Studies in Art Education, 13*(3), 4—23.

Reichard, G. (1934). *Spider Woman: A story of weavers and chanters.* New York: Macmillan.

Roessel, R. (Ed.). (no date). *Handbook for Indian education.* Tempe: Arizona State University.

Saville-Troike, M. (1984). Navajo art and education. *Journal of Aesthetic Education, 18*(2), 41—50.

Schmid, H. (1980). Perceptual organization and its relationship to instructional arrangements in contributing to the effective instruction of a distinguished university teacher (Doctoral dissertation, The Ohio State University, 1979). *Dissertation Abstracts International, 32,* 4390-A.

Schoolcraft, H. P. (1851). *The American Indians: Their history, condition, and prospects.* Buffalo, NY: Derby.

Sevigny, M. (1978). A descriptive study of instructional interaction and performance appraisal in a university studio art setting: A multiple perspective (Doctoral dissertation: The Ohio State University, 1977). *Dissertation Abstracts International, 38,* 6477-A.

Sindell, P. (1988). Some discontinuities in the enculturation of Mistassini Cree children. In J. Wurzel (Ed.), *Towards multiculturalism* (pp. 107—121). Yarmouth, MA: Intercultural Press.

Stuhr, P. (1986). *A field study which analyses ethnic values and aesthetic art education: As observed in Wisconsin Indian community schools.* Paper presented at the American Educational Research Association Symposium; San Francisco.

Troeh, A. (1982). A cross-cultural study comparing Native American and white second and seventh grade students' recognition memory for familiar and unfamiliar stimuli (Doctoral dissertation, University of Washington, 1982). *Dissertation Abstracts International, 43,* 657.

Wax, M., Wax, R., & Dumont, R. (1964/1989). *Formal education in an American Indian community: Peer society and the failure of minority education.* Prospect Heights, IL: Waveland.

Wardle, B. (1990). Native American symbolism in the classroom. *Art Education, 43*(5), 13—24.

Wilson, B., & Wilson, M. (1977). An iconoclastic view of the imagery sources in the drawings of young people. *Art Education, 30*(1), 5—11.

Zastrow, L. (1980). Santa Clara Pueblo art education curriculum design (Doctoral dissertation, Texas Tech University, 1980). *Dissertation Abstracts International, 41,* 1354.

CULTURAL IDENTITY AND REALIZATION THROUGH THE ARTS: PROBLEMS, POSSIBILITIES, AND PROJECTIONS IN NIGERIA

■ SOLOMON IREIN WANGBOJE

I consider it a great honor and indeed a privilege to be invited as a speaker to share my thoughts with you on the occasion of this Congress. Let me congratulate the organizers for providing this forum to enable interaction among artists and educators from many parts of the world. Although congresses have become an annual event, each meeting affords all of us, either as active participants or observers, an opportunity to gain more insights into the many phases of education through art. I find the theme of this congress, namely *Many Arts, Many Cultures*, particularly timely because it carries an explicit recognition of the validity and authenticity of human experience, no matter what culture through which that experience is expressed. If sustained, this recognition of the diversity of human cultures and art forms could open the way for a new era of understanding and respect for the diverse cultures of the world.

Cultural Identity and Realization Through the Arts, my present theme, evokes many reactions depending on how colored the glass is through which we view its meaning. Two concepts of particular significance are *culture* and *identity* and, for a start, I would like to agree with the definition of culture as "the totality of the way of life evolved by a people in its attempts to meet the challenges of living in its environment." This environment is influenced by the social, political, economic, aesthetic, and religious norms and modes of organization which together distinguish one group of people from another. The answer to the question of identity can be found in the simple questions "Who am I?" and "Who are we?" We must look at this theme against a background of a world in which we live and which is faced with spiritual decay, moral laxity, and a mad rush for technological and material triumphs—ideological absurdities where people must meet challenges of adaptation, selection, and constant changes due to dependence on technological development and application. Among these problems, the most pervading and intractable is the problem of identity. Man in every nation and in every culture of the world is compelled to wrestle with a crisis of identity. There is

hardly any people or culture which has not experienced this devastating problem to some degree. No day passes by without news of an individual, group, or nation fighting against another in order to assert its identity or self-image. For example, the many revolutions that have occurred in the various nations of the world, the inevitable wars of liberation currently being waged in the various theaters of war throughout the world, including wars and skirmishes arising out of border disputes, are all designed (not necessarily consciously of course) to define and reinforce some positive self-image, some kind of individual or group identity. On a more desirable level, the clubs we join, the various kinds of societies with which we are affiliated, even the countries from which we derive our citizenship are, essentially, merely different ways of trying to satisfy our deep perennial hunger for some kind of positive self-image or identity, and therefore some kind of meaning or order, in an otherwise largely meaningless and confused existence.

If it is true that our world is characterized by spiritual disorientation borne out of inadequate self and group definition, then it is our duty as members of the human family, particularly in our capacity as artists and art educators, to assist in this search for a new balance through the medium of art. How artists may contribute to this search for a new balance is the subject of this paper; but before engaging this question it is appropriate to mention, however briefly, the causes which underlie this disorientation.

The Problems of Identity in the Modern World

Thanks to recent advances in technology, especially in the areas of transport and communication, our world is rapidly shrinking into a global city in which people from diverse cultures may interact at different levels. It is now possible (for those who can afford it) to speak to friends, relatives, and colleagues across the world, voice to voice (and sometimes face to face) in a matter

Reprinted from *Journal of Art & Design Education* (1986), *5*(1 & 2), 23—31.

192

of seconds. It is also possible for one to have breakfast in one's own city of residence and lunch and supper in a far distant city like London, New York, Moscow, or Lagos. We are able to do this because air travel has become easy, fast and safe, and because of these startling developments one can envisage a time when it will be possible for people to travel around the world in minutes and even to neighboring planets within hours. When this happens, it may be possible for one to live in one continent and go to work in another, in much the same way as modern day workers have to commute long distances by car, train, or tram in order to get to their places of work and return to their various places of abode.

Technology is not the only factor responsible for the shrinking of the world, for there are other factors no less revolutionary in their impact on mankind. I refer to certain international patterns of behavior that have become a way of life throughout the world. For example, there is hardly any culture in the world which has not yet come under the influence of the International Monetary System. Almost every nation and every culture on earth trades with every other nation, thus allowing money and goods to move freely across national frontiers at a breath-taking speed that was not conceivable a generation ago.

In addition to the monetary system which unites the world into one global market, there is also the international political system which has done much to unite several parts of the world into large political units. Thanks to the forces of colonialism still actively at work (under various disguises) in various parts of the world, many so-called "backward" peoples and cultures have assimilated the political ideologies, economic, and cultural destinies of their former colonizers. As a result of this process of assimilation we can now speak of western democracies and socialist regimes; we can also speak of Francophone and Anglophone African countries with all the economic, political, and cultural dependence that these terms entail. We may also speak of Third World nations sharing similar political structures borne out of their recent emergence from the colonial experience; similar patterns of economic productivity and consumption; similar problems of development and a common destiny in their pursuit of economic, political, and cultural freedom. Still in the same line of thought we may mention cultural organizations whose membership is spread among the various nations of the world. These organizations unite their members in pursuit of a common ideal and a common method of realizing their goals. Here several examples come to mind, and the

most notable of these are the *International Red Cross Society*, the *Rotary Club*, the *Jaycees, Lions, Masons* and *Rosicrucians*. In addition we may also mention learned societies, such as our own *International Society for Education Through Art*, which brings together people from diverse cultural backgrounds for the purpose of realizing artistic as well as educational objectives that are beneficial to all mankind.

We live in a world that is thirsting and screaming for a unity of sorts; and in response to this demand, human beings are finding ways and means of bringing about unity politically, socially, and culturally. This tendency is most desirable, and should be encouraged by all means, for it is a welcome change from the various battles, skirmishes, and wars which have characterized man's precarious tenure on this planet. For too long, our way of life has been racked by serious socioeconomic and spiritual upheavals that have tended to drive a wedge between peoples of various cultures, thereby emphasizing their differences rather than the similarities that they share. These upheavals have fostered resentment and in some cases outright hatred of one group by another, making the world fragmented, hostile, and embattled and therefore less fit for human habitation. So it is quite reassuring to note that the world appears to be reversing its habits of hatred and hostility. We have everything to gain by uniting under a common standard for the pursuit of those goals which will bring about global peace and prosperity, and everything to lose by pursuing an opposite course of action. Clearly then, the world must have unity if it is to survive. But this unity also entails certain problems, which must be given serious consideration if we are to avoid stifling the harmonious development of the various cultures and peoples which make up that unity. In its drive towards unity, the world becomes a melting pot in which the smaller cultures can be swallowed, and indeed are being swallowed, by the larger cultures.

It is a fact of history that the countries or nations of the developed economies, by virtue of their technological advancement, material prosperity, and military might, have often set the standards of behavior, as well as the values that shall be held most dearly, in other cultures of the world as well. As a result of this cultural imperialism, the smaller (and usually weaker) cultures have always had to adjust to the standards and the values of the developed nations in order to survive. Because of having to survive through adaptation, the smaller nations of the world are in real danger of losing their cultural identities, or submerging them within the identities of the more dominant cultures, thereby

initiating a trend of cultural development which is as threatening as it is undesirable. This trend in cultural evolution is evident in most Third World nations, particularly African nations in which the local cultures have not only been infiltrated by alien concepts and values but also degraded. One of the consequences of this trend is that the people from dominant cultures often have no respect for the cultures and peoples of other lands. Needless to say, this lack of respect for the cultures of other lands can breed, and often does breed, permanent resentment on the part of people from weaker cultures, thereby inciting them to assert their cultural identity which they consider as important as asserting themselves.

As an artist and art educator, I believe that the Creator of the world (who is the Supreme Artist) must have had a purpose in creating a world teeming with diverse peoples and cultures. I also like to believe that these cultures were not created just for the sake of emphasizing cultural diversity but because of what each culture (at whatever stage of development) can contribute to the overall well-being of mankind. I may liken cultural diversity to the different colors on a painter's palette: in trying to execute a painting, the painter needs all the various colors for producing the different effects that he requires in order to create a successful work of art. It will be a disadvantage indeed if the painter is forced to use only blue or brown or yellow or some other hue. The result would be likely to be monotonous and uninteresting, and lack depth and sensitivity.

As it is with the painter working with a single color, so it is with a world rushing headlong into the embrace of a monoculture. Unless something is done quickly to arrest the present trend of cultural development, the world may develop a single culture; and in this development it is the smaller and so-called "backward" cultures that run the greatest risk of being absorbed and forgotten. Not only will such cultures lose their belief systems but also the patterns of behavior arising from those beliefs. Their dress styles, their eating habits, their arts, their architecture, their technology will become extinct; and the people of these former cultures will embrace alien standards and values. In other words, such people will have lost their identity, and with it their opportunity to make the kind of contribution that only their own culture would have made to the overall well-being of mankind.

It seems clear that as the world shrinks into a *global city* with the possibility of international brotherhood, it also offers the threat of a monoculture in which,

through the law of survival of the fittest, smaller and weaker cultures will be replaced by the more dominant ones. This is a threat that we cannot afford to ignore because it will bring undesirable consequences into the world. It is imperative that all peoples of the various cultures of the world should consider ways and means of meeting this threat and restoring a reasonable degree of *unity in diversity* rather than unity in conformity.

The Possibilities of Asserting Cultural Identity in the Modern World: The FESTAC Example

In this search for cultural unity in diversity the arts can make a useful contribution. The arts are particularly appropriate because they are probably the most effective and most permanent of all the means by which a people may assert its cultural identity. The arts are effective in this regard because of their use of symbols, myths, and other forms of inherited and accumulated understanding, to create visions of life embodying the fears, hopes, aspirations, and beliefs belonging to specific cultures. The arts also use techniques and materials found in each culture to express and interpret that particular cultural experience. In this way, until recent times, a culture, however small or "backward," managed to maintain a certain identity through the arts; but at the present time, for small cultures, any identity made possible through artistic expression is threatened by a dominant tendency towards international unity.

It is true that, even in such threatened cultures, the content of art works still retains a certain degree of uniqueness, perhaps through a deliberate effort at selection of subject-matter, but the methods and the materials are no longer authentic. In my home country of Nigeria, for example, as a result of western training and exposure to the western tradition of artistic production, many Nigerian artists have learned to use not only western modes of expression, but also western materials, western pigments, western dyes, western tools, and other materials of artistic production. Consequently, it is no longer as easy as it once was to tell whether a particular work of art has been produced by a Nigerian artist or by, say, an American artist. It is not possible to make these distinctions because techniques and materials have become internationalized and therefore have lost a certain degree of their cultural integrity. To some extent the content of the art itself has not remained inviolate. Western artists have executed works of art using African subject-matter, that is, African symbols, motifs, and myths just as much as

African artists have attempted works of art using European symbols, motifs, and myths. On the surface it seems almost impossible to tell which work is specifically European and which work is specifically African. This difficulty arises because the cultural identity which the artist once projected through artistic expression is not eroded by this tendency towards international unity. However, it is gratifying to note that although artistic expression appears to have lost its cultural identity, there is still something left in the form of *cultural sensibility*. It seems as if that habitual way of looking at, and responding to, the world which is peculiar to any particular culture has remained relatively untouched by the wind of conformity now sweeping the world. To be sure, this sensibility is itself an expression of cultural identity, being formed and established within the framework of culture; it is also true that sensibility can be modified by external influences, but such modifications are so slow that they seem to survive cultural changes. It is this sensibility which offers the best hope for the pursuit of cultural identity and its realization through the arts. In the African context this sensibility is most clearly demonstrated in the crafts which survive in various traditional communities across the continent. The crafts such as those of weaving, dyeing, pottery, wood carving, and metal design have successfully resisted the influence of modernization (which almost always means internationalization and therefore loss of identity). For example it is still possible today to identify many African crafts in terms of materials, techniques, and location. At their best, these crafts reveal not only the ancient artistic skills cultivated in their culture, but also the ideas which have persistently engaged the attention of the people, and the peculiar motifs and symbols they have selected, in order to express those ideas inspired by their inherited culture.

Although these crafts are useful and enjoyable in themselves, cultural sensibility attains its most powerful and dynamic expression in the performing arts. In Africa, and I dare say in several other parts of the world, especially the Third World nations of Asia, South America, and the Caribbean Islands, the performing arts realized in the context of festivals have been recognized and used as some of the most potent instruments for defining and reinforcing cultural identity. It is in recognition of this unifying function of the performing arts that many Third World nations have instituted festivals of the arts. The Caribbean islanders have their Calypso carnivals, the Brazilians have their carnivals, the Spanish speaking nations have their bullfighting fiestas. Though it does not belong to a Third World nation, the City of Edinburgh has apparently rediscovered the possibilities of the Festival of the Arts which it holds every summer. In Africa also there has been a series of arts festivals attended by peoples of African descent. The first of these festivals, *The Negro Arts Festival*, took place in Dakar in 1966. This was followed by the *Algiers Festival of Negro Arts* in 1969. The most recent and the most famous of these festivals is the *Second World Black and African Festival of Arts and Culture*, otherwise styled FESTAC '77, which took place in Lagos in January and February 1977. Attended by 56 nations with 41 other nations and organizations present as observers, FESTAC was perhaps the most colorful and impressive festival organized anywhere in recent times. Its objectives were:

1. to ensure the revival, resurgence, propagation, and promotion of Black and African culture, cultural values, and civilization;
2. to promote Black and African artists, performers, and writers and facilitate their world acceptance; and
3. to facilitate a periodic "return to origin" in Africa by Black artists, writers, and performers uprooted to other continents.

FESTAC thus represented a collective effort to come together as a people, with a view to setting in motion a new cultural awakening and cultural awareness in the Black and African world.

Among its many memorable highlights were the various dance performances from African nations and from Africans in the diaspora. Underlying the diverse dance movements, colorful and frequently exotic costumes, plastic arts, musical instruments, and songs was the *consciousness* of the various participants that they belong together, that they share a common past, a common future, have similar aspirations, and pursue a common destiny. Most participants left the festival feeling that old links had been renewed and strengthened, new links had been forged, and that all had returned to their source of life for a kind of spiritual regeneration not possible in any other way.

From the experience of FESTAC, I have come to the inescapable conclusion that in a world plagued by disorientation and confusion, (especially in the Third World nations, where the threat of cultural annihilation is most serious) man needs arts festivals in order to structure his experience for optimum understanding and appreciation. It is my humble submission therefore that in our search for cultural identity, the performing arts remain our best and most viable option for suc-

cessful accomplishment, for they help us answer the critical questions to which we must find satisfactory answers if our life is to remain meaningful and constructive, "Who Am I?" and "Who Are We?"

Projections for the Future

As long as the world continues in its present course of development, permitting dominant cultures to absorb weaker ones, the crisis of identity which currently plagues mankind will continue to escalate. It is therefore our privilege and responsibility as artists and art educators to assist the world (however feeble that assistance may be) in finding a new balance on an explicit recognition of the uniqueness and value of each culture as an important aspect of mankind's heritage. This assistance may take several forms. First, we can assist the world by encouraging (through papers, discussions, and exhibits) the art forms of the various cultures to flourish so that the contributions which those cultures can make to the general well-being of mankind will not be lost to the world.

In this way, the more culturally disadvantaged will learn to regain confidence in their cultural heritage, and especially in the institutions which have evolved therefrom. However this confidence can grow only if the people concerned will take the initiative to look within their cultures to rediscover and document forgotten strengths, neglected ideas, and abandoned processes, and use these to tackle the challenges of living in a modern world. Thus they can maintain a sense of continuity with their cultural past and retain a foundation from which they can launch confidently into the future.

Second, we can assist the world by adopting the festival model as a guide to charting new directions in art education. I have seen from the FESTAC example what a festival can do in opening up new levels of self and group awareness. I believe that the festival as an educational concept can be applied profitably (with the necessary modifications to reflect local realities) in the teaching of art at the primary, secondary, and tertiary levels. This use of the festival model will encourage students at the various levels of education to experiment with local materials and traditional techniques to create new artistic productions. Experiments have been carried out in my home country along these lines and the results so far have been quite encouraging.

Third, we can also assist by modifying the present format for art education congresses. Until now our congresses have taken the seemingly invariable form of reading papers, holding discussions, and occasionally mounting art exhibitions. Some of you may probably feel as I do that this format is rather narrow and sometimes uninteresting. I believe we can broaden the scope of congresses, and consequently make them more interesting, by adopting the festival approach—at least occasionally—both at the regional and international levels. Such a modification will encourage the host country to bring forth the vintage of its cultural identity as realized through not only the visual arts but the performing arts as well. In this way art educators can take the lead in promoting cultural identity through the arts—a leadership which I am sure will attract a massive following.